Science Exhibitions
Curation and Design

D0879246

Science Exhibitions
Curation and Design

Anastasia Filippoupoliti

MUSEUMSETC | EDINBURGH

Contents

10 Introduction
ANASTASIA FILIPPOUPOLITI

PART 1: MAKING SCIENCE PUBLIC

Conventions of Display
Exhibition in Twentieth Century American Medicine
26 MIRIAM POSNER
Yale University, USA

Medicine on Show
54 KEN ARNOLD & LISA JAMIESON
Wellcome Collection
London, UK

PART 2: CURATORIAL CHALLENGES

Table Top Physics
Old Science, New Audience
86 JANE WESS
Science Museum
London, UK

No Objects, No Problem
116 JIM GARRETTS
Thackray Museum
Leeds, UK

PART 3: CUTTING-EDGE RESEARCH EXHIBITED

Exhibition Experiments
Publics, Politics and Scientific Controversy
138 SHARON MACDONALD
University of Manchester, UK

The Exhibition and Beyond
Controversial Science in the Museum
152 SARAH R DAVIES
Arizona State University, USA

Technologies of Representation
Representing Nanotechnology and Society
178 BRICE LAURENT
Centre de Sociologie de l'Innovation
Mines ParisTech, France

The Museum as 21st Century Bestiary
210 DENISA KERA
National University of Singapore

PART 4: ART AND SCIENCE

Desiring Structures
The Dendritic Form Revisited
238 MARIUS KWINT
University of Portsmouth, UK

Delineating Disease:
Drawing Insights in the Medical Museum
268 LUCY LYONS
Medical Museion, University of Copenhagen
Denmark

Vanishing Landscapes and Endangered Species
306 JOSEPH EMMANUEL INGOLDSBY
Landscape Mosaics, USA

PART 5: DESIGN OUTLOOKS

The Visitor Experience at Science Exhibitions:
Design, Exhibits and Interactivity
344 ANTONIA HUMM, GUNNAR M GRÄSLUND
& JÖRG SCHMIDTSIEFEN
ArchiMeDes, Berlin, Germany

Engaging The Public

374 WAYNE LABAR
Liberty Science Center
New Jersey, USA

NanoAdventure:
An Interactive Exhibition in Brazil

394 SANDRA MURRIELLO & MARCELO KNOBEL
UNICAMP, Campinas, Brazil

Storytelling Memories

416 TANYA MARRIOTT
Massey University
Wellington, New Zealand

Science Adrift in an Enterprise Culture:
Finding Facts and Telling Stories
in the Maritime Museum

444 WILLIAM M TAYLOR
University of Western Australia

474 Index

490 About The Authors

502 Also From MuseumsEtc

510 Colophon

CURATION AND DESIGN

Introduction

The idea that lies behind this publication stems from a continuing interest in exploring the visual possibilities of science, and the spatial contexts in which scientific procedures and products are designed as exhibition material. As presented in a museum context, science is a rather a challenging subject. From initial idea to final exhibition product, a fascinating process of translation takes place. Scientific facts are coherently interpreted and exhibition media deployed – without losing the essential points of the message.

The history of exhibition design comprises a wealth of visual techniques that characterise each period. The nineteenth century, for example, developed a variety of media to display scientific concepts and objects. In the lecture theatre (such as the Royal Institution of Great Britain), in the wooden showcases of King George III Museum at Kings's College London, or on the library tables of the Royal Astronomical Society of London, it was always *contemporary* science that was presented.[1] These methods influenced the way science would be presented right up to the twentieth century.

Similarly, the fashionable international exhibitions that flourished during the late-nineteenth and early-twentieth centuries changed the way science was presented to the public – and in terms of their design contrasted dramatically with the displays of the scientific institutions and museums of the second part of the nineteenth century.[2] These large-scale events created a new relationship between the space, the science on display and the audience.

Any definition of today's science exhibitions would be as fluid and elusive as it would have been then. A blend of techniques and physical spaces, and a wealth of collections and curators, make up a network that produces this particular type of thematic display. And – in contrast to other types of thematic displays – attempting to define this one is not easy.

It is, however, a fact that science is treated with some hesitation in the exhibition space. How close and how distant is it from other sorts of thematic displays? How do curators approach this particular exhibition genre? What design models should be implemented to best transmit the scientific message? How effective is the exhibition as a means of communicating current research to the public? And what role could the visitor play in this context? Usually science exhibitions face obstacles – both conceptual and material – to their production. For example, the narrative in exhibitions that present the history of science is usually didactic, and fairly impersonal, whilst also implying that science is a finished product. Biographies of scientists end up as isolated and compartmentalized, failing to link to cultural-historical facts. Yet, the museological articulation of science is a complex but fascinating subject to treat, at both practical and theoretical levels.

Since the last decade of the twentieth century a wealth of theoretical writings has discussed the visitor experience in science museums and science centres in the context of the Public Understanding of Science movement, and of the

quality of science information these sites transmit to the broader public.[3] Furthermore, new insights point to a shift in focus from science as a finished product to science as a continuous process – science in the making.[4] Sociology of science approaches have extensively influenced that shift in the reading of science exhibitions.[5] The present book attempts to bring together current and on-going research by an interdisciplinary group of thinkers on the issue of translating a scientific idea to a vivid exhibition script that will allow visitors to construct meaning. In parallel, it analyses the components of a science exhibition, how its design is usually conceived, and how it transforms an idea into a solid exhibit. It also discusses that interactive triptych: curation-design-visitor.

Science Exhibitions: Curation and Design explores, then, the articulations of the exhibition space which are produced to interpret scientific processes – current as well as historic. It aims to examine the potential, as well as the confines, of the three-dimensional exhibit as a means of projecting scientific knowledge and authority. A range of authors tackle the subject: historians of science and art, sociologists, architects, museum professionals and artists. They treat the subject in an interdisciplinary way; each adopts a distinctive theoretical perspective. They come from a number of professional backgrounds and academic research fields. Spanning the sociology of scientific knowledge, the history of science and science communication and visual and material culture theory, the authors analyze what they regard as critical in this

specialized field. Both museum practitioners and researchers with curatorial experience place the science exhibition at the core of their argument and suggest a number of interesting proposals for new viewings/visions of the science exhibition. This selection of critical approaches accurately reflects the current geography of science curatorship.

The authors' understanding of exhibition space is multi-levelled, ranging from the four-walled museum space to the natural environment that can form the canvas on which to interpret scientific concepts. As in art installations, the science exhibition can be situated beyond the enclosed space of the museum to appear in other places as well.

In terms of structure, the book parallels the process of exhibition making. It curates papers thematically and interweaves a number of issues that underpin the display of science: the science event, the curatorship of history of science subjects, the challenge of communicating current research in the museum, the dialogue between art and science methodologies inside and outside the museum, the mutations of design... these are just some of the leading and linking themes throughout the volume's papers.

All the authors have taken the visitor as a common denominator, expressing the potential for public involvement in the process of science presentation and interpretation. The process of curation and design suitable for science exhibitions reflects an "extrovert" stance towards the public, which is indeed another linking theme of these essays.

The book's own narrative starts with an historical

perspective on the science exhibition. In *Conventions of Display: Exhibition in Twentieth-Century American Medicine* Posner examines the history of the Scientific Exhibit which was developed to accompany the American Medical Association's professional meetings from the 1890s to the late 1970s. The Science Exhibit enabled physicians to communicate their latest discoveries or synthesized existing research. That gradually brought to the fore a number of values within medicine's professional culture that were not visible until then. Posner draws links with today's medical data presentation and proposes a new look – along the lines of a fair – for public medical culture. In *Medicine on Show*, Arnold and Jamieson discuss the approach of the Wellcome Collection (London, UK) which combines in an interdisciplinary way medical exhibitions and live event programmes with scientists as a means for visitors to explore science and enter into debate.

Linear histories – as generally perceived – produce a narrative of a great scientific past, isolated from the context to which the original exhibits once belonged. Historians argue that such a conception has treated these objects as ahistorical, as being forever powerful and unquestionable with an abiding *essence*. How is the muscological narrative of the history of science composed? What is the role of the material culture of sciences in studying and projecting the history of a scientific idea or concept? Wess confronts these issues in *Table Top Physics: Old Science, New Audience*. She unfolds step-by-step the process of developing an exhibition proposal on the history

of physics at the Science Museum (London, UK) and reflects on how to make nineteenth-century physics attractive to a twenty-first century audience. On the other hand, Garretts in his contribution *No Objects, No Problem* investigates alternative ways to curate an exhibition without the "usual" collection of authentic objects. How does an abstract idea become an exhibit? Using the temporary exhibition *Meaning on Movement* at the Thackray Museum (Leeds, UK) as a case study, he provides a detailed record of how the curatorial team faced this challenge and the methodological steps followed in order to produce the exhibition scenario and eventually the display.

Recently, researchers have shown an interest in how to visually communicate controversial issues, how to present the process of debating scientific discoveries to a broader public. What qualitative results can this process produce? And how can these be further exploited? A group of essays focuses on the idea of the exhibition as a laboratory setting where cutting-edge research can be put on display. MacDonald's paper *Exhibition Experiments: Publics, Politics and Scientific Controversy* provides the context in which to argue for exhibitions as a way to redefine visitor perceptions of science, emphasizing the importance of design in visitor interaction. Davies, then, explores how controversial technologies are dealt with in museum spaces in *The Exhibition and Beyond: Controversial Science in the Museum*. While Laurent, in *Technologies of Representation: Representing Nanotechnology and Society* examines the challenge from a sociology of

science perspective, analyzing three European projects and their impact on the design and communication of science. He suggests that the exhibition should become a space for exploring science policy as well as a platform for visitor involvement. Finally, Kera in *The Museum as a 21ˢᵗ Century Bestiary* suggests that museums are sites for experimentation with bio- and nanotechnologies and places where people meet their future by exploring emergent and hybrid networks.

Kwint's essay begins the next section which explores the interrelationship between art and science in translating scientific ideas to visual forms. What is the impact of the one to the other? In *Desiring Structures: The Dendritic Form Revisited*, Kwint records the stages in curating an exhibition on tree-like forms held at the Museum of Design (Zurich, Switzerland). Lucy Lyons, artist in residence at the Medical Museion (Copenhagen, Denmark), investigates delineation in her article *Delineating Disease: Drawing Insights in the Medical Museum*. Delineation is a method of drawing developed as a system to help understand an inherited disease. She argues for the important role that drawing can play in communicating medical information. Finally, in *Vanishing Landscapes and Endangered Species*, artist Joseph Ingoldsby argues for a new visual language for scientists to communicate with the public. In this context the artist can play an integral role in the raising of public consciousness. The series of installations entitled *Vanishing Landscapes and Endangered Species* is used as a case study to explore a blend of art, science and technology as a means of advocacy.

Design needs to consider visitors and "accommodate" the content of the exhibition to their needs: information and entertainment. The linear exhibition is often accused of producing impersonal narratives that fail to encourage interaction among visitors. How does an architectural team approach the challenge? And where does the visitor fit into this process? Architects ArchiMeDes offer an enlightening insight in *The Visitor Experience at Science Exhibitions: Design, Exhibits and Interactivity*. Using *Expedition Zukunft* as a case study – commissioned by the Max Planck Society (Germany) – the authors argue for the relationship between hands-on exhibits and design and discuss the process from concept to subtle architecture that allows organic and technical structures to merge. The public is not a passive, homogenous group; it is a group multi-dimensional in terms of the background knowledge and experience it brings to an exhibition. Visitor involvement in the design of an exhibition is the subject of LaBar's paper as well on the work of the Liberty Science Center, USA. In *Engaging the Public*, he explores how visitors can be involved with the exhibition process from the beginning using social media tools. What sort of qualitative evaluation can we derive from it? And how might this change the process of exhibition development?

New styles of exhibit design are discussed in the following two contributions. Murriello and Knobel discuss the challenge of developing interactive exhibits on nanoscience and nanotechnology. In *NanoAdventure: An Interactive Exhibition in Brazil* the authors focus on an exhibit

developed by the Exploratory Science Museum (Campinas, São Paulo) which explores the potential of interactive games and other visual communication techniques. Marriott, in *Storytelling Memories*, argues for the use of new media design techniques within interactive museum installations as an opportunity to provide a multi-vocal navigation experience to the visitor. She does so by presenting the development of an interactive platform (*Storytelling Memories*) that permits immersion within a museum environment. Finally, Taylor in the concluding essay, *Science Adrift in an Enterprise Culture: Finding Facts and Telling Stories in the Maritime Museum*, provides a broader perspective on science's role in the design of a maritime museum. How do other types of exhibitions use scientific concepts to develop their narratives? Taylor uses the history of naval architecture as a point of departure to argue for the development of scientific ideas in the maritime museum.

At the end of each chapter the reader will find a selection of literature that constructs – theoretically and practically – the approach to the subject of science exhibitions. A blend of publications in museology, science communication, history and the sociology of science make up most of the reading lists. Ultimately, the book can serve as a tool both for those who curate (and those envisage curating) science exhibitions and for active researchers in museology and science communication.

The narratives articulated in the present volume are complemented by those in a companion volume, *Science*

Exhibitions: Communication and Evaluation, in which the essays authoritatively address communication issues and evaluate museum case studies from a broader science education perspective.

Our initial intention was to produce a single volume of essays. However, the sheer number of perceptive contributions we received determined that two volumes would be needed, one focusing on Curation and Design, and the other on Communication and Evaluation. However, the practical division into two volumes in no way suggests that these two spheres should be viewed other than as wholly interdependent.

Anastasia Filippoupoliti
Historian of Science and Museologist
Democritus University of Thrace
May 2010

Notes

1. On the useful "lessons" from the past of science exhibition and design, see mainly R. Brain (1993). Going to the Fair. Readings in the Culture of Nineteenth-Century Exhibitions. Cambridge: Whipple Museum of the History of Science; A. Fyfe and B. Lightman (2007). Science in the Marketplace: Nineteenth-Century Sites and Experiences. Chicago: The University of Chicago Press; A. Filippoupoliti A. (2009). "Aspects of a public science: the uses of the collections of the Royal Institution of Great Britain" in Early Popular Visual Culture Journal, vol. 7:1, 45-61.

2. See mainly P. Greenhalgh (1988). Ephemeral Vistas: the Expositions Universelles, Great Exhibitions and World Fairs, 1851-1939. Manchester: Manchester University Press; J. A. Auerbach (1999). The Great Exhibition of 1851: A Nation on Display. New Haven: Yale University Press.

3. See mainly J. Durant (ed.) (1992). Museums and the Public Understanding of Science. London: Science Museum Publications; S. Butler (1992). Science and Technology Museums. Leicester: Leicester University Press; the publication of the Journal of Public Understanding of Science in 1992; S. M. Pearce (ed.) (1996). Exploring Science in Museums. London: The Athlone Press; G. Farmelo and J. Carding (eds.) (1997). Here and Now: Contemporary Science and Technology in Museums and Science Centres. London: Science Museum.

4. See mainly S. Macdonald (ed.) (1998). The Politics of Display: Museums, Science, Culture. London: Routledge; S. Lindqvist (ed.) (2000). Museums and Modern Science. Canton, MA: Science History Publications & The Nobel Museum; S. Macdonald (2002). Behind the Scenes at the Science Museum. London: Berg; D. Chittenden, G. Farmello and B. Lewenstein (eds.) (2004). Creating Connections, Museums and the Public Understanding of Current Research. Lanham: Altamira Press.

5. See for example the research papers published in the journal Social Studies

MAKING SCIENCE PUBLIC

Conventions of Display: Exhibition in Twentieth-Century American Medicine

MIRIAM POSNER

Yale University

If you've been to a large scientific or medical conference, you're probably familiar with the poster session: the tradition, peculiar to the sciences, of displaying research results in poster form. Typically, the researcher stands in front of her poster, ready to take questions from passersby. It's an unusual institution that points back to a colorful twentieth-century tradition of exhibiting scientific information. This essay investigates this tradition at one institution: the American Medical Association's (AMA's) Scientific Exhibit, a feature of annual AMA meetings from 1899 to 1980, in which physicians presented their work in the form of exhibits.

Though historians rarely mention it, a "scientific exhibit" (consisting of many smaller exhibits) was virtually ubiquitous at large medical meetings throughout most of the twentieth century. Physicians (individually or in groups), public-health agencies, and medical organizations frequently mounted exhibits in order to attract publicity or demonstrate discoveries. The contents of exhibits varied widely, but they often included a wide array of media, including drawings, photographs, films, and models. The scientific exhibit was explicitly non-commercial; exhibitors were forbidden to exchange money, negotiate contracts, or mention trade names[2]. It dwelled, however, in close proximity to the commercial exhibit, its profitable counterpart, in which manufacturers paid to promote their wares. In this essay, I

argue that scientific exhibiting should draw our attention to several under-recognized values within medicine's professional culture: multimediality, the impulse to collect and synthesize an array of data to describe the human body; palpability, the continuing desire to test virtual evidence against that which can be touched and felt; and showmanship, the consistent ambivalence professional medicine has demonstrated toward the profession's association with the commercial sphere.

The scientific exhibit emerged at the AMA in 1899 and was gone by 1981. The AMA, however, was far from the only medical group that included an exhibit as part of its annual meeting. The scientific exhibit was a common feature of many larger state and national medical conventions in the mid-twentieth century. I have chosen to focus here on the AMA because of the organization's well-documented interest in asserting itself as the authoritative voice of American medicine.[3] Inconveniently for my purposes, the AMA as an organization is not historically static; its goals, constituency, and importance have changed over time. In the 1940s and 1950s, for example, the AMA was uncontested in importance within the medical profession. Today, however, a proliferation of specialty societies has shifted the AMA away from the center of the field. Nevertheless, the organization serves as a useful, if not infallible, index of the place of exhibiting in relation to the medical profession.

The American Medical Association has been intensely interested throughout its history in establishing itself as the

dominant voice in allopathic medicine. The organization was founded in 1847 with the mission of advancing the cause of the medical profession and promoting the exchange of ideas among physicians.[4] At its outset, the AMA's members were especially concerned with improving the social standing and reputation of physicians, mounting campaigns to regularize medical education, to establish a code of medical ethics, and to educate Americans about the dangers of quack pharmaceuticals. The AMA's powerful lobbying arm has had a strong hand in campaigning against health maintenance organizations in the 1930s and, in the 1950s, against Medicare. The AMA has been politically strongest when the medical profession has been at its most unified. In the early part of 1960s, when the AMA was entrenched in a battle against Medicare, the AMA claimed at least 70 percent of American doctors as members.[5] Since that high point, however, the AMA's membership numbers have represented steadily smaller percentages of practicing physicians as the medical profession has fractured into smaller subfields. In 2008, the AMA's 236, 153 members represented about 23 percent of the nation's physicians.[6]

Conventions were always an important part of the AMA's culture and governance. It is at these annual meetings that the group's governing board meets to determine policy and where physicians read papers to their assembled colleagues. By these meetings, in the words of one of the AMA's founders, "an exciting, vivifying, and healthful influence shall be exerted over the length and breadth of the country, until a correct and

noble sentiment is engendered in the bosom of every member of the profession."[7]

Twentieth-century medical exhibiting bears a resemblance to a number of older traditions of display. World's Fairs and expositions, popular throughout the nineteenth century, combined a rhetoric of progress with an emphasis on spectacle. Nineteenth-century industrialization had produced an unprecedented bounty of goods, and new methods of merchandising placed a premium on the objects' attractive display. Medicine itself has a strong history of display for the purposes of teaching. Since the eighteenth century, teaching institutions maintained specimens and models in order to teach anatomy. The tradition was particularly strong in Europe, where model-making and specimen preservation could be high art. But it was well-established in the United States as well, at institutions like the Army Medical Museum, founded in 1862, and the Mütter Museum, founded in 1858. Surgery, too, has long been taught by example, in surgical theaters like those depicted in Thomas Eakins' 1889 painting *The Agnew Clinic*. The science of pathology also grew rapidly in importance and sophistication in the last quarter of the nineteenth century. Microscopy injected the discipline with new life, and institutions established or expanded their pathological specimen collections in response. The Army Medical Museum, under George Otis, was particularly influential in modernizing and popularizing the study of pathology in the United States.[8]

It was this burgeoning interest in pathology that provided

the impetus for the AMA's first scientific exhibition, in 1899. An Indiana physician, Frank D. Wynn, received $300 from his local medical association to bring his pathological specimen collection to the annual AMA meeting in Columbus, Ohio. Wynn's exhibit was a somewhat homespun affair: the physician rented an empty warehouse and built the display tables himself.[9] So popular was the exhibit, however, that the AMA voted in 1902 to make such a display a regular feature of its annual meeting.[10] The AMA began awarding medals to notable exhibitors in 1908. By 1918, exhibiting was so popular that the AMA turned down half of its applications. Film screenings, which the AMA considered part of the exhibit program, were also popular, if slower to take hold. The AMA introduced motion-picture theaters in 1915, but banned surgical films in the theaters in 1921, citing the films' potential for manipulation and self-promotion. In 1928, the motion-picture theaters were discontinued entirely, on the grounds that their popularity detracted from attendance at lectures, but physicians continued to screen films inside exhibit booths. Finally, in 1941, the AMA reinstituted the motion-picture theaters at conventions, explaining that film spectators were clogging the aisles at the exhibit hall.[11] During the pre-World War II years, the exhibit hall at annual conventions held as many as 250 different booths. Attendance at medical conventions dropped off during World War II, but by the end of the war physicians were returning to the AMA, and exhibiting with even greater enthusiasm.

Based on the numbers of exhibits, the post-World War II

period until the mid-1960s was the high point in scientific exhibiting at the AMA. The 1957 convention, for example, featured 400 exhibits. And as the exhibits increased in number, they also increased in the elaborateness of their presentation. At one 1947 exhibit on the cardiovascular system, a physician could see charts, drawings, diagrams, color slides, photographs, X-rays, live patients who would submit to examination, and demonstrators who could answer questions. The physician could also attend a screening of a film on cardiovascular surgery in one of the convention's three motion-picture theaters. By the mid-1960s, however, the scientific exhibit had decreased in size. The 1980 meeting offered one exhibit and a few films, but by the next year's meeting, exhibits had disappeared from the program, replaced by a poster session.[12]

Thomas G. Hull, a longtime secretary of the AMA's Council on Scientific Assembly, was the Scientific Exhibit's greatest champion during the most active years of exhibiting at the AMA. A bacteriologist who had worked at the Illinois Department of Public Health, Hull served as the director of the scientific exhibit from 1930 to 1959.[13] Hull placed great stock in the ability of exhibits to advance the cause of medical science. "Within its limitations of time and space," writes Hull, "the exhibit is probably the best device which man has invented to communicate facts and ideas about the physical world."[14] Under Hull's tenure, the number of exhibits at AMA annual meetings increased from ten in 1930 to 385 in 1959.[15]

Over the years, the AMA standardized its procedures for

exhibitors. Physicians interested in exhibiting submitted a sketch and an information form to the AMA's Bureau of Exhibits, which selected applications on the basis of scientific rigor, novelty, and scientific contribution. An exhibit proposal was to be declined if it contained advertising. The Bureau's rules required that the exhibit's author "or a member of his research team" be present in the booth at all times.[16] A physician's presence within the booth was an important part of the program's conception. These attendants could "demonstrate, discuss, and answer questions while surrounded by the visual materials of their respective subjects," wrote Thomas Hull. "While the conventions are in progress, the exhibit booths becoming the common meeting ground of physician, scientist, teacher, and student."[17]

Scientific exhibits varied a great deal in their appearance and constitution. The displays of wet pathology that characterized exhibits in their first years gradually gave way to more elaborate exhibits that made use of a variety of media. The AMA encouraged exhibitors to use a number of different visual and tactile modes to convey information: "New and improved methods in the production of photographs, drawings, and other pictorial matter as well as three dimensional media have placed in the hands of the exhibitor a wealth of materials with which to tell his story and express his ideas," write Hull and Tom Jones in *Scientific Exhibits*, a 1961 guide to exhibiting at medical conferences.[18] One contemporary writer divided AMA exhibits into four types: the "pin-up" type, which included charts and photographs;

exhibits that used both charts and models; exhibits that made use of film transparencies in viewboxes; and freestanding, portable exhibits that contained x-ray films, models, and "other material."[19] AMA exhibits could either demonstrate a new scientific development or synthesize existing concepts.

Exhibiting guides frequently stress clarity and directness. "Plan the material so that the first glance will give the visitor the main idea of the exhibit," advises one guide to exhibiting, "even though the details may keep him occupied for a considerable length of time."[20] Hull and Jones recommend arranging materials symmetrically, in a four-and-a-half foot band located for optimum visibility. They advise that "the exhibit must above all be graphic," with a minimum of text.[21] Exhibit organizers encouraged the use of color in scientific exhibits, cautioning, however, that overbright backgrounds and decorations could result in "gaudy displays."[22] Hull and Jones recommend the use of pathological specimens and anatomical models, though they warn against materials that serve merely decorative purposes. "Living" models – men or women who made themselves available for demonstrations – were a frequent feature of medical exhibitions. "If such a person, either man or woman, is pleasing to look at," write Hull and Jones, "nothing is lost from the demonstration. Under no circumstances, however, should a beautiful girl be included just for 'window dressing.'" But sick patients, the authors admonish, should be left in the hospital. "The days are gone when surgical operations were performed before the assembled audience at a medical meeting."[23] Films and slide

projections were also a popular feature of medical exhibits, often projected within the booths themselves, though Hull and Jones advise against "lurid and spectacular" subjects.[24]

Why look at exhibits?

AMA's exhibiting tradition suggests a cluster of little-discussed themes in the way that medical information was formed and conveyed during the twentieth century. The first of these themes, palpability, relates to physicians' consistent ambivalence about whether, and when, to favor vision over touch as a mode of gathering information. Multimediality is also an important part of the scientific exhibit: physicians used the exhibit hall as a way to gather together many competing ways of visualizing and describing the human body. Showmanship provides a third structuring concept: the fairground-like setting of the exhibit hall tested physicians' ambivalent relationship with self-promotion, visibility, and commercialism. The following three examples demonstrate how a discussion of exhibition can shed light on each of these themes.

A multimedia space

Most histories of the medical profession draw, logically enough, on the remnants of that history that can be found in archives: journal and newspaper articles, letters, and organizational papers. One might get the sense from these documents that medical knowledge is constructed and purveyed largely through the written word. But exhibits rarely

survive more than a few years, and because of this, historians seldom mention their existence in professional medical culture. Exhibiting tells us that physicians spent a great deal of time and energy creating multimedia spaces where knowledge could be created by synthesizing a number of different media, including photographs, X-rays, moving images, recorded sound, diagrams, illustrations, and models.

Photographs and descriptions of exhibits show that the booths frequently contained an impressive variety of media. One award-winning exhibit from 1957, "A Study of Fetal Cardiac Energy," combined drawings, graphs, a magnetic tape recording of the fetal heartbeat, and a fetal electrocardiograph.[25] Another exhibit from the same year, "The Nonvenereal Diseases of the Genitals," contained a set of stereophotographic viewers through which physicians could see images of penile, scrotal, vulvar, and anal lesions.[26] In 1955, "Epidural Anesthesia for Caesarean Section" combined charts, diagrams, moulage, and "an opportunity for visitors to try an epidural puncture."[27] "Living demonstrators" added another sensorial dimension to scientific exhibits. One 1953 photograph shows two young men (presumably veterans) standing in a Veterans Administration display on prosthetics, demonstrating the use of their artificial limbs as physicians look on.[28] Another photograph shows a patient-demonstrator on a hospital cot before a number of seated men. The patient's arms are folded behind his head as a doctor places a hand on his abdomen.[29] In instructional pamphlets and articles, exhibiting experts encouraged scientists to capitalize on the

exhibit's ability to combine media: "the exhibit," writes Hull, "combines the advantages of visual mediums and language into a specific coordinated technique that has a higher teaching potential than any other known modality."[30]

At the AMA, medical films were understood to be an extension of exhibiting practices. Film was presented under the auspices of the Bureau of Exhibit, classed under the heading of the Scientific Exhibit in the meeting program, and held in theaters directly adjoining the exhibit hall.[31] Indeed, as described above, films moved in and out of exhibit booths themselves. Closed-circuit television (televised broadcasts of surgical operations) was also a popular component of medical conventions, introduced in 1948 and popular through the 1980s.[32]

The physicians convening during the post-War years were experiencing an explosive growth in medical knowledge about the body, and a corresponding efflorescence of medical images. The exhibit space offered them a chance to synthesize these multiple ways of seeing the human body: they could match a living patient with his electrocardiogram or compare a surgical film with a medical moulage.

A 1978 pamphlet from the American Academy of Orthopaedic Surgeons makes this quality of exhibiting explicit. Pairing an anatomical model with a transparency "permits a registrant to correlate those things he's seen on the x-rays … to a 'feel' object."[33] In the space of the exhibit, physicians could order different modes of knowledge, integrating the tangible with the visual and the graphical with the textual.

Palpability

The American Medical Association had met for more than fifty years before, at its Columbus, Ohio, annual meeting of 1899, it mounted a pathological exhibit.[34] The practice immediately caught on, and by 1900, the number of displays grew from one to sixteen. The exhibits on offer largely consisted of anatomical specimens, along with skiagraphs and a set of photographs "illustrating different types of insane." [35] By 1902, 2,100 specimens filled a 75-by-75-foot hall in St. Paul, Minnesota, presided over by a corps of fifty demonstrators.[36] Interestingly, the first pathological exhibit took place just as medical museums were in decline, and as photomicroscopy, the x-ray, and film were gaining in popularity. Why did physicians introduce this seemingly outmoded method of display?

The exhibit organizer's discussion provides a number of clues. The collections on view, writes Frank B. Wynn, the Indianapolis physician in charge of the exhibit, "presented tangible proofs of the important relationship between bacteriology and diagnosis, as well as its bearing on surgical and sanitary procedures." [37] The mention of "tangible proofs," as well as the reference to bacteriology, suggest a subtext of anxiety about acceptable brands of evidence. Germ theory, still far from universally accepted, could have been bolstered, for example, with photomicroscopy. But it was "tangible proof" on demand in 1899: "bacteriologic demonstrations, such as the Widal test, guinea-pig and culture experiments." [38] To revive the fading nineteenth-century tradition of specimen-collecting in the era of the x-ray, microscope, and motion

picture suggests a distinct suspicion about the proof-bearing capabilities of the photographic image. "Let the exhibit become the arena in which the investigator demonstrates to his co-workers the proofs of original work," suggests Wynn. "What in this way can be made plain to many competent witnesses will be spared the innuendoes of scepticism and will receive just recognition promptly."[39]

The discussion of the exhibit also suggests an effort to organize and master an abundance of information. Too many papers are presented at the annual meeting, writes Wynn: "Taken all in all the effect even on the most attentive listener is too often somnolent."[40] Far better to look to specimens for information: "the spirit of the age ... demands brevity; calls for facts rather than theories and deeds rather than words."[41] But exhibits' ability to condense information could be improved, adds Wynn, with better organization of the exhibit space. The physician recommends "a collection half the size and specimens selected with a view to illustrating certain phases of pathology."[42]

Wynn's remarks suggest a model of medical knowledge that bears more resemblance to the anatomical museum than the MRI. In this view, the body itself supplies the most trustworthy information. Proof is obtained from the physical substance of body parts, rather than through any attempt to interpret them. Yet Wynn does not exactly distrust images; skiagraphs and photographs are part of the exhibit. Rather, photographic images are one among a number of types of evidence. Photographs, like lectures, must be matched against

flesh, the true test of representation.

When historians write about medicine and visual representation, they often argue that as the decades advanced, medicine shifted its focus from touch to sight as the definitive mode of knowledge gathering.[43] As it did so, medicine delved more deeply and thoroughly into the body, subjecting it to greater scrutiny and management. Technologies like the x-ray, ultrasound, and MRI translate corporeality into images, submitting the body to modes of organization based on the authority of vision. The presence of the scientific exhibit in medicine does not necessarily contradict this overall view, but it does suggest that the situation was more complicated than one might expect. Historians Loraine Daston and Peter Galison describe a similar complexity in the transitions between scientific epistemes during the nineteenth and twentieth centuries: "This is not some neat Hegelian arithmetic of thesis plus antithesis equals synthesis, but a far messier situation in which all the elements continue in play and interaction with each other." [44] Perhaps physicians conceded the dominance of virtual ways of seeing even as they used their own eyes and bodies to calibrate the new regime. Physicians vacillated between vision and touch, resorting to the tangible at moments when information and images threatened to overwhelm. They also employed strategies like exhibits that helped connect the physical with the virtual.

Showmanship

To exhibit is, of course, to show. The popularity of the practice

suggests the elements of grandstanding and self-promotion inherent in the proliferation of a new theory or procedure. The vision, moreover, of a room filled with exhibit booths evokes carnivals, fairs, and medicine shows, particularly since physicians often served as "demonstrators" at their own exhibits. Such associations consistently made the AMA nervous, particularly when exhibiting techniques threatened to leak from the medical to the public sphere. 1902's pathology exhibit, reports an AMA historian, had to be purged of curious mothers pushing strollers.[45] A 1920 *JAMA* article warned of a suit brought against a physician whose film of a caesarean section was shown in commercial theaters.[46] The 1921 ban on surgical films was due in part to the films' sensationalistic quality: "The films are sometimes used as a means of self-exploitation," *JAMA* reported. "The use of surgical films, in certain instances, has been the means of promoting individual methods."[47]

I attribute American medicine's unease with show-manship to the profession's interest in publicly dissociating itself from the commercial sphere, to its determination to ally medicine with the scientific objectivity, and to its concern for maintaining control over the images it disseminated. Nevertheless, an element of showmanship has been consistently present in the construction of medical knowledge. This ambivalence toward theatricality is perhaps best evidenced by the medical profession's alternating embrace and rejection of medical television. The medium made its first appearance at an AMA meeting in 1948, when

Northwestern University broadcast footage of live surgical procedures via closed-circuit television. More than two thousand physicians watched the procedures at three sites, on a phalanx of individual television sets and on a specially manufactured eight-foot-by-ten-foot screen.[48] The broadcast was deemed a success, and helped inaugurate a widespread vogue for broadcasting live televised operations and clinics to physicians. At one "Videclinic," in 1955, Dwight Eisenhower introduced a program on coronary artery disease to an audience of 22,000 physicians assembled at ballrooms and auditoriums in thirty-two cities. Photographs of the broadcast suggest a distinctly theatrical flavor: hundreds of physicians sit assembled before a giant screen flanked by velvet curtains.[49] The AMA also embraced television as a public-health and public-relations tool, broadcasting several series of half-hour programs on topics such as *Your Good Health and the Mighty Atom* and *How to Keep Your Baby Well*.[50]

In other contexts, however, medical authorities were much more uneasy with the reach and access television provided. One can get a sense of this unease in the negotiations of the Association of American Medical Colleges with NBC to offer a continuing-education program to physicians via an open-circuit broadcast. The AAMC, which worked closely with the AMA, played an important role in the promotion of surgical films during the post-war period. Open-circuit television, however, proved ultimately unpalatable. In 1959, NBC suggested to the AAMC that the association collaborate with the network to produce a series of continuing-education

broadcasts for physicians. AAMC officials initially professed interest, and NBC responded with a proposal for a program called Postgraduate Medicine. The program would air from 7:00 to 8:00 a.m. on Saturday mornings. "This hour," NBC's public-relations official wrote, "was selected in the belief that it would reach most physicians after they had arisen but before their professional activity was started ... and there would be the smallest possible audience from the general public." The program, the proposal assured, would be conducted in the gravest of tones: "We shall not load the program with gimmicks... The success of this experiment depends upon the fact density of its content and upon the sober intensity of its representation."[51]

AAMC officials initially favored the proposal, in part as a way to wrest control of medical education from unqualified pretenders. "Several organizations and individuals outside of the field of medical education have been attempting to secure their own place in the sun," noted one AAMC official, "by developing programs inferior and shallow in nature."[52] Yet, to NBC's frustration, the AAMC dithered. An internal memo suggests why. AAMC's imprimatur, writes Frank Woolsey to Darley, would give undue authority to the show's advertisers. (This despite the fact that 1955's Videclinic was sponsored by Smith, Kline & French.) Moreover, broadcasting medical information over open airwaves could pose dangers: "It is difficult to see how the needed clinical information may be transmitted in a manner which may be subjected to the scrutiny of the public without harmful effects... Such

a presentation might produce a disconcerting amount of iatrogenic disease."[53] The AAMC thus backed out of NBC's proposal. By 1961, however, the AAMC was meeting with the AMA to plan its own National Television Institute for Continuing Medical Education – to be broadcast on a closed circuit.[54]

The AAMC's negotiations evince a telling ambivalence about the dissemination of medical information. The presentation of such information was laudable even in a sensational format, as the Videclinic suggests, as long as it was confined to an audience of professionals. Once exposed to the public sphere, however, such presentations bespoke sensationalism and the artifice of theater. On open airwaves, moreover, medical presentations shared an unpleasant intimacy with commercial broadcasts. They also offered the possibility that privileged information would escape the control of authorized providers. "What will happen," an AAMC official wonders, "if a layman hears that a certain drug has proven to me most effective in reducing hypertension, knows that his physician has not prescribed this drug, assumes therefore that the physician has not treated him properly and decides to seize upon an opportunity to initiate legal action against the physician?"[55] The unease the AAMC felt about the NBC program speaks to a tension that surfaced frequently when doctors confronted medicine's tradition of exhibition: such practices were both crucial to the doctors' self-construction, and evocative of a type of commercialism and self-promotion that doctors professed to disdain.

Perhaps the most obvious manifestation of medicine's fraught relationship with the commercial sphere is the glaring, but unacknowledged, resemblance of the commercial exhibit to the scientific exhibit. Exhibit officials fastidiously erased any reference to commercial organizations from doctors' displays. "Such instances are distressing," write Hull and Jones, "requiring the covering of the objectionable words with tape after the exhibit has been installed at the meeting." [56] Yet a few feet away, the commercial exhibit thrived unchallenged. One correspondent complained in 1953 of having "had to struggle through three floors of commercial exhibits in order to get to the Scientific Exhibit." [57] The silence about this curious configuration suggests a reluctance to acknowledge the degree to which medicine and business shared an interest in self-promotion (as well as in profit).

The end of the exhibit
By the late 1960s, attendance at AMA meetings began to decline as physicians identified more readily with subspecialties. As attendance receded, so did exhibiting. [58] In 1980, after a meeting that saw only 60 scientific exhibits, the AMA Board of Trustees voted to discontinue the exhibiting program. [59]

The end of exhibiting at the AMA, however, did not mean the end of exhibiting altogether. The tradition of mounting a scientific exhibit continues in a number of subfields. The Radiological Society of North America, a group of medical imaging specialists, still includes a very popular program of scientific exhibits at its annual meeting. The American

Society of Neuroradiology also continues to hold an exhibit, as do the American Academy of Orthopaedic Surgeons, the International Anesthesia Research Society, and the International Society for Clinical Densitometry, to name a few. It would be interesting to learn why these traditions continue in some fields but not others.

Even in organizations where the scientific exhibit has disappeared, vestiges of the exhibiting tradition remain. The scientific poster session remains an important part of medical and scientific culture. Student science fairs, products of the most active period of medical exhibiting, continue to feature prominently in science education.[60] The American College of Surgeons continues to offer awards to producers of medical videos at its annual Clinical Congress. Moreover, the ubiquity of PowerPoint at medical meetings hints that some of the exhibiting work of former years has now been incorporated into illustrated lectures.

Over the course of the twentieth century, American medicine expanded, consolidated its authority, and eventually fragmented into subfields. These developments took place not only in the pages of journals and in scholarly lectures, but in the physical space of the exhibit hall: a lively, multimedia environment where physicians vied with each other to draw attention to the latest scientific developments and research projects. The presence of the exhibit hall within the history of twentieth-century medicine suggests that we need to revise our models of medical epistemology and professional culture. Medical culture could stray far from the

dry dispassion suggested by medical journal articles. It could, on the contrary, be very much like a fair.

Notes

1. Helen Miles Davis, Exhibit Techniques (Washington, D.C.: Science Service, 1951), n.p.

2. Thomas G. Hull and Tom Jones, Scientific Exhibits (Springfield, Ill.: Charles C. Thomas, 1961), 3-4.

3. See, for example, Paul Starr, The Social Transformation of American Medicine (New York: Basic Books, 1983); James Gordon Burrow, Organized Medicine in the Progressive Era (Baltmore: Johns Hopkins University Press, 1977); and James A. Johnson, The American Medical Association and Organized Medicine: A Commentary and Annotated Bibliography (New York: Garland, 1993).

4. N. S. Davis, History of the American Medical Association, From its Organization up to January, 1855 (Philadelphia: Lippincott, Grambo and Co., 1855), 20.

5. Hoover's Profile: American Medical Association, http://www.hoovers.com/ company/American_Medical_Association_Inc/, accessed February 7, 2010.

6. Cathy Blight, Report of the Council on Long Range Planning and Development, #3-A-09 (American Medical Association, June 2009).

7. Davis 1855, 27.

8. For more on these exhibiting traditions, see Zhao Jin Feng, Contagion and Inhabitation: The Contemporary Medical Museum (Master's thesis, Carleton University, 2004); Erin Hunter McLeary, Science in a Bottle: The Medical Museum in North America, 1860-1940 (Ph.D. diss., University of Pennsylvania, 2001); Robert Rydell, All the World's a Fair: Visions of Empire at American International Exposition, 1876-1916 (Chicago: University of Chicago Press, 1984); Julie K. Brown, Making Culture Visible: Photography and its Display at Industrial Fairs, International Exhibitions, and Industrial Exhibitions in the U.S., 1847-1900 (Amsterdam: Harwood Academic Publishers, 2001); Michael Miller, The Bon Marché: Bourgeois Culture and the Department Store, 1896-

1920 *(Princeton, N.J.: Princeton University Press, 1981); Juan Rosai, ed., Guiding the Surgeon's Hand: The History of American Surgical Pathology (Washington, D.C.: American Registry of Pathology, Armed Forces Institute of Pathology, 1997).*

9. *Hull and Jones 1961, i.*

10. Frank B. Wynn, *"The Scientific Exhibit and its Future," Journal of the American Medical Association* 40:6 *(February 7, 1903), 350-352.*

11. Thomas G. Hull, *"Bureau of Exhibits," in Morris Fishbein, A History of the American Medical Association, 1847-1947 (Philadelphia: W. B. Saunders, 1947), 1047; ibid., "Surgical Motion Pictures," Journal of the American Medical Association* 87:19 *(November 6, 1926), 1563; Hull 1947,1047.*

12. *"Scientific Exhibit," JAMA* 242:17 *(October 26, 1979), 1869; "AMA Winter Scientific Meeting," JAMA* 244:17 *(October 24, 1980), 1910-1915.*

13. *American Medical Association, House of Delegates Proceedings, Annual Session 1931, 18; and House of Delegates Proceedings, Clinical Session 1959, 133.*

14. *Hull and Jones 1961, 3.*

15. *American Medical Association House of Delegates Proceedings, Clinical Session 1959, 59.*

16. *American Medical Association Council on Scientific Assembly Scientific Exhibit Code (February 1961), American Medical Association Archives, Chicago, Illinois.*

17. Tom Jones and Thomas G. Hull, *"Scientific Exhibits," Journal of the American Medical Association* 151 *(April 25, 1953), 1482-1485.*

18. *Hull and Jones 1961, 3.*

19. Arthur H. Bulbulian, *"Scientific Exhibits" (1959), quoted in Hull and Jones 1961, 17.*

20. *"Plans and Preparations for Your Exhibit in the Scientific Exhibit, American*

Medical Association," undated typescript, Otis Historical Archives, Armed Forces Institute of Pathology, Washington, D.C.

21. Hull and Jones 1961, 21.

22. Ibid., 61.

23. Ibid., 73-74.

24. Ibid., 87.

25. "A Study of Fetal Cardiac Energy, " in American Medical Association., AMA Scientific Exhibits, 1957.New York: Grune & Stratton, 1957), 11.

26. "The Nonvenereal Diseases of the Genitals," in ibid., 43.

27. "Epidural Anesthesia for Caesarean Section," American Medical Association, AMA Scientific Exhibits, 1955 (New York: Grune & Stratton, 1955), 17.

28. Hull and Jones 1961, 75.

29. Ibid., 104.

30. Hull and Jones 1953, 1482-1485.

31. Hull 1947, 1042-1065.

32. "Medical School to Televise," Journal of the American Medical Association 136:15 (April 10, 1948), 989; and "Closed Circuit Television in the Neurological Setting," Journal of Visual Communication in Medicine 10:2 (April 1987), 66-68.

33. "How to Prepare a Scientific Exhibit" (pamphlet; Rosemont, Illinois: American Academy of Orthopaedic Surgeons, 1978), n.p.

34. "Report of Judicial Council," Journal of the American Medical Association 32:24 (June 17, 1899), 1375.

35. "Report on Pathological Exhibit," Journal of the American Medical Association 35:1 (July 7, 1900), 43-44.

36. Wynn 350-352.

37. Ibid. 350.

38. Ibid.

39. Ibid. 351.

40. Ibid. 350.

41. Ibid. 351.

42. Ibid.

43. See, for example, José van Dijck, The Transparent Body: A Cultural Analysis of Medical Imaging (Seattle: University of Washington Press, 2005); Bettyann Kevles, Naked to the Bone: Medical Imaging in the Twentieth Century (New Brunswick, N.J.: Rutgers University Press, 1997); Lisa Cartwright, Screening the Body (Minneapolis: University of Minnesota Press, 1995).

44. Daston and Galison, Objectivity (Brooklyn, NY.: Zone, 2007), 18.

45. Hull 1947, 1051.

46. "Sued for Exhibiting Motion Picture of Operation," Journal of the American Medical Association 75:19 (November 5, 1920), 1289.

47. "Surgical Motion Pictures," Journal of the American Medical Association 87:19 (November 6, 1926), 1563.

48. "Medical School to Televise," Journal of the American Medical Association 136:15 (April 10, 1948), 989.

49. "Education by Television," Journal of the American Medical Association 157:12 (March 19, 1955), 1026.

50. "Television," Journal of the American Medical Association 141:10 (November 5, 1949), 686.

51. Edward Stanley, NBC's director of public affairs, to AAMC president Ward Darley, December 21, 1959, AAMC Collection, National Library of Medicine, Bethesda, Maryland.

52. Tom Coleman to Ward Darley, November 25, 1959, AAMC Collection, National Library of Medicine, Bethesda, Maryland.

53. Frank Woolsey to Ward Darley, February 19, 1960, AAMC Collection, National Library of Medicine, Bethesda, Maryland.

54. J. Frank Whiting to Ward Darley, February 23, 1961, AAMC Collection, National Library of Medicine, Bethesda, Maryland.

55. Frank Woolsey to Ward Darley, February 19, 1960, AAMC Collection, National Library of Medicine, Bethesda, Maryland.

56. Hull and Jones 1961, 4.

57. William P. Boger, quoted in Agenda, Meeting of the [AMA] Committee on Scientific Exhibit, Chicago, October 1, 1953, AMA Archives, Chicago, Illinois.

58. A 1971 Scientific Assembly news bulletin notes that "scientific exhibit applications have considerably decreased in number in recent years. ... In 1967 there were 446 applications as compared to 302 this year" ("Post Mortem on the Atlantic City Convention," [AMA] Council on Scientific Assembly News Bulletin no. 1, July 1971, AMA Archives, Chicago, Illinois).

59. Minutes, AMA Council on Continuing Physician Education, April 8–9, 1980, AMA Archives, Chicago, Illinois.

60. The Science Service, an organization founded by Edward Scripps and William Emerson Ritter in 1927, presented the first National Science Fair, now called the Intel International Science and Engineering Fair, in 1950. See "First National Science Fair," Science News Letter, May 27, 1950, 326–327.

Medicine On Show

KEN ARNOLD & LISA JAMIESON

Wellcome Collection

London

Wellcome Collection opened in central London in June 2007. In preparation for its launch, a crucial question we puzzled over was what might be the best exhibition with which to launch a venue determined to throw fresh light on medicine and health. Functioning in part as a public face for one of the world's largest research charities, it clearly needed to be an unambiguously scientific show. But a key part of our conception for this new visitor attraction was that it should tackle scientific topics and issues in a thoroughly cultural context. Our approach had therefore to appeal to devotees of the arts and humanities too. Now much in the world of medicine can come across as dark and gloomy; since opening, we have tackled the topics of death and skeletons, war and diseases, madness and sadness. But to start with we wanted something more upbeat. A conversation with the writer Louisa Young suggested the perfect topic: the heart.

As any teenage science student will tell you, the heart sits at the centre of most things biomedical. The history of human inquiry into this most vital organ has given us triumphant stories of research and discovery: William Harvey's seventeenth century insights into blood circulation, and Christian Barnard's landmark efforts to replace the South African grocer Louis Washkansky's malfunctioning heart in 1967. But the subject of the heart cannot seriously be contemplated without also addressing the passions, beliefs, subjective meanings and all the consequent creative imaginings that it has invoked. Wellcome Collection's Heart show therefore included drawings by Leonardo da Vinci (one

of the first to draw the organ directly from nature), tables of veins and arteries prepared in renaissance Padua, and a heart-lung machine used to replicate the work of those organs while surgeons operate on the patient's own. It also presented zoological specimens ranging from a 1.5 meter whale heart to a shrew's minute specimen – thus drawing out the relationship between animal size and rapidity of heartbeat.

But alongside this scientific and clinical material, the exhibition also showcased leaves from an ancient Egyptian book of the dead (depicting the heart being weighed against the feather of truth), religious iconography (both sober Protestant images and much bolder, bloodier Catholic ones), and contemporary artworks from Annette Messager and Jordan Baseman – the latter's poignant, and periodically alarming video installation superimposed a sound-track of Billy Graham's biblical rhetoric over film footage of open heart surgery. We also included a series of listening posts where audiences could hear popular heart-related songs such as Elvis Presley's *Heartbreak Hotel*. Most dramatically of all, through the collaborative efforts of the Papworth Hospital, the show displayed the preserved malfunctioning heart of Jennifer Sutton (27 years old at the time), who had undergone a transplant operation just weeks before the opening. Extraordinarily, Jennifer was able to come into the exhibition half way through its run to look at her old heart. A popular exhibition, The Heart established a number of core characteristics of how Wellcome Collection's programming. It was, we hoped, visually bold, gracefully interdisciplinary and

uncompromisingly concerned with real objects, real people, real stories.

Coinciding with the exhibition, one of the very successful live events staged at Wellcome Collection during its opening season was based on the idea of giving audiences an opportunity to witness surgery as it actually happened. So during a July evening in 2007, an audience of some 200 or more crowded into Wellcome Collection auditorium to watch, via a two-way live video link, an open-heart operation taking place in real time at the Papworth Hospital near Cambridge. Not only given an opportunity to observe and learn about this extraordinary medical accomplishment – one that has nonetheless become routine in many parts of the world – attendees were also able to question leading heart surgeon Francis Wells as he performed a complex reconstruction of a mitral valve. What remains so memorable from that evening was the intense sense of curiosity and rapt attention visible on the faces of just about everyone in the audience, so clearly caught up in the drama of this life-saving surgery. Aspects of medicine have, of course, been conducted within the public domain for much of its history – medicines were bought and sold in various forms of entertainment for centuries and surgical operations sometimes drew public audiences – so our event was, in some ways, doing no more than self-consciously drawing on a longstanding public interest in the performance of medicine. And if, as has been vigorously contended by some recent commentators, contemporary medicine has become worryingly depersonalized – removed

from the public domain – then events like 'live surgery' might not just be satisfying a public interest but also maybe helping to re-humanise parts of scientific medicine.

Dramatically put into practice on that evening, this style of live event represents the second strand of Wellcome Collection programming, where the broad spectrum of contemporary experiences of medicine and health are given a stage and spotlights. Much of medical science is highly visual and exhibitable (iconographically speaking, medicine is surely the richest of all the sciences), and the 13 temporary exhibitions we have presented to date have each capitalized on some aspect of this sparkling vein of visual and material culture. But the lived understanding of wellbeing has much else to it that is captured with more energy and more subtlety in direct accounts of human actions and interactions. In particular, it is the heightened sense of an experience shared with others that makes live events such a vibrant part of the programming of a venue like Wellcome Collection. People come to find out about subjects, to listen to speakers, to watch audiovisual productions, and particularly so that they can move with ease from one of these activities to another. But it is the fact that they have gathered together with other people for a common experience that makes the visit special, unique even. Make no mistake, people go to museums, galleries and the like to be with other people, even though intriguingly their interactions with them are likely to be rather fleeting. In this way, lively public venues have perhaps taken over some of the roles previously performed by churches, markets and

town squares – that is, providing a place to congregate and commune with like minded people, and to contemplate and engage with loftier ideas, be they religious, artistic, or, in our case, predominantly scientific.

The world of contemporary science of course throws up another crucial role served by live programming, and that is keeping up with the dizzying pace with which its ideas change. It is a mere ten years since the first draft of the human genome was sequenced; and now people can, for a few hundred dollars, have their own DNA analysed in order to detects risks of developing everything from breast cancer to baldness. This speed of development in the science, as well as its ethical and regulatory framework, presents particular challenges for curators of permanent and temporary exhibitions – how to cover a field of endeavour that, within a matter of months, can throw up radically different findings? Here too live events come into their own. With a lead time of months rather than years – and in extremis, even just days of preparation if the team are well connected and fleet-enough-of-foot – key players can be assembled in the same room at the same time for events that engage audiences with up-to-the-minute, and especially contested topics.

In the last couple of decades, live events have in fact become increasingly important to museums and galleries eager to be as vibrant and reflexive (audience-aware) as possible. They provide opportunities to attract new audiences, people maybe who would not ordinarily consider themselves exhibition attendees, but who nonetheless enjoy discussion and debate

of topical issues. They also represent a way of refreshing the offer for existing visitors, encouraging repeat attendance and, consequently, reinvigorating their view of the core collection. The realisation of this has meant that live programming has recently grown in variety, confidence and quality. And clearly the public appetite for this fare has yet to be sated. These are indeed good times for live events: whether it is a Friday Late at London's V&A Museum or an entire city's institutions opening up for Museums at Night 2010. As Henry Porter remarked in a recent Observer article "...what seems to me to be new is that the general level of discourse is rising. There is a thirst for seriousness as well as sophisticated fun..." (The Observer, 22 March 2009)

The proposition behind Wellcome Collection then is to share a public programme of topical, interdisciplinary exhibitions and a varied series of serious, sophisticated but also fun live events. Along with the spaces equipped to present these, the venue also comprises two permanent galleries – the historical and anthropological Medicine Man and another Medicine Now, in which objects from art, science and daily life are juxtaposed in order to explore themes from contemporary medical science. As its name suggests, Wellcome Collection is in part a collection of 'things', many of them quarried from warehouses crammed with weird and wonderful artefacts accumulated by Henry Wellcome. More than that, it is also a collection of perspectives, stories, voices and ideas. And most importantly of all, it is a place in which myriad intriguing connections between all of

these can be probed and celebrated. The habit of using short-term projects (exhibitions and events) to reach across gaps between disciplines, professions, institutions and belief systems exemplifies a conviction that our understanding of health and medicine can only hope to be more than partial if we are prepared to explore not just the work of scientists and doctors – vital though that clearly is. Our programming therefore revels in the intriguing insights that can result from connecting past and present; professional and lay; science, art and the rest of life. A cross between museum, gallery and event centre, this venue serves as a platform for invention and investigation: a place to think out loud, in public. In a phrase that graces much of our marketing material, we aim to offer a free destination for the incurably curious.

Reviving and reconsidering the venerable tradition of putting medicine on show, Wellcome Collection aims to be serious while avoiding drab earnestness, playful but not frivolous, entertaining without gaudy superficiality, and daringly experimental while, we hope, eschewing pretention and obscurity. In the following account, we will first describe a little of the historical traditions from which our work emerges. By paying close attention to this legacy, while endeavouring to re-interpret and re-focus it in ways relevant to audiences drawn from 21st century London and beyond, we have deliberately not tied ourselves to any formulaic approaches to exhibition and event-making. Nonetheless, we have evolved some useful guiding habits, and we will go on then to set out those broad ideas before closing the chapter

with descriptions of some five projects that capture the range of our efforts to put medicine back on show.

Cabinets for the curious

Wellcome Collection is part of the biomedical research charity Wellcome Trust, an organisation effectively formed through Henry Wellcome's will when he died in 1936. "With the enormous possibility of development in chemistry, bacteriology, pharmacy and allied sciences, [stated Wellcome in this detailed blueprint for his lasting influence on medicine and culture,]...there are likely to be vast fields opened for productive enterprise for centuries to come." This idea has effectively governed the work of the Trust over the last 70 years, informing its dispersal of an annual budget currently in the region of £600 million. But Wellcome's concerns were far wider than just medicine and its 'allied sciences', growing as they did out of an extraordinarily wide-ranging and energetic life. Along with business and pharmaceutical research, he also maintained interests in archaeology and collecting; travel and a range of other philanthropic concerns.

At the core of Wellcome's business success lay a commitment to the application of science in the search for pharmaceutical products, and an innovative and astute approach to marketing and communications, one which saw the company trademark one of the world's most famous and enduringly powerful brands: 'Tabloid', a name combining the words 'tablet' and 'alkaloid'. The consequent commercial success he enjoyed provided Wellcome with riches enough

lavishly to finance his increasingly passionate desire to collect as much of the world of medicine as he could lay his hands on. His concern for material culture may well have started with a boyhood discovery of a Neolithic stone arrowhead among some Indian burial mounds close to his home. From there his collector's passions expanded to encompass an overarching concern with "the preservation of health and life [that had, in all ages, he argued]... been uppermost in the minds of living beings." Medical in flavour then, his collection grew in ambition effectively to become a 'Museum of Man' – covering nothing less than the entire history of humankind's struggle for survival. And by the time of Wellcome's death, his collection numbered over a million pictures, books and objects, rivalling the scale of some of Europe's most famous public museums. His colossal hoards of objects capture medicine as much within the context of art as science, but also they embody vast swathes of the everyday experience of health and sickness. As such, they now maybe strike us as thoroughly relevant and modern in character: unselfconsciously interdisciplinary and multicultural.

Wellcome's efforts at making a museum did not emerge in a vacuum; rather they closely resembled some of the inspiration behind the very first museum instinct in modern Europe. The well-known images of 16th and 17th-century museums (replete with hanging polar bear and canoe, minerals and shells and a table for specimens in the foreground) provide a colourful reminder of the tradition that Wellcome was updating. Not infrequently run by medical men, sometimes

on medical premises, and full of objects that could also be found in the stores of apothecaries, the medical instinct in making such museums ran deep in the European tradition, and the histories of medicine and museums have frequently overlapped and intertwined ever since. Interestingly, these early museums were invented at exactly the same time as microscopes, telescopes and vacuum chambers. And, with a little lateral thought, one can see how they too effectively served as walk-in instruments of inquiry, places where material things could be studied and turned, as philosopher Hilde Hein has put it, into "reservoirs of meaning". One other crucial aspect of early museums needs highlighting: the meanings created in them were designed to be shared with visitors. Museums were distinctly not a private enterprise; what they revealed was quintessentially public property.

Wellcome Collection, and 70 years earlier, Henry Wellcome's own museum making efforts, were extensively influenced by some of these very old ideas about the role of material culture and museum spaces in the shaping of public knowledge. But much closer to home, Wellcome Collection also builds on thinking developed during the last two decades about how the public context for science should best be nourished. For much of the second half of the 20th century, increasing energy was expended on efforts to make sure the public shared in scientists' convictions about the significance of their discoveries and the potential social value of its application. Public education and public understanding were initially the favoured concepts used. Towards the end

of the century, however, much criticism was levelled against what was held to be an unhelpful 'empty vessel' metaphor for how the public might find out about science. The 'deficit model', as many started to call it, was thought to demean the abilities as well as dignity of those who didn't know about science. Surely, it was contended, a reciprocal model would be more effective, one in which scientists and the public were in dialogue, learning about each other. Wellcome Collection has benefited enormously from the insights gained from this shift in thinking, and the use of 'dialogue' is at the core of many of our events, the majority of which provide ample opportunity for our often well-informed audiences to voice their opinions, experiences and expertise. But it might just be that Wellcome Collection has also added other ingredients to the on-going debate about how the public can effectively and meaningfully relate to scientific ideas. For Wellcome Collection also places a premium on the idea of creating new means of witnessing science and its cultural context in an entertaining fashion.

How to put medicine on show

At its best, Wellcome Collection hosts a buzz of engaged interaction: between a range of expertise and lay experiences, and between exhibits and voices that suggest connections and similarities, but that also relish differences and even contradictions. Two of the loudest 'voices' belong to the arts and sciences, which together feature in most of our productions. The notorious American/Russian writer Vladimir Nabokov long ago made the poetic observation that

"there is no science without fancy, and no art without fact". Interesting things happen, we believe, when the 'fancy' of science faces up to 'facts' in art. Drawing on that conviction allows us at times to get away from one of the deadening clichés shored up by separate science museums and art galleries, that somehow science exhibits should mostly feed information and understanding, while art can only properly work on our emotions. In Wellcome Collection, we just as often champion the opposite. Visitors will, we believe, sometimes imagine and dream in front of the science and learn and are informed by the art.

The role of contemporary art in this dialogue is probably best grasped at the level of a particular artwork such as Mark Quinn's Silvia Petretti – Sustiva Tenofivir, 3TC (HIV), a sculpture that confronts visitors to Wellcome Collection on arrival. One of a series of works entitled 'Chemical Life Support', it was cast from polymer wax mixed with a day's dose of the pharmaceutical substances taken by the sculpture's subject to treat her medical conditions. Silvia Petretti is in fact HIV positive and the drugs she takes offer assistance to her body's failure to defend itself. By quite literally incorporating the fruits of pharmaceutical research into the sculpture itself, this life-scale, radiant white figure seems both figuratively bold, classical even, but also vulnerable, radically so when we consider the serious medical condition suffered by the subject. Artists have, of course, always been voracious consumers of pictures, materials and image-making technologies drawn from science and elsewhere; the products of their

labours invariably reflecting creative acts of borrowing and reinvention. Quinn's sculpture therefore appears almost literally impregnated with issues that surround AIDS, and the role of pharmaceuticals in its treatment. Many contemporary artists are also eager to reinvent the goals, practices and habits of scientists, thus fashioning themselves as investigators of improbable even impossible 'experiments', undertaking their own idiosyncratic forms of 'field-work' into the world of medicine.

This spirit of interdisciplinary investigation is equally evident in the range of Wellcome Collection's live events. A single month's programming (October 2009, for example) included a discussion between a philosopher and neuroscientist about morality; drawing classes tied into an exhibition of Victorian anatomical wax models; an early career statistician describing her group's work on the National Survey of Sexual Attitudes in the UK; an after dinner performance/presentation by a psychologist who moonlights as a magician; and a discussion amongst authors short-listed for the Wellcome Trust Book Prize, exploring the differences of approach between those writing fiction and non-fiction. It is, we believe, this type of varied, rich and innovative programming (with maybe just a dash of charm thrown in too) that has established the unusual, possibly even unique character of this new venue.

Based on the idea of varied 'conversations' between different perspectives, Wellcome Collection works by putting on idea-based projects. In essence, these are curator-led investigations,

which are distinctly not shaped by the imperative simply to 'disseminate' what is already well known. There is nothing wrong with this approach; it is very effectively exploited by a number of museums, particularly ones focussed on science. But it is not our approach. Instead, we seek to deal with primary materials – with real objects, real art, real experts and fundamental topics – that we substantiate or witness in a public context, and that we, crucially, juxtapose with others in a way that might not have been done before. Our public shows can therefore sometimes represent moments of real insight in themselves, and this not just for the visitors, but also occasionally even for the artists, historians, scientists and other expert participants too. Museums and galleries have long made significant contributions to the sphere of knowledge and learning, but generally through what they keep and how (often in a somewhat passive manner) they are displayed. Part of the thinking behind Wellcome Collection is that we need now to take much more seriously the idea that museums and other cultural spaces also have a significant role to play in actively contributing to and even shaping public knowledge. The resulting understanding often emerges most readily out of projects that pick away at themes, puzzles and ideas that are not easily contained, or constrained, by a single discipline. New understanding can, it seems, readily arise in the gaps of comprehension between areas of expertise, and those between medicine, science, health, design, art and history seem to us especially fertile.

One key implication of this approach to curating public

projects is that collaborative working practices are almost inevitable. It is difficult to think of any exhibition or event held during our first few years of programming that has not involved some sort of partnership with another institution, artist, scientist or other expert. The energy and enthusiasm apparent in so much of what goes on in Wellcome Collection undoubtedly emerges from the mutual interest and excitement that these partners have in their shared initiative, though it is also crucial that a determination to reap independent benefit is also maintained by each. There is a strong sense too that visitors can be collaborators. Our initial evaluation of Wellcome Collection visitors indicates that 35 – 40% of them have some sort of involvement in the subjects and disciplines we cover, including art, design, history, as well as science, medicine and health. Intriguingly, this suggests that the gap between producers and consumers, performers and audience members is less absolute than sometimes imagined.

Following on from this cross-disciplinary and highly collaborative practice embedded within Wellcome Collection, a number of investigative habits inform the way we produce exhibitions and events. The first, in fact, is that each project is itself more important than any set of 'principles' – that is to say, each event and exhibition should be tackled on its own merits and should follow its own logic. After that, in our exhibitions we tend to start from either a theme or a set of exhibits. For our topical shows (we've tackled the heart, sleeping and dreaming, war and medicine, and identity) we work out from there to find exhibits that stretch

and surprise us. For other shows we work in the opposite direction, seizing a set of exhibits and then teasing out their thematic significance: skeletons in a show that highlighted the work of osteologists; designs intriguingly derived from crystallographic images in an exhibition entitled Atoms to Patterns; and diary drawings by artist Bobby Baker that also shed much light on mental health practice and the stigma surrounding this area of illness. We are also concerned to show as much original material as possible, and to draw from as broad a range of sources as budgets and pragmatics allow. We also place a premium on intelligent design that shows off the exhibits as sympathetically as possible without itself becoming too much of the show. Finally, we are also keen to make the interpretation – the gallery guides, panels and labels – as lively and accessible (as well written) as we can.

With events too Wellcome Collection adheres to some guiding instincts about how to deliver the best shows we can. Our commitment here is to present multi-vocal insights that give visitors an opportunity to encounter different perspectives and experiences in order both to celebrate common themes, but also not to shy away from exploring divergences and even conflict. Here too, we champion authenticity (giving a platform to those who really know what they are talking about, who can do so with vigour and assurance). We also aim to capture and exploit the drama, the atmosphere of professional theatre and national radio. And we try to ensure that each event is hand crafted from concept through production to delivery by the same person,

so that they are able to imprint on it something of their own personality. There is no mass-production at Wellcome Collection. People give up their leisure time to come to our events and to reward that commitment we try to present an evening or lunch time of interest and intrigue, clarity but unusualness, diverting entertainment and a core 'specialness'. This working method is not necessarily the cheapest or most efficient way to work, but if we are prepared to measure success in richer terms than simply cost per head or bums on seats – in terms of our visitors' depth of engagement, the long-term legacy of their visit, and their inclination to develop a sense of loyalty – then there is no doubt that this way of working has great value and effect. We'll close by looking at five examples of Wellcome Collection exhibitions and events.

Example 1: Materials Library presents...
In the spring of 2007, while Wellcome Collection was still under wraps, we commissioned the maverick and blossoming Materials Library to curate an evening in celebration of FLESH. They assembled a cast of stars – world champion body builders, high class butchers, respected artists and decorated plastic surgeons – to provoke and demonstrate a curiosity about the properties and behaviours of that most fundamental of medical materials: flesh.

On the night itself visitors were encouraged to sample cured meats while viewing one of Günter von Hagens's plastinated slices of a human body (part of the Medicine Now gallery); saw bones beside a case of ancient surgical

amputation devices; freeze fruits in liquid nitrogen in front of a cased Peruvian Mummy; and learn how to suture pig skin. This was an event that flew in the face of standard expectations of what can be done in a Museum and how adults should behave at science events. The intellectual context – two permanent galleries of medical science's material culture – was as important as the physical context. Its success lay in the clever combination of serious science, provocative demonstration, visceral engagement and the fact that in this adult-only environment visitors were able to unleash a childish naivety and be as curious as a 10-year-old without hesitation, embarrassment or ridicule.

Materials Library is an interdisciplinary collaborative team who make objects, events and exhibitions that foreground materiality. They are also engaged in both scientific research and artistic practices that explore the 'senso-aesthetics' of materials – how we relate to their look and feel. This multidisciplinary team brought a lively and varied set of interventions to Wellcome Collection's permanent galleries, which complemented our approach to curating exhibition. Their selection of a universal, everyday concept (flesh) explored through lateral deviation, in equal parts scientific and artistic, encouraged simple, thought provoking engagement with experts, objects and ideas that left a lasting impression. "I love the hands-on approach and being able to get blood everywhere!" said one participant; while another was delighted at "the wide range of sensations exposed (taste, touch, smell, sound...)". A third appreciated

the value of "Interdisciplinarity that guided the event, that allowed for contingent associations of materials, experiences and feelings." To the eclectic approach of Materials Library the Wellcome Collection events team further encouraged access and a license to experiment with the galleries, embrace the scientific, cultural and artistic aspects of flesh and acted as "champions" within the larger institution to win support for this brave and at times risky event.

Following this success, Materials Library were invited to return in November 2008, this time on the theme of HAIR. Over 800 people joined us that evening and their journey began by donning a temporary moustache or beard before investigating the biology of hair, learning to spin, felt and knit; while for the particularly hirsute, visitors were encouraged to find out about the practice and culture of plucking, shaving or waxing. The most recent event of this type (a single theme explored across a variety of activities presented throughout the building) was an evening curated by the artist Alex Julyan, devoted to exploring the marketing of medicines from 18th century quack doctors through to modern day alternative therapies and our current understanding of the placebo effect. These spectacular evenings curated by inventive, inquisitive teams for audiences who are prepared to be moved – physically, emotionally and intellectually –provide a powerful way of engaging adult audiences with science within its social and cultural context. Their periodic appearance in Wellcome Collection's programme has quickly become one of the hallmarks of our programming.

Example 2: Exchanges at the Frontier

On the eve of the UN Climate Change conference in Copenhagen in December 2009 the Intergovernmental Panel on Climate Change's key scientist, Dr Rajendra Pachauri came to Wellcome Collection to participate in an early Saturday morning discussion about the threat of climate change to human health and wellbeing. It was one of a series of events in which the philosopher A.C. Grayling tested some of the world's top scientists on their work and its importance for humanity. His guest participants represented a cross section of science today: specialists in neuroscience, climate science, astronomy and particle physics, who are all still actively engaged in research. As a venue that normally focuses on medical interests, we were in this series inclined to open up our platform to a broader field of sciences, inviting those whose interests were in the physical sciences, or astronomy, or indeed extra terrestrial intelligence (the latter being the focus of work for the astronomer Seth Shostak.) The idea of the series was to encourage these women and men at the very forefront of what is know, or indeed can be known, to discuss at a more philosophical level what we should expect scientific investigations to tell us and the even broader question of what place science occupies within contemporary society and culture.

To undertake this audacious series, we brokered a partnership with the BBC World Service, who recorded each of the events and edited them for broadcast to 40 million listeners, thereby influencing the public view of medicine,

science, health and wellbeing on a scale that Wellcome Collection could only dream of. Working closely with a BBC producer to agree a tight set of questions and a choreographed routine for each event allowed us to create something of value and significance to listeners in, for example, West Africa, while at the same time not compromising the experience of the live event for the participants present in Wellcome Collection. The opportunity given to the audience to ask questions brought a welcome change of pace and an element of surprise to an otherwise carefully planned script. In this example, Wellcome Collection furnished the staging ground for a type of event where ideas could be witnessed freshly spun by the minds of the very scientists who originally hatched them.

Example 3: Sleep Talk and Music for Sleepless Nights
Wellcome Collection was host to an entirely different type of event in February 2008, when we held a two-day symposium, Sleep Talk, programmed along side our temporary exhibition Sleeping and Dreaming. Co-curated with the Deutsches Hygiene Museum in Dresden, the show drew together some 300 objects in order to encourage visitors to explore the biomedical and neurological processes that take place in the sleeping body alongside the myriad areas of our social and cultural lives linked to sleep and dreams. This accompanying event began on Friday evening with a recital by the classical music ensemble Manning Camerata, who performed Domenico Scarlatti's *Pun el sonno* (written to help

Philip V of Spain rise after a sleepless night) and Giacomo Puccini's *Crisantemi* (similarly crafted after a sleepless night) – a musical evening then curated around our anxieties and dependence on a 'good night's sleep'.

Well rested, visitors returned on Saturday for a day of presentations and discussion exploring how we understand sleep, the impact of its absence upon our lives and the difference in the understanding and practices of sleep across times and cultures. Russell Foster, Professor of Circadian Neuroscience at the University of Oxford, for example outlined the unanticipated costs on physical and mental health of our working at all hours ("occupation of the night"), and pleaded for a return to the sleepier pre-industrial times. Eluned Summers-Bremner from the University of Auckland took us on a whistle stop tour of the history of insomnia, shedding light on its appearance in the art, literature and social arrangements of earlier cultures. And Kenton Kroker from York University in Toronto tried to answer the seemingly simple question: what in fact is insomnia? This style of event enables the exploration of a topic in much greater depth and breadth than is achievable either through an exhibition or indeed a short event. By assembling a multi-disciplinary cast on the platform at different times something rare and memorable can be created, a crucible in which new thought and understanding can be provoked in both audience members and speakers.

In this example the event producer is acting as a curator (assembling people and performances rather than objects

and images); researching, selecting and positioning different elements and aspects of one theme to create an event with a strong central argument and a satisfying completeness, crucially different to any notion of comprehensiveness. A close, productive working relationship with the exhibition curators is essential for success here. It is crucial that event producers should begin thinking about a supporting programme early, encouraging the curators to identify possible topics and speakers as they undertake their exhibition research and refinement. These events are not simply a 'bolt on'; nor are they a literal, live re-interpretation of the exhibition content. Rather they use the exhibition as a point of departure for ideas, exploiting what is not necessarily captured in the gallery experience. These events therefore both add to as well as take from the exhibition.

Example 4: Skeletons
Few topics in museums have been as vigorously debated as that of human remains: whether museums should acquire them; keep or return the examples they have; and whether they should then be put on public display, and if so when, where and how. In the sometimes heated arguments about these questions, 'objective' scientific opinions are frequently pitted against more empathetic 'subjective' viewpoints. Our exhibition Skeletons: London's Buried Bones in part set about confounding that simplistic dichotomy. Selected from the extraordinary 17,000 skeletons kept in the Museum of London, the two dozen or so displayed made it clear that

the scientific study of bones can add to rather than detract from our emotional encounters with them. Researchers described the care, bordering on love, that they applied to putting together the bones of some of the skeletons, and our show attempted to carry these sentiments into the gallery. The osteological information presented in short captions next to the skeletons somehow managed to animate the seemingly 'lifeless' bones on display.

The conceit of the show was simple: we would present about 26 skeletons in the gallery, selected in order to represent as broad as possible a range of local origins (from a wealthy Chelsea butcher to anonymous 'paupers' from a graveyard in the city); of ages (from a 22 week old foetus to an octogenarian); of historical periods (from Roman to Victorian); representing different types of medical condition (from medieval male whose spine contained a lodged arrowhead to an early-modern female whose skull showed characteristic scarring from syphilitic lesions). The skeletons were supported by showcases designed to provide clear and easy visual access, but which also managed to preserve a strong sense of respect – platforms that we were eager would neither resemble coffins nor mortuary slabs. Three other ingredients completed the display. First, short, clear captions primarily focussing on the osteologist's appraisal of what could be inferred about these buried Londoners from looking at their bones. Second, Thomas Adank's haunting and rather lonely photographs of the sites from which the bones were removed as they appeared today – a complex of flats in Bermondsey Abbey for example,

or a well-kept churchyard in Chelsea, or a Pizza Hut car park in Merton Priory. And third, a map of London showing the distribution of the sites across the city. Along with the idea of showcasing the imaginative as well as informative power of the scientific data drawn from these old bones, the exhibition also highlighted the historical and geographical richness of a layer of London just beneath the city's bustling surface, making apparent the poetic connections between London's vibrant present and its living past, with a tangible sense of the latter quite literally supporting the former.

Example 5: Identity: Eight Rooms, Nine Lives
Recent advances in scientific, and particularly biomedical techniques have made the task of uniquely identifying each of us easier and easier – finger prints, voice recognition technology, iris scanners and DNA profiling has all enabled the establishment of databases that can capture what distinguish you from me from everybody else. But none of us, surely, imagines that these facts can cumulatively be used to sum up who we are, even if we are not sure who in fact that is. There is a tension then between the precise external data about us that national states greedily collect (tokens of identification) and the vaguer internal feelings about ourselves with which we endlessly grapple (the question of our identity). This complicated knot of issues and ideas was the focus of one of our more ambitious thematic exhibitions – Identity: 8 rooms, 9 lives.

A comprehensive survey of the themes wrapped up in our

ceaseless concern with our identity seemed like a foolhardy ambition – what topic or perspective could reasonably be left out? To tackle this compelling but overwhelming theme, it seemed that we should radically restrict our horizons. How about, we wondered, if we just looked at a few historical and contemporary figures whose lives and interests shed light on some of the most significant sub-themes – some broadly reflecting the role of science and others more concerned with creative investigations or lifestyle choices? Rather than pretending that the topic of identity could be circumscribed in one exhibition, we set about instead simultaneously presenting eight small shows – one on Samuel Pepys and more generally the act of capturing and shaping our identities through keeping a diary; another about the issue of gender focused on April Ashley, who was one of the first people in the UK to undergo a full sex-change operation; a third on Francis Galton and his passion, obsession even, with measuring human traits (anthropometrics) that could distinguish one individual from another; a fourth on Franz Joseph Gall, a nineteenth-century pioneer of phrenology – the attempt to correlate skull-shape with human characteristics as diverse as criminality and creativity; the fifth concerning Alec Jeffreys – a geneticist who was responsible for the initial breakthrough that enabled the development of so-called DNA finger-printing; yet another on the actress Fiona Shaw, whose work revolves around her ability convincingly not to be herself; another on Claude Cahun – an artist who lived in Jersey under Nazi occupation, whose photographs plot her attempts to flex

and adapt the nature of her identity and sexuality; and finally one that looked at a Norfolk family – the Hinchs – in which there has been at least three generations of twins.

This core idea of presenting 8 mini-exhibitions simultaneously, as if they were almost accidently gathered together around a broader theme, was one that significantly informed the design of the show conceived and executed by Ben Kelly. The first impression on entering the space was of a relatively empty gallery interrupted by large, somewhat eccentric, seemingly unfinished rooms supported by green-painted steel frames and faced in plywood. Apart from a selection of mirrors distributed around the periphery of the gallery – some borrowed from Sigmund Freud's collection, others owned or used by Michael York and David Garrick, and yet more that play tricks with visitors' reflections – there appeared to be next to no exhibits on display at all. This impression changed dramatically once visitors entered any of the eight rooms. For once inside, it became apparent that this was in fact the densest exhibition yet presented at Wellcome Collection. The effect now was one of being immersed in the visual and material culture of the particular individual being explored – amongst hundreds of the fingerprints collected by Galton, dozens of ordinary diaries collected by British Museum curator Irving Finkel in Pepys' diary room and a wall full of press cuttings and other ephemera in April Ashley's room.

The intellectual coup of this show (curated by Hugh Aldersey-Williams and James Peto) was to maintain a breadth of investigative vision, while swiftly bringing visitors

into close proximity with bite-sized ingredients of human proportion – elements of people's lives that anyone can relate to. This then was a display of mostly ordinary things – diaries, newspaper clippings, finger-prints, and film clips – that cumulatively built up a rich and nuanced picture of one of the most profound questions we can ask – who are we? Here, as with the most successful of Wellcome Collection's projects, making a show of the science of medicine (genetics, forensics, phrenology and neuroscience) only made sense when presented alongside the fruits of artistic endeavour and evidence of daily life.

CURATORIAL CHALLENGES

Table Top Physics:
Old Science, New Audience

JANE WESS

Science Museum

London

This paper explores some of the issues encountered by the construction of a proposal for an exhibition on nineteenth century physics at the Science Museum in London. It addresses both the treatment of the subject and its portrayal to a lay audience.

In 2008 the Science Museum asked for proposals from curators for medium-sized object-based exhibitions. 'Table Top Physics' was one of those considered on the short-list. Physics was chosen as a topic for a submission because it is a subject with which our audiences are acquainted at least by name. The subject matter would have been familiar in some shape or form to everyone who was studying or had studied physics or core science at secondary level in the UK. The nineteenth century was chosen as a time frame because we have an excellent collection of material from this period. As many of the objects were originally intended for demonstration they are particularly appealing.

The exhibition was intended to mix elements of a traditional object-rich display such as we present in our *Science in the 18th Century* Gallery, and elements of a hands-on nature as in our current *Launch Pad* gallery. It was intended that replicas of the original instruments on display will be available for the 21st century audience to manipulate, conveying in a straightforward manner how they work. This can then be used to discuss the more profound question of how they were interpreted, and how that may differ from how we interpret them now.

It was a condition of acceptance of these exhibition

proposals that they contained relevance for, or at least recognition of, the subject as pursued in the early twenty-first century. So this proposal, while being historical in nature, needed to accommodate a reference to contemporary physics. To make the nineteenth century distinctive it was decided there would be a **contrast** to physics in the early twenty first century in the salient characteristics featured, and that one particular aspect would be chosen as representing this contrast most succinctly.

The scoping of this exhibition proposal raised a number of questions, the answers to which were to drive both the historical exposition and the presentation strategy. Firstly, and fundamentally, concerning the integrity of the understanding of the discipline physics, in what sense can the subject be characterized holistically in this period? To what extent do we take into account the moving away from natural philosophy and the establishment of a recognized discipline which, from an institutional history perspective, only began to take shape in the mid century? More specifically, could we include demonstrations of appealing, but relatively early instruments such as the kaleidoscope and stereoscope and maintain rigour?

Secondly, and crucially given the contrast required: What is the salient characteristic of nineteenth century physics, as opposed to physics in 2009, which can best be utilized to engage a twenty first century audience? Thirdly, if we are primarily contrasting physics now and then, is it also possible to show development during the nineteenth century, or

should we take a vista or snapshot approach? Lastly, the over-arching issue: Can we enable our audiences both to empathise with the nineteenth century mindset and learn something of physics as we understand it today? Or put more specifically: Can we use nineteenth century objects to teach contemporary science?

The exhibition was intended to cover a mainstream British national curriculum subject, compulsory for nearly everyone until 16, and was targeted at our mainstream audiences; families and schools. It was intended to use objects as the leading presentation strategy and was historically rooted. Because of these two aspects, it confronted head-on the challenges posed for science museums trying to satisfy requirements which can sit awkwardly together.

The proposal particularly tapped into the concerns that Simon Schaffer refers to in his essay *Object Lesson* published in *Museums of Modern Science* in 1999 where he points out that 'worries about the very capacity of ... artefacts securely to communicate the right message always accompany the science museum as an institution'. [1] It also incorporates the multiple activities that he cites, in that it endeavours to incorporate the simultaneous engagement with the nineteenth century mindset and the learning of twenty first century physics. The final questions encapsulate the enduring tension for science museums trying to combine active scientific learning with a study of the past.

In order to raise funds and test ideas a taster exhibition was put together in our area for potential sponsors. The

objects in this were chosen from across a range of topics within nineteenth century physics because they were popular demonstration items of the time, and while a few had been around for a century or more, many were chosen specifically because they had no eighteenth century counterpart. This was to enable points to be made specifically about the nineteenth century and to give a distinctly nineteenth century feel, but also to display objects not currently on exhibition elsewhere in the museum.

Also, while the individual objects may be nineteenth century and demonstrated then, if too many of the ideas were derived from earlier periods, the exhibition could be seen to represent merely nineteenth century demonstration physics rather than physics per se. As one of the arguments was to be that physics was closer to its audience then, to focus too much on demonstration items relating to earlier ideas would muddy that point. Another separate consideration was the possibility of replicating experiments, so objects were chosen because they would lend themselves to hands-on activity. An idea of the scope will be given by a description of some of the objects included in the taster exhibit.

While much of the nineteenth century mechanics demonstration experiments were based on ancient knowledge, the taster exhibit included a devioscope invented in 1881 by French physicist and teacher Georges Sire. While mathematical papers on rotational forces had appeared in the late eighteenth century, the study of relative motion in rotating frames of reference was put on a general footing by Gaspard-Gustave

Figure 1: Savart's wheel giving the notes of a major scale, by William Ladd, 1870. Science Museum London/SSPL

Coriolis in 1835. The spectacular demonstrations of Leon Foucault in the mid century popularised this new area of physics. The device demonstrated that the rate of rotation of the plane of the swing of a Foucault pendulum varies according to the sine of the latitude. At the North Pole it appears to turn once in 24 hours, at the Equator it does not rotate with respect to the Earth.

Acoustics was a topic much-loved by physicists in the

nineteenth century. This piece of apparatus, Savart's wheel, (Fig 1) shows the mathematical relation of pitch to frequency even when it is static. Felix Savart, a surgeon in Napoleon's army before becoming interested in physics, invented the simple device in 1830. If the wheels are rotated along their central axis, and a card held against the teeth, notes will be heard. These wheels give the notes in a major octave with the largest wheel giving the highest note. The wheel was exhibited with a pair of elliptical horns by Lord Rayleigh which represented his important work on the interference of sound waves in about 1900. As a result of these experiments Rayleigh recommended the use of the elliptical shape to improve the audibility of fog horns at sea.

The wave theory of light, an underpinning concept of much of nineteenth century physics, is well-illustrated by an original Wheatstone wave machine of 1842 by John Newman. Charles Wheatstone was appointed to King's College London in 1834, having been noticed for his spectacular acoustical experiments. He designed this machine (Fig 2) to show transverse light waves, in particular the type of polarisation resulting when the horizontal and vertical components are superimposed with various phase differences. The white beads represent particles in the ether. Another exhibit relating to Wheatstone was a Cosmorama stereoscope, which was shown with a set of simple line-figure stereograms visible in 3D. Wheatstone invented the reflecting type of stereoscope in 1838 and David Brewster developed the lenticular type which was made popular by The Great Exhibition. The stereoscope

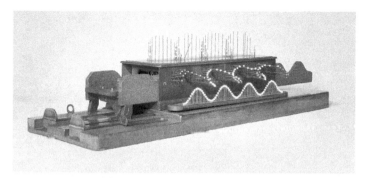

Figure 2: An original Wheatstone wave machine by John Newman, 1842. *Science Museum London/SSPL.*

rapidly became a standard item in middle class households.

The topic of heat was another opportunity to combine old and new. The French Revolution gave an impetus to science, scientific education, and crucially the development of physics. Hippolyte Pixii, was a Parisian maker known for his direct current dynamo. However, he also made more traditional demonstration pieces such as 'pyrometers', what we would now call dilatometers, based on the expansion of metals when heated. The fundamental design of the instruments in the 1830s was similar to that of instruments made a century earlier.

Establishing fundamental laws was central to physics, and the conservation of energy formed the cornerstone of rational thought. A replica of James Prescott Joule's well-known paddle-wheel of 1845, with which he established a relationship between *mechanical force*, or energy, and heat, allowed the introduction of this pivotal topic. Otto Sibum relates that the mechanical equivalence of heat was cited as

Figure 3: Hero's aolipile from Adolphe Ganot's *Elementary Treatise on Physics* 1875[3]. *Science Museum Library and Archives at Wroughton.*

the golden number of the century in 1900, and constituted an important step towards the more general law.[2]

The desire to improve the efficiency of the steam engine provided the impetus for the study of what became thermo-dynamics. A particularly simple demonstration piece was a model of Hero's aolipile (Fig 3), consisting of a sphere of water which can rotate due to jets of steam being emitted. We have an example by Townson and Mercer from 1886 which was placed by the illustration of it in action from Adolphe Ganot's *Elementary Treatise of Physics* 7th edition of 1875. *Ganot's Physics,*

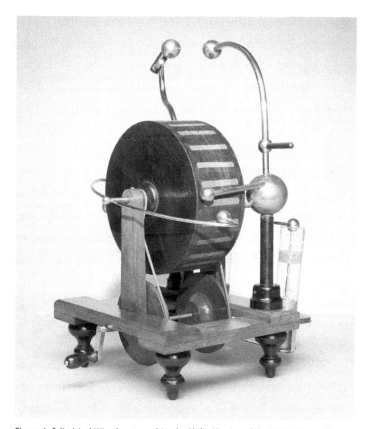

Figure 4: Cylindrical Wimshurst machine by Philip Harris and Co, 1888. *Science Museum London/SSPL.*

as it became commonly known, was the standard text defining the scope of the subject across Europe in the second half of the century. It passed through eighteen editions between 1851 and 1882 in France alone, giving detailed accounts of the apparatus and demonstrations which were being developed to demonstrate the latest discoveries.[4]

While the spectacular electrostatic experiments of the

eighteenth century were largely continued in the nineteenth, the methods of producing charge changed as the 'influence' machines, or those that produce charge by induction, superseded the friction machines. This Wimshurst machine (Fig 4) was displayed with an electrostatic spangle tube dating from about 1850. The spangle tubes were made of glass with spiral strips of tinfoil running down them, which when electrified created a brilliant illumination. Indistinguishable from their nineteenth century counterparts, similar tubes were advertised in instrument makers' catalogues during the second half of the eighteenth century, and the Science Museum exhibits earlier examples which were in the possession of the future George IV in the 1780s. However, James Wimshurst's electrostatic machine was the most successful of the new type of charge creators. It was a novel method of bringing the spangle tubes to life in the late nineteenth century.

Unification has been a driving force in physics since the early 19th century with the combination of electricity and magnetism established by 1820. Michael Faraday's discovery of electromagnetic induction in 1831 spawned an explosion of machines for generating electricity, and electromagnetism became established as an indispensable part of the subject. One of the experimental machines designed by E.M. Clarke in 1836 and made by John Newman was exhibited next to an elegant demonstration model by Harvey and Peak of a rotating disc and electromagnet. This demonstrates that a current flows between the axle and rim of a copper disc if it is rotated between the poles of a magnet.

The Science Museum has a good collection of original radiometers by William Crookes, an archetypical scientist and entrepreneur who conducted experiments in his house. It is well-known, largely due to the work of Richard Noakes[5], that in the early 1870s Crookes became interested in psychic phenomena, something he had to suppress, and devised the radiometer initially to see if humans could affect motion at a distance. The particular instrument chosen for the display used the rotation of the vanes to run a Newton's disc. Finding an acceptable explanation for the action of a radiometer stimulated debate for several years, so the instrument serves well to illustrate experimental findings can be interpreted in different ways.

The initial hypothesis that radiation pressure, a result of James Clerk Maxwell's then recently published electromagnetic theory, could explain the reaction of the blackened surfaces, was seen to be fallacious as the silvered surfaces should have been repulsed more strongly than the blackened surfaces. The issue was taken up shortly after Crookes publicised the instrument in early 1875 by Osborne Reynolds among others. Reynolds suggested that the focus of attention in a radiometer should be the edges of the vanes rather than the surfaces. The faster molecules from the warmer (blackened) side hit the edges obliquely with a larger force than the colder molecules from the silvered side. This is now the agreed interpretation of the workings of a radiometer. William Brock describes this in more detail.[6]

Crookes moved from his radiometers to researching

electricity in low pressure gases, a rich vein of experiment kept active due in part to its spectacular effects. Because his tubes were nearly evacuated he could see the effects of 'cathode rays', not simply the streams of light made manifest by the standard Geissler tubes. In the first decade of the twentieth century tubes with over thirty different minerals became available commercially, showing coloured phosphorescence when placed in the discharge. The tube displayed was an original Crookes tube from about 1900. Also shown was a Geissler tube with coloured liquid, which was used to demonstrate the beautiful luminosity caused by passing electricity through a gas at low pressure. Coloured liquid or coloured glass was often used to heighten the effect.

The final object provided the contrast to physics now. It was a single-electron detecting chip devised by a team of physicists at the Clarendon Laboratory in Cambridge at the turn of the twenty first century. The modern-day 'electron' grew out of 19th-century work on cathode rays so provided a link; the chip was actually used to measure current generated by a surface acoustic wave. It was devised by a large team of publicly anonymous scientists at the current Cavendish Laboratory, a purpose-built facility on the outskirts of Cambridge, removed from everyday life. To demonstrate how it works to an audience it has to be magnified 15,000 times.

The contents having been scoped, the first three questions posed above need to be addressed. Firstly: Can physics be characterised holistically in this period given the gradual emergence of the discipline during the nineteenth century?

This question is the subject of an essay by Jed Buchwald and Sungook Hong in David Cahan's book *From Natural Philosophy To The Sciences*[7]. They argue that physics had become established as a discipline by 1830, developed into a useful tool during the mid century, and was established in laboratories and institutes by the last third, with an increasing emphasis on instruments and experimentation. David Cahan, in the introduction to the book, argues that this process was an evolution rather than a revolution.[8]

Iwan Rhys Morus points out that for most of the century few practitioners would have described themselves as physicists and the word did not exist until the 1830s.[9] He identifies the rise of mathematical physics in Revolutionary France as a key, followed by the establishment of new ways of training physicists in analytical styles of reasoning which was pioneered in Germany.[10] The universal physical laws became the basis on which to understand nature's workings. These views do not depart greatly from an earlier consideration of the topic by Peter Michael Harman who also laid emphasis on the mathematisation of the subject, and stressed an underlying mechanical approach to nature.[11]

A survey of nineteenth century texts can also give some insight into what was meant by *physics* and what by *natural philosophy* at various times and places. Charles Partington's *Manual of Natural and Experimental Philosophy* of 1828 includes mechanics, the workings of steam engines, horology, wheel carriages, pneumatics, hydrostatics, ballooning, acoustics, optics, magnetism, atmospheric electricity, meteorology and

astronomy, so a wider remit than what we would now consider physics.[12] James William McGauley's *Lectures on Natural Philosophy* of 1850 has part 1 *Physics* and part 2 *Chemistry*, indicating physics was considered a subset of natural philosophy.[13] Even in 1898 St George Mivart's *The Groundwork of Science*, in a chapter on the enumeration of the sciences does not use the term *physics* although the components are included. However *chemistry* features.[14]

In France the term *physics* was introduced earlier. Tiberius Cavallo wrote *The Elements of Natural or Experimental Philosophy* in 1803[15] with contents extremely similar to Jean-Baptiste Biot's master work *Traite De Physique* of 1816[16], so content does not appear to be the defining factor, more the intent to present in a more rigorous style. Interestingly J.D. Everett wrote two books in 1883: *Textbook of Physics* and *Outline of Natural Philosophy*[17] so a direct comparison is possible. The scope of the content is almost identical, but the natural philosophy is written in a more descriptive style. Everett promoted the natural philosophy text as satisfying the "widely felt want of a work at once easy enough for a class reading book and precise enough for a textbook", so as not to turn away any potential audiences. However, much more explicitly, he describes the physics textbook as "exercising the learner in logical and consequential thoughts".

The distinctions coming through this brief survey are those of both scope – natural philosophy was more wide-ranging – and style. It appears that physics was considered a rigorous subject based on logical and ordered institutional

learning, while natural philosophy, by the second half of the century certainly, was considered a descriptive subject for the more leisured or lay reader.

So we have an answer to this particular question. If we are talking about Table Top Physics as essentially representing a range of subjects, which is how our twenty first century audiences will understand the term physics, then the fact that physics as a recognised discipline did not exist in the first decade of the century is not a major problem, because that body of knowledge was available in some form or other.

So having answered the first question we can move onto the second question which concerns the essential selection of the feature which can most effectively contrast physics then from physics in 2009. The clue, not surprisingly, lies in the title of the exhibition and paper. The term was taken unrepentantly from the title of Simon Schaffer's chapter *Where Experiments End: Table Top Trials in Victorian Astronomy* which featured in Jed Buchwald's 1995 book *Scientific Practice*[18]. It was chosen as a result of a process of elimination which will now be described.

Aspects considered for selection were the subject matter, the physical space in which it was practised, the relationship with the audience, the organisation of the individuals who practiced it, and the scale of it. This is not an exhaustive list of aspects of science, but a realistic one.

It was considered that a contrast of subject matter would demand a substantial discussion of physics in 2009, which was not the point of the exhibition. The subject matter in the

nineteenth century would actually be more familiar to our audiences because it is more aligned to the present national curriculum, so the scope of physics in 2009 could not act as a way in. For these reasons subject matter was rejected as the salient feature.

The physical space was an aspect considered, and an early version of the exhibition was called *Parlour Physics*. Sophie Forgan and Graeme Gooday have done pioneering work on the geographies of physics, particularly in their essays in *Making Space for Science*[19], and Simon Naylor in his paper on historical geographies of science.[20] The domestic setting of much laboratory work is worth noting, for example Lord Rayleigh converted the stables at his country estate into a laboratory where he studied classical physics, and especially acoustics. Again Simon Schaffer's work is very relevant. *Physics Laboratories and the Victorian Country House* in Crosbie Smith's *Making Space for Science*[21] particularly describes the situation at Terling, Rayleigh's country estate, relating the physical space to the establishing of authority and economy.

However, from our audience's point of view often these settings are insufficiently distinct from the present understanding of the word *Laboratory* to make a clear point. Nineteenth century physics existed in a remarkably wide variety of settings: the home, schoolroom, public exhibition, lecture theatre, laboratory, field, ship etc and to bring out the domestic element, which had appeal, would have been too restrictive for the compass of the exhibition, and could give a unbalanced impression. As early as the 1840s purpose-built physics

laboratories were appearing, such as the 'New' Laboratory in University College London, which opened in 1846.

A third aspect on which to focus could have been the relationship with the public, which can be argued was more direct in the nineteenth century. Studies by Iwan Rhys Morus[22], Aileen Fyfe[23] and Richard Altick[24] have looked at the spectacular nature of the public interface with science during this period. For example the *National Gallery of Practical Science, Blending Instruction with Amusement*, known as the Adelaide Gallery, claimed to have had half a million visitors by 1841, less than ten years after its founding by wealthy patrons in 1832 to "illustrate scientific subjects in a manner at once interesting and instructive". It was just one of a number of sites endeavouring to combine improvement with entertainment in London at the time.

The well-known prints of Michael Faraday lecturing at The Royal Institution, over a long period in the early to mid century, show him bringing cutting edge discoveries to a lay audience and can be used to make this point.[25] Faraday certainly saw himself as a natural philosopher, but he was working within what we would now class as chemistry and physics, and yet his audiences were immediate and intimate. Similarly John Tyndall, in the same space later in the century, was bringing recent physics in a direct manner to his listeners. "Tyndall has succeeded not only in original investigation and in teaching science soundly and accurately, but in making it attractive".[26]

There are points here to be made about communication

Figure 5 : "Great men" of science. Pictured from left to right are Michael Faraday, Thomas Huxley, Sir Charles Wheatstone, Sir David Brewster and John Tyndall. The montage photographic portrait was commissioned to celebrate Huxley becoming president of the British Association for the Advancement of Science in 1870[27]. *Science Museum London/SSPL.*

strategies, and it would be worthwhile to include them in an exhibition script, but it was decided that they are too abstruse and removed from our modern audience's experience to feature

as the salient contrast between then and now. Any science at any time has to have strategies for persuasion, and to contrast these would demand an exposition of communication strategies in 2009, which would again divert from the focus on nineteenth century practice. Therefore relationship with audience was also rejected as the salient feature.

The organisation of the individuals is another aspect which could have been used. The names of the 'great men' that populate histories of nineteenth and early twentieth century science are known to us to some extent because they tended to work alone, often with the help of technicians who have been largely forgotten and written out of popular histories, but not in the size of teams that make up the physics community today. The small groups in the early purpose-built laboratories such as The Cavendish were growing rapidly by the end of the century, but generally speaking the period can be characterised by a culture of individual contribution.

The images, and especially the group images, of the time impress on modern audiences the cultural differences in the make up of the physics communities then and now (Fig 5). These reflect broad societal changes in opportunities for women and the mobility of the workforce – but they are not particularly a feature of physics, and may even be less apparent here than elsewhere in society. Hence the organisation of science was also rejected.

This leads us to the last feature, the scale of the experiments, the one eventually chosen to contrast nineteenth and early twenty first century physics. Scale is very easy to grasp,

whether it is very large, for example as in the Large Hadron Collider, or very small as in the chip described above.

Another consideration was the desire to have an interactive component, and the ability to perform all this physics in the space of a gallery was immediately apparent. The scale of physics in 2009 would have prevented a gallery of 'hands on' demonstrations.

In choosing scale it must be recognised that all these features are inter-linked. The nature of the content, the organisation of the scientists, the places physics was practised, the relationship with the audience, and the scale, all are inter-dependent. The accessibility of nineteenth century physics is intrinsically bound up with its size. Nineteenth century practitioners were simply unable to investigate at the extremes of scale obtainable now. The intimate, tangible aspect of the apparatus allowed a more immediate communication than the physics of today. Focussing on scale leads effortlessly to considerations of place and audience. The extreme conditions demanded by contemporary physics dictate its physical removal from the public sphere, so while the reliance on democratic support is constant, communication is more challenging and less immediate.

The actual phrase Table Top appertaining to a specific size of apparatus appears particularly apt. The omnipresence of the table in 19th century images is quite remarkable. Even if the experiments are being undertaken outdoors in the field, a table appears a vital part of the set up. One of many such images is that illustrated at Figure 6.

So we come to the third question – should there be a developmental story or a vista or snapshot approach? It is important that physics is seen to have developed during the nineteenth century, however it is also important that it is recognised that physics at any period between 1800 and 1900 was very different from physics today. In any of the features listed above: subject remit, physical space, relationship to audience, organisation of the discipline, and scale, the changes between 1800 and 1900 were demonstrably less than the changes between any time in the nineteenth century and 2009. This on its own would not be a sufficient reason to opt for a vista or snapshot approach, but it is a consideration. Another reason is, tasked with contrasting physics then and now, or at least acknowledging differences, two snapshots give a more consistent approach than a continuum contrasted with a snapshot. A further reason was the desire to avoid a Whig history of continuous progress which can be very alluring and unquestioning in science museums.

So, there is a rationale for viewing physics holistically in the entire nineteenth century. Scale has been chosen as the defining quality to be contrasted with the physics of 2009, the iconic element being the table. The snapshot or vista view has prevailed over the developmental narrative. Now, can we really teach something of the subject of physics with replica nineteenth century apparatus?

This is certainly not the first time this question has been asked and answered. Recreating historical experiments has become a vibrant strand in science and technology studies,

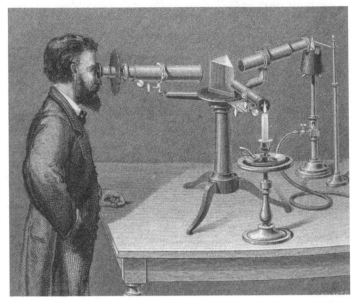

Figure 6: Spectroscopic observations from Amedee Guillemin 'Le Phenomene Des La Physiques' 1868 [28]

often featuring in student projects. Much interesting work has been done by Peter Heering[29], Otto Sibum and a group at Cambridge[30], Jed Buchwald and students[31], Jim Bennett[32], and more recently Hasok Chang[33]. Students at the History of Physics Laboratory at Columbia University at New York were performing historical experiments as long ago as 1970.[34] The earlier work tended to focus on the problems of replication, but this has been a topic of much wider study more recently. Our audiences would be able to handle replicas, and while they may not perform rigorous experiments as such, the hands-on aspect would help them get a flavour of using this apparatus. We have not yet had the privilege Sibum talks of,

of becoming "open laboratories in which the public could experience the success of failure", but visitors would get some feel for the material.

Peter Heering in his study of Marat's helioscope and permeometre came to the conclusion that the effect that Marat described in his observations fitted better with a theory now superseded.[35] This raises the complex issue of observations or *nuggets of experience, vis a vis,* and detached from, accepted theory or *genuine knowledge* as it has come to be understood. Our visitors would experience the difficulty in moving from one to the other, whether it is the current theory or a historically accepted one, or even something peculiar to that individual. These reflections should enable us to raise interesting points and challenge the widely-held position of the truth of contemporary science. The difficulties associated with theorising, an enduring aspect of science, should become graspable.

Chang puts his finger on what we can teach when he talks of *generating doubt.*[36] We can enable visitors to find out what things do – to see the results of experiment, and can open up questions about explanations. They are not a 19th century audience and we need to accept that the meanings they take will be much dependant on their own culture. But as curators we must not be disheartened and throw the baby out with the bath water. Schaffer agrees. While our audiences are immersed in the here and now, "Neither are such artefacts so weak that their otherwise protean meaning is completely dependant on each and every shifting local stipulation".[37]

So the answer to the big question... *can we enable our audiences both to engage with the 19th century mindset and learn something of physics as we understand it today?...* is Yes, but with a vital caveat. We can if and only if our definition of physics – or any other science – is wider than the mere understanding of principles, as these will change. If our meaning of the term physics includes how the subject develops within its context, which as curators it must, then an exhibition on nineteenth century physics which includes hands-on replicas can be rigorous, relevant, accessible and challenging.

Notes

1. Simon Schaffer "Object Lesson" in Museums of Modern Science; Nobel Symposium 112 ed. Svante Lindqvist (Canton Mass: Science History Publications, 2000), 61

2. H. Otto Sibum Natural Standards Pre-print no 172 (Berlin: Max-Planck-Institut für Wissenschaftsgeschichte, 2001), 34 and II. Otto Sibum "The Golden Number of the Century: The History of a Scientific Fact"in Lorraine Daston, Staffan Muller-Wille and H Otto Sibum A History of Facts pre-print no 174 (Berlin: Max-Planck-Institut für Wissenschaftsgeschichte, 2001) 60 Sibum refers to a quote from Thomas C Mendenhall "Commemoration of Prof Henry Rowland" in John Hopkins University Circulars XXl No 154 Dec 1901.

3. Adophe Ganot Elementary Treatise on Physics 7th edition (London: Longmans, Green, and Co, 1875) 386

4. Josep Simon, "Circumventing the 'elusive quarries' of Popular Science: the Communication and Appropriation of Ganot's Physics in Nineteenth-century Britain". In Popularising Science and Technology in the European Periphery, 1800-2000. ed. Faidra Papanelopoulou, Agusti Nieto-Galan, and Enrique Perdiguero, (Aldershot: Ashgate, 2009).

5. See for example Richard Noakes "Instruments to Lay Hold of Spirits: Technologising the Bodies of Victorian Spiritualism", in Bodies/Machines ed. Iwan Rhys Morus (Oxford: Berg Publishers, 2002), 125-163.

6. William H. Brock, William Crookes (1832-1919) and the Commercialization of Science. (Aldershot, UK: Ashgate, 2008) 217 and 225-231

7. Jed Z Buchwald and Sungook Hong "Physics" in From Natural Philosophy to the Sciences ed. David Cahan (Chicago and London: University of Chicago Press, 2003) 163-195

8. David Cahan "Looking at Nineteenth Century Science: An Introduction" in From Natural Philosophy to the Sciences ed. David Cahan (Chicago and London:

University of Chicago Press, 2003) 4

9. Iwan Rhys Morus When Physics Became King (Chicago and London: University of Chicago Press, 2005) 3

10. Ibid 25-53.

11. Peter Michael Harman Energy, Force and Matter: The Conceptual Development of Nineteenth Century Physics.(Cambridge: Cambridge University Press, 1982) 2-3

12. Charles Partington A Manual of Natural Philosophy.(London J. Taylor, 1828)

13. James William McGauley Lectures on Natural Philosophy (Dublin: A Thom, 1850)

14. St George Mivart The Groundwork of Science (London: J.Murray, 1898)

15. Tiberius Cavallo The Elements of Natural or Experimental Philosophy (London; T.Cadell and W.davies, 1803)

16. Jean-Baptiste Biot Traite De Physique (Paris: Deterville, 1816)

17. J.D. Everett: Textbook of Physics (London: Blackie and Son, 1883)and Outline of Natural Philosophy (London: Blackie and Son, 1885)

18. Simon Schaffer "Where Experiments End: Table Top Trials in Victorian Astronomy" in Scientific Practice: Theories and Stories of Doing Physics ed. Jed Buchwald (Chicago: University of Chicago Press, 1995)

19. Sophie Forgan "but Indifferently Lodged...': Perception and Place in Building for Science in Victorian London" and Graeme Gooday "The Premisses of Premises: Spatial Issues in the Historical Construction of Laboratory credibility" in Making Space for Science: Territorial Themes in the Shaping of Knowledge ed. Crosbie Smith and Jon Agar (Basingstoke: MacMillan Press, 1998) 195-215 and 216-245

20. Simon Naylor, "Historical geographies of science: places, contexts, cartographies", British Journal for the History of Science, 38, (2005) 1-12.

21. Simon Schaffer "Physics Laboratories and the Victorian Country House" in
Making Space for Science: Territorial themes in the Shaping of Knowledge ed
Crosbie Smith and Jon Agar (Basingstoke: MacMillan Press, 1998) 149-180

22. Iwan Rhys Morus "Seeing and Believing Science" Isis 97 (2006): 101–110

23. Aileen Fyfe Science in the marketplace: nineteenth-century sites and
experiences (Chicago: University of Chicago Press, 2007)

24. Richard Daniel Altick The Shows of London (London: Belknap Press, 1978)
377

25. For example Tinted lithograph by Leighton Bros after A Blaikley. Faraday
lecturing to an audience including the Prince of Wales and his brother,
December 27th 1855.

26. Edmund Hodgson Yates Celebrities at Home vol 2 (London: Office of 'The
World', 1878) 127

27. Photographic portrait album English Celebrities of the 19th Century part 1
plate 5 (London: Hughes and Edmonds, 1876)

28. Amedee Guillemin Les Phenomenes De La Physiques (Paris, Librairie de L.
Hachette et Cie, 1868) 374

29. Peter Heering "Analysing experiments with two non-canonical devices; Jean
Paul Marat's helioscope and permeometre" Bulletin of the Scientific Instrument
Society 74 (2002) 8-15

30. For example H. Otto Sibum "Reworking the mechanical value of heat:
Instruments of precision and gestures of accuracy in early Victorian
England" Studies in History and Philosophy of Science Part A 26 (1995) 73-106
and Adelheid Voshkuhl "Recreating Herschel's actinometry: an essay in the
historiography of experimental practice" The British Journal for the History
of Science 30 (1997):337-355

31. For example Jed Z Buchwald The Creation of Scientific Effects: Heinrich
Hertz and Electric Waves (Chicago and London: University of Chicago Press,

1994) and Elay Shech "Coulomb's Electric Torsion Balance Experiments of 1785"
http://exphps.org/pdfs/projects/coulomb%20experiments.pdf

32. Jim Bennett "Can Science Museums Take History Seriously?" in The Politics
of Display: Museums, Science, Culture ed. Sharon MacDonald (London:
Routledge, 1998) 173-183

33. Hasok Chang Inventing Temperature: Measurement and Scientific Progress
(New York: Oxford University Press, 2004).and Hasok Chang "The Myth of the
Boiling Point", http://www.ucl.ac.uk/sts/chang/boiling/.

34. Samson Nashon, Wendy Nielsen and Stephen Petrina"Whatever happened
to STS? Pre-service physics teachers and the history of quantum mechanics"
Science and Education 17 4 (2008) http://www.springerlink.com/context/
x0563481j54517pm/

35. Ibid 28

36. Hasok Chang "Complementary Science" The Philosophers' Magazine 40
(2008) 17-24

37. Ibid 1

No Objects, No Problem?

JIM GARRETTS

Thackray Museum

Leeds

This paper addresses the issues involved in delivering *Meaning from Movement*, a temporary exhibition held at the Thackray Museum in 2009 about the life and work of Dr Geoffrey Waldon, who developed distinctive theories of learning and development. However, these derived from complex ideas developed over a number of years and would be unfamiliar to the overwhelming majority of museum visitors. The museum does not hold any collections pertaining to Dr Waldon, neither could material be sourced from other museum, archive or library collections and unfortunately it did not prove possible to engage the support of Dr Waldon's family. The paper details how these problems were addressed and therefore how the methodology behind the exhibition's design was executed.

Introduction

Museum and gallery collections can be exotic, intriguing, affirming, pleasurable and challenging – they can stir emotions, inspire connections and stimulate ideas. While this observation (Glaister 2005, 8) may well be true, curators face particularly tough challenges when the material culture needed to interpret a theme in an exhibition is at best scarce and at worst non-existent. Indeed, this dilemma was discussed at a recent meeting of the Thackray Museum's Research Sub-Committee, when its Chair, Dr Robert Anderson raised the issue of whether a museum's exhibition policy should be governed by topics in which it held strong collections or whether it was more important to offer as broad a range of exhibition themes as possible. Can curators be too object-

centred? A recent collaboration between the BBC and the British Museum has created *A History of the World in 100 Objects* (to which the Thackray Museum is also contributing), which will doubtless prove to be very popular. This initiative "aims to pull together human civilisation in its entirety" (Rustin 2010) and also has a dedicated website that will similarly attract many visits. However, it would be naïve to presume that a history of the world could not also be told in other ways, such as in terms of developments in scientific, political, philosophical and religious thought, without being wholly dependent on objects.

The challenge

I was appointed Senior Curator at the Thackray Museum on 1 September 2008, by which time the two half-yearly temporary exhibitions for 2009 had already been planned. I was given responsibility for ensuring that the exhibition for the second half of the year would be delivered. This was to be based upon the work of the late Dr Geoffrey Waldon (1930–1989), who took an interest in neurology, observing many children with a wide range of developmental problems. Meetings involving practitioners familiar with Dr Waldon's methods had taken place in early 2008 and exhibition dates had been fixed.

My brief was to "create an innovative, interactive and exciting exhibition that would bring the work of Geoffrey Waldon to life". There was clearly a strong practical aspect to his work and therefore it would be very important to engage the visitors, encouraging them to try the type of activities

that Geoffrey had devised to study human development for themselves. Moreover, the exhibition was sited adjacent to *Lifezone*, the museum's large interactive area for young people and therefore it needed to be particularly accessible, both intellectually and physically, to a wide range of users.

Formulating the exhibition's design

The first task was to find out as much as possible about Dr Waldon and plan what the exhibition's outcomes should be. Meetings were convened from March 2009 onwards with three key members of the Waldon Association, established in 1987 to promote further investigation into Dr Geoffrey Waldon's ideas and to study the scientific principles and educational applications that support his theories. They had all known Geoffrey personally and therefore were able to provide detailed information based on first-hand experience. An exhibition designer was also commissioned who had done previous work at the museum and who was recommended by museum staff. An exhibition outline was compiled, which included the following learning outcomes for visitors:

· To be able to access basic information about Geoffrey Waldon; when he lived, where he worked and what he looked like, so that a lasting impression of him could be created.

· To understand the basic ideas underlying The Waldon Approach and what Geoffrey meant by "fundamental general understanding".

· To appreciate the learning process through which

humans progress during their first two years.

- To find out about the six principle methods by which humans "learn how to learn" and to explore some of them by practical application using special interactives in the exhibition based upon special *Waldon activities* that Geoffrey had devised.
- To understand that observation of those with developmental problems undertaking Waldon activities could help to identify what type of difficulties existed, so that corrective measures could be applied.
- To be able to find out about (i) other practitioners in the field, both past and present, (ii) resources to explore the subject further and (iii) the current work of the Waldon Association.
- To be able to feedback opinions about the exhibition.

Exhibition content

While it is not the intention in this paper to provide a comprehensive and detailed account of the exhibition, it is nevertheless worthwhile at this point to give a general description. As there were no collections on display, a key element of the design brief was to make the exhibition visually attractive, to appeal to the visitor. The exhibition space occupied a small rectangular gallery measuring approximately 8 metres by 6 metres and which had room for approximately 16 display panels. The entrance to the gallery was in the centre of one of the long sides. The intention was for visitors to enter the gallery and move around in a clockwise

Figure 1: Biographical details. *csdesigns and Ann Clarke.*

rotation. This direction of visitor flow was considered to be the most appropriate, as the panels would be read from left to right, although they were also designed to be discrete elements that could be read in any order. An interesting analysis of visitor flows has been conducted at the Art Gallery

and Museum, Kelvingrove in Glasgow by the Welsh School of Architecture. From the data gathered, it would seem that "... the style of visits to the museum is informal and exploratory rather than controlled..." (Grajewski and Psarra 2002, 37) and therefore it was felt advantageous to keep the exhibition as open as possible, avoiding segregated areas. Various Waldon activity interactives for visitors to try out were mounted on the gallery walls at child-friendly height and around an interactive station in the central space.

The first panel (Fig 1) provided biographical details about Geoffrey Waldon; he had qualified as a doctor from the University of Aberdeen in 1961 before becoming a Registrar at Queen Mary's Hospital for Children in Surrey. Between 1961 and 1965 he took an interest in neurology (the study of the nervous system) and observed many children, some of whom had developmental problems. His studies led him to form his theories about the development of understanding. He established the Centre for Learning to Learn More Effectively in Manchester, where he worked with children and adults for many years. The Waldon Association was able to supply a photographic image of Dr Waldon. The first line of text on the first panel asked a question of visitors, "...to help draw them into the display." (Martin 1997, 62) It stated, "You are reading this panel because you have learned to read – but how did you learn how to learn?"

Fortunately, footage also existed of Geoffrey Waldon articulating his ideas and beliefs in a film entitled *Understanding UNDERSTANDING*, made in 1980. Permission

Figure 2: Ideas and theories. *csdesigns and John Gooding.*

was kindly given by the film company for extracts to be included in a presentation of twelve audio-visual clips, which also showed a child exhibiting classic learning how to learn behaviour throughout its first two years. This film, which was edited, captioned and installed on a solid state video store by a company which had previously worked with the exhibition designer, ran continuously. A 42-inch plasma screen was also

purchased and deliberately sited so that it could be seen from the gallery entrance, thereby encouraging visitors to come into the space.

Other panels introduced Dr Waldon's ideas and theories. There were complex issues to interpret and therefore it was important that panels were designed in a bright, lively and engaging manner and that they could be easily read (Fig 2). Four panel texts have been abbreviated below as examples:

The early development of fundamental understanding does not depend on the activities of parents or teachers, nor on the customs or rituals of any particular society, nor the child's ability to speak or understand speech, much less on its ability to read, nor on the child's interaction with either adults or other children of a similar age. Understanding does not develop through copying other people's behaviour and has nothing to do with sophisticated toys or high-tech gadgetry. However, it does totally depend upon the capacity to move and the inner drive to be active; the form and structure of the human body; the activity of sensory receptors and the rest of the nervous system.

In some ways, the human body doesn't appear to be particularly special. Many animals are specialised, such as the giraffe, which has a long neck so that it can feed on the leaves of tall trees, or the hedgehog which has prickles to protect it from attack. The human being, on the other hand, is a highly unspecialised animal. Although we can do many different things, we are often clumsy, but we can even learn from the things we do by accident. Unlike claws, paws or hoofs, our hands are ideal for experimenting with and manipulating the environment. While one hand can do quite

a lot, two hands working together can do almost anything! It's not surprising therefore that humans have learned to create and use simple hand tools such as stone axes and have later used their hands for more complex processes such as the development of conventional language. When it comes to using our brains and our intellect, we are very special indeed.

All understanding arises directly from the organising of patterns of movement in time and space, in other words: "...meaning comes from movement..." For example, a baby spending a few minutes putting wooden cubes in a row or in a pile is not only placing them in space but is also arranging them in time. Such activities are not merely games; this is the way that the infant learns to understand the world.

The Waldon Approach was devised in the 1960s. It is a systematic approach to education based on observation of the normal processes of learning and development in the human baby, infant and child. Some important principles of the Waldon Approach are:

Meaning comes from movement: All human understanding comes directly from the organising of patterns of movement in time and space. We learn by spending time moving ourselves and objects in our environment.

Learning comes from doing: Babies and children learn the most basic things about themselves and their world by picking up and handling objects and finding out how to do more with them. This activity increases their general understanding and allows them to become more effective learners.

Learning-how-to-learn: "During the first year the child is preparing himself for the business of coming to understand the

world. *In the second year he gathers experience very effectively but in a rather haphazard manner and soon he must develop his general understanding more efficiently and more selectively. He must start to impose his own order on everything he meets with so as to make it more comprehensible. This duty is performed by the mental processes which I refer to as the learning-how-to-learn tools, which are forged during the third, fourth and fifth years, from the experience gained in the second year, with the bodily apparatus organised during the first year."* (Waldon Association).

The learning-how-to-learn interactive element

There are six learning-how-to-learn tools through which the developing child learns how to learn. The interactives in the exhibition linked to four of them and were based on some of those designed by Dr Waldon to develop learning to learn skills. A label accompanied each interactive, indicating which particular learning tool was being addressed. The six learning-how-to-learn tools are:

Matching: This involves the child comparing objects and matching up those with the fewest differences. Matching draws the attention to odd ones out and eventually to the concept of similarity.

Sorting: This involves the allocation of objects or patterns to sets on the basis of noticed similarities and is a counterpart to Matching. It may focus the child's attention on a feature that it had not noticed before. This leads to classification and the natural creation of categories. Partition Sorting puts items into distinct groups separated from one another,

Figure 3: Interactives. *Thackray Museum.*

while Intersection Sorting places items in specific squares on a grid according to guidance given on the grid's rows and columns.

Seriation: Starting with the simplest pattern-making (an example would be putting objects in a row), seriation involves making sense of an activity even when not all the clues are there. This is the basis of deductive reasoning, when the child is able to make sense of something using only a certain amount of information, such as choosing the right cube to fill a gap in a row of cubes arranged in order of size.

Brick building: Brick building develops an understanding of the use of space. It involves the discovery of direction, relative position and functional relationships between

objects, such as whether small bricks fit on top of bigger ones better than large bricks do on top of smaller ones. It allows the child to recognise the effects of moving, arranging and re-arranging things and to make sense of what it is doing.

Drawing and use of Tools: This can be seen as a two-dimensional version of brick building, but it also involves the use of a tool such as pen, pencil or brush. The actions used are equivalent to those involved in using other simple tools such as the rake, spoon and lever, or more complex tools such as tweezers, pliers and scissors.

Coding: This begins with the earliest accidental associations that are made between things that the infant is aware of, but eventually develops into an organised use of chosen symbols. Coding enables signs or actions to represent other objects or actions. This is the basis of using symbols, such as *the heart* representing love.

There were two crucial principles that the exhibition sought to convey through interactive engagement:

- Understanding does not develop through copying other people's behaviour and has nothing to do with sophisticated toys or high-tech gadgetry.
- Waldon activities are not the main part of the learning process, but are simply a way of getting us to do things. The learning itself comes from what the learner does and how it is done – playful, wholehearted involvement in activities is what counts. There are no right or wrong answers; it's not what you do, it's the way that you do it!

The first of these principles was demonstrated by the manufacture of interactives (see Figs 3, 4), using very simple materials by two companies who had both previously worked with the exhibition designer. These were arranged in the gallery with child-friendly platforms provided as appropriate:

Two matrix boards (4 x 4) and (5 x 5), on which patterned tiles were placed according to guidance tiles placed around the board's perimeter.

A set of four metal matrix boards, each (3 x 3), and a card park holding thirty-six magnetic picture tiles which could be selected and moved to any of the boards in any order. There were nine animal tiles, nine fish tiles, nine building tiles and nine vehicle tiles. Whilst some visitors would notice this and simply divided them up into their respective topics, some put together nine picture tiles that were the same colour; some put together fish and animals on the same board that were all facing in the same direction, emphasizing the different interpretations of how the tiles could be distributed.

A set of four vertical poles, mounted on a base, onto which a variety of objects could be threaded.

A set of sixteen patterned cubes, arranged onto four parallel horizontal rods and which could be rotated to create a large number of designs.

Three jigsaws, which fitted within a frame and which could be laid one on top of another. One jigsaw comprised only straight edged pieces, the second had only round edged pieces and the third involved a combination of both straight

Figure 4: Interactives. *Thackray Museum.*

and round edged pieces. Each jigsaw was a different colour.

A pegboard containing one hundred drilled holes, into which either plain or green wooden coloured pegs could be fitted, enabling a vast array of patterns to be created.

Photographic imagery included in the exhibition panels was produced by a member of the Waldon Association who is also a contemporary artist. He emphasised the use of simple Waldon activity materials such as brightly coloured clothes pegs, curtain pole rings, wooden blocks and plastic pieces.

The second principle was more difficult to demonstrate. In professional terms, children with developmental problems

can be observed by experts in the field (such as members of the Waldon Association) while they are undertaking Waldon activities. Conclusions can then be drawn to identify where particular difficulties exist. However, in order for such analyses to be completely objective, it is vital that the child is able to carry out the activities at her/his own pace, without external comment, encouraging or otherwise. Waldon made a distinction between asocial learning, where an individual learns by her/himself without the influence of others and social learning, where the assimilation of knowledge is influenced by others.

In asocial learning, "The child does everything for him- or herself. He chooses the behaviour from his store of experience; he initiates the action in his own time; its performance is reinforced, or rewarded, by the pleasure he takes in it, and in future it is likely to be chosen again because of the pleasure he has previously taken in it. Whatever he does and how-so-ever he does it is good. Even if what happens is not quite what or how intended, it is still good. Everything new he learns grows out of what he has learned before and contains the essence of what has gone before. Therefore, the more soundly anything is understood, the richer and more varied the state of understanding, the more probable it is to prove the source and foundation of wide-ranging and mature abilities in the future." (Waldon Association) "The adult is there in the background to make sure the child feels safe and secure, but there is little or no social interaction between them at this time. There are no social rewards – the satisfaction comes from the activity

itself." (Stroh, Robinson and Proctor 2008, xix)

However, in social learning, "When the child does interact more sociably with other people the whole mood or atmosphere changes. The forms of this learning and the kinds of understanding which result are then quite different… within the social context other people can play a major part in shaping the child's behaviours by heavily reinforcing those responses which are both apparent and seem desirable. This deliberate selection for encouragement of only some of the child's behaviours is only partly a conscious act on the part of older members of society and is guided by what seems best for the child." (Waldon Association)

It was important that museum visitors not only had the opportunity to try out some of Dr Waldon's learning-how-to-learn activities, but that they understood what each activity was intended to demonstrate. However, any interactive interpretation providing a detailed summary of what was expected of the participant would be by definition anti-Waldon, because visitors would need to be effectively learning asocially. There had to be no pressures whatsoever on the visitor who needed to freely interact with the activities as s/he saw fit. This approach is unusual to find in a museum context, when curators are expected to educate through careful explanation. While "…affective gains – the enthusiasm and enjoyment generated by museum visits – may be as valuable in the long-term as the cognitive gains – the assimilation of facts and information." (Martin 1997, 36) in most museum situations, affective gains were certainly what

were desired through the use of interactives in this particular exhibition.

Conclusion

There was a section in the exhibition inviting feedback. Questionnaires were provided, asking visitors about the exhibition and giving them the opportunity to have their contact details added to the museum's visitor database in order to receive further communications about future events and activities. From the exhibition's opening on 13 July 2009 until the end of the calendar year, the museum received 26,045 visitors. Not all of those would necessarily have seen the *Meaning from Movement* exhibition and of those who did, not all would have completed a questionnaire. A total of 348 questionnaires were completed in the exhibition gallery during this period. Ignoring 53 spoiled responses, 179 (60%) scored either 4 or 5 (out of 5) to the two questions dealing with (i) how interesting they found the exhibition and (ii) how much they enjoyed the exhibition. A total of 234 (79%) indicated that they would recommend the exhibition to friends and family.

In summary, the exhibition's brief was met. Visitors found out about Dr Waldon, his ideas and theories. They had had the opportunity to try out some of the activities based on his designs and in so doing appreciated how the learning process works in humans. Thereby, visitors were able to answer the question asked of them on the first exhibition panel: they learned how they learned how to learn!

References

Glaister, Jane. 2005. *Collections for the Future*. London: Museums Association

Grajewski, Tadeusz and Psarra, Sophia. 2002. Track Record. *Museum Practice* 19: 36 – 42

Martin, David. 1997. Introduction to Interpretation. *Museum Practice* 5: 36 – 38

Martin, David. 1997. Display Text. *Museum Practice* 5: 62 – 65

Rustin, Susanna. 2010. The greatest exhibition you could ever have. *The Guardian*, 2 January, pages 26 – 27

Stroh, Katrin, Thelma Robinson and Alan Proctor. 2008. *Every Child Can Learn*. London: SAGE Publications Limited

Waldon Association: *Understanding UNDERSTANDING. An introduction to a personal view of the educational needs of children*. Geoffrey Waldon, 1980 (revised 1985)

http://www.waldonassociation.org.uk/Introduction to Waldon.htm

CUTTING-EDGE RESEARCH EXHIBITED

Exhibition Experiments: Publics, Politics and Scientific Controversy

SHARON MACDONALD

University of Manchester

Any exhibition, whether it admits it or not, seeks to position the visitor; that is, it encourages those who visit to behave and interact with the exhibits in certain ways. It does this through such strategies as whether to encourage visitors to touch the exhibits; through the complexity of the information that it provides; through how far the exhibition is presented as a stated matter of fact, a puzzle to be deciphered or as something to be interpreted as visitors choose. One way to talk about this is in terms of the imagined or intended visitor: the perfect visitor that exhibition-makers implicitly have in mind when they create an exhibition. (This *ideal visitor* used to be mostly modelled largely upon the learned curators themselves; today a child with a limited attention span is more usual.) Visitors are variously imagined as playful and flighty; or as serious and knowledgeable; as empty vessels waiting expectantly to receive curatorial wisdom; or as argumentative types who will need to be convinced. In practice, exhibitions may be chimeras of bits of pieces of the different visitors imagined by different exhibition-makers.

Of course, real visitors do not always behave in the way that the exhibition-creators hoped. This is not only because real visitors are less perfect than imagined ones, and neither is it only because of their considerable variety and the fact that they come with all sorts of other agendas than learning about science – that is, they may be more concerned to flirt with their companion, think about where to go for lunch or create their own group performance. But even beyond the inevitable awkwardness of real visitors – which should not, however,

be overstated or used as an excuse by exhibition-makers to not try harder – there are all kinds of features of exhibition itself, of how certain kinds of spaces and juxtapositions, of certain kinds of exhibitionary hints, work that are still too poorly understood. This means that exhibitions often just do not work quite as intended. Areas of research with names like *space syntax* and *affective communication* are trying to help us better understand these matters – and, thus, the techniques of what Michel Callon calls *interessement*, or how to *lock allies* as he also puts it.[1]

There is a politics, in its broadest sense, to the way in which an exhibition (or its maker) seeks to position or lock the visitor. One aspect of this politics that has been much discussed and embraced in recent years is the possible shift from *public understanding of science* to visitor *interessement* in science.[2] Put simply, this is a shift from looking at the visitor as an empty vessel waiting to be filled with proper scientific knowledge – with the exhibition and the visitor sharing the blame for any deficiencies of uptake; to a position in which visitors – like the scallops and nets in Michel Callon's famous study of Breton scallop fishing – are all seen as actors in their own right, but who have to be somehow enrolled and positioned as allies by (in this case) the researchers. In the interessement model, science, and museums as one of the agencies responsible for mediating scientific knowledge, cannot hope to simply impart established knowledge but must somehow allow the public to participate in more active terms, including being put in a position of questioning science itself.

The public, that is, is positioned more democratically as a potentially knowing player, a co-worker, than as a passive subject of authority. This article is concerned with some of the difficulties in trying to undertake this in exhibitions, as well as with its potential.

Strategies of engagement and some dilemmas
There have been a number of partially interlinked ways in which this has been attempted. One has been to show unfinished science or science in the making.[3] This has drawn on sociology and history of science perspectives to highlight non-heroic aspects of science – the mess, uncertainty and social and political factors involved. This has also sometimes been talked about under the label of the Public Understanding of Research – directing attention to the processes of constructing knowledge.[4] Art works and art installations have also increased in science exhibitions and can provide another means for encouraging different kinds of audience relationships to science. After all, the public is probably more used to the idea that they can have their own opinions on art works than they are about scientific knowledge; and art works can potentially elicit emotions about science-related topics that may more readily prompt reflection than it might a more conventional informative display. Another, often overlapping, approach, is to look at areas of scientific controversy. In controversies there is no single fixed position, so allowing debate and showing that science does not speak with a single voice. Moreover, many controversies concern ongoing issues

– global warming, GM foods, nuclear energy, genetic testing, enhancement drugs – and so are also unfinished, as well as often being matters of direct public concern.

Yet these are matters that museums are often very bad at dealing with. Partly this is because of temporality. Museum displays traditionally take a long time to put in place and then they themselves remain fixed for a long time: they are thus not well suited to the often rapid position changes of controversy. Furthermore, it may be hard to acquire suitable objects with which to display ongoing controversy and many museums are also under at least some compulsion to collect and display what they can of their existing collections. Scientists' perceptions of the nature and role of museums may also mean that they do not wish to interact with them in the same way that they might interact with other media. In research that I carried out in the Science Museum at the end of the 1980s, one exhibition topic was food.[5] This was a time of numerous controversies about food, with high-profile scientists expressing different views on matters such as the health value of fats and sugars in the diet. To highlight the idea that scientists have different ideas about these matters, the exhibition-makers asked some of these scientists for summary statements of their views to become part of the new gallery. However, although these scientists frequently gave opposing views to the press, all restricted themselves to very conservative statements for the museum. No scientist wanted to find themselves associated with an outdated view ten years later within the walls of a respectable national

institution. The result was a display of consensus rather than the disagreement that the museum staff had intended. The same research also suggested that visitors tend to expect museums to be presenting established facts and this may mean that they do not readily perceive attempts to highlight ambiguity or uncertainty of knowledge. For example, another part of the exhibition tried to convey the idea that we should take dietary regulations with a pinch of salt as it were, whereas numerous visitors reported that the aim of the exhibition was to tell them about which foods were good and which were bad – an idea that was specifically refuted on one text panel. It should be noted, however, that despite the textual comment there were other features of the exhibitionary strategy that played into visitors' interpretation. Interactive puzzle-solving exhibits were understood – not surprisingly – as about trying to find the right answer. The medium thus ran counter to the intended message; as did the wider expectation of the institution – at least at that time.

Experiments in displaying scientific controversy

Despite these difficulties, there have been other interesting attempts to display scientific controversy in museums and this is something that the public may well have become more likely to expect. Nevertheless, I would argue that when exhibitions attempt this, they should also consider carefully the media that they employ to do so, for the particular techniques of interessement may shape the engagements. In a book that I edited with Paul Basu we used the term

exhibition experiments to describe exhibitions that play with the exhibition form in some way in order to, among other things, try to reformulate the relationship between what is displayed and the visitor to it.[6] Here I want to take one example from that book, an exhibition about genetically-modified food by a Vienna-based group called Xperiment![7] One interesting aspect of their account is that at the outset of their project there was no expectation that they would create an exhibition. Their remit was simply to undertake some form of public communication on this subject. They began by trying to get further understanding of the topic, interviewing a wide range of players, including scientists and anti-GM activists, such as Greenpeace; and recording these interactions. On the basis of this they drew big maps – storyboards – of the different positions and players involved. Then the idea came to them that rather than transform this further, they should use this idea of a storyboard and their own journey to try to understand the different perspectives as the communication. That is, they should present their own learning in the making rather than boil it down into a finished product. An exhibition seemed to them to be especially suitable to do this because, as they saw it, it would allow them to directly interact with visitors and to literally take them through their own journey. So they created a large storyboard to lay on the ground that could be walked and sat upon. This was first exhibited in Vienna (2001) and then at the Landesmuseum in Zurich (2002). Visitors were invited in and usually offered something to eat and drink by the members

of the team and then they would walk around the map and discuss it with members of Xperiment! The emphasis was on dialogue. Interestingly, visitors often wanted to know the position of the team-members themselves – were they really activists or scientists, perhaps hiding behind the impression of being mere mediators? But these interactions, and the opportunity for visitors to probe further, were an important part of the learning process in relation to which visitors could also formulate their own positions. Xperiment! members would openly discuss their own positions and aspects of how these had changed during their own engagement with the materials.

This, then, was not an example of interessement in the sense of trying to lock allies into a fixed position. But it was an example of engaging visitors in the same kind of ongoing learning-process as members of the team of exhibitors themselves – or an exercise in what Xperiment! dubbed *performing shared incompetence.* Sometimes team-members learned new facts or pieces of news in these engagements and their own positions sometimes altered in the process.

The rather provisional nature of the storyboard and the direct contact with the exhibition-makers were clearly key aspects of the exhibition design that played into the notion of science as unfinished and debatable. This was also a feature of an exhibition on the same topic in 2006, *Mapping Controversies,* also in Vienna, at the Gallery of Research.[8] Here, the idea of a kind of map was also used, though in this case it was turned into a more three-dimensional installation and visitors' were

encouraged to become performers whose short arguments would be projected onto screens. The making of visitors into part of the exhibition performance is a trend that we have seen in many parts of the museum world; and it clearly relates to our theme of the changing positioning of visitors in relation to institutional knowledge. Another feature of the Gallery of Research was that the space itself was rather unfinished – indeed, it was something of a building site due to the location, with all participants needing to wear hard-hats! This too fed into the sense of the unfinished that was part of the exhibition's point.

In conclusion, exhibitions of scientific controversy can be a means of trying to shift visitor understandings of science and their relationship to it. Part of my argument here, however, is that simply displaying controversial topics does not necessarily do this alone. There are, after all, many potentially controversial matters displayed in museums with no attention to their controversial nature – exhibitions about, say, cars, chemicals or DNA; though occasionally, as in the famous case of the *Enola Gay* at America's National Air and Space Museum, that lack of displayed controversy itself becomes publicly controversial.[9] What I especially want to emphasise, however, is that what is involved is not just about what is displayed but also about how it is displayed. And this is a matter of potentially much subtlety that we still only understand imperfectly. It is a matter that deserves more research – and more experiment.

There are two other points that I also want to make here as

these have bearing on the current keenness to try to represent scientific controversy in exhibitions. First, despite all of the current talk about allowing the public to understand the changing or controversial nature of science, we should not forget that there may be a place for telling about the relatively fixed and known – and that visitors may want this too. Visitor research carried out on the Science Museum's *Science Box* exhibits – small temporary exhibitions whose point was to tackle controversial topics and as part of this to make visitors' views and comments part of the ongoing exhibition – reported that while visitors liked seeing other visitor views they also often expressed frustration if this was not accompanied by enough of what they viewed as hard fact. They expected this from the museum.[10] And there are still many who would argue that one duty of a museum, perhaps especially a national one, is to try to present the most authoritative accounts possible.

This brings me to my second, and final, point. It seems to me that what also matters here is that the public understands what exhibitions are trying to do and why; that they understand the different kinds of roles that different institutions might have; and that they are also able to raise questions that go beyond exhibitor intentions, to interpret aspects of the content and display strategies of exhibitions themselves. I have argued that there should be greater sophistication within museums about the nature of exhibition design and how this interacts with content – indeed, these should be seen as integral rather than separate matters. This could, I think, also be used to help prompt

audiences to be more aware of some of the implications and effects of different exhibitionary strategies. What we are talking about here, then, is not just the public understanding of science or of research but of exhibiting – or representation – too. What I am calling for, in effect, is getting visitors engaged or interested in the very processes of interessement.

Notes

1. On space syntax see Hillier Bill, Tzortzi Kali, «Space syntax: the language of museum space», in Macdonald Sharon Companion to Museum Studies, Oxford: Blackwell, 2006, pp.282-301; on 'affective communication' in exhibitions see Macdonald Sharon, «Interconnecting: museum visiting and exhibition design», CoDesign, vol.3 (1), 2007, pp.1-14. Callon Michel, «Some elements of a sociology of translation: domestication of the scallops and the fishermen of St Brieuc bay», in Law John, Power, Action and belief: A New Sociology of Knowledge?, London: Routledge, 1986, pp.196-223.

2. This has been directly discussed by Franco Panese in «The meaning of displaying scientific objects in museums», in Valente Maria (ed.) Museums of Science and Technology. Interpretations and Activities to the Public, 2007, Rio de Janeiro: MAST/CIMUSET/ICOM/UNESCO. Other works discussing the problems with and shift away from Public Understanding of Science perspectives include contributors to: Irwin, Alan and Wynne Brian (eds) Misunderstanding Science: the Public Reconstruction of Science and Technology, Cambridge: Cambridge University Press, 1996, and, more specifically on museums, Chittenden David, Farmelo Graham and Lewenstein Bruce (eds) Creating Connections: Museums and the Public Understanding of Current Research, Walnut Creek: Altamira Press, 2004.

3. Shapin Steven «Why the public ought to understand science-in-the-making», Public Understanding of Science, 1.20, pp.27-30; Durant John «The challenge and the opportunity of presenting 'unfinished science'», in Chittenden et al op cit., pp.47-60.

4. Chittenden et al op cit.

5. Macdonald Sharon Behind the Scenes at the Science Museum, Oxford: Berg, 2002. The following examples are discussed in this book.

6. Macdonald Sharon and Basu Paul (eds) Exhibition Experiments, Oxford:

Blackwell, 2007.

7. Xperiment! Kraeftner Bernd, Kroell Judith and Warner Isabel «Walking on a storyboard, performing shared incompetence: exhibiting 'science' in the public realm», in Macdonald and Basu op cit, pp.109-131.

8. Yaneva Albena, Rabesandratana Tania and Greiner Birgit «Staging scientific controversies: a gallery test on science museums' interactivity», Public Understanding of Science, 2009, 18.79.

9. See, for example, Gieryn Thomas «Balancing acts: Science, Enola Gay and history wars at the Smithsonian», in Macdonald Sharon (ed.) Politics of Display. Museums, Science, Culture, London: Routledge, 1998, pp.197-228

10. Mazda Xerxes «Dangerous ground? Public engagement with scientific controversy», in Chittenden et al op cit., pp.127-144, p.142. Another finding from my Science Museum research is also relevant here. This is that visitors partitioned 'kinds of science', as they often described it, to discriminate between the kind that might be unstable and controversial and other kinds. That is, they did not necessarily extend from a topic like GM foods to think that other parts of science should also be matters on which the public might legitimately have a view. As one of the visitors said in response to a question about scientific controversy, 'It's just food, isn't it?' So by showing some science in the making, visitors may not extrapolate this to all science. But perhaps they are quite right not to do so?

Acknowledgement
A version of this article was presented at the conference Exposer des Idees, Questionner des Savoirs. Les enjeux d'une culture de sciences citoyennes, organised for the Reseau Romand Science et Cite, and held in Neuchatel, January 2009. A version of the paper was subsequently published in the conference proceedings of the same name, edited by Roger Gaillard and

published by Editions Alphil – Presses Universitaire Suisses (2010). I thank Roger and his colleagues for the original invitation and hospitality and the various conference participants for their comments.

The Exhibition and Beyond: Controversial Science in the Museum

SARAH R DAVIES

Arizona State University

Visit the Science Museum London's *Energy Gallery* – open since 2004 – and you'll interact with exhibits on topics such as where our energy comes from (the sun, ultimately) to the problem of energy security (through acting as a fictional country's energy minister). This innovative and award winning gallery uses a combination of art installations, interactive exhibits, and computer databases of case studies to inform and entertain its visitors. It also, however, makes a concerted effort to engage those visitors not just through information provision but in dialogue: in the *Energy Ring* exhibit you are invited to "join the conversation" by inputting your views on a number of questions. Doing this enables you to have a real-time effect on the exhibit's appearance – to have some sense, in other words, of live interaction with the content of the gallery.

This move towards conversation or dialogue is not unique either to *Energy: Fuelling the Future* or to the Science Museum. Visitors are increasingly being asked to feed back their opinions; to not just absorb information but to inform museum staff, and other visitors, of their views on it, and to participate in the production of gallery content. (At times, this has led to very public controversy – as in the Science Museum's recent poll on climate change; Jones 2009; Science Museum 2009).

It is this move that I will discuss in this essay, placing it in the historical context of science in museums and further situating it within recent trends in the practice of science communication more generally. I will suggest that attempts to incorporate conversational or dialogic approaches into

galleries can be understood as a response to the changing nature of science in contemporary society: when science and technology themselves seem uncertain, dangerous, and controversial, it becomes difficult to represent them within a form that can be both static and didactic. It is within this context, I will argue, that exhibition developers can learn from the recent turn throughout the UK, Europe and North America towards public participation or public engagement with science. Indeed, existing museum-run dialogue activities can be seen as a move beyond the exhibition to create new spaces for public debate.

I begin my discussion, however, with a short account of the historical development of science in museums.

From generation to generation

Museum science has a long and illustrious history. From Enlightenment cabinets of curiosity to the interactive exhibits of science centres, museums have sought to display, demonstrate and communicate the facts of the natural world. That there have been changes in how this is achieved – in the tools and techniques of display and learning – is as clear as this sense of long history. As Paulette McManus notes, individual institutions often house a number of the different stages that this development has involved: *In large national museums, it is not unusual to find that the museum of the 1990s also houses the museum of the 1940s or the nineteenth century with each element demonstrating the communicative priority of its time. This stratification occurs because there have been four stages in the*

development of science museums and the larger museums have
often housed at least three of them. (McManus 1992: 159)

McManus's four stages are an "ancestral form" – private
cabinets of curiosities, such as those owned by Sir John Soane
or Sir Hans Sloane – followed by three generations of public
science museums. For McManus, the first generation of
science museums (or, more accurately, science in museums)
consisted of the opening out of private collections to the
public. Such institutions – she gives the 1753 founding of the
British Museum as an example – were object rich and often
had strong connections to universities and private research;
public education, then, was frequently a secondary ambition.
As Tony Bennett (1997) has described, it was not always easy
to gain access to such institutions, and the public that they
sought to inform was a narrowly circumscribed one. Bennett
sees a second phase of museum development within a further
opening out of museums to the population at large – women,
children, social classes beyond the working man – which took
place in the latter half of the nineteenth century. Similarly,
McManus' second generation combines this shift to fully
public institutions with a change of content: there was a new
emphasis, she suggests, on science and industry. Museums
continued to be object-rich, but the objects displayed were
the fruits of technology – steam engines, mill machinery,
and, later, cars and aeroplanes. (The UK's National Museum
of Science and Industry, of which the Science Museum is the
best-known part, might be taken as an example of this.) As
Lehr and her co-authors note (2007), the increasing use of

such objects emphasised the progress of technoscience and celebrated its achievements.

The shift to a third generation of museums which took place in the mid twentieth century marked a more dramatic change of direction. According to McManus, earlier forms of the museum space, from private collections to the most impressive showcases of national technological achievements, had always continued to focus on objects: however presented or interpreted, and whether natural or man-made, it was the object that was the focus of the museum experience. In third generation museums this focus is lost and ideas become important. Galleries are developed not according to the kind of objects they hold but by the ideas they seek to teach, either through self-directed discovery or through a narrative describing a particular abstract concept. Perhaps the paradigmatic example of this type of museum is the science centre. Influenced by discovery learning in science education (see Driver et al 1994), science centres such as San Francisco's Exploratorium (Hein 1998), the Science Museum's Launch Pad or Cardiff's Techniquest sought to enable visitors to discover for themselves, through physical interaction with hands-on exhibits, the techniques of scientific discovery or the fixed principles underlying natural science (Bradburne 1998).

As McManus points out, many large institutions contain the remnants of all these different stages: the cluttered, object-rich gallery, the hagiographic celebration of industry's achievements, and the hyperactive atmosphere of bottom-up scientific activity will all be familiar to anyone who has

visited – for example – the Smithsonian Institution or the Deutsches Technikmuseum in Berlin. Features of all of these can and have been critiqued – that, for example, they are overly celebratory, or that they take science out of its social context (Pedretti 2002). Perhaps more pertinent to the discussion here, however, is the argument that none of these forms are suitable for presenting contemporary science and technology. If – as I will suggest in the next section – our understanding and experience of technoscience has changed dramatically over the last decades, how should museum science also change in order to adapt?

The risk society in the museum

Taking a Foucauldian approach to museum studies, Bennett has written extensively on the work that different kinds of "exhibitionary complexes" perform (1995; 1997; 2004; 2005). He argues, for example, that the gradual focus on evolution within nineteenth century museums can be understood as part of a broader programme promoting liberal agendas: evolutionary narratives "functioned as progressive technologies aiming to produce new historical subjects with new and carefully regulated developmental capacities" (1997: 185). Museums are, in other words, not innocent spaces. They are in flux with the societies that surround them, both being shaped and shaping them. They perform particular functions and are used in particular ways. This being the case, what can we – in the context of science in museums – say about the structural changes that have occurred within much of the

global north over the past decades?

While a number of authors have discussed these changes in detail – perhaps most significantly Ulrich Beck (1992), in his thesis of a move towards a risk society in which the distribution of risk becomes more important than access to material goods – they have also become a key part of everyday experience. We live in the age of Chernobyl and the cold fusion controversy, of genetic engineering and the MMR vaccine. If science museums have, in the past and in various different ways, attempted to present the "facts" of science to lay audiences, in recent years these facts have started to appear neither stable nor straightforward (Wynne 1992). There is a widespread sense that technoscience is becoming a somewhat different beast to that which it appeared to be in the past (Nowotny et al 2001).

This is perhaps particularly obvious in the UK and in Europe, where there is an increasingly ingrained sense of cynicism towards – not science as such – but those who control and guide it (Gaskell et al 2006). While trust in scientists remains high (People Science and Policy 2008), research has found that lay publics, citing previous negative experiences of the governance and guidance of science such as BSE-vCJD and various accidents around nuclear power, are cautious about the ways that new technologies may be integrated into society. (As Brian Wynne [2006] has pointed out, such caution is an entirely reasonable response to patterns of false reassurance and over-confidence which have marked government handling of a number of public scientific controversies.) Recent

qualitative research on public perceptions of nanotechnology
– viewed by governments and industry as a key emerging
technology with the potential to re-shape society (Roco
and Bainbridge 2003) – has, for example, indicated that lay
people tend to respond to discussion of the technology with
concerns about the secrecy of its development, its seemingly
unstoppable progress, and the questionable motivations of
those driving it forward (Davies et al 2009a). Increasingly,
governments and public institutions are attempting to take
such concerns into account at early stages of technological
development by acknowledging that technologies such as
nano have ethical, legal and social implications (ELSI).

The contemporary context of science in museums, then,
is one in which science must be seen as contested, uncertain,
and – particularly in the context of emerging technologies –
very much still up for grabs. If scientific development ever
was straightforwardly objective (see Cooter and Pumfrey
1994) – something about which it is not possible to have an
opinion – then that is certainly not the case now. Hence,
of course, museum exhibits such as the *Energy Ring* where
you can express your opinion on topics from whether it is
worthwhile trying to conserve energy to what, should energy
have a colour, it would be.

Public perceptions of and interactions with scientific
information, then, have become increasing complex over the
last decades, and science museums are quite rightly starting to
respond to this (see Chittenden et al 2004). But it is important
not to over-simplify this move. How able are exhibition spaces

– as a genre or form – to deal with controversial and contested science?

At least some research suggests that exhibition and gallery spaces can be deeply problematic contexts for this kind of science. However well-intentioned exhibition developers are, museums are spaces which are read by visitors as didactic and fixed (Rennie and Williams 2002). In display, the fluidity of science in the making is often lost, and too often the facts of science are presented in a way that ignores their inescapable social context. Even the development of more interactive exhibits continues to present challenges for the presentation of science in which facts are disputed, experts unclear, and ethics more pressing than technologies.

As an example of these challenges we might return to London's Science Museum and to the detailed ethnographic work which Sharon Macdonald performed on the development of its (now defunct) *Food for Thought* gallery (see Macdonald and Silverstone 1992; Macdonald 2002). The gallery was seen, from its earliest stages, as a venue for incorporating controversial science into museum content: it was self-consciously viewed as being populist and as a break from more traditional forms of display by the project team involved in its development. A food poisoning controversy broke during the gallery's planning stages, and this was duly seen as an important debate which should be covered within it. However, as Macdonald charts, the representation of controversy was hampered from the beginning by the constraints of gallery design and of the institutional line that was expected to be taken. Even

the team's populist aims of being clear and accessible tended to negate the presentation of conflict and disagreement – as Macdonald notes, giving an accurate picture of the scientific uncertainties at stake often does not lend itself to readily comprehensible gallery text. She and Roger Silverstone conclude that: *The representation of scientific controversy in museum exhibitions is not simply a matter of putting controversy on show, nor does it necessarily involve following the techniques used by other media. Our argument is not that the representation of scientific controversy is impossible but that there are certain features of the museum exhibition medium, and the institutional and organizational imperatives in which it operates, which make the representation of ongoing controversy problematic.... In particular, the long construction period of a major exhibition, and even more its long lifetime, are disincentives to the display of controversy.* (Macdonald and Silverstone 1992: 85)

Macdonald and Silverstone are careful not to say that incorporating controversy into museum galleries is impossible *per se* – merely that their analysis suggests that it is very difficult. And, indeed, a number of both practitioners and analysts have charted attempts to create exhibitions which highlight the contested status of science (and other academic knowledge forms) – attempts which have had varying degrees of success (Chittenden et al 2004; Delicado 2009; Einsiedel and Einsiedel 2004; Gieryn 1996; Kohn 1995; Pedretti 2002). It seems possible, from these discussions, that experimenting with new forms of the science exhibition – such as those inspired by art installations, or those that move away from

the museum space altogether – may aid in the presentation
of uncertainty and debate (Horst and Michael forthcoming).
Yaneva and colleagues, for example, suggest that large scale
installations enable the simultaneous representation of many,
conflicting, voices and give visitors some understanding of the
multiplicity of perspectives within controversies (Yaneva et
al 2009). While such experimentation may offer fruitful ways
forward, I want to suggest that another avenue for museums
in grappling with the presentation of contemporary science
is to move beyond the exhibition or gallery space altogether.
In the next section I discuss how exhibition developers
might learn from the recent turn throughout the UK, Europe
and North America towards public participation or public
engagement with science.

Beyond the exhibition: dialogue in museums
Understanding the new mood for dialogue which has –
ostensibly, at least – reigned within science communication
and science policy over the last decade in the UK and Europe
requires some historical context. A well defined narrative (see
Gregory and Lock 2008; Kearnes et al 2006) tells of the rise of
interest in public understanding of science (PUS) throughout
the 1980s; the critique of assumptions (such as a deficient
public and the coherence of science) embedded within PUS
activities by critical authors such as Brian Wynne, Mike
Michael and Alan Irwin in the 1990s; and the gradual taking on
board of these criticisms by policy and science communicators
in the 2000s, leading to a more dialogue-focused approach

to PUS. (In this telling, the story is a peculiarly British one, triggered by fears about brain drains and an anti-science public and set about with UK specific controversies such as BSE and Foot and Mouth Disease; many of its key elements, however, can be found in both the US and in Europe – although often in a slightly different terminological guise. The notion of scientific literacy, for example, is more common in the US than PUS.) In the UK these trends were crystallised in the 2000 Science and Society Report (House of Lords 2000), which – in its overt commitment to dialogic approaches rather than one way communication – had the effect of initiating a shift in PUS activities and organisations towards the language of public participation and dialogue. That is to say, organisations with no remit other than to promote science – such as the (former) British Association for the Advancement of Science, the Royal Society, or individual universities or science departments – started to make use of notions such as participation, engagement and science and society.

There is no shortage of literature on this move (for example, see Council for Science and Technology 2005; Jackson et al 2005; Parliamentary Office of Science and Technology 2001; 2006; Wilsdon and Willis 2004). For better or worse, there is also no single definition of what the turn towards dialogue and public engagement means (though the UK's National Coordinating Centre for Public Engagement is even now attempting to find a consensus answer to this).[1] Miller sees it as a way of combining expert and lay knowledges: new knowledge is generated "by a dialogue in which, while

SARAH R DAVIES · 163

scientists may have scientific facts at their disposal, the members of the public concerned have local knowledge and an understanding of, and personal concern in, the problems to be solved," (Miller 2001: 117). The UK's Parliamentary Office of Science and Technology sees dialogue as a way for MPs to be informed of "the issues of day" by bringing people together "in small groups to deliberate on national or local issues, and so provide considered and informed contributions from many perspectives" (Parliamentary Office of Science and Technology 2001: 1). Another contribution suggests that that dialogue is "a context in which society (including scientists) can address the issues that are arising from new developments in science ... dialogue is an open exchange and sharing of knowledge, ideas, values, attitudes and beliefs" (Jackson et al 2005: 350).

Several authors have, however, pointed out an internal conflict within much of this discussion (Davies 2009; Irwin 2006; Wynne 2006). While the need to democratise science, and to incorporate into it lay knowledge and perspectives, is frequently emphasised, there is often also a further purpose – concealed to greater or lesser degrees – of straightforwardly promoting science. The Third Report, for example, views the "new mood for dialogue" as triggered by a "crisis in trust" in science, and, within the report, public engagement ultimately has the aim of increasing the chance that policy "decisions will find acceptance" (House of Lords 2000: 7). These aims – democratisation and the promotion of science – may not, of course, always sit happily together. As Alan Irwin has noted (2006), such reports contain an uneasy juxtaposition of what

might be called old and new talk about science governance.

At least some of these tensions can be found at the junction between this latter history – of public engagement with science – and that traced earlier, of (new and controversial) science in museums. While some have argued that museums are an ideal venue for the new forms of public debate that contemporary science, with its potentially world-changing impacts and systemic uncertainties, requires (Bell 2008; Durant 1994), there has also been a degree of soul searching around the exact relationship between democracy, public debate, and museum spaces (Davies et al 2009b; Lehr et al 2007; McCallie et al 2007; Rennie and Stocklmayer 2003). (In a recent paper, for example, my co-authors and I unpick the framing of dialogue events in museums, acknowledging critiques of them as solely focusing on the transmission of scientific facts to lay publics while suggesting that they can be viewed as sites of symmetrical learning and empowerment – see Davies et al 2009b). In this essay, however, I want to focus on museum dialogue as one possible next step for the representation of controversial science in the museum – one that goes outside the exhibition or gallery, with all the baggage that entails, to create a new kind of space which cannot but emphasise the complexity, and multiplicity, of science in the risk society.

In doing this it is useful to return to McManus's (1994) generational breakdown of the development of science museums. McManus stops at the third generation: science centres and related institutional forms which emphasise ideas rather than objects. Lehr and co-authors (2007), however,

after noting that even third generation museums do not offer scope for critically evaluating or questioning scientific knowledge, suggest that we are now seeing the emergence of a fourth generation – one which may enable us to reshape "our understanding of the role of informal science institutions in society" (p.1480). Fourth generation informal science institutions would involve a move to the active contestation of ideas; to spaces that would effectively display, and allow the collaborative interrogation of, multiple perspectives on controversy and on science in the making. Live, dialogic spaces would thus avoid the challenges of controversial science that Macdonald and others have described: becoming overly didactic through reliance on authoritative text panels; enshrining fluid debates in long term exhibitions; limiting the number of voices represented; allowing no genuine interaction with the ideas under debate.

What do, and could, these spaces look like in practice? As part of their appeal is their fluidity, I do not want to define too closely how dialogue in museums should be structured. There are also a number of published accounts of existing processes, in a number of different sites and under a number of different nomenclatures (see Bell 2008; Davis 2004; McCallie et al 2007; Reich et al 2006). I will, however, give one example of how discussion of science beyond the exhibition can be structured by returning once again to the institution I am most familiar with: the Science Museum, London, and in particular its off-shoot the Dana Centre.

The Dana Centre is part of the UK's National Museum of

Science and Industry (NMSI) and is housed in a purpose-built building on the same site as the Science Museum, in South Kensington. It opened in November 2003 in a substantial building: several of its floors are devoted to office space but it also includes an event space (d.café) on the lower ground floor, an internet lounge and gallery overlooking the event space, and a studio and meeting room (d.studio and d.study). The event space doubles up as a café-bar, and during the day is open for this purpose. Dana Centre events are held in the evening, and maintain the café's informal atmosphere, including a seating layout around café tables rather than as in a theatre or lecture. While the Centre uses a number of different event formats, one common one which has spread to other venues is the panel debate. My field notes (from research at the Dana Centre between 2005 and 2007) indicate that such events can be understood as having a number of different stages (see Davies 2009 for further details):

Introductions: Often initially of a facilitator, who then takes the floor to introduce the event format, the subject matter and a panel of between two and four invited speakers.

Voting: Dana events usually have an initial voting phase (using an electronic voting system operated by participants using handheld boxes), in which visitors are asked to give their opinions on a number of different questions related to the topic of the event.

Speaking: Invited experts – generally including one or more scientists, but which may also include social scientists, authors, or representatives of special interest groups – take

the floor for between five and fifteen minutes each in order to talk on the topic of the event.

Questioning/commenting and answering/responding: This period is generally the longest of the event, lasting around an hour in total (including a break of around ten minutes). The floor is opened for visitors to ask questions, make comments, and debate with the speakers and each other.

Last words: In some events, speakers are given the floor at the end to give what are termed parting or last words.

Voting: Further votes may then be carried out, and the results compared with those from the earlier vote (giving a sense of whether those present have changed their views at all).

Finishing: Finally, the facilitator concludes the event, often giving information on future Dana Centre events, thanking participants, and providing housekeeping information such as the time that the bar closes.

For those interested in further detail, webcast events are archived on the Centre's website.[2] The key point, however, is the time and space given to dialogue and debate. Not only are multiple perspectives on whatever topic is under discussion presented, through drawing together a panel involving different kinds of expertise and – often – different positions on the issue, but each of these perspectives can themselves be interrogated, developed and added to in the course of the event. Both panellists and other participants have an opportunity to do this, in a way that begins to break down traditional notions of expertise. Information (scientific or otherwise) may certainly be presented, but it is clearly connected to its

(partisan) source and can be viewed as contingent – just one view amongst several within a controversy.

The efficiency of moving beyond the exhibition space in dealing with new and controversial science (metaphorically, at least – a dialogue activity might be held in a variety of locations, including galleries) might best be seen by briefly comparing Dana Centre activities with the Science Museum's Energy Gallery's dialogue exhibit, the *Energy Ring*. As described earlier, this allows visitors to input their answers to a range of questions. These, however, cannot be shown live on the Ring's graphic display: they rather get sent for moderation and a select few are later put up on the Ring. While the Energy Ring is a beautiful and striking exhibit which allows visitors a degree of playful interaction, then, there is no sense of the negotiation or contestation, through live feedback, of different positions. Visitors can only respond to a set of predefined questions; they cannot bring their own issues for debate or reply to other visitors' comments. In contrast, dialogue events allow for a much more fluid negotiation of controversy and contested science. They highlight the transient nature of the science in question, and point to the now widely shared sense that new kinds of science require new kinds of public debate and involvement (Macnaghten et al 2005).

I have, in this essay, suggested that it is helpful to understand science in the exhibition as moving into a new stage. Our day to day experience of science is shifting, as technologies become both increasingly pervasive and undercut with radical uncertainties, and the presentation

of new, controversial and emerging science and technology needs to acknowledge this. But depicting science as contingent is often difficult in traditional gallery and exhibition spaces (Macdonald 2002). Even science centres and interactive exhibits tend to reinforce notions of science as static, solid, and expert – a view which is wildly divergent with the ways in which it is experienced in public and private life. I have therefore suggested that it may be helpful to draw on recent experiences around public engagement with science to see science in museums as moving into a fourth generation, in which live debate and dialogue become an important part of the representation of science in the making.

Whether as part of national, government-sponsored processes of consultation or as small-scale and local engagement activities (see Turney 2006), then, public dialogue on science can enable emerging and controversial science and technology to be presented within the museum while remaining contested, fluid, and uncertain. Although dialogue activities do continue to have limitations for participants and developers, I would suggest that they offer scope for experimentation and new and exciting ways for exhibition developers to present science to their audiences.

Notes

1. See www.publicengagement.ac.uk.

2. See www.danacentre.org.uk/events/webcasts.

Acknowledgement: Some of the research discussed in this essay was supported by an AHRC doctoral grant. I would also like to thank staff and participants at the Dana Centre for their support of the research and the help they gave, as well as Ellen McCallie, Elin Simonsson and Jane Lehr for many productive discussions on these topics.

References

Beck U. 1992. *Risk Society: Towards a New Modernity*. London: Sage.

Bell L. 2008. Engaging the Public in Technology Policy: A New Role for Science Museums. *Science Communication* 29 (3): 386-398.

Bennett T. 1995. *The Birth of the Museum: History, Theory, Politics*. London: Routledge.

-----. 1997. Regulated restlessness: museums, liberal government and the historical sciences. *Economy and Society* 26 (2): 161-190.

-----. 2004. *Pasts Beyond Memory: Evolution, Museums, Colonianism*. London: Routledge.

-----. 2005. Civic Laboratories. *Cultural Studies* 19 (5): 521-547.

Bradburne JM. 1998. Dinosaurs and white elephants: The science center in the twenty-first century. *Public Understanding of Science* 7 (3): 237-253.

Chittenden D, Farmelo G, Lewenstein BV (Eds.) 2004. *Creating Connections: Museums and the Public Understanding of Current Research*. Oxford: AltaMira Press.

Cooter R, and Pumfrey S. 1994. Seperate Spheres and Public Places: Reflections on the History of Science Poularization and Science in Popular Culture. *History of Science* 32 (3): 237-267.

Council for Science and Technology. 2005. *Policy through dialogue: informing policies based on science and technology*. London: Council for Science and Technology.

Davies Sarah, Macnaghten Phil, and Kearnes Matthew

(Eds.) 2009a. *Reconfiguring Responsibility: Lessons for Public Policy* (Part 1 of the report on Deepening Debate on Nanotechnology). Durham: Durham University.

Davies S, McCallie E, Simonsson E, Lehr JL, and Duensing S. 2009b. Discussing dialogue: perspectives on the value of science dialogue events that do not inform policy. *Public Understanding of Science* 18 (3): 338-353.

Davies SR. 2009. Doing Dialogue: Genre and Flexibility in Public Engagement with Science. *Science as Culture* 18 (4): 397-416.

Davis TH. 2004. Report: Engaging the Public with Science as it Happens – The Current Science and Technology Center at the Museum of Science, Boston. *Science Communication* 26 (1): 107-113.

Delicado A. 2009. Scientific controversies in museums: notes from a semi-peripheral country. *Public Understanding of Science* 18 (6): 759-767.

Driver R, Asoko H, Leach J, Mortimer E, and Scott P. 1994. Constructing Scientific Knowledge in the Classroom. *Educational Researcher* 23 (7): 5-12.

Durant J. 1994. The Science Museum and Public Understanding of Science. *Museum Development* (May 1994): 31-34.

Einseidel AA, and Einseidel EF. 2004. Museums as Agora: Diversifying Approaches to Engaging Publics in Research. In *Creating Connections: Museums and the Public Understanding of Current Research*, eds D Chittenden, G Farmelo and BV Lewenstein, 73-86. Oxford: AltaMira Press.

Gaskell G, Stares S, Allansdottir A, Allum N, Corchero C,

Fischler C, Hampel J, Jackson J, Kronberger N, Mejlgaard N, Revuelta G, Schreiner C, Torgersen H, and Wagner W. 2006. *Europeans and Biotechnology in 2005: Patterns and Trends*. European Commission.

Gieryn T. 1996. Policing STS: A Boundary-Work Souvenir from the Smithsonian Exhibition on "Science in American Life". *Science, Technology, & Human Values* 21 (1): 100-115.

Gregory J, and Lock SJ. 2008. The Evolution of 'Public Understanding of Science': Public Engagement as a Tool of Science Policy in the UK. *Sociology Compass* 2 (4): 1252-1265.

Hein H. 1998. *The Exploratorium: The Museum as Laboratory*. Washington and London: Smithsonian Insitution Press.

House of Lords. 2000. *Third Report: Science and Society*. London: The Stationery Office, Parliament.

Irwin A. 2006. The Politics of Talk: Coming to Terms with the 'New' Scientific Governance. *Social Studies of Science* 36 (2): 299-320.

Jackson R, Barbagallo F, and Haste H. 2005. Strengths of Public Dialogue on Science-related Issues. *Critical Review Of International Social And Political Philosophy* 8 (3): 349-358.

Jones J, 2009. 18th November. Science Museum: Close Your Climate Change Show. *The Guardian*.

Kearnes MB, Macnaghten P, and Wilsdon J. 2006. *Governing at the Nanoscale: People, policies and emerging technologies*. London: Demos.

Kohn RH. 1995. History and the Culture Wars: The Case of

the Smithsonian Institution's Enola Gay Exhibition. *The Journal of American History* 82 (3): 1036-1063.

Lehr JL, McCallie E, Davies SR, Caron BR, Gammon B, and Duensing S. 2007. The Role and Value of Dialogue Events as Sites of Informal Science Learning. *International Journal of Science Education* 29 (12): 1-21.

Macdonald, S. 2002. *Behind the scenes at the Science Museum.* Oxford: Berg.

Macdonald S, and Silverstone R. 1992. Science on display: The representation of scientific controversy in museum exhibitions. *Public Understanding of Science* 1 (1): 69-87.

Macnaghten P, Kearnes MB, and Wynne B. 2005. Nanotechnology, Governance, and Public Deliberation: What Role for the Social Sciences? *Science Communication* 27 (2): 268-291.

McCallie E, Simonsson E, Gammon B, Nilsson K, Lehr JL, and Davies SR. 2007. Learning to Generate Dialogue: Theory, Practice, and Evaluation. *Museums and Social Issues* 2 (2): 165-184.

McManus PM. 1992. Topics in Museums and Science Education. *Studies in Science Education* 20: 157-182.

Miller S. 2001. Public understanding of science at the crossroads. *Public Understanding of Science* 10 (1): 115-120.

Nowotny H, Scott P, and Gibbons M. 2001. *Re-Thinking Science: Knowledge and the Public in an Age of Uncertainty.* Oxford: Polity.

Parliamentary Office of Science and Technology. 2001. Open Channels: *Public Dialogue in Science and Technology.* London:

Parliamentary Office of Science and Technology.

-----. 2006. *Debating Science*. London: Parliamentary Office of Science and Technology.

Pedretti E. 2002. T. Kuhn Meets T. Rex: Critical Conversations and New Directions in Science Centres and Science Museums. *Studies in Science Education* 37 (1): 1-41.

People Science and Policy. 2008. *Public Attitudes to Science 2008*. Swindon: RCUK.

Reich C, Chin E, and Kunz E. 2006. Museums as Forum: Engaging Science Centre Visitors in Dialogues with Scientists and One Another. *Informal Learning Review* 79 (July-August): 1-8.

Rennie L, and Stocklmayer SM. 2003. The communication of science and technology: past, present and future agendas. *International Journal of Science Education* 25: 759-773.

Rennie LJ, and Williams GF. 2002. Science Centres and Scientific Literacy. *Science Education* 86: 706-726.

Mihail C. Roco and William Sims Bainbridge. 2003. *Converging Technologies for Improving Human Performance: Nanotechnology, Biotechnology, Information Technology and Cognitive Science*, London: Kluwer.

Science Museum. 2009. "More to work to be done to convince public of urgent need for climate change solution" says Science Museum Director." Available from http://www.sciencemuseum.org.uk/about_us/press_and_media/press_releases/2009/12/Prove%20It%20Announcement.aspx.

Turney J. (Ed.) 2006. *Engaging Science: Thoughts, deeds, analysis and action*. London: Wellcome Trust.

Wilsdon J, and Willis R. 2004. *See-through Science: Why public engagement needs to move upstream.* London: Demos.

Wynne B. 1992. Misunderstood misunderstanding: Social identities and public uptake of science. *Public Understanding of Science* 1 (3): 281-304.

-----. 2006. Public Engagement as a Means of Restoring Public Trust in Science – Hitting the Notes, but Missing the Music? *Community Genetics* 9 (3): 211-220.

Yaneva A, Rabesandratana TM, and Greiner B. 2009. Staging scientific controversies: a gallery test on science museums' interactivity. *Public Understanding of Science* 18 (1): 79-90.

Technologies of Representation: Representing Nanotechnology and Society

BRICE LAURENT

Centre de Sociologie de l'Innovation

Mines ParisTech

Museums produce representations: they are said to represent, and thereby contribute to solidifying citizenship, national pride or power relationships (Duncan, 1995; Haraway, 1984; Gable, 1996; Macdonald, 1996). Responding to the uncertainty and fluidity of social identities, they might also work on new ways of representation in order to challenge the position of visitors by moving them to the place of the represented other (Riegel, 1996), or include communities in the design of exhibits that directly concern them (Macdonald, 2003; Clifford, 1997). In any case, the exhibit builds a representation of the visitor, since it inscribes the public in its design (Macdonald and Silverstone, 1990), as do other technical artifacts (Akrich, 1992). This of course is potentially contested, and resisted by visitors (Macdonald, 1995).

Science is a complex issue for the representation performed by museums, for the representation to be displayed relies a great deal on a body of knowledge that is mastered by experts. Yet scientific controversies render problematic the representation of science as a straightforward description of natural phenomena that experts can provide, and forces one to think of new formats (Macdonald and Silverstone, 1992; Yaneva et al., 2009). An increasing number rely on interactivity, which may or may not stabilize the boundary between the visitor and an existing body of knowledge (Barry, 2001). In this essay, I am interested in the science exhibit as a place where various representations are to be produced. Considering nanotechnology as a case to study the roles and practices of the science exhibit, this paper

interrogates the channels through which the science exhibit represents both nanotechnology and the social. As Science and Technology Studies (STS) have shown, scientific and political representations can be analyzed symmetrically, by describing the chains through which scientific instruments (for the former) and political devices such as elections (for the latter) allow actors to act as spokespersons for both nature and society (Callon, 1986). In this perspective, representation is thus understood as the outcome of a process of articulation of different instruments, or *mediators* (Latour, 1995). The chain going from *nature* to the scientific results that represent it is made up of several mediators (such as samples, experimental results, or intermediary graphs) as is the chain going from *society* to its representatives (e.g. through the subset of workers enlisted in a union, and the elected representatives of the latter). One can describe these heterogeneous chains as *technologies of representation*. Following this methodological trend, this paper uses an empirical example in order to describe different ways of representing nanotechnology and society, different technologies of representation, that the science exhibit can use. Thereby, it explores the modalities through which the science exhibit might be an actor in current calls for public engagement in science and technology (Bell, 2008; Kurath and Giesler, 2009).

The nanotechnology exhibit
The exhibit I am interested in was produced by three French science centers: the Grenoble and Bordeaux Centres de Culture

Scientifique, Technique et Industrielle (Centers for Scientific, Technical and Industrial Culture, CCSTI), and the Paris Cité des Sciences et de l'Industrie. The Grenoble CCSTI led the project and was the first to host the exhibit, from September 2006 to February 2007. It was then displayed at the Cité des Sciences from March 2007 to September 2007, and in Bordeaux from August 2009 to January 2010. The exhibit was entitled *nanotechnologies: infiniment petit, maxi défi (Nanotechnology[1]: Infinitely Small, Big Challenge)* in Grenoble, *Expo nano* in Paris, and *Nanomondes (Nanoworlds)* in Grenoble. I will refer to it as the *nanotechnology exhibit* for the sake of clarity in this paper (although I will mention some differences between the three presentations of the exhibit).[2]

Nanotechnology as a scientific domain reveals some particularities, with additional significance for the people involved in the nanotechnology exhibit. First, the study of ethical, legal and social implications (ELSI) was a key component of nanotechnology programs from the start. For all its ambiguities[3], the emphasis on ELSI occurred in a state that was characterized by expectations about potential issues rather than scientific controversies. Second, the situation in France, and especially in Grenoble is particular. In Grenoble, nanotechnology is a program of local scientific and industrial development that follows a long tradition of local support for technological research (Laurent, forthcoming). And anti-nanotechnology activists have been vocal in criticizing nanotechnology development programs, both national and global, as undemocratic and mere *programs of control* of both

nature and society (Laurent, 2007). Social protests in the local Grenoble area are directed against global nanotechnology programs, including their accompanying ELSI activities, which are described by the anti-nanotechnology activists as ways to make people accept nanotechnology developments.

Therefore, the designers of the nanotechnology exhibit considered that what was to be represented was nanotechnology "public issues". For the staff of the science centers involved, some of these issues were economic (since nanotechnology is a challenge for local development), others social and political (questions are raised about how to take public decisions about technological development), and others ethical (dealing with privacy issues or the potential transformation of human nature)[4]. To the representation of these "nanotechnology issues" was added another objective: the exhibit was supposed to "open a debate and give voice to all stakeholders".[5] The last item seems less familiar for a science exhibit, yet it was a key focus for the nanotechnology exhibit designers. The Grenoble designers conceived the nanotechnology exhibit as a part of a series of debates. Public meetings about nanotechnology issues were organized in Grenoble as the exhibit was held (Laurent, 2008), and the Grenoble CCSTI was one of the organizers of them. In Paris, the presentation of the exhibit was accompanied by a two-day public event during which scientists and officials commented on nanotechnology-relataed contributions that had originated from public consultations and expert bodies over the previous two years. Indeed, the exhibit designers considered debate

necessary: *It is therefore by displaying and practicing debate that the visitor should grasp and contribute to the collective thinking on nanotechnology*[6].

The two dimensions of *displaying debate* and *practicing debate* were thus considered closely related to each other from the early stages of the project: the debate[7] was as much within, as it was around, the exhibit. The next sections go into the details of the exhibit and will explore the means by which the display and the practice of the debate were conducted. At this point, suffice it to say that for the exhibit designers, the display and practice of the debate implied that technical and social representations were to be produced. In particular, the preparatory stages of the exhibit suggested that it was necessary to represent, in some ways, the *imaginaries* that shaped the actors' understandings of the *nanoworld*.[8] That was felt necessary if the visitor was to participate in the collective thinking, in ways that were still uncertain at the early stages of the design of the exhibit, but which will be described in the remainder of this paper.

The nanotechnology exhibit consisted of four modules. *Step into the nanoworld* (*Entrez dans le nanomonde*) was designed as a way to explain the differences among physical scales. *Manipulating atoms* (*Manipuler les atomes*) focused on technologies of manipulation of matter at the nanoscale. *They're already there* (*Elles sont déjà parmi nous*) dealt with the current and potential applications of nanotechnology. *Does the future need us?* (*L'avenir a-t-il besoin de nous?*) quoted Bill Joy's now famous critical article – *The Future Doesn't Need Us* (Joy, 2000)

– and raised questions about the future of nanotechnology. The exhibit thus appears a much simpler design than other examples of science exhibits[9], as it seems to be based on a distinction between the facts of nanotechnology and possible values bearing on them. Yet the actual layout of the modules was not linear. They were conceived as independent of each other, and although the available space at the Grenoble center required the display of the modules in line, the other stagings of the exhibit avoided a linear progression between modules. At the Cité, there were two possible entries; in Bordeaux, visitors could enter the exhibit through each of the modules. More fundamentally, the seemingly clear distinction between scientific facts, industrial applications and social values does not account for what will be the focus of this paper, namely the multiplicity of technologies of representation of both nanotechnology and the social elements.

Displaying and practicing nanoscale manipulation
Early discussions on the design of the exhibit showed a concern for nanotechnology applications. The idea was to display "what nanotechnologies do rather than what they are" [10] in order to "involve the visitor" in the exhibit. The third module of the exhibit was indeed conceived as a display of many potential applications of nanotechnology, as well as examples of the natural occurrence of nanomaterials. The difference between what nanotechnology is and what nanotechnology does proved eventually rather artificial. For the physicists involved in the scientific committee, nanotechnology was above all a

Figure 1: The nano-manipulator

set of techniques aimed at manipulating matters at the atomic scale (i.e. nanoscale). Nanotechnology is based on instruments such as the scanning probe microscope, that allows individual atoms to be seen by displacing them. Acting at the nanoscale implies coping with physical forces that have different properties than at the macroscale. Therefore, representing what nanotechnology is was translated into representing how these forces apply. Interactive devices were thus used in modules 1 and 2 of the nanotechnology exhibit, some of them quite simple, others more sophisticated. Examples of the former included a boxing glove to be used by visitors to move lego-like colored objects. They could thus feel what it was like to manipulate matter while being hindered by physical constraints similar to

those which researchers faced when working at the nanoscale. A more sophisticated tool was a so-called *nano-manipulator* which consisted of a screen on which visitors could see the moves of a virtual scanning probe microscope, and a joystick they could use to move the microscope's tip and feel the resistance of the atoms thereby displaced – this resistance being quite different to that of macroscale objects because of quantum effects (Fig. 1). The nano-manipulator had been developed by scientific researchers interested in the control of instruments for use at the nanoscale.[11] For them such an instrument was to be used by technologists, and, as an educational object, by students and visitors, like those of the exhibit. They describe the interest of the instrument as follows: *The force feedback feeling given by our instrument appears much more relevant than the simple observation of an approach-retract curve, since the user can interact in real time with the surface, and thus perform a complex action: modulate the speed, stop the movement, approach or retract with a real time dynamic response, events which cannot be done without this specific architecture. (...) The introduction of a simulator between the manipulation instruments existing in user space and the manipulated nano-scene increases the online efficiency: the operator is able to interact with the virtual scene so as to study its properties and to rehearse the actions he plans to undertake, subsequently, on the real scene.* (Marlière et al., 2004 : 251)

For its designers, the nano-manipulator was supposed to enact a representation of nanotechnology that got into the actual manipulation of objects rather than a visual, photography-based device. More than a game-like and

somewhat childish activity, which can always be understood as "yet another object onto which celebratory high-tech fantasy can be projected" (Barry, 2001: 111), interactivity was the necessary condition to represent what nanotechnology objectivity is, namely about building, with constraints, trials and errors. The representation of nanotechnology that the nano-manipulator enacted meant both displaying nanotechnology as a research practice.[12]

The nano-manipulator was based primarily on touch, but other senses were mobilized as well: *Thus, a student is immerged in the nanoscene through a real-time modelling station equipped with a force feedback device and generating the visual and auditory scene in accordance to the dynamics of the phenomena. He/she is present in the interaction since he/she can act on the scene and perceives the nano-scale effects through the main sensorial channels: haptic, vision, audition.* (Marchi et al., 2005)

This was a major idea for the design of the exhibit: visitors should experience the nano-world through sensory channels. Elsewhere in the exhibit, visitors could listen to sounds and touch things. For instance, visitors entered the first module after passing a curtain made of white, rigid threads. Thereby, the exhibit was supposed to bring the visitor into the "nanoworld", and having him/her act on/within it. This argument was important for the Bordeaux organizers when they decided to add several large scientific pictures of nanoscale devices, that were displayed in the entrance corridor of the exhibit (Fig. 2). For them, it appeared necessary to add a spectacular visual dimension that

Figure 2: "Spectacular representation" of nanotechnology at the Bordeaux CCSTI. The picture represents a molecular carried by a "nano-vector".

was not sufficiently present in the interactive representation of nanotechnology.

The motivation for this addition was not that vision was in some ways a more exact representation of nanotechnology. Rather, the Bordeaux organizers felt it necessary to add another channel in the multiplicity of representations the exhibit was supposed to perform: *For us staging an exhibit means using all possible means, including art. Because our scientist friends didn't see that! [He refers to the picture above]. First, there's no color at this scale. Second, it's a mere reconstitution that represents what was worked upon by the scientist. And true, it brings something. One can say: "Wow, this is great". You're suddenly moved into a world, and then you can start understanding they're constructions*

Vous êtes un Détracteur !

Vous considérez l'usage des nouvelles technologies comme une soumission à la dictature d'une société hyper technicisée. Vous luttez contre cette société où les technologies, de plus en plus présentes dans votre quotidien, constituent, d'après vous, une menace supplémentaire pour l'être humain.

You are a Detractor!

You consider the use of new technologies as submission to the dictatorship of a society that is over-technical. You are combating this society in which technologies are increasingly pervasive in your daily life, because you see these technologies as constituting a further threat for human beings.

¿Es usted Detractor?

Considera usted el uso de las nuevas tecnologías como una sumisión a la dictadura de una sociedad hipertecnificada. Lucha usted contra esta sociedad en la que las tecnologías, cada vez más presentes en su día a día, constituyen, en su opinión, una amenaza adicional para el ser humano.

Figure 3: The "detractor" category, one of the possible results of the interactive questionnaire.

of atoms.[13]

Spectacular vision – as one could label this channel of representation – was one medium among others, and an important one since it could help the visitor be included in the nanoworld. In a later stage, he/she could intervene in it through devices such as the nano-manipulator, and others that enacted representations of the future.

Representing the future

The design team raised the question of the future early in the preparation of the exhibit, as nanotechnology was conceived as a domain which was still in the making. Eventually, the future was represented through a separation between "applications" (whether existing or potential) in the third module (*There're already among us*) and a module specifically devoted to the future (*Does the future need us?*). Several industrial applications of nanotechnology (such as electronic chips and high performance ceramics) were displayed in the third module, alongside natural nanotechnology (such as lotus leaves that do not absorb water because of their nanoscale structure). Applications could then be used as an entry point to make visitors think about the future they envisioned.

Social scientists were involved in the design of an interactive questionnaire that was eventually presented as a part of module 3. The objective of this questionnaire was: *Not only to present the "nano-inside" applications, but also to present them in a context of use, so that the public can voice an opinion on*

Vous êtes un Fan !

Enthousiaste et admiratif des nouvelles technologies, toujours à jour dans vos mises à jour, victime de la mode High-tech, vous avez vite compris que, dans la société de l'information et de la communication, être branché, c'est être connecté !

You are a Fan!

An enthusiast and an admirer of new technologies, never slipping behind schedule in your updates, a victim of High-tech trends, you quickly understood that in the infor- mation and communication society, being «in» means being connected!

¿Es usted un Fan?

Entusiasta y admirador de las nue- vas tecnologías, siempre al día en sus actualizaciones, víctima de la moda High-tech, ha entendido rápi- damente que, en la sociedad de la información y de la comunicación, estar conectado es estar al loro.

Figure 4: The "fan" category, one of the possible results of the interactive questionnaire.

potential uses.[14]

The sociologists involved in the preparation of this part of the exhibit had defined a classification of technology users according to their relationships with technological innovation, especially ICT. Visitors were thus invited to answer a set of questions about their use of technology through an interactive screen[15]. They could then be told which category they belonged to: *detractor, humanist, utilitarian,* and *fan* (Fig. 4). Figure 3 is an example of the "detractor" category, to which the anti-nanotechnology activists supposedly belonged. The pipe smoking, José Bové-like character considers nanotechnology as *another threat to human beings.* As it represented nanotechnology through examples of possible applications, the interactive questionnaire thus displayed a representation of society, as shaped by social science through the study of people's relationship to technological innovation. Simultaneously, the interactive questionnaire also offered a way for the visitor to enter into debate: the visitor was expected to reflect on his own attitude to innovation.[17]

Other parts of the exhibit were devoted to the future. Module 4 displayed pictures representing *futurs antérieurs* (past futures), that is, literary and science fiction works, and myths about science (Fig. 5). In Grenoble, module 4 followed the other three and the question of futures was addressed after nanotechnology in scientific practice had been described. In Bordeaux, science fiction was seen as a possible entry point in itself, for it was considered a way for visitors to understand that nanotechnology had been present in

Figure 5: Science-fiction books and movies used to display myths about science.

their cultures, even before it became a scientific enterprise: *Nanotechnology culture is at first a visionary culture, even before a scientific one. Writers, film-makers... they did science-fiction before nanotechnology was done in the lab. Before the scanning probe microscope, there was the microscope of the imagination... And this is important because lots of visitors won't enter the exhibit through technologies, but through these cultural nanoworlds.*[18]

Consequently, additional showcases were used, in which science-fiction books were displayed and could be skimmed through. Here was another channel of representation: other spokepersons were mobilized (writers and film makers) in

Figure 6: Cartoon in module 4 used to display nanotechnology privacy issues.

order to display the future of nanotechnology.

To these past futures were added *possible futures* (*futurs conditionnels*). Here was the ELSI part of the exhibit, which described through cartoons the potential issues of nanotechnology. Figure 6 is the one used to display the risks to privacy that nanotechnology applications in electronics and data storage could raise. These issues were possible futures in that they were represented as a future to be acted upon, through the opinions of four people at the end of module 4. Two philosophers and two physicists discussed in video recordings the democratic control of nanotechnology, and its potential ethical and safety issues, by answering questions: *What are the potential risks of nanotechnology? What precautions should we take? What ethical issues does*

nanotechnology development raise? Are new relationships between
science and society implied by nanotechnology development?

These opinions were a means of presenting the
nanotechnology debate, as were guided tours, especially to
groups of students. Animators would explain what potential
scenarios nanotechnology could lead to. They would mention,
for instance, the storage of personal information using nano-
electronics, or the improvement of human nature (e.g. in order
to see in the infra-red spectrum) thanks to nano-medecine,
ask their audience what they thought of these, and explain
the potential problems and questions they raised. These
discussions, mostly led by graduate science students, took
place at various points during the visit to the exhibition.
They were the means by which museum staff could "make
sure that some issues (were) heard".[19] For instance, organizers
at Bordeaux could focus on the uncertainties surrounding
potential risks of nanoparticles for the environment and
human health, which they thought was not sufficiently made
explicit in the content of the exhibit. While they felt there was
no controversy about nanotechnology[20], the uncertainty about
health risks implied an active involvement on the part of the
museum to make issues heard and picked up by visitors.

Representations of and by the visitors
The visitor was not supposed to passively acknowledge the
representation of nanotechnology issues. Displaying and
practicing debate was encouraged by devices that aimed at
involving visitors more directly, inviting them to take sides.

For the Grenoble organizers, the exhibit was supposed to turn visitors into *questioning citizens*, possibly participating in one of the many public meetings that were held. Creating questioning citizens was not a simple process. Describing possible relationships to technology (as seen below) was a way to do so, which built on representations of the social. Other techniques were supposed to collect the opinions of visitors. Sheets of paper (*petits papiers*, the organizers called them) were provided at the end of the exhibit for visitors to leave written notes. Three entry points for comments were proposed:

- *Sum up in one sentence what you think now, you would say that nanotechnologies are...*
- *As you see it, the main reason for pursuing research and development of nanotechnologies is...*
- *In your opinion, the main danger of nanotechnologies is...*[21]

The exhibit thus included a device that aimed to represent the opinions of the visitor. Yet the sheets could not speak for themselves and answers needed to be re-elaborated. A team of sociologists[22] analyzed them in order to study "the ways in which visitors of this kind of exhibit are ready to take part in debates on social issues with scientific components, such as the future of nanotechnology research" (Ancel and Poli, 2008: 1). Therefore, their analysis was more than a study of the "opinions of the visitors of the exhibit" (Ancel and Poli, 2008: 1). It could be used as a tool to understand how and why people participate (or not) in "large public debates on

science/society issues". What one of the scholars responsible for the study of written notes identified was the following: *The tone was very serious, very few paradoxical modalities, (...) with references to real, concrete stuff in order to express one's opinion.*[23] An important issue was the fact that: "people responded to each other. At that point I said *this is like a debate.*" For her, the debate that was happening was: "in language and not in the content. Because the content is extremely binary: it's nice, not nice, I'm scared..."

Hence, the *discursive community* which was thus formed was what mattered most (more than the actual content of visitors' opinions): these little notes created the questioning citizens that were sought. By displaying the little white notes as part of module 4, the exhibit designers produced not only representations of visitors' opinions, but also – and for them, more importantly – a representation of the "debate" itself. The little white notes hanging on the walls physically showed the intervention of visitors, which was all the more convincing as social scientists explained in evaluation reports and professional documents (Ancel and Poli, 2008) that a "debating community" had actually been constituted.

A last device used to produce questioning citizens was a game, *PlayDecide*, adapted from a device called *democs* and developed by a think tank (the New Economic Foundation). Democs is conceived as a "new way to help people to talk about politics. It's a game-like process which gives players all the information and structure they need to share ideas on difficult ideas".[24] *PlayDecide* is an adaptation of democs that focuses on

technological issues and has been distributed through the web across Europe and some other countries. The Grenoble CCSTI was a member of a European project involving several European science centers, and as such was encouraged to use *PlayDecide* along with the other partners. *PlayDecide* was an integral part of the exhibit in Bordeaux, and a special module was added in which visitors were invited to use the game. It is based on a set of characters that are supposed to be played by the participants. Each of them receives a card describing the character s/he is supposed to embody. For instance, two of the cards read:

- *I am a transhumanist. I anticipate a convergence of genetic, stem cell, brain, cybernetic and nanotechnology research, which will open up permanent human genetic changes and much else. These would not only eliminate genetic diseases but also enable enhancements.*[25]

- *I'm an Anglican priest. I believe that a human life is a sacred life. I welcome the medical potential of nanotechnology, but I am disturbed by reports that it could be used to enhance human abilities or graft computer chips in the brain.*

Participants are then expected to defend the positions of their respective characters, while listening to the others. Using *PlayDecide* as part of the exhibit thus produced questioning citizens as visitors actively participated in the representation of both nanotechnology and society.[26] Here, the representation of nanotechnology issues – through typified characters supposed to embody potential attitudes about future nanotechnology developments – was the basis for visitors to play roles that represented social groups, which,

according to the designers of the game, needed to cooperate. Thereby, the whole setting could display the nanotechnology debate as much it was an opportunity to practice it.

Conclusion

A simple, three-step model seems to be the organizing principle of the exhibit: first, representing the facts at a distance, then various opinions, and eventually letting the visitor formulate his own. Yet the above descriptions show that representation is not so simple a process. The exhibit is not a passive intermediary in a chain that goes from nanotechnology to the public. In the example considered here, many representations of the public were used. Nanotechnology was represented by many different channels, which may require awe, intervention, reflection on potential issues, or role-play. Through these multiple technologies of representation of both nanotechnology and society, the nanotechnology debate was displayed as much as it was practiced, to the point where it makes little analytical sense to retain the separation between the two. When visitors acted in the nanoworld through the nano-manipulator, opinions of philosophers and scientists were shown, futuristic visions of potential issues were presented, comments about potential scenarios were made by tour guides, little white notes written by visitors were hung in module 4, and characters in *PlayDecide* were played by visitors, nanotechnology and the debate about it were both displayed and practiced. Representation thus appears as a complex task that enacts as much as it describes. Far from a stable, mirror-like process, representation is best understood as the mobilization of

a variety of mediating devices that connect material elements, scientific and social science knowledge, and visitors themselves. Thereby, the exhibit produced a representation of nanotechnology and society as a global set of technical activities, potential applications, issues for future public thinking, and forms of individual and collective engagement – a global representation of which the exhibit was itself part.

Nanotechnology is an interesting case study for scholars interested in the science exhibits, for several reasons. First, the current emphasis on interactivity and hands-on is, in the case of nanotechnology, more than a fad that transforms the science exhibit into a playground. Representing nanotechnology is representing technologies of intervention at the atomic scale, which implies intertwining the display of, and the intervention on, material objects. Second, nanotechnology was not considered as a controversy for the designers of the exhibit, in the sense that they did not identify vocal disagreements among scientists. Yet multiple concerns for ethical, legal and social implications needed to be taken into account, for they were part of nanotechnology policy programs. As a consequence, the nanotechnology exhibit was neither a case of public understanding of science nor an opportunity to display controversies. Representing nanotechnology was representing nanotechnology's futures, and thereby representing nanotechnology's issues as potential and still uncertain. The representation of these issues was connected to that of the nanotechnology debate, which supposed that these issues could be differently understood,

and were still open to discussion and future public decision. Third, the nanotechnology exhibit formed part of the current concern for public engagement in science and technology in general, and in nanotechnology in particular. The exhibit was part of a program of public meetings and consultations, which does not mean that the role of the exhibit as a public engagement site was clear. Students of public engagement in science and technology often evaluate mechanisms according to their impact on decision-making[27]. This example compels one to restrain from adopting this evaluating position in order to account for the multiple ways in which the science exhibit might be a representation of the social as well as a representation of science. Multiple ways for the exhibit to be a "public engagement" device may thereby be considered. As a social scientific instrument to study the public; as an inquiry into the expectations of people for future exhibits; as an opportunity to make visitors think about their personal opinions about nanotechnology; or as a role-playing device in which visitors are included, the exhibit does "public engagement". Yet one has to accept that the science exhibit might not fit into the "ladder model" of citizen engagement, in which engagement mechanisms are sorted according to their "impact" on decision-making processes (Arnstein, 1969). Nor is it necessarily a preparatory stage for people to participate in a later debate. Rather, a science exhibit such as the one studied here should be understood as a mechanism that contributes to the enactment of nanotechnology public issues by both "displaying and practicing" the debate about them.

Notes

1. In French, "nanotechnologies" (plural) is commonly used, whereas the singular is more frequent in English, which thus sets the focus on the overall nanotechnology science policy program rather than on several applications.

2. This chapter is based on interviews with science center staff members involved in the design of the exhibit and participants to the scientific committee of the exhibit. I also had access to the Grenoble CCSTI's archives. Interviews were conducted in French and archival materials are in French. The translations into English are mine.

3. Calls for ELSI studies have been said to be based on "folk theories" (e.g. supposing that the public follows a "wow to yuck" curve in its acceptance of technology) (Rip, 2006), while the commissioning of social scientists by policymakers is characterized by ambiguities and contradictions (MacNaghten et al., 2005).

4. Interview with the director of Grenoble CCSTI (May 7th, 2009).

5. Project presentation, internal document, June 19th, 2006.

6. Nanotechnologies: grands enjeux pour l'infiniment petit: exposition itinérante, internal document, Grenoble CCSTI.

7. In French, "débat" has a less confrontational tone than its English counterpart. I keep the word "debate" in this paper, but readers should keep in mind than it can refer to exchanges that do not necessarily confront two opposed arguments.

8. The exhibit designers had commissioned a report to two sociologists, who identified various "worlds" that defined understandings of nanotechnology, and carried specific images (Le Quéau and Combes, 2006).

9. For instance, Yaneva at al. explain that the display of science in the museum might involve reshaping the museum's space in order to stage science in the making, with its difficulties, pitfalls, shortcomings and controversies (Yaneva

et al., 2009).

10. Quotes in this paragraph are from internal preparatory documents of the exhibit.

11. A researcher who was a member of the team that had developed the nano-manipulator was a member of the scientific committee of the exhibit.

12. Daston and Galison's analysis of the move from "representation" to "presentation" in the last, nanotechnology-focused, chapter of their book on objectivity directly echoes the type or representation of nanotechnology performed by the nano-manipulator (Daston and Galison, 2007).

13. Interview, Bordeaux CCSTI, December 17th, 2009

14. Meeting report, internal document, June 26th, 2006.

15. E.g. the following questions: Do you think ICT: A- Prevent true social relationships; B- Allow to participate in social networks; C- Are useful tools to increase the efficiency of social relationships; D- Are but possibilities among others to weave links with others.

17. The results of the questionnaire were then supposed to be studied by the team of people that had designed it. This was eventually not done.

18. Interview, Bordeaux CCSTI, December 17th, 2009.

19. Interview, Bordeaux CCSTI, December 17th, 2009.

20. There are indeed controversies related in nanotechnology, for instance about potential health risks of nanoparticles. To be fair, most of the discussions on the later topic were not visible at the time of the design of the nanotechnology exhibit.

21. The questions were translated into English in the exhibit. I kept the original formulation and did not modify the wording.

22. The social scientists who intervened in the design of the interactive questionnaire specialized in the study of technology users. The scholars who studied the written notes were linguist and sociologist.

23. *Interview with one of the author of the report, Grenoble, July, 17th, 2009. The following quotes in this paragraph are excerpts from the same interview.*

24. *http://www.neweconomics.org/projects/democs (accessed on December 30, 2009).*

25. *PlayDecide guidelines.*

26. *Eventually, the group is supposed to vote for or against four "policy positions", going from "rapid nanotechnology expansion, minimum regulation" to "no nanosciences unless specifically and publicly agreed" and might add a fifth one.*

27. *For an example about science centers, see Kurath and Giesler, 2009.*

References

Akrich M., 1992, The De-Scription of Technical Objects, in Bijker W., Law J. (eds.), *Shaping Technology/Building Society*, The MIT Press, Cambridge, MA: 205-224.

Ancel, Pascale and Marie-Sylvie Poli, 2008, Opinion publique et nanotechnologies, *La lettre de l'OCIM*, 118 : 4-12.

Arnstein, Sherry R., 1969, A ladder of citizen participation, *Journal of the American Planning Association*, vol. 35, n°4, pp. 216 – 224.

Barry, Andrew, 2001, *Political machines. Governing a technological society*, London and New York: Continuum.

Bell, Larry, 2008, Engaging the Public in Technology Policy: A New Role for Science Museums, *Science Communication*, 29(3): 386-398.

Callon, Michel, 1986, Some elements of a sociology of translation: domestication of the scallops and the fishermen of St Brieuc Bay, Law, J (ed.), *Power, action and belief: a new sociology of knowledge?* London, Routledge : 196-223.

Clifford, J., 1997, *Museums as Contact Zones in Routes: Travel and Translation in the Late Twentieth Century*, 186-219, Harvard: Harvard University Press

Daston, Lorraine and Peter Galison, 2007, *Objectivity*, New York, Zone Books.

Duncan, Carol, 1995, *Civilizing Rituals: Inside Public Art Museums*, London: Routledge

Gable, Eric, 1996, *Maintaining boundaries, or 'mainstreaming' black history in a white museum*, in Macdonald and Fyfe

(eds.): 177-202.

Haraway, Donna, 1984, Teddy Bear Patriarchy: Taxidermy in the Garden of Eden, New York City, 1908-1936, *Social Text*, 11: 20-64.

Joy, Bill, Why the future doesn't need us?, *Wired*, August 4th, 2000.

Kurath, Monika and P Giesler, 2009, Informing, involving or engaging? Science communication, in the ages of atom-, bio- and nanotechnology, *Public Understanding of Science*, 18(5): 559-573.

Latour, Bruno and Peter Weibel, 2002, *Iconoclash. Beyond the image wars in science, religion and arts*, Cambridge, MIT Press.

Latour, Bruno and Peter Weibel, 2004, *Making things public. Atmospheres of Democracy*, Cambridge, MIT Press.

Latour, Bruno, 1995, The 'Pedofil' of Boa Vista: a photo-philosophical montage, *Common Knowledge* 4, 144–187.

Laurent, Brice, 2007, Diverging convergences, *Innovation: the European journal of Social Sciences*, 20(4): 343-58.

Laurent, Brice, 2008, *Engaging the public in nanotechnology? Three models of public engagement*, CSI Working Paper N°11.

Laurent, Brice, forthcoming, Grenoble, in Guston, David (ed.), *Encyclopedia of Nanoscience and Society*, London, Sage.

Le Quéau, Pierre and Clément Combes, 2006, *Images du Nanomonde*, Report for the Grenoble CCSTI, CSRPC/ Université Pierre Mendès France.

Macdonald, Sharon and Roger Silverstone, 1990, Rewriting

the museums' fictions: Taxonomies, stories and readers, *Cultural Studies*, 4(2): 176-191.

Macdonald, Sharon and Roger Silverstone, 1992, Science on display: the representation of scientific controversy in museum exhibitions, *Public Understanding of Science*, 1 : 169-87.

Macdonald, Sharon, 1995, Consuming science: public knowledge and the dispersed politics of reception among museum visitors, *Media, culture & society*, 17(1) : 13-29

Macdonald, Sharon (ed.), 1996, *The Politics of Display*, London, Routledge.

Macdonald, Sharon, 2003, Museums, national, postnational and transcultural identities, *Museum and Society*, 1 (1): 1-16.

Macdonald, Sharon, and Gordon Fyfe (eds.), 1996, *Theorizing Museums*, Oxford, Blackwell.

MacNaghten, P., M. Kearnes et B. Wynne, 2005, Nanotechnology Governance and Public Deliberation : what Role for the Social Sciences, *Science Communication*, 27(2) : 268-291.

Marchi, Florence and al., 2005, *Educational tool for nanophysics using multisensory rendering*, First Joint Eurohaptics Conference and Symposium on Haptic Interfaces for Virtual Environment and Teleoperator Systems, March 18-20, 2005: 473 – 476.

Marliere, Sylvain, Daniela Urma1, Jean-Loup Florens, and Florence Marchi, 2004, Multi-sensorial interaction with a nano-scale phenomenon: the force curve, *Proceedings of*

EuroHaptics, Munich Germany, June 5-7, 2004

Riegel, Henrietta, 1996, *Into the heart of irony: ethnographic exhibitions and the politics of difference*, in Macdonald and Fyfe (eds.): 83-104.

Rip, A, 2006, Folk theories of nanotechnologists, *Science as Culture*, 15(4) : 349 – 365

Yaneva, Albena, Tania Mara Rabesandratana and Birgit Greiner, 2009, Staging scientific controversies: a gallery test on science museums' interactivity, *Public Understanding of Science*, 18(1) :79–90

The Museum as 21st Century Bestiary

DENISA KERA

National University of Singapore

Contemporary art and exhibition practices increasingly reflect upon the emergent forms of life and matter created in the bio and nanotech laboratories. They translate scientific protocols into art manifests (Symbiotica, Marta de Menezes, Eduardo Kac, Adam Zaretsky, etc.), philosophical tractates (Donna Haraway, Hannah Louise Landecker, Nikolas Rose, Aihwa Ong, Catherine Waldby, etc.) and experiments with new institutional models of presentation and production. They articulate how these new forms of life and matter enter and transform our culture, society and politics. They raise and express the expectations and fears that resemble in many ways the Medieval Bestiaries and their treatment of monsters and wonder.

Artists and curators working with biotechnologies and nanotechnologies simply deal with the new forms of monsters and wonder that is created by present science and technology. Semi-living tissues, immortal cell lines, custom-made bacteria, artificial DNA, viral quasispecies, various transgenic, chimeric, synthetic and copyrighted organisms, all challenge our anthropocentric presumptions about life, evolution and nature. The artworks dealing with these emergent sciences make us realize how our normative and aesthetic ideals are culturally and socially bound to certain assumptions on what is alive, human and part of the organic life on this planet. The art–science reflections and translations thereby transform the gallery space into something of a "post-biological" arena, a place in which the organic and the non-organic, the natural and the constructed, the human and the

non-human, physis and techné, mix, play and blend.

The museum as a post-biological arena in which we play different organisms one against another is also a moral and aesthetic space, a 21st century bestiary which expands the ambiguities of a society and politics immersed in science and technology. The ambiguities are already present in many of the concepts we use to describe our present situation in terms of technological society, information society, network society, post-industrial society, service society, globalized society, transnational empires etc. What are these hybrid, technological, social and political concepts trying to name and whose interests do they serve?

The museum is becoming a place where such questions are posed by artists and curators and where we are testing the different relations to the newly discovered biotech and nanotech entities. When artists create sculptures from tissues, do performances with DNA, make installations from biotopes and use media displays made from bacteria, they are testing the limits and possible connections between what is given by tradition and society and what is made in the laboratory. Do such artworks provoke us to change our views on what is a society today or force us to re-evaluate the meaning of science and technology that destabilize our sense of security, order and values? How to reconcile the challenges of every new discovery and innovation with the demands placed on us by the principle of justice, ideals of a good life, aesthetic judgment on beauty and various values? How to balance scientific facts discovered in laboratories with the norms,

values and rules defined by our institutions and traditions? These are just some of the questions that summarize the twin response of artistic practices to the emergent sciences.

Biopolitical fears and post-human fantasies

On one side, artists are trying to formulate a conservative response that is close to the philosophy of biopolitics, questioning the effects that technology and sciences have upon our individual and collective lives. On the other side, their artistic practices are close to what we can call a "portraiture of a passing species" that represents our post-biological and post-human future and redefines what society and politics mean today. The bestiary for the 21st century is connecting both approaches and agendas; it is a biopolitical freakshow and at the same time a portrait that mirrors the changing perspectives on what it means to be human.

From the biopolitical perspective (Michel Foucault, Giorgio Agamben, Francis Fukuyama, Roberto Esposito) we are facing the end of history and the depolitisation of human societies by technology and science which reduce politics to the management of biological life. Such management lacks any historico-political or aesthetic and moral aspirations and leads to a dangerous homogenization. Attention is given to what Giorgio Agamben calls the "last, post-historical and apolitical mandate" which is physical fitness and reduction to physiology: "Genome, global economy, and humanitarian ideology are the three united faces of this process in which post-historical humanity seems to take his own physiology

as its last, impolitical mandate" (Agamben 2004, 77).

The post-biological and post-human perspective (Bruno Latour, Donna Haraway, Deleuze & Guattari) criticizes this narrow view of what is politics and history and questions the whole dichotomy between the social, the human and the natural on one side, and the technological, the non-human on the other. The clear distinction between what is material and semiotic, biological and political is unattainable in a world where we are witnessing assemblages and networks between both and where organisms could be viewed as communities, forms of "symbiogenesis" (Lynn Margulis), co-evolution and mutualism and as a form of "sociable life" (Myra J. Hird).

While the bestiary for the 21st century is trying to connect moral lessons to some new monsters or to produce a portrait of a "passing species" by rethinking possible post-human futures, both strategies create a strong impact on the public. Contemporary art involving biotechnologies and nanotechnologies is an arena and a space in which we confront our deepest fears and fantasies related to otherness and agency behind what is human. It is a space of the "uncanny", where life is at its most vital expression because it faces paradoxes, death and the other (inorganic) life as described by one of the first curators and supporters of these artistic practices, Melentie Pandilovski, who as the director of the Australian based Experimental Art Foundation organized numerous events on the theme: *Bioart poses a micro/macro, life/death relation that travels in waves of matter moving. The force of bioart is an ethics of affect that functions through the micro-physics of power*

to effect strange new ways of becoming life. It calls into question the operations of indeterminacy at play in the constitution of the human. The human is forced to acknowledge its properly contingent existence as a macro construction that is formed in translation from the micro. The human is thereby encouraged to give up its claim to superior status and engage in an ethical relation with its surround. Like art, biotechnologies also affect new relationships between matter and life, human and non-human. Bioart must function in rhythm with these techniques in order to pose a critical counterpoint to their operations. (Pandilovski 2008).

In a similar fashion to which the Medieval Bestiaries describe and define our relation to the unknown, to the transgressive and the monstrous, various contemporary art projects and philosophical essays are dealing with the issue of the "uncanny". In both cases we are searching for a new model of the common world where strange new entities are discovered and invented. These probes into the emergent forms of global collectives and hybrid identities of the biotech and nanotech age do not serve any teleology or ideal. They simply bring forward the dynamic and heterogeneous agency of the material world and the "new relationships between matter and life" (Pandilovski 2008). They make us realize that the world outside is not a passive *hyle* (substance) which we can shape according to our will but it has the attributes of the Nietzschean "abyss that looks back at us" which is one of the first, dramatic formulations of the importance of non-human agency and the "uncanny" in the last century.

Post-human and post-biological condition

The post-human and the post-biological condition replaces the aesthetics and moral values of beauty, integrity and unity with expressiveness and hybridity. Our world becomes a stage and an arena in which we do not strive for perfection but for constant change and for new types of connections and networks between the different entities and actors that appear. While science protocols and experiments may bring more lasting networks between different actors, artistic performances and philosophical theses create often new and unimaginable combinations to help us grasp alternative futures. They help us face the challenges of the biotech and nanotech age and the new forms of symbioses between the organic and the inorganic worlds, between technology and society.

For many centuries, only philosophers dared to work on these limits of our thinking and matter, to investigate the ultimate nature of our being and our world and to seek what constitutes reality. By the end of the 20th century metaphysical questions are not only back but they are increasing in number and urgency with disciplines such as theoretical physics, astrophysics, biotechnology and nanotechnology. Not only are the limits of our thinking and matter still at stake but also the limits of what we consider human and even organic life are becoming more burdensome. All these questions are transgressing into experiments with science and technology. The metaphysical pursuit today involves not only human minds but also machines and different instruments. Since

the 17th century the instruments of science and technology, different protocols and machines, have taken on the traditional roles of the philosophers, reflecting on the limits and notions of life, community, reality, meaning and truth.

The explorations of the limits and border zones between the human and its other (non-human, non-organic life) are examined in one of the most important exhibitions on biotechnology and art in recent years. *Sk-interfaces. Exploding Borders in Art, Technology and Society* (Liverpool, FACT in 2008 and Casino Luxembourg in 2009) uses the metaphor of skin to explore the limits and interactions between us and some form of alterity. Jens Hauser, who curated the exhibition, reflects his long term involvement with this type of art as a research of these limits: *sk-interfaces explores what was once believed to be the limit of our bodies and identities, the external boundaries, but which are currently being perceived as more and more unstable. Launching FACT's 2008 Human Futures programme, sk-interfaces emphasizes the growing importance of the liminal state of 'inbetween-ness' which we encounter in the age of technological extensions and bio- and nano-political changes, even beyond the consequences of the digital age. Its focus is on the process of becoming, rather than on snapshots of what we think that we are. Materially and metaphorically, artists explore trans-species relationships, xenotransplantation, telepresence and permeable architecture. The exhibition presents 'victimless', tissue cultured miniature leather garments or designer replacement hymens, video-, interactive- or haptic installations.* (Sweeney 2008)

We live at a time when different particle accelerators,

colliders, supercomputers and grids investigate the limits of our physical microworld and test our limits of processing data and understanding reality. These are the true metaphysicians of our time, simulating conditions almost unthinkable by human minds and constructing theories and experimenting with the frontiers of matter. We live at a time when different models of computer networks from WWW to P2P networks and different forms of distributed and cloud computing create not only new businesses and economies but new legal issues, new social dynamics, new regulatory bodies, institutions and a whole new politics. We live at a time when biotechnology creates hybrids and hard-to-define forms of life which turn our world into a post-biological arena and almost a circus. Museums are simply becoming these liminal spaces, these skins through which we experience the various forms of limits and "inbetween-ness" that Jen Hauser is trying to define. In them we are testing and trying to define the cultural, social and political perspectives on our biotech and nanotech future.

The task of categorizing these new types of entities, phenomena and beings and defining their rights and relations to the rest of the planet and the universe is what we are doing as curators but also as viewers of biotechnological and nanotechnological art in the public experiments presented in museums. Museums are simply what Jens Hauser describes as incubators: *in which the technologies of our age make new aesthetics and models of self-understanding breed and hatch... But we should not see sk-interfaces as a 'sci-art' exhibition. Its aim is not to illustrate knowledge or scientific methods but to subvert them*

to primarily non-utilitarian ends, in order to make us think about
how our technologies and media have taken over the role of our skins
through which we relate to the world. (Sweeney, 2008)

The bestiary as a search for normative ideals for messmates
The bestiary for the 21st century that is created by the various
nanotech and biotech exhibitions across the world is simply
questioning the central role of humans and the normative
ideals based on humanism. Are science and technology still
signs of human dignity, greatness and intelligence or do they
mark our decline and end? How to resist the anthropocentric
bias implied in these questions? Should we try to define
something of a post-human condition in the age of science and
technology which includes not only humans but also our new
"worldmates" or as Donna Haraway calls them "messmates"?
How to connect or divide political and social issues of justice
from biological issues of evolution and technological issues of
innovation? How are the natural processes of evolution, the
social processes of globalization and the general processes of
negentropy in the universe linked?

By trying to formulate the new normative ideals, we are
also formulating new questions about our common future.
Biotech and nanotech art are the ideal probes into these new
forms of interactions and networks between society, nature
and technology. The emergent and hybrid effects of these
misalliances force us to constantly reconsider and adapt our
views of society, evolution and nature but also of philosophy
and art. The only thing that remains constant in these

processes is the critique of anthropocentrism. We are simply witnessing systems and ecologies which are as complex as society or nature and which we cannot label either as human constructions nor as natural facts. To appreciate these complex and hybrid networks we need new normative concepts which will surpass the limitations of anthropocentrism. Since we cannot know in advance what is the form of this newly formed "us", we can only experiment (Latour 2004).

The post-human condition is not a state or some definitive equilibrium but only a constant experiment and search for new forms of networks between emerging entities in our universe. The simple rule is to accept all entities and actors as partners rather then labeling them as monsters and enemies or even slaves: no hierarchy and no divisions, only an endless play of networks and new collectives which include more and more foreigners, parasites and other hard to define actors. The universe does not start nor does it end with humans. In this "cosmopolitical" (Latour 2004) universe we cannot have a universal law and goal but only processual and tactical decision making that changes in every concrete situation. The normative ideal of this cosmopolitical and post-human order is a processual one. The goal is not to act according to the maxim of one's agency which can become a universal law for the agency of that kind. The cosmopolitical ideal is to act so that every situation remains a unique and unrepeatable chance for new decisions and negotiations between new and different agencies and actors.

Mutations between museums and laboratories

Museums and exhibitions working with bio- and nanotechnologies are sites for such cosmopolitical negotiations and experiments with our future. They are places where the public engages with emergent and hybrid science and tests the limits of imagination. We describe them as a post-biological arena and bestiary to explain our struggles to define and form relations with emergent entities and to imagine our common future. Such spaces bring emergent science and technology to our everyday life and they have the power to create a personal experience as Marta de Menezes, a well known artist working at the intersection between art and biology, summarizes: *Bioart is like science fiction, a great way to think about important social, philosophical, political, ethical, aesthetical, biological, artistic... issues that we face ourselves everyday at a more personal level as well as a more general level. I think of it that it is a way of doing science fiction in the visual arts, which coincidentally makes the fiction part closer to reality than we would expect! And for me this is the major clue about bioart, it is how far can you go in the line between fantasy and reality through fiction.* (Skype interview with the artist, January 15, 2010).

Marta de Menezes is also a founder of Ectopia, an experimental laboratory and artist residency housed at the Instituto Gulbenkian de Ciência in Oeiras, Portugal, that represents the important trend in bioart and nanoart practices which create new forms of institutions. Under the Ectopia program, the Institute's scientists collaborate with participating artists not only in the presentation of bioart

in museum and gallery spaces but in the actual creation and production of new works. Spaces such as Ectopia or The Arts and Genomics Center at the University of Leiden and the artistic laboratory and Centre of Excellence in Biological Arts – SymbioticA at the University of Western Australia are probing new types of relations between research, art, public display and involvement in the sciences. These hybrid forms of institutions are similar to the hybrid forms of life we are witnessing in the science laboratories in terms of their ability to create new networks and assemblages, whole new ecologies of actors.

This is well summarized on the main page of SymbioticA www.symbiotica.uwa.edu.au: *SymbioticA is an artistic laboratory dedicated to the research, learning, critique and hands-on engagement with the life sciences. With a strong emphasis on experiential practice, SymbioticA facilitates a thriving program of residencies, research, academic courses (undergraduate and postgraduate), exhibitions, symposiums, and workshops. Researchers and students from all disciplines work on individual projects or in interdisciplinary teams to explore the shifting relations and perceptions of life. As a research centre within the School of Anatomy and Human Biology at The University of Western Australia, SymbioticA enables direct and visceral engagement with scientific techniques. Crossing the disciplines of art and the life sciences, SymbioticA encourages better understanding and articulation of cultural ideas around scientific knowledge and informed critique of the ethical and cultural issues of life manipulation.*

From the Academy of Sciences to Academy of Games

Public fantasies and fears, scientific facts, aesthetic values and social norms all meet and merge in these new types of institutions and interactions between exhibition, research and artistic creation. Spaces based at the universities such as SymbioticA and Ectopia or independent institutions such as ANAT (Australian Network for Art and Technology) revive original ideas about the interaction between science, technology and the public envisioned way before the first museums and professional scientific institutions in Europe by G. W. Leibniz. In his famous *Odd Thought Concerning a New Sort of Exhibition (or rather, an Academy of Sciences; September, 1675)* Leibniz ceases to discuss the advancement of sciences and technology in terms of metaphysical and philosophical issues of truth, limits of human mind and reality. Progress in sciences and technology is discussed in a modern and even cynical way as a phenomenon defined by money, intensity of attention and level of public support related to the wonder that science and technology can attract. Science and technology are linked to society and they are defined by their ability to generate new ecologies of interest and influence, new institutions, networks and relations between different actors. They are connected to business, art, entertainment, tourism, and simply everything that can raise human curiosity and wonder. Inspired by the 16th and 17th century Cabinets of Curiosities (*Kunstkammer, Wunderkammer*) and the emerging museums and collections of natural and artificial rarities (*rerum naturalium, curiosa*) Leibniz is envisioning revolutionize and accelerate science

and technology by linking it both to the general public and political and economic elites of his time.

"Academy of Sciences" and even "Assembly of Academies of Sciences" that will exhibit new inventions to fundraise money from the general public, rich aristocrats and the court to support innovations by presenting the technological progress in different countries. "Academy of games and pleasures" modelled as a casino that will engage and trick the naïve public into gambling and indulging in complex games and mechanical toys designed by the scientist. A place to present technological wonders with various functions from entertainment to state surveillance. "Theater of Nature and Art" connecting performances, opera, scientific experiments, exhibitions of mechanical toys and new media, exotic plants and animal species. "General clearing house for inventions" using various business models to strike a balance between investment and profit in science and technology and involving investors and different stakeholders. "Museum of everything that could be imagined", "Museums of rarities", menagerie, observatory, anatomical theater... these are just some of the expressions, descriptions and examples that Leibniz uses to discuss a proposal for the diffusion of scientific knowledge and for strategies to promote and support innovation in the 17th century (Wiener 1940).

Leibniz's "academy" points to something between a business incubator, technological park, science museum, performance space and even a tourist attraction. This "odd thought" (*drôle de pensée*) on a "new sort of exhibition" (*nouvelle*

sorte de representations) is almost a prophetic vision of the type of public engagement and hybrid organization which we are witnessing today. Spaces such as Ars Electronica in Linz, ZKM in Karlsruhe, FACT in Liverpool, Laboral in Gijón, numerous smaller centers around the world (Le Cube in Issy-les-Moulineaux, CIANT in Prague, MediaLab Madrid, RIXC Media Space in Riga, Art & Technology centre – Eyebeam in New York) but also festivals (Transmediale in Berlin, Pixelache in Helsinki, TransGenesis in Prague) as well as novel forms of public performances (TEDx conferences) and alternative incubators (Hackerspace, The HUB) all represent this move to the hybridity of forms, functions, interests and goals that define the type of spaces in which science, business, art and technology meet. These spaces not only present novel research in science and technology or new business models and ideas but they literally perform the uncanny ability of science and technology to bring together new actors and create new heterogeneous networks between them.

Institutional mutations in the age of curiosity
The hybrid potential of science and technology to create new networks and hard to define types of institutions is well represented by the famous centers such as Ars Electronica in Linz with its museum of the future closely connected to the annual festival but also incubator (Futurelab) or FACT in Liverpool (Foundation for Art and Creative Technology) that incorporates exhibitions, education and research projects, runs its own cinema, shop and even consultancy, training

and multimedia services. Another space that is connecting art, business and museum functions is Laboral, an "Industrial Creation Centre", a hybrid institution that is part of the economic revitalization of a whole region in Spain (Asturia) involving the public but also the political and economic elites of the region and the research capabilities of the local universities. The famous ZKM (Zentrum für Kunst und Medientechnologie) in Karlsruhe also connects the various educational, research and museum functions.

Even more interesting in this respect are the small-scale types of institutions and events that fulfil Leibniz's vision. Alternative forms of incubators, open community labs and high tech kibbutzes that are self-funded and organized by the researchers and entrepreneurs themselves like Hackerspace (http://hackerspaces.org/) , The Hub (http://www.the-hub.net/), NextFab studio (http://nextfabstudio.com/) demonstrate well Leibniz's early thoughts on self-supporting and autonomous "clearing houses for inventions". After brainstorming the various functions of his Academy, Leibniz is very pragmatic about the type of business model for such future and science and technology oriented institutions: *The use of this enterprise to the public as well as to the individual would be greater than might be imagined. As to the public, it would open people's eyes, stimulate inventions, present beautiful sights, instruct people with an endless number of useful or ingenious novelties. All those who produce a new invention or ingenious design might come and find a medium for getting their inventions known, and obtain some profit from that. It would be a general clearing house for all*

inventions, and would become a museum of everything that could
be imagined. (Wiener 1940, 239). He is even anticipating the
membership-fee model which is common in these alternative
incubators and studio places "preferably different rooms
like palace shops in the same house where private parties
having rented the rooms, would show the rarities" (Wiener
1940, 236). In a margin note he adds a definition of what we
call incubators nowadays: "Having a fund, there would be
a perpetual income from interest and from other sources,
such as the formation of companies for new manufactures"
(Wiener 1940, 236). Leibniz believed it is good to bring people
from different backgrounds together and connect them, so
the people that are good in "defraying expenses" will work
with people that could "constantly invent new things" which
is exactly the model under which these new spaces operate.

What is intriguing about this model of science and
technology involvement with business, art and the general
public, is the importance that Leibniz ascribes to its temporal
aspects, to the events and performances that take place in
such spaces. The vivid descriptions of the silly and purely
entertaining event such as the "Ballets of horses. Races round
a ring and Turkish head.... Power of a mirror to kindle a fire..."
(Wiener 1940, 237) are coupled with more serious ones that
remind us of today's TEDx conferences which Leibniz would
describe as "comedies of the styles, debates of each country,
a Hindu comedy, a Turkish, a Persian, etc. Comedies of the
trades, one for each trade, which would show their skills,
peculiarities, jokes, master-pieces, special and ridiculous

styles. In other comedies, Italian and French clowns who would perform their buffooneries" (Wiener 1940, 238) or in another place as "Amusing and colloquial disputes" (Wiener 1940, 237). TEDs(x) conferences – science performances that fuel the interest and investment in science and technology – share the same values that Leibniz expressed: a global and complex ecology of interests and connections across society. The academy and the museum in Leibniz's understanding is basically like his monads, an expression of a new type of ontology of networks or fractals. These institutions and monads represent, mirror and interact with the whole in every part so that the "smallest particle of matter is a world of creatures, living beings, animals, entelechies, souls (more monads)" and "a garden and a pond of gardens and ponds" (Wiener 1940, 66).

Summary

From nano- and bioart exhibitions, to annual new media festivals, various museums of the future and alternative incubators, we are witnessing similar mutations of traditional institutions and practices dealing with art and science. The involvement with emergent sciences and technological inventions transcends business, art and research. The functions of such spaces vary from the more obvious like popularization and presentation to the more professional like investment in innovation, to the more creative functions and experiments envisioning our common future. The goal seems similar to some early ideas and visions of science, technology

and art interactions. Their main function is to foster and accelerate the ability of science and technology to serve very different purposes and connect actors in new networks and ecologies. While the Medieval Bestiaries and cabinets of curiosities served an age of wonder that believed in miracles and God's interventions, we are entering an age of curiosity that believes in hybridity and chance mutations. In these new types of institutions and practices, we dream together with Michel Foucault (1980) of a new age of curiosity: *Curiosity is a new vice that has been stigmatized in turn by Christianity, by philosophy, and even by a certain conception of science. Curiosity, futility. The word, however, pleases me. To me it suggests something altogether different: it evokes 'concern'; it evokes the care one takes for what exists and could exist; a readiness to find strange and singular what surrounds us; a certain relentlessness to break up our familiarities and to regard otherwise the same things; a fervor to grasp what is happening and what passes; a casualness in regard to the traditional hierarchies of the important and the essential.... I dream of a new age of curiosity. We have the technical means for it; the desire is there; the things to be known are infinite; the people who can employ themselves at this task exist. Why do we suffer? From too little: from channels that are too narrow, skimpy, quasi-monopolistic, insufficient. There is no point in adopting a protectionist attitude, to prevent 'bad' information from invading and suffocating the 'good'. Rather, we must multiply the paths and the possibilities of coming and goings.* The last sentence in this famous quote summarizes the 21st century bestiaries and alternative institutions. Their whole purpose is to "multiply

the paths and the possibilities of coming and goings"
(Foucault 1980), the possible networks and future scenarios.

References

Agamben, Giorgio. *Homo Sacer. Sovereign Power and Bare Life.* Meridian. Stanford, Calif.: Stanford University Press, 1998. Print.

Agamben, Giorgio. The Coming Community. *Theory out of Bounds V.* 1. Minneapolis: University of Minnesota Press, 1993. Print.

Agamben, Giorgio. *The Open : Man and Animal.* Meridian, Crossing Aesthetics. Stanford, Calif.: Stanford University Press, 2004. Print.

Bishop, Ryan, John Phillips, and Wei-Wei Yeo. *Beyond Description : Singapore Space Historicity.* The Architext Series. London ; New York: Routledge, 2004. Print.

Burns, Timothy. *After History? : Francis Fukuyama and His Critics.* Lanham, Md.: Rowman & Littlefield, 1994. Print.

Deleuze, Gilles, and Félix Guattari. *A Thousand Plateaus : Capitalism and Schizophrenia.* Minneapolis: University of Minnesota Press, 1987. Print.

Deleuze, Gilles, and Félix Guattari. *Anti-Oedipus : Capitalism and Schizophrenia.* New York: Viking Press, 1977. Print.

Dennett, and Daniel. "E Pluribus Unum? Commentary on Wilson & Sober: Group Selection." *Behavioral and Brain Sciences* 17.4 (1994): 617-18 pp. 2.07.2009 <http://ase.tufts.edu/cogstud/papers/wilsonso.htm>.

Esposito, Roberto. *Bíos : Biopolitics and Philosophy.* Posthumanities Series. Minneapolis: University of Minnesota Press, 2008. Print.

Esposito, Roberto. Communitas : *The Origin and Destiny of*

Community. Cultural Memory in the Present. Stanford, Calif.: Stanford University Press. Print.

Foucault, Michel. *The Masked Philosopher* (1980), http://www.stuartgeiger.com/ossdebate/index.php?title=Foucault%27s_Masked_Philosopher

Foucault, Michel, et al. *Society Must Be Defended : Lectures at the Collège De France, 1975-76.* 1st Picador pbk. ed. New York: Picador, 2003. Print.

Foucault, Michel, Paul Rabinow, and Nikolas S. Rose. *The Essential Foucault : Selections from Essential Works of Foucault, 1954-1984.* New York: New Press, 2003. Print.

Foucault, Michel, Michel Senellart, and Collège de France. *The Birth of Biopolitics : Lectures at the Collège De France, 1978-79.* Basingstoke [England] ; New York: Palgrave Macmillan, 2008. Print.

Foucault, Michel, Michel Senellart, and Arnold I. Davidson. *Security, Territory, Population : Lectures at the Collège De France, 1977-1978.* Houndmills, Basingstoke, Hampshire ; New York: Palgrave Macmillan, 2007. Print.

Fukuyama, Francis. *Our Posthuman Future : Consequences of the Biotechnology Revolution.* London: Profile Books, 2002. Print.

Fukuyama, Francis. *The End of History and the Last Man.* 1st Free Press trade pbk. ed. New York: Free Press ;, 2006. Print.

Gottweis, Herbert, Brian Salter, and Cathy Waldby. *The Global Politics of Human Embryonic Stem Cell Science : Regenerative Medicine in Transition.* Health, Technology, and Society. Basingstoke [England] ; New York: Palgrave Macmillan,

2009. Print.

Haraway, Donna Jeanne. *When Species Meet*. Posthumanities 3. Minneapolis: University of Minnesota Press, 2008. Print.

Hird, Myra. *The Origins of Sociable Life: Evolution After Science Studies*. Palgrave Macmillan, 2009. Print.

Kac, Eduardo. *Signs of Life : Bio Art and Beyond*. Leonardo. Cambridge, Mass.: MIT Press, 2007. Print.

Kac, Eduardo. *Telepresence & Bio Art : Networking Humans, Rabbits & Robots*. Studies in Literature and Science. Ann Arbor: University of Michigan Press, 2005. Print.

Kac, Eduardo, et al. Eduardo Kac : *Telepresence, Biotelematics, Transgenic Art*. Ed. no. 6. ed. [Maribor, Slovenia]: Association for Culture and Education, KIBLA Multimedia Center, 2000. Print.

Landecker, Hannah. *Culturing Life : How Cells Became Technologies*. Cambridge, Mass.: Harvard University Press, 2007. Print.

Langwith, Jacqueline. *Stem Cells*. Opposing Viewpoints Series. Detroit: Greenhaven Press, 2007. Print.

Latour, Bruno. *Politics of Nature : How to Bring the Sciences into Democracy*. Cambridge, Mass.: Harvard University Press, 2004. Print.

Latour, Bruno. *We Have Never Been Modern*. Cambridge, Mass.: Harvard University Press, 1993. Print.

Margulis, Lynn. *Gaia to Microcosm*. Dubuque, IA: Kendall/Hunt Pub., 1996. Print.

Margulis, Lynn, and Karlene V. Schwartz. *Five Kingdoms : An Illustrated Guide to the Phyla of Life on Earth*. San Francisco:

W.H. Freeman, 1982. Print.

Max-Planck-Institut für Wissenschaftsgeschichte. *Experimental Cultures : Configurations between Science, Art, and Technology, 1830-1950* : Conference, Berlin 7-9 December 2001. Preprint,. Berlin: Max-Planck-Institut für Wissenschaftsgeschichte, 2002. Print.

Ong, Aihwa. *Neoliberalism as Exception : Mutations in Citizenship and Sovereignty.* Durham [N.C.]: Duke University Press, 2006. Print.

Ong, Aihwa, and Stephen J. Collier. *Global Assemblages : Technology, Politics, and Ethics as Anthropological Problems.* Malden, MA: Blackwell Publishing, 2005. Print.

Ong, Aihwa, and Michael G. Peletz. *Bewitching Women, Pious Men : Gender and Body Politics in Southeast Asia.* Berkeley: University of California Press, 1995. Print.

Pandilovski, Melentie. *Journeys to the Other Side of the Navel : Art of the Biotech Era.* Experimental Art Foundation Press, 2008. Print.

Rose, Nikolas. *The Politics of Life Itself : Biomedicine, Power, and Subjectivity in the Twenty-First Century.* Princeton, NJ: Princeton University Press, 2006. Print.

Rose, Nikolas *Governing the Soul : The Shaping of the Private Self.* London ; New York: Routledge, 1990. Print.

Rose, Nikolas *Inventing Our Selves : Psychology, Power, and Personhood.* Cambridge Studies in the History of Psychology. Cambridge, England ; New York: Cambridge University Press, 1996. Print.

Rose, Nikolas *Powers of Freedom : Reframing Political Thought.*

Cambridge, United Kingdom ; New York, NY: Cambridge University Press, 1999. Print.

Shannon, Thomas A. *Genetics : Science, Ethics, and Public Policy : A Reader.* Readings in Bioethics. Lanham, Md.: Rowman & Littlefield Publishers, Inc., 2005. Print.

Sweeney, Gaynor E., *sk-interfaces and Jens Hauser: Interview and Review by Gaynor Evelyn Sweeney* (2008), http://www.artinliverpool.com/blog/2008/03/sk-interfaces-at-fact-review-and-interview/

Wiener, Philip P., "Leibniz's Project of a Public Exhibition of Scientific Inventions," *Journal of the History of Ideas*, Vol. 1, No. 2 (Apr., 1940), pp. 232-240, http://www.jstor.org/pss/2707335

Mark A. Hlatky et al., "Quality-of-Life and Depressive Symptoms in Postmenopausal Women after Receiving Hormone Therapy: Results from the Heart and Estrogen/Progestin Replacement Study (HERS) Trial," *Journal of the American Medical Association* 287, no. 5 (2002), http://jama.ama-assn.org/issues/v287n5/rfull/joc10108.html#aainfo.

Waldby, Cathy. *Aids and the Body Politic : Biomedicine and Sexual Difference.* Writing Corporealities. London ; New York: Routledge, 1996. Print.

Waldby, Cathy, and Robert Mitchell. *Tissue Economies : Blood, Organs, and Cell Lines in Late Capitalism.* Science and Cultural Theory. Durham [N.C.]: Duke University Press, 2006. Print.

ART & SCIENCE

Desiring Structures:
The Dendritic Form Revisited

MARIUS KWINT

University of Portsmouth

The possibility of an exhibition on dendritic, or branching, forms struck me in December 2003 as a momentary daydream during a long procedural meeting at the Department of History of Art at Oxford University. I was contemplating the satisfying form of a bare horse-chestnut tree outside our windows as it fanned up defiantly into the winter sky from the precincts of our less-than-picturesque 1970s office-block. Framed by the window and flattened almost into an image by the lustre of UV-proof film on the plate glass, the absorbing intricacy of its exposed structure instantly evoked the range of tree-like figures, many of them anatomical or cartographic, that I had encountered in much scientific imagery and its artistic derivatives over the years.[1]

Dendritic forms provide rich and informative figures of attention to many different disciplines. They are often supremely diagnostic, enabling scientists to make rapid taxonomic judgements about the various substances they inhabit, whether by allowing homologies to be deduced between the circulatory systems of different species, or by determining the distinct functions of neural dendrites in brain tissue. Dendritic forms are also open to the plastic work of the imagination, evoking all sorts of shapes and associations in their fractal structures, some of them conventional, some of them entirely idiosyncratic. The blasted tree has long served as an emblem of dread and desolation, whereas family-trees, trees of knowledge and trees of cosmic unity have helped to fabricate an impression of lineage, substance and natural order.

Surely this imagery was ripe for the curatorial and editorial picking, especially in a way that might profit from the multimedia and interdisciplinary licence of the exhibition format, and capitalize upon the ease with which one can electronically transmit and manipulate modern scientific images? The different contexts and materials would be united by a common form simple and recurrent enough to constitute a primary school collecting assignment, but which would also mobilise reports from the frontiers of scientific research, and incorporate great moments from the history of science, such as Leonardo da Vinci's anatomical drawings. Moreover, an exhibition dealing with fairly straightforward and consistent principles of form and structure might provide some relief from the media-savvy egotism that seemed to dominate much contemporary art.

Initially I thought that it might be a quality coffee-table book project, with prominent scientists and designers introducing appealing dendritic images pertaining to their expertise. In any case, I knew that it was a promising idea, and my neuroscientist partner agreed as we sketched it out that evening. When I mentioned it to the Head of Department, the distinguished historian of art and science, Martin Kemp, he paused for a moment and said thoughtfully, nodding: "There's a lot of mileage in that". In spite of my inattention in the Departmental meeting, he helpfully suggested some contacts, and I was soon busy buttonholing scientific colleagues and friends and asking them about significant dendrites in their fields. However, not until I mentioned it to a Swiss doctoral

student whom I was supervising, Barbara Bader, did the clock start ticking. She too liked the idea, had further suggestions, and sensed an opportunity to reprise links with her mother country. She smartly emailed the director of Zurich's Science et Cité and Brainfair festival of art and science, and learned that the city's Museum of Design (Museum für Gestaltung) was planning to contribute to the festival, and that they might consider such an organizing theme as mine. However, by the time negotiations got under way in earnest, there was only a year left before the planned opening on 30 April 2005.

Once the project was agreed, we scheduled a series of monthly meetings lasting a couple of days each, mainly in Zurich, but some in Oxford. It was all impossibly glamorous, if carbon-hungry, as I flew regularly across the snowy Alps and saw the seasons change in a beautiful European city. The process and dynamic that emerged was also instructive to me. My idea had at its conception been fairly fully formed. I had a lot of potential areas in mind, and my research questions had been: a) why is the dendrite such a recurrent form, both in nature and in culture? And b) what does it signify in these many different places? However, Janser was clear that, since this was a Museum of Design, we should be stressing artificial rather than natural processes; the science of the image rather than the nature it represented. Essentially, we were to advance a critique rather than a celebration or communication of scientific visual culture. This was an adjustment for me, but it gave the exhibition an achievable and appropriate focus. Janser proved an effective chief curator with formidable

Figure 1: Scanning electron micrograph of myxobacteria, coloured in the original publication according to disciplinary norms with orange 'buds', brown 'trunk' and blue 'sky'. (© Gesellschaft für Biotechnologische Forschung Braunschweig, Heinrich Lünsdorf)

intellectual versatility and integrity. I realized that it was one thing to be an academic in charge of an essentially discursive process, often with elastic research deadlines; it was quite another to be responsible for obtaining and displaying engaging objects that could feasibly be exhibited for more than four months.

We soon agreed that it was only through the abstraction and construction of images, for example brain cells prepared as microscope slides, that some phenomena become visible as dendrites. This process of selection and isolation would inevitably invoke some of the genres of visual culture, including pictorial conventions such as landscape painting

that are deeply embedded in popular sensibilities. We dwelt on how scientists make choices, not only in the conscious direction of their research, but also on how they would focus, colour, cut and finally select their pictures for publication (Fig. 1). We learned rapidly about many technologies of the scientific image, from confocal microscopes used for the mapping of neurons, to the creation of 'electron trees' caused by the break-down of plastic insulation under very high voltages.

As well as hoping to demystify what might be called the *technological sublime* mode of presenting scientific imagery in glossy and impressive ways to the public, Janser was keen to consider the more blatantly fictive aspects of the dendritic form. We trained our scepticism of the metaphorical power of the tree, and its persuasive role in shaping habitual thoughts about order, cause and effect; about the nature of growth and development; and about patterns of exchange and movement. The capacity of the tree to combine both evident complexity and lucid simplicity in one form lends it the power of verisimilitude: dendritic forms can look realistic and accommodating even when they are not. We also explored the use of the branching form as a design solution, such as the case of the now standard XTree file management system developed in the 1980s, whose late author is now largely forgotten after his company was assimilated into the Microsoft and Apple giants. My original proposal was to call the exhibition *Winter Tree* after its source of inspiration, but this apparently had misleadingly snowy and coniferous overtones in German,

Figure 2: Arthur R. von Hippel and Fred Merrill, Lichtenberg figure, c. 1948: high voltage electrode applied to photographic plate in pressurised gas, partly to hypothesise about conditions on other planets (courtesy of the von Hippel family)

so we eventually decided on *Einfach Komplex: Bildbäume und Baumbilder in der Wissenschaft*, best translated as *Simply complex: picturing the dendritic form in the sciences.*

Sustained by Bader's assiduous and often inspired research, and thanks to the prompt and generous responses of most of the scientists we consulted, candidate material was gathered and evaluated in terms of curiosity, aesthetic

impact, narrative interest, disciplinary and/or cultural importance, and practicality of exhibition. We could see from the outset that the dendritic form served to represent three main themes – order, growth and exchange – so these formed the three sections of the exhibition. We then subdivided these three themes more or less confidently into a few key chapters concentrating on scientific areas (including social sciences such as linguistics and history) in which the visualisation of dendritic forms had played a crucial role, or *vice versa*.

Chapters within the *Exchange* section included, for example, *Electricity* which explored the two-century old tradition of making Lichtenberg figures (Fig. 2) and electron trees; and *Neuroscience*, which examined the plotting of neuronal dendrites from the nineteenth century microscope drawings of Camillo Golgi and Santiago Ramón y Cajal to the latest Swiss 3D computer plotting and animation techniques (Fig. 3). Exhibits in the *Order* section included several art historical trees (Fig. 4) curated by Astrit Schmidt Burkhardt, whose extensive scholarship reveals the importance of genealogical diagrams to critics, historians and sometimes satirists of art. There were also several simple book diagrams illustrating decision theory, narrative structure and moral choice, from Roland Barthes among others. We had textbook linguistic schematisations from Noam Chomsky and, since Janser stressed the need to show the limitations as well as the possibilities of the dendritic form, we included Gilles Deleuze and Felix Guattari's critique of these notions in the deliberately non-hierarchical rhizome theory of the 1970s. One

Figure 3: Three-dimensional digital reconstruction of a neural dendrite. The shape of a neuron fairly directly expresses its function, so some neuroscientists seek the most total graphical representation possible (© Anne McKinney, Brain Research Institute, University of Zurich and Marius Messerli, Bitplane AG, Zurich, 2004)

of the most absorbing linguistic manifestations of the Order section was the work *Synonymes* (1994) by the British-based artist Pierre Bismuth, a large thesaurus-map of unexpected and quite poetic, but perfectly accurate, connections in meaning between very different kinds of word.

Our general interest in the working image was set against a cultural-historical background that considered some important mythological and artistic representations of trees. The star object here was an approximately four by two metre eighteenth century painted family tree of some notable Zurich gentry: at the other end of the scale, there was a tiny ancient Syrian cylinder seal borrowed from the Museum of

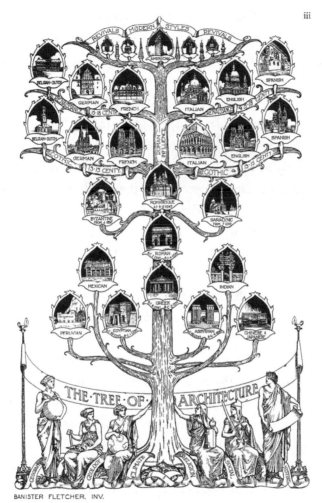

BANISTER FLETCHER, INV.

This Tree of Architecture shows the main growth or evolution of the various styles, but must be taken as suggestive only, for minor influences cannot be indicated on a diagram of this kind.

Figure 4: Frontispiece to Banister F. Fletcher (1866–1953): A History of Architecture on the Comparative Method: For Students, Craftsmen and Amateurs, 6th edn; 1921, London, B. T. Batsford. Note the European trunk and American apex (showing the Flatiron building in New York), and the 'dead-end' fate of certain oriental and exotic styles.

the Bible and Orient in Fribourg, and measuring only 2.3 by
1.2 centimetres, showing a tree representing the cosmos,
flanked by two deities. The range of more utilitarian exhibits
was interspersed with contemporary artistic 'commentaries'
on the dendritic form. In conceiving the show I had had in
mind the beautiful glass lungs *Capacity* (2000) (Fig. 5) blown
by Annie Cattrell, to which I had been introduced some years
previously by my colleague Martin Kemp, so I was glad to
secure her participation and loan of the work in question early
on. Kemp also introduced me to Andrew Carnie, who in 2002
had made what turned out to be one of the most popular
of our installations, *Magic Forest*, an elegant projection of
neural dendrites onto voiles in a darkened chamber which
was inspired by the drawings of Cajal, and which employs the
lulling sound of automatically-loading 35mm slide
projectors.

Our conversations proved rewarding byways of the project
that fed back into the objective: so too was my contact with
Carnie's main scientific collaborator, Richard Wingate at
King's College London, who commented that our discussions
prompted him to re-evaluate his doctoral research, in which
he spent three years internalising the shape of neuronal
dendrites by painstakingly drawing them. The year after
the exhibition, Wingate and I co-wrote an article for *Nature
Reviews: Neuroscience* on the history of the discovery and
representation of the brain cell.[2] The exhibition provided a
basis for interdisciplinary work that continues to this day.
In conversation with others too, including the materials

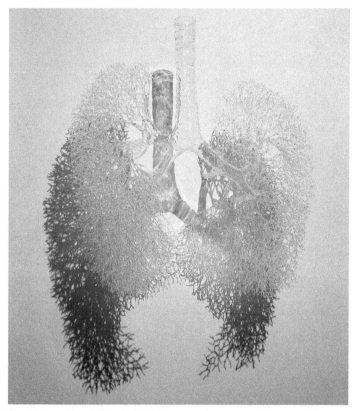

Figure 5: Annie Cattrell, *Capacity*, 2000, laboratory glass, approx. 40×40×20 centimetres: "Cattrell's beguilingly translucent remaking of the *tree* of the air passages in lungs, exploit[s] an instinctual sense of the rightness of size of the branches at each stage in the system," writes Martin Kemp.

scientist Richard Todd, I found that we were able to draw out common strands that conventional academic operations tended to ignore. The open visual basis of the exhibition gave one the liberty to research by looking as well as reading: previously unnoticed dendritic forms such as a patch of

Figure 6: Gerda Steiner and Jörg Lenzlinger, Mixed Woodland, 2005, installation of wood branches, toys, decorative and found objects, and crystallising salts with medical pump over inflatable paddling pool to catch the drips. (photo by Gerda Steiner and Jörg Lenzlinger)

coalescing condensation on a bathroom mirror, or the fern-like aggregations of paint on a child's potato print, were now phenomena to be investigated.

Thanks partly to the generous support of the Science et Cité fund and the Swiss National Lottery, and enjoying a thousand square metres of space in the Museum's main hall, Janser was able to coach several fresh and notable artistic commissions. These included *Mixed Woodland* (Fig. 6), a hanging assemblage of twigs decorated by filigree trinkets and natural curiosities slowly being colonised by pink salt crystals. This was an exuberant reworking of a familiar school chemistry experiment by the Swiss representatives at the 2003 Venice Biennale, Gerda Steiner and Jörg Lenzlinger.

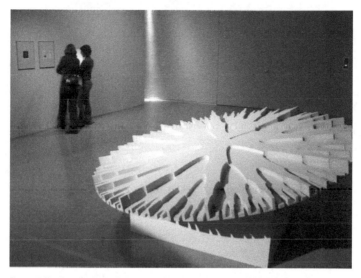

Figure 7: Urs Beat Roth, *Circle Structure*, 2005, industrially cut MDF sheets, with segments proportioned and branching according to the Fibonacci series of numbers (photo by Marius Kwint)

The Museum of Design had been established in 1933 as part of a late Bauhaus-style attempt to unite design reform with industry and education, and was attached to a school of art and design, the Hochschule fur Gestaltung und Kunst Zurich, and an Institute of Cultural Studies. The designer and mathematician U. B. Roth, who taught at the HGKZ, made *Circle Structure* (Fig. 7), an elegant disc of rhythmically branching shapes based upon the Fibonacci series. He later sent me a rather touching note and drawing, thanking me for the "great challenge" of a "wonderful" exhibition, and briefly explaining his method. The HGKZ also ran an artists-in-labs scheme, and two of its members were included in our exhibition. Thomas Isler built *Test Field*, a more conceptualist

critique of the media representation of science, featuring his video interviews of antagonists in the debate on genetic modification. These enactments of irrevocably divergent narratives were then displayed on monitors around isolation tents taken from a recently notorious GM crop trial near Zurich. Onto the inside of these were projected shadowy, dancing images of the controversial (and of course dendritic) crops in question. Reflecting the importance of bifurcating algorithms in creating digital worlds, Daniel Bisig's *Biosonics* machine was a green pool of artificial life-forms who responded to the visitors' presence and evolved their own sounds during the course of the exhibition.

In the exhibition publication (emphatically not an exhaustive catalogue) we attempted to focus the critical attention of our audience upon the visual plane by commissioning six brief expert case studies of significant moments in dendritic visualisation. They included Martin Kemp's reflection on the rules governing proportionate subdivision in fluid flows, sensed as a unified field by Leonardo da Vinci in his drawings of lungs as well as in his depictions of the canals and channels of the external world, and articulated in the eighteenth century by the Swiss mathematician Daniel Bernoulli. The historian of scientific photography, Kelley Wilder, wrote on the strangely organic-seeming Lichtenberg figures of the German émigré scientist Arthur von Hippel and his English collaborator Fred Merrill, produced at MIT in the 1940s by applying an electrode to a photographic plate in pressurised gas (Fig. 2). Nick Lambert,

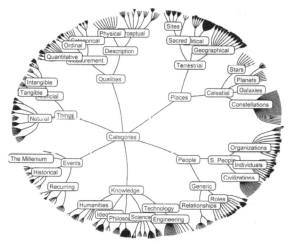

Figure 8: StarTree hyperbolic data-search interface: "[T]he clean separations of the tree exude algorithmic tractability while permitting a diversity of visual forms," writes coauthor Jeffrey Heer (© Jeffrey Heer and Stuart K. Card, Palo Alto Research Center Inc., 2004)

a historian of computer art, wrote on the simulation of diffusion-limited aggregation (DLA) and the importance of fractal geometry to digital graphics; and the computer interface designer Jeffrey Heer wrote on the StarTree fish-eye database navigation system (Fig. 8), which was inspired by the Dutch artist M. C. Escher's *Circle Limits*. There were also contributions by Richard Wingate and Astrit Schmidt-Burkhardt on their above-mentioned topics.

The interpretations of our book designer, Leander Eisenmann, the poster designer Martin Woodtli, the publisher Christina Reble, and the exhibition architects Alexandra Gübeli and Yves Milani, were also important for sharpening the critical aesthetics of the project. Each of them studiously avoided disguising the means of the exhibition's

production, giving the viewers some credit for judgement, and acknowledging the uprootings and prunings upon which all displays are predicated. True to its heritage, the Museum of Design was careful to induce an authoritative, studio-style approach to production, and to ensure that the decisions of all players formed a substantial part of the research outcome. The process was remarkably open and consultative. Having one's idea produced without any prior institutional links or substantial track record in curating was an astonishing opportunity, and a credit to the Museum.

These methods were to a large extent vindicated by the shortlisting of *Einfach Komplex* for the Prix Expo prize administered by the Swiss Academy of Sciences, and the later inclusion of Woodtli's poster and leaflet in R. Klanten et al's book *Data Flow: Visualizing Information in Graphic Design* (2008) which is proving popular with my graphic design students. The Museum was pleased with the overall result, too: the exhibition was well and prominently reviewed in the German-language and wider press, including *Kunstforum International* and *Nature*, and some 11,000 visitors came over the four months following its opening that glorious late spring day in 2005. Some of them also wrote appreciative comments in the guest book: "This is one of those rare exhibitions that is so well put together that it makes you want to jump in the air and shout for joy", wrote a visitor from Lonely Planet Publications. In spite of the difficulties of doing it on top of a normal teaching and the ambiguous status of an exhibition as a form of assessable academic research, it was indeed a golden moment.

My following essay was translated into German for the publication. It is a deliberately brief introduction to our visual purposes in the exhibition, without any attempt to explain the science of dendritic formation. I have, however, tried to pick up a common thread of meaning between the various poetic manifestations of the dendritic form in widespread visual culture – its frequent connotations of sensitivity and lyricism in film, in the press, in visual art – and its more technical and specialist significances within academia. What seemed to link these various manifestations was a generalised quality of *desire*: of wanting, transcendence and movement, of creating structure in the act of trying to escape it. This seemed to me to be the predicament of all substance, at least as apprehended through our subjective consciousnesses.

Modern science has opened up new and extraordinary ways of seeing the universe and of abstracting what is seen as theory, often supported by intriguing and elegant diagrams, notations and illustrations. From the molecular recesses of our bodies to the unimaginable leagues of deep space, rationalist, empiricist scientific understanding has offered up a vertiginous journey to the imagination, and much gratification to the eye. To some extent scientists have always operated on a strongly visual plane – one thinks of the famous anecdote of the German chemist Friedrich August Kekule (1829–96) dreaming of a snake swallowing its tail, inspiring him with the formula for benzene – but the advent of the computer and improved printing technologies have given them new powers to produce, manipulate and disseminate

their images.

The power of scientific imaging within the media has attracted the attention of art historians, artists and other lay commentators who have been emboldened with a post-modernist scepticism about disciplinary divisions. Much of the resulting art–science trend has, however, been largely celebratory. This is particularly true of the many spectacular pictures emanating from neuroscience, where some scientists and their journalistic collaborators allow all sorts of unwarranted hints to go out unchecked: that the images of neurons show the inner workings of the mind, rather than mere components of the nervous system; or that heavily conditioned maps of enhanced blood flow to regions of the brain derived from fMRI scanners penetrate our intentions in a God-like fashion.

Nevertheless, the convergence of disciplinary traditions does hold out the promise of a more critical understanding of the limitations of the kinds of images that have been deployed with great effect in the battle for public recognition and funding, as well as to convince professional peers. This includes the arts and humanities and their attempt to re-appropriate their erstwhile monopoly on compelling insights into the human condition. Each time a scientist puts pen to paper (or eye to lens, or hand to computer mouse), the graphic results do not take place in a vacuum where their logic and function remain pure, but become part of the traffic of visual culture, where words and images tug, infiltrate and collide with one another on the slippery surface of metaphor,

allusion and analogy. The creation of meaning has always been an untidy business, involving the conflation and cross-wiring of categories, and the necessary obscuring of present omissions along with past insights. In the mind of even the most rigorous viewer, cutting edge images cannot but operate amid streams of memory, tradition and association, some of them personal, some of them cultural, many of them derived from eras when science was not institutionalised and normalised as it is now, and was prefigured largely by what we now call religion and mythology.

Amid the many images produced by scientific endeavour, the branching, or dendritic form (Greek *dendron*, tree) arises with notable frequency. Not only, of course, is it the essential shape of most of the vegetation that (still) covers much of our planet, but with the help of spacecraft it can also be traced among sublimely vast gas and dust nebulae in space, marking the presence of liquid methane rivers and lakes on Saturn's moon Titan, and distinguishing the sprawl of human communications back on earth. Geologists ponder dendritically patterned fissures and sediments within the rocks that lie beneath our feet, while anatomists have shown that the nerves and capillaries of our bodies that enable us to sense all these phenomena are themselves dendritically formed. And branches also persist among the many diagrams that both natural and social scientists have drawn to propose causal links within the phenomena they discuss.

The sub-discipline of genealogy in particular has marshalled the figure of the tree. Spurious connections were

no obstacle to the graphic imaginations of sixteenth century scholars who spent many hours proving and illustrating beyond doubt that, for example, the Habsburg monarch who employed them was directly descended from the ancient Roman emperors. Traditions of genealogical conjecture and illustration assumed new dangers during the high tide of evolutionary theory of the nineteenth and early twentieth centuries. Naturalistic trees such as that which graced the frontispiece of Banister Fletcher's *A History of Architecture* (1905) (Fig. 4) implied the modern vigour of certain species or cultures associated with the trunk, and the barren or primitive nature of others indicated by the lower branches which terminate unproductively.

The tree-like form has made for an especially potent rhetorical device, partly because of its overtones of naturalness, but also because of the particular associations of trees with extensive world mythologies of perception, self-orientation and growth. Trees enjoy interplay with light and darkness, and their image has long been deployed at the threshold of what humans can see, and what they can only imagine. Perhaps the archetypal example is the tree of knowledge, from its dire portents of divine wrath in the Garden of Eden, to its more optimistic rendering, as a source of human betterment, in the Enlightenment's central publication, the *Encyclopédie* of 1751. In connecting the earth with the sky, trees seemed to offer a structure to the cosmos, as well as to balance stasis and change, and so the universe was depicted as a tree in ancient Syrian and Norse mythologies,

among others. The bifurcating form, often expressed as a tree of life as in Buddhist and medieval Christian examples, has also served neatly to express the predicament of humankind within that universe: having to make choices – to commit to a line – with imperfect knowledge and sometimes disastrously different outcomes. The tree was an important visual aid to the construction of morality. In general, trees have provided ready analogies to human subjectivity: standing alone, or in populations, varying in size and appearance, recognisably individual, and responding to seasons and circumstance, living, flourishing, dying, and reducing to a skeletal form.

Not only did the figure of the tree help shape ideas of a greater but intangible order, but obviously tree-like forms could also be found within the microcosm. Dendritic structures could be seen in diagrams of the tiniest snow crystals that Robert Hooke first based on microscopic observation in his *Micrographia* (1665). Perhaps most richly suggestive have been the detailed botanical analogies that might be drawn in the human body: in the successive branches of the cardiovascular systems that were anatomised most spectacularly during the Renaissance by Vesalius and Leonardo; in the optic nerves drawn by the Arab mathematician Ibn al-Haytham in the tenth and eleventh centuries; or the dendrites of individual brain cells that were first identified by the pioneering Spanish neuroanatomist Santiago Ramón y Cajal (1852–1934).

Many of these anatomists have since been recruited by the media to provide historical background to what might be called ontological imaging, in other words, a newly

Romantic vision of what man is. No longer need he be shown as the victim of storms, avalanches and shipwrecks in the melodramatic style of nineteenth century European painters: his fragility and precariousness can be witnessed from the inside. From the outside too, the human body might be likened to a tree, with a trunk, nodes, and arms. In Christian iconography, the sight of a man nailed to a cross, often transliterated as a tree, held a special power as the realisation of a divine symmetry. During the late twentieth century, mathematicians would devise a geometrical method for describing fractal shapes including lightning paths and river systems, and possessed the camera technology to zoom in or out and see that they exhibited self-similarity whatever the scale. Whatever the religious or physical origins of the order at hand, the persistence of different branching forms in nature has helped to deliver the understanding of form as variations upon a universal theme of natural law.

The dendritic form clearly provides, therefore, a versatile and robust mechanism, both within the natural world, and to our minds. Based on the simple principle of one becoming two or more, it can accommodate infinite complexity and variety, and do so visibly. Much of its scientific value is a result of its evident relationship between form and function: in neuroscience, the intervals between the various nodes and branches of a neural dendrite determine the ebb and flow of impulses, and therefore serve as a reliable index of its purpose and position in the overall nervous system. To the hydrologist, the pattern of rivers, streams and rivulets on a map gives an

Figure 9: Hydrology of central Switzerland, covering the area of a 1:75 000 scale map, but with a level of hydrological detail normal to Swisstopo's 1:25 000 maps (VECTOR25 © 2004 swisstopo (BA056922)), exhibited as part of a series showing that cartographers decide how many generations of branching to represent.

instantaneous picture of a river system's absorptive potential, the nature of the terrain and vegetation through which it runs, its actual location, and so on (Fig. 9).

All of this, however, depends on the capacity to abstract a discrete dendritic form from its context, which often consists of unfathomable interrelations with other dendrites. We compromise our understanding of the dendritic form in identifying it, because it is often the highest visible entity within a larger system, which is frequently described, in a similarly allusive and vague fashion, as a network. Principally, this job of abstraction is done by drawing: the scanning and plotting of a frequently delicate and sometimes moving structure onto an isometric surface, which can

involve a pleasurable affirmation of one's physical skills and tasteful sensitivity. Drawing is a task that presses the dendritic mechanisms within one's own body (retinal ganglia, motor neurons, fingers and touch receptors) to their limits. Photography could be considered a branch of drawing: today, it serves many of the same functions of rapid recording that drawing previously did, and in the 1840s the technique was also originally called the *Pencil of Nature*. Photographs and "photogenic drawings" of bare trees, decomposing leaves and other filamented objects such as feathers and lace served as early demonstrations of the astonishing capacities of the medium to capture complexity in an instant.

Computer visualisation techniques such as FilamentTracer (Fig. 3) are elaborations of this drawing process, albeit highly promising ones because of their increasing ability to store and manipulate large quantities of data and to reconstruct the phenomenon in four dimensions (the fourth being time) so as to render its development fully accessible to inspection. However, the most enduring visual appeal of the dendritic form is probably when it is represented plainly in two dimensions. The imagination so eagerly envelops the viewer in its flattened arbours, that deliberate attempts at three-dimensional illusion are mostly superfluous.

Perhaps this theme of uptake explains much of the fascination of dendritic imagery. Pictures of neurons, river valleys, electrical discharges, and indeed bare trees suspend for our eyes the complex processes of growth, becoming, communication and migration. They allow us to see matter

and energy visibly channelled until they burst forth from nodal points, revealing the nature of the substances and forces at stake. They depict a morphology of generalised, universal desire, present in the anatomy of the generative organs, in the subcutaneous vessels and nerves of touch that allow us to share physiques, in the outstretched arms of the child, the probing fan of the neural growth-cone as it hunts for the right chemical gradient, or in the panicky waltz of electrons towards the electrode in a Lichtenberg figure (Fig. 2). Dendritic forms can even be seen in the flames that provide a metaphor for desire itself. The recurrence of the dendritic form can make even the most inanimate and alien phenomena appear tender and subjective, knowing as we do that we have shape in common with some of the most remote structures that can be envisaged or known.

Such poetics naturally have their dangers. Eagerly grasped by the eye, or lyrically imposed by the hand in the attempt to create order, the branching form can offend truth, obscure complexity and ignore differences in the act of representing them. It is the objective of this project to explore both the traditions and the limitations of the dendritic form as an organising principle, as a means of identification, and as a pleasure. Design is a matter of exercising choice, and it carries with it the responsibility to criticise the implications, however seductive, of the forms that may stem from it. If the result is inconclusive, that is appropriate.

Notes

1. *This article is a revised version of "Desiring Structures: Exhibiting the Dendritic Form",* Interdisciplinary Science Reviews *30.3 (2005): 205–21, and republished by kind permission of Maney Publishing.*

2. *R. Wingate and M. Kwint, 'Imagining the Brain Cell: the Neuron in Visual Culture',* Nature Reviews: Neuroscience *2006, 7, 745-752.*

References

P. Ball: *The Self-made Tapestry: Pattern Formation in Nature*; 2001, Oxford, Oxford University Press.

B. Bader, A. Janser and M. Kwint (ed.): *einfach Komplex: Bildbäume und Baumbilder in der Wissenschaft*; 2005, Zurich, Edition Museum für Gestaltung.

A. Bejan: 'The constructal law of organization in nature: tree-shaped flows and body size', *Journal of Experimental Biology*, 2005, 208, 1677–1686.

A. Bejan: 'Constructing a theory for scaling and more', *Physics Today*, 2005, 58, (7), 20 (see www. physicstoday.org/vol-58/iss-7/p.20.html).

J. H. Brown et al.: 'The fractal nature of nature: power laws, ecological complexity and diversity', *Philosophical Transactions of the Royal Society of London* B, 2002, 357, 619–626.

T. C. Halsey: 'Diffusion-limited aggregation: a model for pattern formation', *Physics Today*, 2000, 53, (11), 36.

M. Kemp: 'Trees of knowledge', *Nature*, 2005, 435, 888.

M. Kemp: *Visualizations: The Nature Book of Art and Science*; 2000, Oxford, Oxford University Press.

B. B. Mandelbrot: *The Fractal Geometry of Nature*; 1983, New York, NY, W. H. Freeman.

J. Nittman, D. Gerard and H. E. Stanley: 'Fractal growth of viscous fingers: quantitative characterization of a fluid instability phenomenon', *Nature*, 1985, 314, 141–144.

P. Prusinkiewicz: 'In search of the right abstraction: the synergy between art, science, and information technology

in the modeling of natural phenomena', in *Art @ Science*, (ed. C. Sommerer and L. Mignonneau), 60–68; 1998, Vienna, Springer-Verlag.

A. I. Sabra (trans.): *The Optics of Ibn al-Haytham*; 1989, London, Warburg Institute.

L. J. Schaaf: *The Photographic Art of William Henry Fox Talbot*; 2000, Princeton, NJ, Princeton University Press.

A. Schmidt-Burkhardt: *Stammbaume der Kunst: Zur Genealogie der Avantgarde*; 2005, Berlin, Akademie Verlag.

D. W. Thompson: *On Growth and Form*; 1992, Cambridge, Cambridge University Press (first published 1917).

E. R. Tufte: *Visual Explanations: Images and Quantities, Evidence and Narrative*; 2003, Cheshire, CT, Graphics Press.

A. R. von Hippel with F. Merrill: *Lightning strokes in other worlds: the wonders of Lichtenberg figures*, 1982, vonhippel.mrs.org/vonhippel/AvHLightning.pdf

J. Whitfield: 'All creatures great and small', *Nature*, 2001, 413, 342–344.

See also the following websites: astronomy.swin.edu.au/~pbourke/fractals/dla3d, www.levitated.net/daily/levDLA.html, www.servus.at, www.ucl.ac.uk/wibr/3/research/neuro/mh/mh.htm, www.xtreefanpage.org.

Delineating Disease: Drawing Insights in the Medical Museum

LUCY LYONS

Artist & Post-Doctoral Fellow,

Medical Museion, University of Copenhagen

Walking into a medical museum can be an exciting, daunting, informative and sometimes confusing experience. Members of the public will naturally have different levels of scientific knowledge. Some may be actively involved in the sciences and others may just have a curiosity about the subject in general. Whilst education is not always the primary motivation to visit a medical museum, there is a level of interest that drives the public to explore further. There is an expectation upon entering a museum that it is a place where one is able to discover interesting facts and gain new information. Part of the experience of visiting a museum is concerned with self-improvement and visitors often seek out things they might already recognize to confirm or alter their opinions. They also take different amounts of understanding from the exhibition. There may be a sense of extending their knowledge and furthering their interests rather than being educated in a new topic (Cameron, 2005).

It is not easy to tell exactly what visitors are looking at or more importantly what they have learned from what they have seen. Surveys, interviews and market research can tell us a great deal but the answers often have to fit into the format of the question type and cannot allow for individual idiosyncrasies. Often, constant head turning action can be observed in visitors when there is a lot to see and they carry on walking while swivelling their heads from one object to another, barely glancing at anything but searching for something to capture their attention as they continue walking. Then there is the information overload that sometimes occurs

when the visitor spends so long engrossed in reading lengthy textual explanations that the object on display becomes of secondary interest or importance.

Medical museums offer their own unique problems and challenges. Some have objects that may be perceived by the public to be gory. This can repel the viewer who is too shocked to look or conversely it can encourage the viewer to indulge solely in the shock and gore factor and ignore the value of the object as an important artefact. Medical conditions can be complex and difficult to explain to the public again effectively making the visitor spend more time deciphering dense text on information panels than looking at the object itself.

One way to promote understanding is through the use of entertaining hands on style exhibitions. These are particularly popular with science museum exhibitions and often aimed at children. They are useful in promoting interest in science in general. Art is used as another way to communicate information to the public; however, mixing science and art can bring about its own problems especially when attempting to turn science into art, as is often the case in works made by artists inspired by objects or concepts within a collection. The Contemporary Art Trail at London's Science Museum includes installations, videos and multimedia thought-provoking art works by a variety of well-known contemporary artists including Yinka Shonibare, Antony Gormley and David Shrigley. Their works are integrated into the museum collections and "explore artists' perspectives on the past, present and future of science and technology".

Visitors may not always be sure if they are looking at art or looking at science and it is not always clear what they are supposed to understand from the encounter. Visitors to museums of medical sciences do not necessarily also visit art galleries so might not be familiar with the context of artefacts seen within the gallery context (Falk et al., 2006).

A method I suggest that promotes visitor engagement with medical museum objects and concepts and communicates medical insights in a clear way is the activity of drawing. This has been shown to work in two ways, as a participatory method of bringing about understanding of objects through the activity of drawing and from insights gained by the viewers looking at the drawings made from observing the objects in question. Unlike other methods of receiving information that are passive, drawing is a participatory activity.

I will discuss the use of drawing as a method of communicating medical insights within the context of the medical museum, the laboratory and the project space. I will focus on two case studies; PhD research undertaken to examine the role of drawing as a method of understanding a rare congenital disease and a project based at the Gulbenkian Institute of Science (IGC) in Lisbon to examine the use of drawing in the laboratory and to present information to the general public. I will also discuss the different role of photography. First I will outline the development of delineation as a drawing research tool.

Delineation: drawing as a phenomenological experience

The system of drawing called delineation I developed to investigate disease is seen to be a phenomenological process that can record and present visual experiences as visual knowledge. It is both a practical method of coming to understand an object by becoming familiar with it through the activity of drawing and a valid method of communicating these insights clearly to viewers.

The term delineation developed from its original use by the 19th Century Scottish artist and pathologist Sir Robert Carswell (1793-1857). He used it to describe the drawings he made of patients in the poor hospitals of France.

You should see these Delineations...that you may appreciate their value not as art, but as instruments of medical science by means of which more precise, more accurate and more perfect information may be acquired and communicated respecting the various and numerous organic changes to which the human body is subject. (Carswell, 1831).

Drawing had been established as an art form but its application to pathology was new as was Carswell's belief that his delineations could communicate knowledge of disease. Carswell felt his delineations were not just helpful but essential to the understanding of disease.

Carswell's definition is the basis of my interpretation of the activity of delineation and is crucial as a point of departure for this investigation. Through delineation, the investigator not only records data, but also understands and expresses observed phenomena. This approach creates a situation in

which the presence of the delineator is explicit and a vital part of the process of interpretation and rather than examining generic examples and seeking explanation through the investigation of causal relationships and comparisons only, delineation makes use of a specific system rather than generic models. It is less concerned with purely causal events and uses intentional reasoning and understanding of the subject within a phenomenological framework (Searle, 1983).

This involves shifting from the scientific third person to the subjective, descriptive form of observation of the first person that is based on experience and not just observation as a way to present experience of uniqueness of encounters with FOP and to find a way of presenting these encounters to others in a dignified, respectful and informative way. This takes into account the significance of the experiences of the activity of delineating, the experience of the laboratory environment as well as the experience of the object. Importantly, the framework presents understanding of the object and not just a demonstration of a rendering of it as a complex object.

Delineation presents the relationships developed and an understanding of how knowledge has been accumulated. It provides another valid form of presenting and communicating information. The activity of drawing offers insight through processes of close observation and continuous drawing and presents visual experience concurrently with evidence of the process of its own making. The drawing acts as a way of presenting visual experience and leads us back to the object itself and the particular fugitive collection of moments in

which it was experienced. Understanding brought about by the action of drawing and the relationship between object and delineator, and between delineation and observer is formed by this phenomenological activity.

Like other methods, delineation has a foundation in observation. Where it differs is in its concern with offering a unique and specific system with which to present understanding of encounters and make sense of them directly and spontaneously, therefore making it interpretive, rather than the generalizing method preferred in science that aims to offer explanation. Merleau-Ponty and Heidegger both believed science created models that it then manipulated, "science makes everything appear as an object in general". (Moran, 2004, 400).

It is human nature to try to interpret and understand the encounters we have with the world around us. "Nothing is more difficult than to know precisely what we see." (Merleau-Ponty, 1992, 58). Delineating visual experiences of phenomena is an attempt to achieve this. The act of drawing brings understanding of an object and the relationship between the delineator and the image is presented through the activity of making.

The first case study examines the disease Fibrodysplasia Ossificans Progressiva (FOP), a very rare and under-researched area of study. The main data comes from a series of projects that form my PhD *Delineating Disease: a system for investigating Fibrodysplasia Ossificans Progressiva*. Delineation has been used as a method of understanding the experience of the

phenomena encountered and as a clear and precise way to present these insights to the visitors of the Hunterian Museum at the Royal College of Surgeons of England.

Delineating disease

FOP is a congenital disease affecting only one in two million people. The disease demonstrates the devastation caused when a gene triggers the over-production of bone growth. Progressive heterotopic ossification occurs in the connective tissue both spontaneously and through trauma. These are known as flare ups and result in the growth of a secondary skeleton. The extra bone forms spurs and then finally bridges by meshing with another part of the body effectively locking limbs. This is known as ankylosis. Not only is this a relatively unknown disease but it is extremely difficult to convey to those unfamiliar with it how horrific the effects of the disease are in a way that avoids shock or clouds the evidence by softening the evidence.

This five-year study was based within the Royal College of Surgeons of England and as part of the project it was planned that the outcomes would be displayed to the public in the Hunterian Museum in the College in 2008. The challenge of this research was to find a method of investigating FOP in a way that would present clear information and offer insight to, medical professionals, researchers and the general public in the context of a medical museum. It was important to communicate experiences of the processes used to reveal the specimens as well as present information about the disease

itself. The relevance of the objects, where and how they were collected, preserved and displayed and how they can/ are being accessed for further research is often overlooked. It can easily be forgotten that museums are not just places to display exhibitions but are institutions where scientific research takes place and can communicate the processes and outcomes of this work (Falk et al., 2007).

The main data comes from a series of projects. These include delineations from living sufferers, from historical skeletal specimens and the largest project, which depicts the process of maceration and preparation of two donors. Core characteristics distinctive to delineation as developed within this inquiry include the following:

- Delineation uses closely observed detail which attempts to present the visual experience as directly and precisely as possible throughout the duration of time spent in the presence of the object being portrayed.
- Delineations are not formed from imagination or composites of remembered images but are observational drawings that reveal the unique and specific details of each encounter.
- They both present the journey of understanding taken by the delineator and communicate new insights revealed by the activity of drawing information observed directly in the presence of an object.
- They are made using lines rather than tone and do not make use of colour. Marks made on the paper

remain part of the record of understanding achieved by the delineator, even if removed. Areas rubbed out, smudged, indented, and re-drawn create lines and marks that are sensitive and reflective of the accumulation of experiences. These marks reveal the development of the delineator's understanding as the drawing progresses and demonstrate sensitivity and respectfulness towards objects being observed.

Drawing to understand: workshop

The activity of delineation can inform others participating in the process of drawing. A drawing workshop was set up with students from different specializations in archaeology. The archaeologists were not trained in drawing and initially drew the FOP skeleton in terms of being different from a normal skeleton. They agreed they formed a connection through the activity of drawing and the more they drew the more precisely they observed and the better they understood the object they were looking at and gained further insight into the experience of FOP. They all agreed that:

- The act of drawing makes you spend more time looking and this action makes you see more detail.
- Drawing raises questions of where bone finishes and ossified tissue begins.
- There is a need for a drawing module to be included in their courses. They all felt they would benefit greatly from this inclusion.
- The most important thing drawing teaches is how to look.

- Things they did not understand visually became clearer as they continued the process of drawing and they could see better how everything fitted together.

Whilst it is the action of drawing that leads to understanding, it was concluded that the actual picture acts to re-enact and appreciate the parts previously focused on. It was also felt the activity stopped them seeing information in only two dimensions but forced them to understand it in three.

From the evidence presented in the outcomes of this workshop I would conclude not only that drawing as an activity does present visual experiences and with that understanding but that this is not dependent on the quality and experience of the drawer. When conveying knowledge further to an audience, there must be a level of skill in the activity to produce delineations that can offer enough detailed information as to prove informative, but at the stage when the drawer is gaining insights into the object being experienced, it is through the activity itself, the continuous act of observing and drawing, that knowledge is acquired. It is the process of attempting to achieve accuracy rather than the success that encourages the type of intense scrutiny that is part of the system of delineation. This dialogue is how understanding is achieved. Through it, the visual experiences unique to each participant reveals not just that the FOP skeleton is different, but how different it is. (Lyons, 2009)

Issues of exhibiting

People want to know about science and medicine and the

museum is a key location to promote understanding. Museums are seen as authoritative and reliable. Hands on museums do not necessarily succeed in teaching but generate a level of public interest in the medical sciences. The model for these uses educational reproductions without historical artefacts where other museums are object based with educational value placed in the understanding of the object.

The research at the Hunterian Museum displayed the outputs of medical science but also demonstrated the processes, research and historical context of the objects in a way that was accessible without being overtly shocking and remained sensitive to the subject matter. It was essential to communicate experiences of the actual objects and to present the complexity and time consuming processes used to produce them to those involved in the medical sciences, patients and helpers of those with FOP, other researchers and the general public. Delineation allows a practical method to present the continuing techniques employed, the developing objects and the continuous and changing experience of these encounters in a tangible form. These delineations were able to be viewed by anyone who chose to visit the museum and not only presented clear, precise visual information but told the story of the presence of the specimens, the experiences of FOP and placed the disease and the work done behind the scenes of the museum into context. Historical artefacts, conservation and preparation techniques were revealed and insight and understanding of a rare and horrific disease was communicated sensitively without the overuse of text

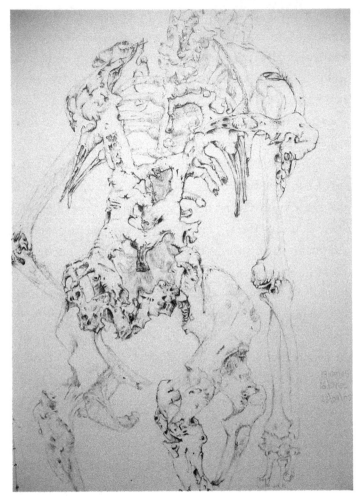

Fig. 1: Lyons, L. (2005). *Delineation 4. Mr. Jeffs 2 Close Up*. Pencil on paper.

information panels.

The process of considering what was to be conveyed to the museum visitor provided a starting point for identifying the main categories and groups within the delineations.

The selection process continued in the Hunterian Museum in preparation for the exhibition held from 16th September – 23rd December 2008. There were several constraints to consider; the gallery space, the expectations of the curator, expectations of the public, ethical concerns and the order in which the delineations were placed.

Different viewers gained a variety of insights into this material. Expert clinicians saw that the delineations highlighted relevant areas bringing particular features to their attention and offered new perspectives on the disease. Professor Paul Wordsworth and Professor James Triffitt at the Nuffield Orthopaedic Hospital, University of Oxford were involved in the project and were particularly interested in drawings showing the union between the bones. It was felt that some delineations were explaining remodelling and revealed visual information about forming and joining of bone.

The ability of the delineations to highlight particular features was felt to be an important and useful way to make the viewer more aware of specific areas of interest. Whilst emphasis important to the delineator may not necessarily be of equal relevance to others, the delineations were seen to be successful in offering a different perspective of FOP as they present clearly what I have seen and understood. It was agreed that the system of delineation, as developed in this project, demonstrated how I had experienced and accumulated knowledge from these encounters and gained further understanding of which details are more relevant in the object being observed.

The delineations were felt to clearly demonstrate the extent of ossification and deformity produced by FOP and raised interesting questions. The experts felt that the delineations proved to provide: essential visual material as there are very few skeletons available and it is not possible to keep returning to them as you can to the delineations, a clear way to show how the bone actually joins up, much clearer visual information than X-rays or CT scans, clear demonstration that the myofascial planes and connective tissue are affected rather than the muscle fibres themselves, confirmation of lack of ossification in the diaphragm and smooth muscle and many new impressions about the disease.

It was also felt that delineations raised interesting questions about where does one sort of bone stop and the other begin, where the bone is growing and where should experts be looking. They considered the delineations gave much more information than a patient documentary could and highlighted the effect of FOP as a major process in these people. Professor Triffitt and Professor Wordsworth thought other medical science professionals could benefit greatly from seeing the delineations and would gain greater understanding from the information conveyed than from other methods of visual communication. (Fig. 1).

Delineation revealed information about where new bone is to be found. A private viewing of the *Delineating Disease* exhibition at the Hunterian Museum was held for the delegates of the *Bones in Unwanted Places* seminar, 13th – 15th November 2008. Dr. Fred Kaplan, a leading US authority on

FOP was amongst the visitors. In an email sent on November 17, 2008, he revealed the insights he gained from seeing the exhibition of delineations: *I learned an enormous amount from it and saw things I never saw before. More importantly, you showed us an aspect of "looking" and "observing" that brought us to the patients in a participatory way, something that most never get to do.* (Fig. 2).

Rather than an image of a shocking object, delineations can reveal detailed aspects of the condition and attention is spent attempting to capture as precisely as possible the uniqueness of each of these continuing phenomenal experiences. The action itself of placing the tip of the pencil on a page and moving it to present the encounter as it is being experienced allows for a depth of detail and insight to be revealed. Paying such attention to detail allows every idiosyncrasy and nuance particular to each object to be portrayed. The emphasis on these elements of individuality specific to each encounter, dignifies the donors, the people with FOP and the specimens. No additions or embellishments are made to the delineations and the drawing activity presents explicitly visual experiences of a human condition.

A museum is a repository where one seeks out information and has a different role to the gallery. The Hunterian Museum provides an appropriate vehicle to display the evidence of research. The delineations were housed within an environment where experts and members of the public would expect to find information. The setting provided the correct context and demonstrated the role of delineation as a process

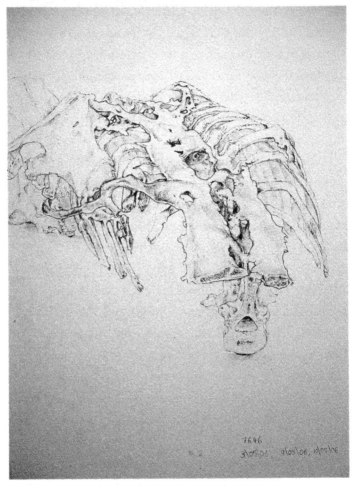

Fig. 2: Lyons, L (2006). *Delineation 29. 7646 Marrow.* Pencil on paper.

to record and communicate encounters with pathology.

The exhibition at the Hunterian museum provided a good arena for experts and others who are able to see the work in its wider context, as they would not in a gallery. (Lyons,

2007) In an email sent on October 24, 2008, Dr. Robert Hicks, Director of the Mütter Museum at the College of Physicians, Philadelphia, USA wrote: *Your drawings afford the opportunity to interpret your images both as vehicles of scientific information as well as how they depict an unusual condition of the human body in an engaging way.*

Many visitors to the exhibition had never heard of the disease. This included medical and surgical experts who attended. Some told me they found the delineations presented the experiences of FOP to them very clearly. Several claimed to have understood what the effects of the disease are to the body from looking at the delineations. One artist told me she knew nothing about FOP previously, but the delineations helped her understand where the regular skeleton ended and the extra bone began. In her opinion, she understood this clearly from the delineations yet had no previous knowledge of the condition.

In two reviews, the delineations are perceived as sympathetic and respectful. Anna Hales, an art theorist and writer based in London wrote: *The detail in each piece is extraordinarily exquisite. However gruesome this disease, these images are not - they display a genuine sense of humanity.* (Hales, 2008).

In the second review, Jennie Gillions, writer and museum worker, found the delineations to be respectful, gentle and sympathetic. She described them as: *Profoundly affecting, neatly tying together the medical and emotional aspects of this condition... All of Lucy's drawings demonstrate an affinity and*

compassion for her subjects...[and the] ability to look deep into her subjects and build a relationship with them, while still directly interpreting what she sees. (Gillions, 2008).

Delineation presents the visual experience of each unique encounter with phenomena in a manner that is understandable and familiar to a wide audience. Its advantage is the ability to offer an insight into FOP for sufferers, medical professionals and to those who have an interest but either find direct encounters with disease or illness difficult or would never have the opportunity to experience them in reality.

Seeing through drawing: taking a photo

But surely a photograph could impart the same information. A camera is an excellent tool that can capture detailed information quickly and in full colour. The visual information is presented to us as a photograph, which may be studied, by a clinician or other researcher. The colour and composition can easily be added to or changed digitally if needed. It is a quick and efficient way to create an image that can be reproduced in large quantities in various formats. There is no longer a need to bring cumbersome sketchbooks and waste time drawing things when we can just take a photo. "Convenience [has] trumped engagement". (Kimmelman, 2009).

A photograph is able to show a subject, but cannot claim to present knowledge and visual understanding of an encounter in the same way the action of drawing it can. Drawing allows you look slowly and carefully and build a relationship by spending time in the presence of the object being viewed. This experience

becomes part of your understanding of the object.

A camera does not see light in the same way the human eye does. We do not perceive the greenish hue of fluorescent light that is automatically captured when photographed with some processes. Our depth of field and peripheral vision constantly shift to give a rich view but in photography these remain fixed. Our eyes and head move more than we realize when observing a scene. This visual data is far richer and more diverse than the visual information that can be captured from a statically positioned camera or even from manipulation of several images to form a composite. Cropping in photography occurs initially when looking at an object through the viewfinder and often later when the image is printed or uploaded. This visual editing offers a subjective record and, especially in the case of medical photography, can deliver information but not necessarily understanding. Most importantly, a camera can only record instantaneous events rather than the actual data experienced over a period of time.

Whilst resemblance between object and drawing is not a phenomenological analysis of the experience I would argue that delineation is a phenomenological activity that does fulfil that role. When looking at pathological specimens, there are a number of things being observed: pain, deformity, bone, connective tissue, or swirls, twists and curlicues. I have visual experiences of an object both as fragmented and as a whole. I also experience objects as new and unknown things whilst simultaneously comparing them with something more familiar. As I can only present these encounters from the

delimited confines of experiencing the world from inside my body, I can only present these continuous and fugitive visual experiences subjectively. During the activity of portraying these encounters, I become conscious of other qualities I perceive within the objects and the visual experiences I have of them. I experience the process, marks, smudges, scribbles and indentations on the pages. I experience the smell of the wood and graphite from my pencil, the pencil shavings, putty from my rubber and the wood pulp from the paper. These are cumulative experiences.

Delineation can be seen as system with which to interrogate the world around us in an intense and sustained manner. There is no prior knowledge of how this relationship will be, even if there is prior knowledge of the object to be experienced. Information and experience, accrued through the duration of this adds to the whole experience.

Drawing on paper with a pencil or other hand tool, objects directly being viewed, can record, analyse and offer new knowledge of them, inexpensively, through its application. Delineation as a system for recording involves coming to know the subject through the process of delineating it and understanding how it functions through that activity.

Dignifying the subject through the activity of drawing
Most often images of the medical body are depicted using medical imaging techniques. X-rays, CT Scans and other forms of medical imaging technology are vital to diagnostics however, it can be difficult to exhibit them and the process

used to create them (Söderqvist et al., 2009). It is not easy to explain how they have been made and even harder to 'read' the information they contain, a skill which takes years of training and experience. Drawing over a period time can present new insights and information that can widen and complement these methods and is an activity in which those with little or no experience can participate. Drawings can be viewed by the public who bring with them a level of knowledge about what is required to make a drawing that is far greater than the general understanding of how a CT scan is made.

Interest in medical museums can stem from our natural desire to know how our bodies work and what can happen to them. The medical body is often depicted in the context of examples of unusual symptoms, suffering and surgical objects. We can relate to these objects and they remind us of situations we might find ourselves in, vulnerable, lying in our night – clothes, on public show, unsure and in unfamiliar surroundings. Gazed at by clinicians, medical students, nursing staff, carers and visitors, we lose our individuality and sometimes our dignity. Being examined or medically observed can reduce a person to a state that is less than human. It can be a frightening experience to be scanned or have an X-ray where staff hide in another room or wear heavy metal aprons to protect them. The objects and concepts in medical museum exhibitions pertain to these complex feelings and experiences that viewers bring with them when looking at the objects.

There is humanity in the action of drawing that restores

the dignity and respect that can be sometimes overlooked in the medical gaze. This is where a relationship is formed through the engagement and mutual participation in the dialogue created. There is willingness to be drawn and willingness to understand the experience being observed and it is this balance that is found and developed by the drawing activity.

Engendering dignity: drawing the familiar and unfamiliar

In May 2009 I was invited to participate in a residency *Drawing: between art and science* at the drawing project space Espaços do Desenho at Fábrica Braço de Prata. The residency combined working in conjunction with the scientists at the Gulbenkian Institute of Science (IGC) and drawing with the public in the project space to test the theory that the activity of drawing leads to understanding whilst remaining respectful of the subject being observed. It was funded by the generosity of the British Council Darwin Now award.

This two-part project began with the scientists at IGC and me drawing together. For me, the use of drawing worked as a way to understand experiences and phenomena encountered, especially as a way to gain understanding of things unfamiliar to me. It continued to test the theory that the activity of drawing leads to understanding whilst remaining respectful of the subject being observed.

The notion of dignity means that nothing should be taken for granted and often we stop looking at the everyday and the overly familiar in detail because we think we know these

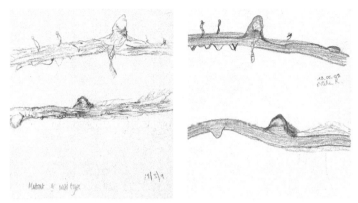

Fig. 3: (Above left) Lyons L. (2009). Mutant and wild type seeds. Pencil on paper.
Fig. 4: (Above right) 'E' (2009). Mutant and wild type seeds. Pencil on paper. (Reproduced by kind permission of the artist.)

things so well. Close observation and the activity of drawing reignites interest in the viewer and reveals the unexpected qualities and idiosyncrasies not previously noticed in the familiar object.

The scientists found that by drawing materials and protocols with which they were familiar, things became re-seen and the scientists gained new insight into their subjects, something they had not previously expected. Several outcomes were achieved. Fig. 3, drawn by me, and Fig. 4 made by a scientist, both depict mutant and wild type germinating Arabidopsis seeds observed under a light microscope. Having the opportunity to observe the seeds at this stage of development and level of magnification, the scientist discovered there were interesting phenomena she had not previously noted that could be relevant. Having spent years studying this material, new insights were revealed

Fig. 5: Lyons, L. (2009). *Female Mutant Drosophila*. Pencil on paper.

Fig. 6: 'Z' (2009). *Female Mutant Drosophila*. Pencil on paper. (Reproduced by kind permission of the artist).

to her prompting her to make the decision that she would change her protocols to include extra time to make drawings at each stage.

Fig. 5 is a drawing of a mutant female Drosophila fly. The scientist who drew the same fly shown in Fig. 6 realized there were tiny hairs on the fly's abdomen that despite years of familiarity she had not previously noticed. The activity of drawing in both these cases leads to re-seeing and therefore offered new information about familiar objects. The objects were given the dignity and respect they deserved by the act of spending more time carefully observing them and drawing them in an attempt to understand them more clearly.

Exhibiting in the project space
Over the last ten years my research has been created in the lab or dissection room rather than in the traditional setting of the artists' studio. As a way of both bringing the lab into the gallery and demonstrating my theory on the role of drawing, I allowed bacteria to grow on Petri dishes left in the project space at Fábrica Braço de Prata. This bacteria was formed from the breath of all the visitors to the drawing space. As they walked in and out they left a trace of themselves via the growth on the Petri dish. Using a microscope and drawing attachment which acts like a small camera lucida, I invited members of the public to come and draw the bacteria they saw when looking down the microscope (Fig. 7).

As with the workshop run with the archaeologists, none of the people who took part in these drawing activities had

Fig. 7: Lyons, L. (2009). *Bacteria Drawing*. Installation shot 1. Pencil on paper.

any previous art training. The visitors to the space not only spent time looking at something they would not normally want to look at or worse would wish to destroy with cleaning products, but became actively engaged with understanding it. Through the activity of drawing they participated in learning

more about bacteria and due to the observation required spent a large amount of time looking at something they would not usually bother to see. The activity of drawing it lead to their forming a relationship with it and finding details they had previously overlooked. Some began to scrutinize the bacteria at length, to the extent that queues of people formed as people waited for a turn at drawing bacteria. The use of the microscope and lens to reveal the detail of the bacteria meant the public not only gained respect and understanding about bacteria but also learned about the experience of looking down a microscope and engaging with a basic piece of scientific equipment.

Often people will say "I can't draw!" and they become anxious and think they are expected to make a perfect drawing. Using a drawing attachment on the microscope which allowed them to look down the microscope and see the bacteria whilst simultaneously seeing a projected image of their own hand holding the pencil meant they were effectively tracing what they saw directly onto paper. They engaged with something that would normally repel them and through the activity of drawing, they saw the beauty and detail in bacteria. Rather than being concerned with the mechanics of making a drawing, they concentrated on the activity of actually looking, something we all frequently forget to do.

Joining together all the drawings made, the piece *Bacteria Drawing* grew and developed collaboratively, paralleling the growth of the actual bacteria itself. Within the project space not only were my delineations and drawings displayed

showing how I had come to understand phenomenon through the activity of drawing, but drawings by those not trained in drawing. This brought together the evidence of how important the activity of drawing is to understanding and dignifying observed subjects. The scientists learned more about familiar material than they had anticipated and the public saw the beauty of the unfamiliar by drawing. Through drawing, my experiences of the work done by scientists at the IGC and their own journey of discovering new insights were communicated to the visitors of Espaços do Desenho at Fábrica Braço de Prata.

Joining these were the experiences of the public and the insights they had gained into understanding the process of looking down a microscope and the time spent observing bacteria and examining the detail of the encounter. The project showed that drawing is not mere documentation but is about participation. This participation is embodied in the relationships that develop between artist and object and that the object observed is dignified through the respect and understanding gained in the activity of drawing.

Drawing insights

The activity of making is crucial and the experience of the object becomes a part of the experience of depicting that encounter and therefore part of the whole experience. The significance of process in this context is one that has been largely overlooked. It goes beyond acknowledging the object's presence and becomes part of the experience of living it. The

process of looking connects the thing experienced and the person experiencing. A drawing is overt in laying bare the experience of its own making as marks are inscribed, removed and smudged. There are fingerprints and grooves on the page, scratch marks, layers of line and various weights of mark. The transparency of its making allows it to be tacitly recognized as drawing.

The action of observing an object and drawing it is one that can be perceived as being too simplistic and its value can often be overlooked. Educationally, it is an activity that can train students how to look and hone observational skills. By requiring my students to investigate the world around them by drawing, they are forced to spend more time looking at objects and analyzing what they are looking at and attempt to gain insight into that experience. In my research I suggest that skills gained from this process would be valuable to those also studying medical imaging. The activity would serve to enhance their observational skills and support their developing knowledge of technical imaging equipment. This step in the process of imaging has been neglected and it would be beneficial to students to learn the art of observation before applying its use to digital photography etc. The activity of delineation provides a suitable system in which to acquire, present and build upon these skills.

The advancement of technology should not negate the ability of first hand close observation and the interpretations that can be formulated from this experience. When looking at an object we bring our own past experiences, knowledge and

biases into the equation. But when observing an object during the activity of drawing, these become less important than the need to not make assumptions, to look and see the object as if for the first time, each time and treat each experience of the object as unique. This is when we move away from what we think we see, from the idea of the object to the object itself and how we see it.

One must be able to describe what one sees in order for the visual experience to be complete and meaningful. (Boudreau et al., 2008, 860).

Observation is a key skill in both science and art and development of observational skills is experiential. It is also understood that observation occurs on more than one level, looking at the part and looking at the whole.

Advantages of using drawing as a method of understanding and communicating information are:

- The activity makes you actually stop and look more slowly and therefore carefully at an object.
- It does not try and compete or detract from the original artefact but enhances and complements it.
- There is a sense of understanding drawing. It is a universal activity which everyone has engaged in so may require practice but not explaining in the same way some forms of digital formats might.
- It allows the drawer to build a relationship with the object. By spending time looking, they can see things they would not normally notice and interpret this in their own way.

- It is a cost effective way of communicating information as materials and tools are inexpensive.
- It is participatory so rather than receiving information in a passive form, visitors produce their own results of their developing knowledge.

The system of delineation has been used to understand the unfamiliar within the setting of pathology. There is scope for this to develop beyond this to other scientific fields and into teaching practice. Other potential future research would involve using drawing as a way to gain further insight into the already familiar. Scientists often work with the same material and repeat processes over long periods of time. Drawing here would be a useful and valid way to re-see all too familiar phenomena and gain fresh insight by the use of close observation coupled with the activity of drawing. The potential for the role of drawing to be used as an activity that reveals new insight and understanding in the observer and communicates knowledge to an audience, is far reaching.

The use of drawing as a method to both bring further insight into objects and to promote public understanding of these objects and their contexts is only one example of how medical museums and their exhibitions can incorporate a participatory activity that complements other successful methods. It is hard to tell if the success of a medical science exhibition should be judged by how much the public appreciated the objects themselves and the manner in which they were displayed, or by the amount of scientific knowledge they acquired as a result of their visit, but drawing is a

flexible activity that can accommodate different levels and perspectives of experience and understanding gained by individual visitor.

While there is still much call for the need for the public to understand science better, there is surely evidence in museums that `understanding' is no longer being understood narrowly but that museums are coming to tap more of their particular abilities to excite interest and multiple understandings and meanings. (MacDonald, 2004,13).

Medical museums do not have to be only about the object or always require large amounts of accompanying explanatory text or forsake the object completely for hands on style exhibitions that show no real artefacts at all. Evidence has shown that drawing can highlight the experiences of the objects, the manner in which they came to be presented and the historical context in which they are shown. Without resorting to the use of costly technology that may interfere with and "outshine" the subject of an exhibition, drawing and the activity of drawing can bring researchers, medical scientists and the general public closer to experiencing the objects and their context and so communicate deeper insights.

References

Boudreau, Donald J., Eric J. Cassell and Abraham Fuks. 2008. Preparing medical students to become skilled at clinical observation. *Medical Teacher* 30: 857–862.

Behan, P. O. and W. M. H. Behan. 1982. "Sir Robert Carswell": Scotland's Pioneer Pathologist. In *Historical Aspects of the Neurosciences*, ed. Clifford Rose & William F. Bynum, 273–292. Raven Press Books, NY.

Cameron, Fiona. 2005. Contentiousness and shifting knowledge paradigms: The roles of history and science museums in contemporary societies. *Museum Management and Curatorship* 20: 213–233.

Caswell, Robert. 1830.[Letter].10 April. Held at University College London Special Collections.

Caswell, Robert. 1831.[Letter]. 25 June. Held at University College London Special Collections.

Carswell, Robert.1838. *Pathological Anatomy. Illustrations of the Elementary Forms of Disease*. London: Longman Orme Brown Green and Longman.

Delicado, Ana. 2007. *What do scientists do?* In museums of scientific practice in museum exhibitions and activities. The Pantaneto Forum, 26(4).

Falk, John H., Lynn D. Dierking, Léonie J. Rennie and Gina F. Williams. 2006. Forum: communication about science in a traditional museum – visitors' and staff's perceptions, *Cult Scie Edu* 1: 821–829.

Frich, Jan C., and, Per Fugelli. 2003. Medicine and the Arts in the Undergraduate Medical Curriculum at the University

of Oslo Faculty of Medicine, Oslo, Norway. *Acad Med.* 78: 1036 –1038.

Gillions, Jennie. *Hunterian Museum exhibits drawings of rare disease.* Review. Retrieved 5 October, 2008 from http:// www.24hourmuseum.org.uk/exh_gfx_en/ART61332. html

Hales, Anne. *Interface, a-n website.* Review. Retrieved 10 September, 2008 from http://www.a-n.co.uk/interface/ reviews/single/462218

Hollman, Arthur. 1995. The paintings of pathological anatomy by Sir Robert Carswell (1793-1857). *British Heart Journal,* 74: 566-570.

Horder, Jenny. 2003. Promoting health through public programmes in university medical museums. *Museoligia* 3: 127-132.

Kaplan, Frederick. S., M. Le Merrer, D. L. Glaser, R.J. Pignolo, R. E. Goldsby, J.A. Kitterman, J. Groppe, and E. Shore. 2008. Fibrodysplasia Ossificans Progressiva. *Best Practice & Research Clinical Rheumatology,* 22(1): 191-205.

Kaplan, Frederick. S., W. McCluskey, G. Hahn, J. A. Tabas, M. Muenke, and M. A. Zasloff. 1993. Genetic Transmission of Fibrodysplasia Ossificans Progressiva. *The Journal of Bone and Joint Surgery America,* 75A(8): 214-1220.

Kaplan, Frederick. S., J. A. Tabas, F. H. Gannon, G. Finkel, G. V. Hahn, and M. A. Zasloff. 1993. The Histopathology of Fibrodysplasia Ossificans Progressiva. *The Journal of Bone and Joint Surgery America,* 75A(2): 220-230.

Kimmelman Michael. 2009. At the Louvre, many stop to

snap but few stay to focus. *New York Times* Retrieved 19
August 2009 from http://www.nytimes.com/2009/08/03/
ats/design/03abroad.html

Kipfer, Barbara Anne. 2007. *The Archaeologist Fieldwork Companion*. Blackwell Publishing.

Lyons, Lucy. 2006. Walls are not my friends: issues surrounding the dissemination of practice-led research within appropriate and relevant contexts. *Working Papers in Art & Design*. 4, (November 1), http://sitem.herts.ac.uk/ artdes_research/papers/wpades/vol4/llfull.html

Lyons, Lucy. 2009. *Delineating Disease: a system for investigating Fibrodysplasia Ossificans Progressiva*. PhD diss. Sheffield Hallam University

MacDonald, Sharon. 2004. *Exhibitions and the Public Understanding of Science Paradox*. The Pantaneto Forum, 13, Retrieved 18 August, 2009 from http://www.pantaneto. co.uk/issue13/macdonald.htm

Merleau-Ponty, Maurice. 1992. C. Smith, (trans.) *Phenomenology of Perception*, (1962 ed.). Routledge & Kegan Paul Ltd.

Moran, Dermot. 2004. *Introduction to Phenomenology*. Routledge.

Rust, Chris., and Adrian Wilson. 2001. A Visual Thesis? Techniques for reporting practice-led research. *Proceedings of 4th European Academy of Design Conference*, April 2001, Aveiro, Portugal.

Rust, Chris. 2007. Unstated contributions – How artistic inquiry can inform interdisciplinary research. *International Journal of Design*, 1(3): 69-76.

Searle, John R. 1983. *Intentionality An Essay in the Philosophy of Mind*. Cambridge University Press.

Smith, David W. 2005. Phenomenology. In *The Stanford encyclopaedia of philosophy* ed. E. N. Zalta Retrieved 9 August, 2006 from http://plato.stanford.edu/archives/win2005/entries/phenomenology/

Söderqvist, Thomas, Adam Bencard, Camilla Mordhorst. 2009. Between meaning culture and presence effects: contemporary biomedical objects as a challenge to museums. *Studies in History and Philosophy of Science* 40: 431–438

Suarez, Andrew. V and Neil D. Tsutsui. 2004. The value of museum, collections for research and society. *Bioscience* 54(1): 66 -74.

Taub, Liba. 1998. On the role of museums in history of science, technology and medicine Endeavour Vol. 22(2): 41- 43.

Turk, J. L. 1994. The medical museum and its relevance to modern medicine. *Journal of Royal Society of Medicine*, 87(1): 40 – 42.

Wakefield, Denis. 2007. The future of medical museums: threatened but not extinct. *Medical Journal of Australia*, 187(7).

Wallace, Marina. 2008. Crossing Over and Delineating Disease, *Med Humanities* 34: 115-116

Vanishing Landscapes and Endangered Species

JOSEPH EMMANUEL INGOLDSBY

Environmental Artist

Landscape Mosaics, USA

We live in a time of vanishing landscapes and endangered species. E.O. Wilson states that, "Over the next half century, up to one-third of the world's plant and animal species may be lost forever. Conservation biologists regard this as the first mass extinction since the age of the dinosaurs."[1] In the United States alone, 30% of the nation's plant and animal species are at risk of disappearing, and over 500 species are missing or may already be extinct.[2] We have lost over half our nation's original wetlands, 98% of our tall-grass prairies, and virtually all virgin forests East of the Rockies. Since the colonization of America, four American bird species have gone extinct, including the Passenger Pigeon, once the world's most abundant bird.[3] Today, there is recognition that change is progressing with such speed that shifts and loss of plants and species can be documented within our lifetime.

Recent projections on the velocity of climate change by scientists at the Carnegie Institution, Stanford University, the California Academy of Sciences and the University of California at Berkeley calculated the temperature velocity for different parts of the world based on current and projected future climate models.[4] The findings pinpoint those ecosystems of critical environmental concern where biodiversity is most threatened by the speed of climate change. The study found that global warming would impact flat areas such as mangrove swamps, flooded grasslands, coastal marshes and savannas with a velocity of 1 km a year. At higher elevations of the montane grasslands and shrublands, the projected velocity is charted at 110 meters per year. Within the tropical and subtropical

coniferous forests, the movement of landscape boundaries would average 80 meters a year. This will lead to a cataclysmic relocation of plant and animal species to shifting landscapes or to mass extinctions within a lifetime.

Scientists speak of climate change, fragmentation of the landscape, broken trophic cascades, species shifts and extinction, and the loss of the natural and cultural landscape.

However, science is often written using a technical terminology and style, which makes it indecipherable to the general public. There is a need to translate, visualize, and popularize the science at this critical juncture in time. Further, field studies and findings of dire importance are published in academic and scientific journals, or presented as papers to peers at scientific conferences, without any publicity or educational outreach to the general public. There has been a glaring lack of scientific coordination across the disciplines to examine the data using a systems approach to show the interconnection of events and findings, and a visual language to communicate their concerns to the public.

Artists can play an integral role in the raising of public consciousness through advocacy. Art can be used to communicate complex ecological and scientific principles to an audience outside the confines of the academy or science museum. My own series, *Vanishing Landscapes and Endangered Species* blends art, science and technology to advocate for vanishing landscapes and endangered species. The collaborative works examine, explain and illustrate issues

such as climate change, fragmentation of the landscape, broken trophic cascades, species shifts and extinction, and the loss of the natural and cultural landscape.

The progression of my artistic environmental explorations is described within scholarly journals[5] and magazines.[6] My field installations are often set within the threatened landscapes: *Requiem for a Drowning Landscape - Memorial*. Documentation of the work has been exhibited in university galleries, refuge and sanctuary galleries, art galleries and within the New York Hall of Science, opening the eyes of many to the beauty, utility and the fragility of vanishing landscapes and endangered species.

The public events and installations required scientific research and community, corporate, environmental agency collaboration, reviews and permitting. This educational outreach has translated into legislation, protective status of land and species, land acquisition, zoning change and public appreciation for the science of land and sea.

Vanishing Landscapes and Endangered Species is a retrospective of environmental advocacy works, which use art and science to communicate concern for the vanishing landscapes and endangered species of the American landscape from the Great Plains, to the Prairies of the Midwest, to the Eastern forests, to the Atlantic Coast of New England. Works include *Icons of the Vanishing Prairies, Silent Shadows, Crane Effigy Mounds, Spirits of Whooping Cranes, Shrouds for an Endangered Species, Landscape Mosaics, Leaves in Grass, Requiem for a Drowning Landscape* and *Anadromous Awakening*.[7] Works are site-specific to the

American habitat regions and their species.

The pre-Columbian landscape of North America can be delineated into a series of physiographic regions, which include the Pacific Mountain System, the Intermontane Plateaus, the Rocky Mountain System, the Interior Highlands, the Interior Plains – including the interior Low Plateaus, the Central Lowland and the Great Plains Province, the Appalachian Highlands – including the New England Province, the Atlantic Plain and the Laurentian Upland. These physiographic regions include regional habitats, which are based on the geology, hydrology and topography of the regions. Habitat regions (Fig 1) include the Pacific Coast, the Western Forest, Aridlands, Grasslands, Boreal Forest, Eastern Forest and the Atlantic Coast.[8]

COASTS
2 ARCTIC
3 BOREAL FOREST
4 WESTERN FOREST
5 ARIDLANDS
6 GRASSLANDS
7 EASTERN FOREST
8 SUBTROPICAL FOREST

Figure 1: North American Habitat Regions

The colonization of America radically altered the natural and cultural landscapes, their habitats, their species, and the indigenous cultures of the regions. Colonization brought invasive species, disease and overlays of governance,

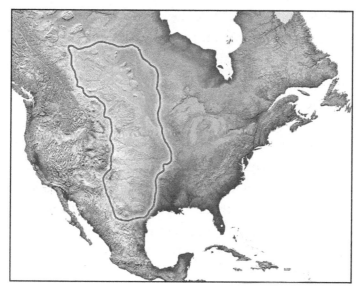

Figure 2: The Great Plains

religious dogma, legal writs, technical advancements, and the privatization and commodification of land, which have reduced the landscapes, species and cultures to a fraction of their former whole.

The grasslands

The shortgrass prairie ecosystem of the North American Great Plains (Fig 2) originally extended from the eastern foothills of the Rocky Mountains east to Nebraska and included rangelands in Colorado and Kansas and the high plains of Oklahoma, Texas and New Mexico to the south.[9] These rangelands were maintained by grazing pressure of American bison, the grassland's keystone species. The dominant grasses of the Shortgrass prairie are blue grama,

(*Bouteloua gracilis*) and buffalograss (*Bouteloua dactyloides*), which have adapted to the semi-arid continental climate of sporadic annual rainfall, extended droughts and high winds. The adventitious rooted, natural grasses of the Great Plains kept the soil in place and trapped moisture, even during periods of prolonged drought and high winds. Here the Plains Indians trailed the vast herds of bison that followed a seasonal migration across the grasslands. These included the Arapaho, Assiniboine, Blackfoot, Cheyenne, Comanche, Crow, Gros Ventre, Kiowa, Lakota, Lipan, Plains Apache, Plains Cree, Sarsi, Sioux, Shoshone, and Tonkawa. The second group of Prairie Indians, were semi-sedentary tribes who, in addition to hunting bison, lived in villages and raised crops such as corn, beans, squash and tobacco. These included the Arikara, Hidatsa, Iowa, Kaw, Mandan, Omaha, Osage, Otoe, Pawnee, Ponca, and Wichita. The tribes followed the migratory herds of American bison which were estimated by frontiersmen at 60 to 100 million animals in the early-19th century. By the close of the 19th century, in the span of a person's lifetime, the bison herds were exterminated by profiteer hunters, political decrees, military action, and manifest destiny.

The land was usurped and the natives suppressed through a series of laws, inventions, and technological advances. These included the development of the land survey system of 1775, the Land Ordinance Act of 1785, the invention of the plow that broke the plains in 1837, the tractor, which replaced the team of horses, the Homestead Act in 1862, the Hatch Act of 1887, the Enlarged Homestead Act of 1909, which populated Shortgrass

prairie lands without a reliable water source, and the Stock-Raising Homestead Act of 1916. These laws, combined with the nationwide expansion of the railroads, which established mechanized transcontinental transportation and telegraph networks with the development of a highway system in the 1920s, revolutionized the population and economy of the American West to which homesteaders, ranchers, settlers and speculators laid claim to lands forcibly abandoned by the indigenous people. The massive influx of new farmers eventually led to catastrophic land erosion on former shortgrass prairie land and the Dust Bowl of the 1930s.

The Dust Bowl area lies principally west of the 100th meridian on the High Plains. The area is semi-arid and receives less than 20 inches (510 mm) of rain annually. The rainfall supports the Shortgrass prairie biome originally present in the area.[10]

The region is also prone to extended drought, alternating with prolonged wetness of equivalent duration. During wet years, the rich soil provides bountiful agricultural output, but crops fail during dry years. Furthermore, the region is subject to winds higher than any region except coastal regions.

The unusually wet period, which encouraged increased settlement and cultivation in the Great Plains, ended in 1930. This was the year in which an extended and severe drought began which caused crops to fail, leaving the plowed fields exposed to wind erosion. The fine soil of the Great Plains was easily eroded and was carried east by strong continental winds. *Black Blizzards* occurred throughout the Dust Bowl,

causing extensive damage and turning the day to night. Witnesses reported not being able to see five feet ahead of themselves. The Shortgrass prairie had been broken by the plows and tractors.

The American bison had been exterminated by 1885, creating a broken trophic cascade. Jackrabbits multiplied during the wet years and starved in the dry years and descended from the hills to the farmers' withering fields by the hundreds of thousands in 1935. The farm families organized drives of rabbits, which were funnelled into pens where they were clubbed to death. The air was filled with their screams and cries. On April 14, 1935, Black Sunday, an eerie calm descended on the landscape, before the silence was broken by a cacophony of chattering calls and the sound of millions of birds in frantic flight ahead of the howling winds and approaching black clouds of fine dust, which turned day into night, blinding and choking all in its path. Many of the farmers thought that God was punishing them for their murderous acts. The dust clouds blew all the way to Chicago where dirt fell like snow. Two days later, the same storm reached cities in the east, such as Buffalo, Boston, New York City, and Washington D.C. That winter, red snow fell on New England.

Dust Bowl conditions, coupled with the economics of the Great Depression in 1929, formented an exodus of the displaced 2.5 million people from the Texas, Oklahoma, and the surrounding Great Plains states. More than 500,000 settlers were left homeless, by ecological catastrophe, unsustainable

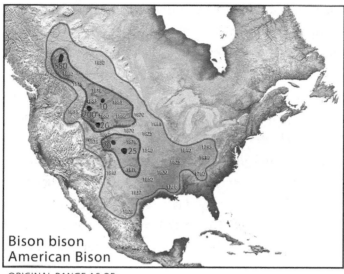

Bison bison
American Bison

ORIGINAL RANGE AS OF:

1870 1870 1889

DARK NUMBERS INDICATE NUMBER OF BISON AS OF JANUARY 1, 1889

Figure 3: The Extermination of the American Bison

farming and economic speculation.

Aside from the Native tribes' expulsion from their homeland, the Dust Bowl exodus was the largest migration in American history within a short period of time. By 1940, 2.5 million people had moved out of the Plains states. By the end of the decade-long drought in the 1940s, the demographics and political economy of the Plains had fundamentally changed.[11]

American bison

Bison were hunted almost to extinction in the 19th century

and were reduced to a few hundred by the mid-1880s from estimates of 60-100 million animals (Fig 3).[12] They were hunted for their hides, choice cuts of meat and tongues, with the rest of the animal left behind to decay on the ground. After the animals rotted, their bones were collected and shipped back east in large quantities on the new transcontinental railroads. The bison bones were ground down for use as fertilizer, for bone china and glue. The US Army sanctioned and actively endorsed the wholesale slaughter of bison herds. Bison meat was a daily ration for the soldiers at frontier outposts and stateside garrisons. The US Federal government promoted bison hunting for various reasons: to allow ranchers to range their cattle without competition from other bovines to weaken the North American Indian population by removing their main food source and to pressure them to resettle onto the newly-established reservations. Without the bison, native people of the plains were forced to leave the land or starve to death.

The current American bison population has been growing rapidly and is estimated at 500,000. However, most of the American bison herds are genetically polluted or partly crossbred with cattle. Today there are only four genetically unmixed herds of the American plains bison and only one that is also free of brucellosis that roams Wind Cave National Park. A founder population of sixteen animals from the Wind Cave herd was established in Montana in 2005 by the American Prairie Foundation. This herd now numbers 76 and roams a 121,000-acre grassland expanse on the American Prairie Reserve. According to scientists, small herd size, artificial

selection, cattle-gene introgression, and other factors threaten the diversity and integrity of the bison genome. The bison is for all practical purposes ecologically extinct across its former range, with multiple consequences for grassland biodiversity. Urgent measures are needed to conserve the wild bison genome and to restore the ecological role of bison in grassland ecosystems.[13]

The wood bison of the Boreal Forest can be readily discerned from the plains bison by body shape and larger size. In 1957, a disease-free, wood bison herd of 200 was discovered near Nyarling River in Wood Buffalo National Park, Canada. In 1965, 23 of these wood bison were relocated to the south side of Elk Island National Park and remain there today as the most genetically phenotypical wood bison. In 2008, the wood bison population in Elk Island National Park, Canada was estimated at 295. Wood bison are federally listed as threatened species in Canada and endangered species in America. Today, bison occupy less than 1% of their former historic range.

Gray wolf

Though once abundant over much of North America, the iconic gray wolf inhabits a very small portion of its former range because of widespread destruction of its territory, human encroachment of its habitat, loss of native prey animals and the resulting human-wolf encounters that sparked broad persecution by ranchers, who would kill wolves that might threaten livestock. Gray wolves were extinct in all of the lower 48 states by the 1970s except for Superior National

Forest in northeastern Minnesota. The federal government stepped in to protect wolves in the mid-1970s. Since then, wolf numbers have grown exponentially in Minnesota, Wisconsin, Michigan's Upper Peninsula and gradually in the northern Rockies. Wolves have also stabilized within Yellowstone National Park, where they were reintroduced in the 1990s. In 2003, the Fish and Wildlife Service divided the gray wolf's range into three areas and reclassified the Eastern and Western populations as threatened instead of endangered. The Eastern segment covered the area from the Dakotas east to Maine, while the Western segment extended west from the Dakotas. Wolves in the Southwest remained classified as endangered. After litigation, in 2004 the Eastern segment was divided to create a fourth segment for the Western Great Lakes region, including Minnesota, Michigan and Wisconsin, as well as in parts of North Dakota, South Dakota, Iowa, Illinois, Indiana and Ohio. In 2006, gray wolves in the Western Great Lakes region were removed from the threatened species list. The wolf population was estimated at 3,865 within the Western Great Lakes region. With deregulation, gray wolf management policies would be set by the states and tribes and could include the killing of problem wolves, which harass livestock or wolves, which stray into unregulated territory. Legal action returned the wolves to the endangered species list by the US Fish and Wildlife Service in 2009.[14]

Bald eagle
It is estimated that in the early 1700s, the bald eagle population

was 300,000–500,000, but by the 1967, when the bald eagle was listed as an endangered species, there were only 417 nesting pairs in the United States. The widespread loss of suitable habitat, illegal shooting and the use of DDT brought the bald eagle to the brink of extinction. With regulations in place and DDT banned, the eagle population rebounded.[15] The bald eagle can be found in growing concentrations throughout the United States and Canada, particularly near large bodies of water, such as the Mississippi River and her tributaries. The bald eagle was officially removed from the US federal government's list of endangered species in 1995 by the US Fish & Wildlife Service and was reclassified as a threatened species. In 2007, with close to 10,000 nesting pairs of eagles in America, the bald eagle was removed from the threatened species list.

The Fields Project – Icons of the Vanishing Prairies
Recognizing the near total collapse of the natural and cultural landscapes of the American grasslands to agriculture and developmental sprawl, I decided to design a monumental earthwork visible from passing aircraft that would communicate concern for the vanishing landscapes and endangered species of the American grasslands.

A site was chosen on a ridgeline of fallow fields. The fields were gridded in 10 feet intervals on each axis. Global positioning was used to position the design, where it was flagged on the grasses for cutting, using the corresponding gridded drawing and field grid to maintain accuracy. Farm

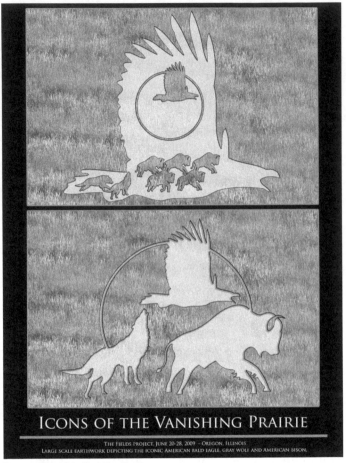

Figure 4: Icons of the Vanishing Prairies

families assisted with the tractor work and layout in 100 degree heat.

We soaked our feet in buckets of iced water at lunch before we returned to the fields. It took two days of field layout and a full day of cutting to complete *Icons of the Vanishing Prairies*.

The Fields Project – Icons of the Vanishing Prairies (Fig 4) is a monumental earthwork set in the Rock River Valley, Illinois on the historic easternmost edge of the former tall grass prairies. Here the iconic bald eagle, gray wolf and American bison, bound by a setting sun, are cut into fallow farm fields east of the Mississippi River. Since European settlement and westward expansion, there has been a 98% loss of the prairies east of the Rocky Mountains, with a subsequent loss of species. This work highlights the fragmentation and loss of the prairies and the near extinction of iconic species of the west, including the American bison, the gray wolf and the bald eagle. The work can be viewed from passing aircraft between Chicago, Illinois and Madison, Wisconsin. The cutting is gold within the green fields of summer, turns green surrounded by the flaxen fields of autumn, and becomes an intaglio in the snow over the winter months. The work is as ephemeral as the grasslands and the species, which inhabited them.

The tallgrass prairie
The tallgrass prairie is an ecosystem native to central North America. Prior to the Euro-American settlement in the 1820s, one of the major features of North America was 240 million acres of tallgrass prairie, which covered a large portion of the American Midwest, just east of the Great Plains, and also portions of the Canadian Prairies. The tallgrass prairie flourished in areas with rich loess soils and moderate rainfall of around 30 to 35 inches (760 to 890 mm) per year. To the east were the fire-maintained eastern savannas. The tallgrass

prairie biome depends upon prairie fires for its survival and renewal. Tree seedlings and intrusive alien species without fire-tolerance are eliminated by periodic fires, caused by lightning and man. Native Americans used fires to renew the prairie for grazing, to drive buffalo and to improve hunting, travel, and visibility. In the northeast, where fire was infrequent, storms and hurricanes represented the main source of disturbance in the climax beech-maple forests.

As its name suggests, the most obvious features of the tallgrass prairie are tall grasses such as Indiangrass (*Sorghastrum nutans*), Big Bluestem (*Andropogon gerardii*), Little Bluestem (*Schizachyrium scoparium*), and Switchgrass (*Panicum virgatum*), which average between 5 and 6 feet (1.5 and 2 m) tall, with occasional stalks as high as 8 or 9 feet (2.5 or 3 m). Prairies also include a large percentage of forbs, such as lead plant, Prairie Rosinweed (*Silphium terebinthinaceum*), and coneflowers (*Echinacea pallida*). The prairie communities can be divided into wet prairie, wet mesic, mesic prairie, dry mesic and dry prairie.[16]

Functionally, the prairie is composed of warm season grasses, cool season grasses, legumes, and members of the sunflower family. Technically, prairies have less than 5-11% tree cover. A grass-dominated plant community with 10-49% tree cover is a savanna.

In the space of a single lifetime, between 1830 and 1900, the biodiverse tallgrass prairie was steadily transformed to farmland. Centuries of accumulated loess and organic matter created a thick mantle of topsoil, which was opened

for farming with the 1837 invention of the steel plow by John Deere in Grand Detour on the Rock River in Illinois. Today, 98% of the original tall grass prairie has been converted to agriculture. The tallgrass prairie has become the breadbasket of America. Over time the family farm has been replaced by corporate family farm and corporate agribusiness, where seed is patented and crops are commodified. Concern has been raised about the impact of agribusiness on the family farm and the impact of genetically engineered crops on the surrounding landscape and species.[17]

Silent Shadows of Whooping Cranes

Over the years, I have been working on developing communication projects, which highlight endangered species and threatened landscapes. This work brought me to the Mid-west in 2004 when I was asked to create a work that celebrated the mid-western landscape. When I researched the area, I found that the Rock River Valley is within the migratory path used by millions of water birds flying across the heartland. I met with botanists who directed me to visit the prairies and meet those scientists, whose life work is the preservation of habitat and the nurturing of the migratory birds.

In 2004, I created Silent Shadows of Whooping Cranes (Fig 5), a monumental earthwork set in the Rock River Valley, Illinois. The work was cut into the fallow fields with the help of the local farmers. It highlighted the memory of the migration flight of the endangered cranes, the loss of critical habitat, and the current efforts to bring the species back from

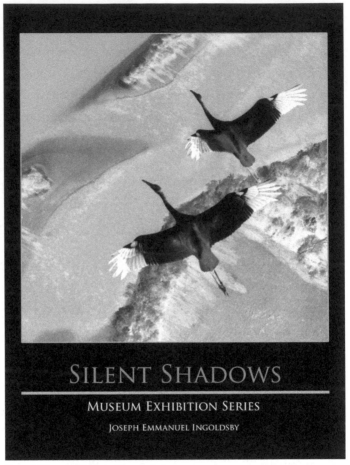

Figure 5: Whooping Cranes – Museum Series

the grave. It was broadcast on television, radio and was in the newspapers.

The Fields Project – Silent Shadows of Whooping Cranes is a large-scale installation within the fallow, agricultural fields of the Rock River Valley. Here, the shadows of whooping

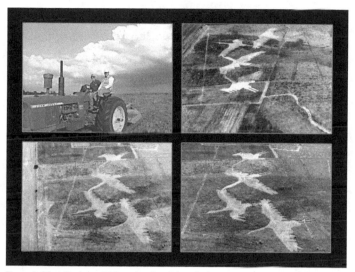

Figure 6: Silent Shadows of Whooping Cranes Installation

cranes in migration flight were cut into the farm field grasses, evoking the historic migration route of these magnificent and nearly extinct birds across the heartland of America. Each shadow spanned close to two acres. A recording of the whooping crane flight call was sounded at noon of each day. Their one-minute, eulogistic call broke the silence of their shadows. In nature, their call could be heard over a distance of two miles. The work was visible along the flight paths of passing jets and small planes. Historically, the nearly extinct whooping crane migrated across the heartland of America. It is estimated that 1,400 whooping cranes existed in 1860. The species was nearly wiped out in the last century with habitat loss, agriculture, development pressures and indiscriminate hunting. Their population declined until 1941 when the last

migrating flock dwindled to an all-time low of 15 birds. Now, the migration is all but a memory. The wetlands and prairies were ideal stopover points for the whooping cranes as they migrated south to their coastal winter range. Today a remnant population is being hand raised and nurtured to fly across the heartland of America once again.[18]

The work *Silent Shadows* is based on research and discussions with the International Crane Foundation, the Whooping Crane Eastern Partnership, Operation Migration, the Nature Conservancy and residents of Oregon, Illinois. I looked at species loss, the prairie landscape and the issues of land use conflict using art to communicate a concern to all who fly, like the cranes once did, across the heartland of America.

Effigy mounds

I returned to the midwest in 2005 and 2006 to continue my research on the prairie landscapes and the migration of the cranes and began to focus on the monumental earthworks called *effigy mounds*, which date from the Woodland period of 700 to 1200 AD. The ancient mounds take the shape of animal forms such as water spirits, bears, man, shaman, winged man and eagles, representing the cosmology of the Woodland cultures. The mounds were constructed at sacred sites across the Mississippi River Valley. The Mississippians built pyramids, temples and plazas, representing a sophisticated culture of language and architecture, similar to classical Aztec.

I began my pilgrimage following the notations of Indian Mounds of Wisconsin[19] with the blessing of the Ho-Chunk Nation and with a guide from Southern Wisconsin Watershed. We stood upon a ridge-line dotted with a series of solstice mounds that were built by the Woodland people during their golden period from 700 to 1200 AD. The mounds are conical with some exceptions. The spring solstice mound is in the shape of a pregnant woman, the Corn Mother, whose knees are the distant hills on the horizon. She gives birth to the sun in the spring. Between her knees the sun rises, casting off the darkness of the long winter in Wisconsin. Below, upon the Southern Wisconsin River valley are hundreds of mounds in the shapes of animals built willow-basket-of-earth by willow-basket-of-earth by the Woodland people a thousand years ago. Today, many of the mounds are a memory or have become part of the scenery as farmers' plows reduce the mounds to flat cornfields or as forest reclaims the floodplain of the broad southern Wisconsin River, where sand bars form islands in the broad expanse of river. This was fertile ground and a sacred place for the Woodland people.

Here, a thousand years ago was a thriving community whose cosmology spoke of the Underworld, Earth, the Upperworld and Afterlife. Each had a vocabulary of forms. The Underworld used a progression of conical mounds, long barrows and water spirit forms. The Earth spoke of bear, deer, fox, man and shaman. Winged men form a transition to the Upperworld where birds of prey predominate. These birds were the vehicles to the afterlife. Many of the mounds

contained the remains of Woodland chiefs and dignitaries. At Eagle Township, there is an eagle one quarter of a mile long, which is slowly disappearing with each season of plowing. This is a tragedy for us all, for with each season we lose a part of the rich tapestry of the cultural history of the land. We are running out of time.

Crane Effigy Mounds

The *Crane Effigy Mounds* is my public art earthwork proposal, produced in collaboration with a broad spectrum of participants. The work is based upon traditional effigy mound construction and symbols of the Woodland golden period and uses the endangered whooping crane and massasauga swamp rattlesnake of Necedah, Wisconsin as earth effigy forms on land restored as prairie and savanna habitat for the endangered Karner Blue Butterfly.

As part of the research for the large scale earthwork, I visited the Wisconsin Historical Society archives to see the original plates of the early explorers to the sacred mound and pyramid sites before they were destroyed by farming, settlement, vandalism and neglect. I spoke with the authors of *Indian Mounds of Wisconsin*. I made pilgrimages to the mound sites in 2004 and 2006. In 2006, I spoke with the Ho-Chunk Nation archeologist and was invited to speak to the traditional court of the Ho-Chunk Nation. I was interested in the meaning of the symbols and their relationship to site. I also wanted to confirm that the Crane Effigy Mounds was appropriate, reverential and respectful to the traditional

culture and religion of the Ho-Chunk people. The traditional effigy forms inspired and gave meaning to the *Crane Effigy Mounds* construction proposal.

The *Crane Effigy Mounds* blends the traditional with the modern in an environmental advocacy piece representing cranes in flight on a 7.37 acre parcel adjacent to the Necedah regional airport. As part of the creative process, I approached the Village of Necedah, which has agreed to donate the village land for the permanent installation of this important work. The villagers feel that art that bridges history, cultures and the environment and which encourages participation and reflection will benefit the greater community of 26,656 Juneau County residents and the 150,000 eco-tourists who tour the whooping crane habitat at Necedah National Wildlife Refuge each year. The *Crane Effigy Mounds* ties in with the long-term open space and recreation goals of the Village of Necedah and dovetails with planning and fundraising efforts – Senate Bill HR 5386 for a new visitor center and interpretive trail system at the Necedah National Wildlife Refuge. The trail system will begin adjacent to the *Crane Effigy Mounds* and tie in to the bike trail through the Village of Necedah. Support was also gathered from the US Fish and Wildlife Necedah Wildlife Refuge, where whooping cranes are raised from eggs, nurtured and prepared to make a migration toward ancestral wintering grounds in Chassahowitzka, Florida – flying behind Operation Migration ultra-light planes, serving as surrogate parents to teach them the route. As part of the creative process, I worked with Operation Migration to gather photographs of the birds

in flight. I visited Necedah to see the endangered cranes and travelled to Florida to see the cranes after a their 64-day journey from Necedah to Chassahowitzka.

To date contact has been made with the Village of Necedah, the Juneau County Economic Development Board, Operation Migration, International Crane Foundation, the Ho-Chunk Nation Archaeology Department and the Tribal Council, the Wisconsin Historical Society, University of Wisconsin at Madison, and with experts in prairie restoration and effigy mound construction. Presentations have been made to community boards and to the Traditional Court of the Ho-Chunk Nation, Wisconsin. Support has been given by the community and by environmental organizations.

We want this to be a celebratory community work with donations of land, earth materials, machinery and some labor to help hold down costs on this two year project. The Village is donating survey and engineering work, volunteers are cutting the locust trees, and the DNR is offering earthmoving equipment to prepare the site. We will solicit further commitments as construction approaches. The artist has researched the project over a three-year period with pilgrimages to the summer prairies of Wisconsin and Illinois and met with botanists and academics at the University of Illinois-Urbana and the University of Wisconsin – Madison and the US Fish and Wildlife Service regarding the pattern of the prairie landscape.

Large-scale site models of handmade cast prairie paper were made prior to the earthwork construction and will be

permanently displayed at the Necedah National Wildlife Refuge in the future. The prairie plants were gathered from Necedah and other locations along the route of the migrating whooping cranes to Chassahowitzka, FLA on the Gulf coast. Mapping pinpoint critical nodes along the migration route. As part of the work, lectures were given about the whooping cranes, the massasauga, and the Woodland culture's effigy mounds within the Mississippi River valley. Also, school groups participated in the making of the large scaled moulds and the actual paper making for the large scaled site models. In the process, art will become an educational avenue to learn about the prairies of the Midwest, the overlay of migration patterns of man and bird, endangered species and the culture of the ancient Woodland peoples and their legacy for all Wisconsin residents and visitors to Necedah.

Crane Effigy Mounds pays homage to the mound builders of Wisconsin and serves as a clarion call to protect the endangered whooping crane and endangered massasauga rattlesnake, killed off by bounty hunters and by the loss of wetland habitat. Prior to the European settlement of Wisconsin and the legislated killing of the Massasauga rattlesnake, the snakes hibernated in crawfish and animal burrows in wet but not flooded soils below the waterline and emerged from their winter hibernation in such numbers that members of the Snake Clan, gathered on the banks of the Yellow River to watch the swamp rattlesnakes emerge by the hundreds and swim across the Yellow River of Necedah to higher ground. The river became a sea of snakes.

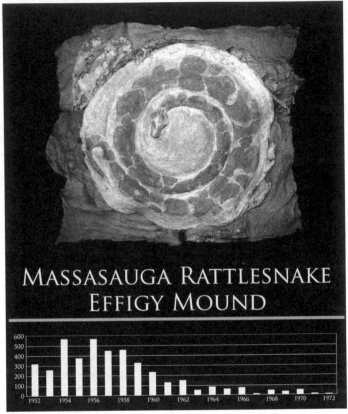

Figure 7: Massasauga Rattlesnake

The Massasauga "swamp" rattlesnake is a venomous endangered species that has all but disappeared from 52 of the 62 townships in which it was found before 1952 in Wisconsin. A bounty was placed on their heads by the Wisconsin legislature between 1952 and 1972 with a devastating effect to their sustainable survival. The graph (Fig 7) shows the population decline in Wisconsin from 1952 to 1972 as a result

of the extirpation.[20]

Work on the actual construction of the mounds is dependent on many factors, including funding. When I came before the Council of Elders, I sought help to place the work in context. The Elders correctly, in retrospect, called the project modern. I thought of it as being educational and reverential art. But it is very true that the work is not a sacred effigy mound. The *Crane Effigy Mounds* use mounded earth depictions of whooping cranes and a massasauga rattlesnake coiled around the observation hill. The whooping cranes along the road are mounds depicting the flight of the whooping cranes and show the wing movement of the birds in flight. These forms are not traditional.

The Council of Elders within the Traditional Court spoke of preserving the meaning and memory of the ancient effigy mounds and that the physical form is secondary. The official policy of the Ho-Chunk Nation is that the historic effigy mound sites are sacred and they can be neither restored nor replicated. The effigy mounds on native lands will be reabsorbed by Mother Earth and remembered by song and story in the future.

I asked, in turn, if preserving the actual physical monuments for all time will teach future generations of the cultural legacy of the Woodland people and in turn the Ho-Chunk nation. The question was never answered.

Restoration of the landscape for the Karner Blue Butterfly
The ancient glacial sand deposits of Necedah evolved into

savanna, pine barrens and southern upland forest. Savannas are partially forested upland communities, maintained by fire with a strong prairie or barrens component in the understory. Bur oak and black oak are the most common trees of canopy with jack and red pine of the pine barrens. Beneath the canopy, herbaceous bluestem and grama grasses are dominant with a mix of bracken fern, forbs and scrub oak in the understory. This is a critical habitat for the endangered Karner Blue Butterfly, who is dependent upon the blue lupine and nectar plants for survival. The oak savannas of the Midwestern United States form a transition zone between the western Great Plains and the eastern broadleaf and mixed forests. Midwest oak savannas are among the world's most threatened communities). Prior to European settlement, oak savanna covered approximately 27–32 million acres of the Midwest. In 1985, only 113 sites (2,607 acres) of high-quality oak savanna remained. Nationwide, over 99% of the original savanna has been lost to agriculture, fire suppression, and over-grazing[21] and Midwest oak savannas are among the rarest and most endangered ecosystems in the nation.[22] Development has destroyed, fragmented, and disrupted natural processes needed to maintain quality savanna ecosystems.

The Village of Necedah's land donated for the *Crane Effigy Mounds* installation is degraded with invasive locust trees and invasive spotted knapweed. The seven acre site will require remedial action, including cutting the locust, grubbing out the roots and stripping the contaminated soil for mound construction. Once the contaminated soil is stripped,

fresh uncontaminated sandy soil can top dress the site in preparation for seeding. Andropogon is to be used on the mound with savanna grasses interspersed with blue lupine as a food source for the endangered Karner Blue Butterfly.

The hope is that this site would be a satellite breeding area for the dispersal of the Karner Blue Butterfly along the Reservation prairie verge. If habitat restoration is successful, the adjacent airport land, also degraded with spotted knapweed, would be restored, coordinating with the Private Lands Program, adding 100 acres of habitat for the Karner Blue Butterfly.[23]

Wetland

The landscape of Necedah, Ho Chunk for "land of yellow waters", was formed by retreating glaciers ten thousand years ago creating vast peat bogs and sand-ridges. Peat bogs evolved into wetlands, prairie communities and Shrub Carr dominated by tall shrubs. Sedge meadows are open wetlands dominated by sedges and grasses. There are several common subtypes: tussock meadows, dominated by tussock sedge, and the grass bluejoint, broad-leaved sedge meadows, dominated by the robust sedges Carex species, wire-leaved sedge and few-seeded sedge. Also frequent are marsh bluegrass, manna grasses, panicled aster, joe-pye-weed, and the bulrushes.

With a permit from the US Fish and Wildlife Service, I gathered these wetland plants at Necedah to use in the creation of paper to cast works within my Environmental Advocacy for an Endangered Species series including: *Shrouds for an*

Endangered Species and *Spirits of Whooping Cranes*. The panels were displayed at the University of Wisconsin Arboretum Steinhauer Gallery and the Necedah National Wildlife Refuge in 2009.

As Artist in Residence at Necedah for 2009, I installed hand-made, prairie fiber paper casts of whooping cranes at critical points within the whooping crane's native habitat. The paper cranes will be allowed to return to the earth, illustrating the slender thread between an endangered species and an extinct species.

The artist can play an integral role in the raising of the public consciousness through environmental advocacy. Art can be used to communicate complex ecological and scientific principles to an audience outside of the confines of the academy or science museum. We stand at a crossroads at a critical point in time. There is an urgent need for comprehensive habitat protection strategies and planning for green infrastructure to avert or slow the process of landscape loss and species extinction. Science can be communicated to the people using art to help educate government officials and fellow citizens about native species and habitats and the benefits they provide.

I have found it necessary to build diverse coalitions to promote a better understanding of science and by exhibiting work within the threatened landscapes to engage the local population. This translates into local initiatives to protect and expand critical natural habitats, to restore native landscapes, and to provide habitat for threatened species. The fieldwork is

supplemented with gallery and museum exhibitions, lectures and writings to connect with a national audience on critical issues such as climate change, vanishing landscapes and endangered species.

Notes

1. *Center for Biodiversity and Conservation, American Museum of Natural History. Humans and Other Catastrophes: Perspectives on Extinction. A summary of the April 1997 symposium of the same name; Wilson, E. O., The Diversity of Life, New York: W.W. Norton & Co., 1992. Also see Wilson, E. O., The Future of Life, New York: Knopf, 2002.*

2. *Stein, B. A., L. S. Kutner, J. S. Adams, eds. Precious Heritage: The Status of Biodiversity in the United States New York: Oxford University Press, 2000.*

3. *North American Bird Conservation Initiative, US Committee, 2009. The State of the Birds, United States of America, 2009. US Department of Interior: Washington, DC.*

4. *Loarie, Scott R., Duffy, Philip B., Hamilton, Healy, Asner, Gregory P., Field, Christopher B., Ackerly, David D.The velocity of climate change, Nature 462, 1052-1055, December 2009.*

5. *Ingoldsby, Joseph E., Vanishing Landscapes: The Atlantic Salt Marsh, Leonardo Journal, 42-2-2009, MIT Press.*

6. *Ingoldsby, Joseph E., Requiem for a Drowning Landscape, Orion Magazine, March/April 2009.*

7. *Ingoldsby, Joseph E., Vanishing Landscapes and Endangered Species, University of Wisconsin-Madison, Arboretum, 2009 http://www. josephemmanuelingoldsby.com/vanishing_landscapes2.html*

8. *H. John Heinz Center for Science, Economics, and the Environment, The State of the Nation's Ecosystems, Cambridge University Press, 2002 and . North American Bird Conservation Initiative, US Committee, 2009. The State of the Birds, United States of America, 2009. US Department of Interior: Washington, DC.*

9. *Fitzgerald, Edward, Map of the Great Plains, Center for Great Plains Research at Univ. of Nebraska-Lincoln, 2008.*

10. *Colorado Water Resources Research Institute , "A History of Drought in Colorado: lessons learned and what lies ahead", February 2000.*

11. *Stock, Catherine McNicol , Main Street in Crisis: The Great Depression and the Old Middle Class on the Northern Plains, p. 24. University of North Carolina Press, 1992.*

12. *Hornaday, W.T. and Gannett, Henry, E.M. Map illustrating the extermination of the American bison, United States: Government. Printing Office, 1889 Library of Congress Geography and Map Division Washington, D.C.*

13. *Curtis H. Freesea,*, Keith E. Auneb, Delaney P. Boydc, James N. Derrd,Steve C. Forresta, C. Cormack Gatese, Peter J.P. Goganf, Shaun M. Grasselg,Natalie D. Halbertd, Kyran Kunkelh, Kent H. Redford Second Chance for the Plains Bison, Biological Conservation, Volume 136 No 2, April 2007.*

14. *US Fish & Wildlife Service, Gray Wolf in Recovery in Minnesota, Wisconsin, and Michigan, December 7, 2009.*

15. *EPA press release (1972-12-31). "DDT Ban Takes Effect". United States Environmental Protection Agency.*

16. *Jones, Stephen R., Cushman, Ruth C. A Field Guide to the North American Prairie, Peterson Field Guides, Houghton Mifflin, 2004.*

17. *Jackson, Wes, The Western Landscape , Interview Transcript , Land Institute.*

18. *Operation Migration, Ultra-light Led Bird Migration, http://www. operationmigration.org/work_weranes.html*

19. *Birmingham, Robert A. and Eisenberg, Leslie E., Indian Mounds of Wisconsin, The University of Wisconsin Press, 2000.*

20. *Johnson et al. 2000. The Eastern Massasauga Rattlesnake: A Handbook for Land Managers. US Fish and Wildlife Service, Fort Snelling, MN 55111-4056 52 pp. + appdx.*

21. Nuzzo, V.A. 1986. *Extent and status of Midwest oak savanna: presettlement and 1985. Natural Areas Journal* 6: 6-36.

22. Noss, Reed F., *High-risk ecosystems as foci for considering biodiversity and ecological integrity in ecological risk assessments. Environmental Science & Policy, Volume 3, Issue 6, December 2000, 321-332.*

23. *Xerces Society, The Butterfly Conservation Initiative, Karner Blue Butterfly,* 2001.

DESIGN OUTLOOKS

The Visitor Experience at Science Exhibitions: Design, Exhibits and Interactivity

ANTONIA HUMM, GUNNAR M GRÄSLUND

& JÖRG SCHMIDTSIEFEN

ArchiMeDes Berlin

How do scientists receive signals from space and what can they deduce from them? What methods do nanotechnologists use to manipulate atoms and molecules? How does the brain work? And what can we learn from cockroaches?

The challenge for science exhibitions lies in presenting such complex issues. On closer inspection, preparing scientific topics for a wider public proves to be a multi-dimensional task: not only does the subject matter have to be translated into a comprehensible language, it also has to be presented in such a way as to arouse the interest of visitors. However, this alone is not enough; it is just as important to sustain visitors' interest for a long period of time despite the often highly abstract subject matter. This can only be achieved by capturing visitors' attention and conveying information through fascination.

To do so, a range of means can be used that essentially contribute towards a varied and stimulating exhibition and therefore visitor experience.

What role do scientific exhibits play in this? And how can they be made comprehensible to the visitors? What role does exhibition design play? And how can it support the subject matter of an exhibition and successfully capture the attention of visitors?

Exhibits
Exhibits are the heart of an exhibition and can illustrate a certain issue whilst enlarging upon or explaining it. Interactive exhibits are ideal for illustrating complex

SCIENCE EXHIBITIONS

scientific subjects as they directly involve visitors. People who become actively involved in something are more attentive and receptive, which enables them to experience an exhibition by engaging several senses – be it visually, acoustically or haptically. This also leads to a more in-depth transfer of knowledge and experience.

A distinction should be drawn between original scientific objects and interactive hands-on exhibits developed specifically for exhibitions.

Original objects

Objects drawn from scientific research are an essential part of science exhibitions, providing a direct link to scientific practice. The fascination of the original – authenticity – is inherent in them. These exhibits provide a direct link to scientific work as they exemplify what researchers do day after day. However, many scientific objects need adapting before they can be incorporated into an exhibition. Just how this is achieved depends on the nature of the individual exhibits and the context of the content matter. Here we outline some methods for adapting exhibits using several examples: visualisation, contextualisation, and the creation of function and interaction.

Larger – smaller

Scientific objects are often difficult to exhibit because they are too big, too small, visually unattractive or overly complex. Only once they have been reconstructed or converted into a

model do such objects become suitable exhibits.

For example, one object only a few centimetres in size – a bent film with tiny electronic circuits printed out of synthetic material – was far too small. To make the printed transistors and memory cells visible to visitors, a simple change was all that was needed: the object was provided with a magnifying glass.

However, if one wants to make structures on a nanometric scale visible, optical aids are no longer an option. A synaptic vesicle (a cell component responsible for transporting proteins) measuring about 40 nanometres in reality could – when simulated in model form – be shown in a 3-D reconstruction at almost atomic resolution.

Models also enable objects to be shown in exhibitions which would otherwise be far too big for any space. A model of the test reactor ITER, in which energy is generated through nuclear fusion, is fifty times smaller than the original but provides an impression of the structure of the reactor.

Contextualisation through presentation

By creating a suitable environment, incomprehensible objects can be explained and made more appealing. Such contextualisation can be achieved through presentation or supplementation with appropriate image resources.

An original probe from the *IceCube* – a glass ball containing electronic components – which verifies flashes of light from neutrino reactions from space, is not comprehensible in itself. As probes of this kind are buried 1.5 to 2.5 kilometres

in the Antarctic ice attached to long ropes, the object was also suspended in this way at the exhibition. It was supplemented with photos and illustrations that not only showed the research station in the Antarctic, but also how it works.

How can nondescript grains and ears of corn be presented in an exhibition? In order to render the evolution of wheat from a primitive grain to our modern forms of cereal comprehensible, the objects were provided with a specially constructed showcase that shows the plant parts in an arrangement reminiscent of a family tree, thus illustrating how they are related and their lineage.

Functional objects

Research labs also produce objects that are unsuitable as exhibits because their function is not immediately obvious to the layperson: they may be incomplete, too unstable or impractical for visitors. In such cases, alterations can help turn a research object into a visitor-friendly exhibit.

For example, flexible thin film solar cells, where it is not immediately obvious how they work and move, were installed so that visitors can activate them at the touch of a button. The light from two lamps ensures that the solar cells generate energy and use it to move.

A research institute provided diffractive elements for another exhibit, the structures of which are computer generated. The aim was to show that laser light can practically be redirected at will. The elements had to be integrated so as to make their properties visible. A solution was found

that enabled the visitors to move a laser beam through the differently structured elements. The result was astounding: despite the moving laser beam, the image projected onto the wall did not change.

Scientific experimental arrangements and prototypes from research labs can also be extremely effective in explaining complex issues at exhibitions. However, such objects rarely satisfy the requirements of an exhibition with thousands of visitors.

For instance, for one exhibit it was necessary to simulate a scientific experiment where researchers study whether haptic impressions – i.e. feeling objects – contribute towards visual face recognition. The research institute provided the basic idea and key components that were transformed into an experiment fit for an exhibition: the visitors could feel a hidden sculpture of a face before matching it to a two-dimensional portrait at a media station.

The prototype of a sensor that measures the CO_2-content in room air and therefore monitors its quality was unsuitable for an exhibition because its sensitive measurement technology was unprotected. The challenge lay in enabling the visitor to try out the device whilst keeping it protected. This required the total reconstruction of the device, which included installing a measurement section that visitors could blow on to observe the effect of the increase in CO_2. However, care also had to be taken to ensure that any gas was quickly led away in order to get the device ready for the next visitor.

Hands-on exhibits and media stations

Suitable exhibits from research are not always readily available for science exhibitions. In order to convey complex subject matter or enable items to be experienced using the senses, it is recommended that exhibits be specially developed. We here concentrate primarily on interactive exhibits which involve visitors and so usually attract a lot of attention.

Hands-on exhibits: These exhibits do not necessarily have to be highly complex. Simple exhibits can also make for a spectacular visitor experience thanks to the interaction offered. For instance, one exhibit demonstrates how the outbreak of epidemics can be prevented by measuring temperatures, as carried out at some airports using heat technology. Visitors are photographed with an infrared camera and see themselves and their body temperature on an infrared picture on a monitor. The experience of seeing one's own picture means that the identification potential of the exhibit is high.

For some exhibits, a simple action like pressing a button is sufficient to interact with them. For example, a "glass" head can show visitors which areas of the brain are active during certain activities, such as reading or speaking. The corresponding region lights up on the head using cross-sectional images of the brain taken with magnetic resonance imaging.

Other exhibits facilitate more complex interaction, such as a demonstrator that explains how light in any given colour is produced from red, green and blue LEDs. Visitors can soften

or intensify the light of the different LEDs with the controls, thus creating their own wide range of light colours.

Some exhibits require the full use of the body and thus provide a particularly powerful experience. Using an exhibit that explains bionic matter by purely mechanical means, for example, visitors can experience at first hand why cockroaches can run over wire mesh without any difficulty. They are given shoes equipped with spikes, just like the legs of cockroaches, and have to run across a coarse-meshed grid. While this would be impossible wearing normal shoes, visitors discover that with their "cockroach legs" they can do it.

Media stations: Interactive media stations not only offer sophisticated opportunities to interact, but also the possibility to provide a large amount of in-depth information. As the information is not obvious at first glance, visitors are not overloaded from the outset and can decide for themselves what they want to see and how far they would like to go.

One example of this is an interactive table with a motion-sensitive surface, which enables several users to simultaneously interact precisely and intuitively by making gestures. The symbols found on the surface can optionally be moved, magnified or activated in such a way that other information planes appear. Such a table can be used for a wide variety of different applications. In the *Science Express* exhibition, for example, it served as an information source to illustrate global challenges. Visitors could select different locations on an interactive map of the world and obtain information at different levels on over-fishing, food

production and population trends.

Media stations can also be combined with other interactive elements. They then serve as a communication platform that provides visitors with specific information or feedback. One example of this is an exhibit that shows how large-scale test series are conducted in labs today using pipetting robots. Visitors can pit themselves against the robots, which fill the micro-titre plates with test substances at high speed, by trying it out for themselves using a pipette and seeing how they fare compared to the robots. A computer calculates the results, which are then displayed on a screen.

Children's exhibits

Children of different ages can become engaged in scientific topics in a fun way through appropriately designed exhibits with simplified presentations.

Walk-in exhibits appeal to small children, such as fluffy spherical seating alcoves in the shape of a sun, inside which a sound installation explains our solar system. In a tunnel which the children can crawl through, child-oriented drawings and background sounds help them find out more about regenerative energies.

The following children's exhibits on bionics and nanotechnology are marked by a higher degree of complexity and interactivity. The basic principle of bionics – i.e. modelling technical inventions on nature – is explained by three rotating cubes that can be arranged in such a way that the natural model, its close-up and its technical realisation stand

side-by-side. The approach of researchers in nanotechnology, who build atoms from innovative materials, however, makes the exhibit comprehensible, with children piecing together figures out of magnetic balls.

Highlight exhibits and the exhibition storyline
An exhibition's storyline is an essential means of keeping visitors interested as they go through the exhibition. It is important to alternate between spectacular and quieter passages. Especially attractive exhibits can be regarded as the highlights. These are primarily items that appeal to visitors through their size, striking appearance or a particularly impressive interaction.

At the *Science Express* exhibition, for instance, a split-flip display was installed at the entrance, constantly displaying new questions on the future. Several metres in length, the wall's sheer size, the sound of the letters as they flipped over and the constant movement caught everyone's eye and whetted visitors' appetite for what lay ahead (Fig 1).

A bright, moving giant globe drew attention to the middle of the exhibition. Visitors could use a touch screen to select certain websites that displayed the often complicated paths (or detours) on the globe that the data takes around the Earth before it reaches us.

The exhibition design
At science exhibitions, exhibits do not speak for themselves as much as at art exhibitions, for example. Therefore, an

Figure 1: A split-flip display constantly displaying new questions on the future is one of the highlight exhibits in *Science Express*. ©www.archi-me-des.com / Oliver Wia

exhibition design is required that creates a suitable framework for the exhibits, or that is even capable of compensating for a lack of attractive exhibits. The design is of major importance to the exhibition to hold the visitors' attention and keep them interested for a longer period of time. If the images from an exhibition theme are successfully transformed into three-dimensional, accessible rooms and presented in such a way that visitors become directly involved in the proceedings, the exhibition design plays a considerable role in fascinating them. Visitors are then normally more receptive to the subject matter itself, which requires more effort and patience: the exhibition texts.

As a key element in information architecture, graphic design plays a crucial role in the presentation of texts. It marks different information levels of texts and pictures. A

consistent typographical concept makes texts easier to read, distinguishes text hierarchies and unitises text length. If an exhibition design is extremely varied, as in the case of *Science Express*, a consistent typographical concept is all the more important: its uniformity adds a degree of familiarity, and therefore stability and orientation. Furthermore, the graphic design defines relationships between textual and picture elements in such a way that the pictures can be deciphered clearly and easily with the aid of captions. This is achieved through consistently designed text/picture labelling and relationships.

The design of an exhibition always occurs within a suspense curve between the purely functional and the aesthetic. Whilst permanent exhibitions generally allow a lot of design freedom, even if the structure of the surrounding architecture needs to be taken into consideration, touring exhibitions are subject to greater functional constraints. They demand a higher degree of modularity to satisfy mobility requirements. Weight, manageability and compactness also play a crucial role. Consequently, the design of a touring exhibition calls for the development of a system construction kit where the components can meet the production, logistics and transportation requirements. The number of different components should be limited yet big enough to facilitate a flexible, large-scale design and provide adapted versions for individual venues. However, even in these exhibitions individual installations, spatially restricted entrance and exit objects, and highlight installations can be integrated to

make the design more relaxed.

In what follows, we will explain this approach to exhibition design using examples from our exhibition practice and illustrate what approaches are available. We will distinguish between two different approaches:

1. The design can directly refer to, reflect and thus illustrate the themes of an exhibition. The design then presents the subject matter. The following description focuses on this approach.

2. However, the exhibition design can also be abstract and find associative forms that transform the subject matter artistically. Not only can such forms be used to create a particular atmosphere, they can also connect the themes of an exhibition. In this case, the design highlights the subject matter and holds it together.

Whilst a higher level of staged and individual solutions is feasible in museum and permanent exhibitions, touring exhibitions are subject to a more reduced and abstract design composition.

Design reflecting content

The focus here is on the exhibition *Science Express*, which was completed in 2009, as it is a prime example of the many ways in which an exhibition design can present subject matter. Presented in twelve train carriages, the exhibition also included many different themes. Every carriage had a different design reflecting particular aspects of the individual themes and incorporating them in such an associative and emotional

way that one could even speak of twelve different exhibitions. What makes the exhibition so special is the extreme layout: a train over 300m long and only 2.8m wide.

The exhibition was commissioned by the Max Planck Society, one of Germany's most important science organisations, and showcased sophisticated scientific material to over 260,000 visitors in more than 60 towns across Germany. It addressed how science and technology is set to change our lives over the next 10 to 15 years.

Although the exhibition moves around, as far as its system requirements are concerned it is effectively a permanent exhibition as the exhibits are fixed in the carriages and do not have to be dismantled and reassembled.

During the following tour through the twelve carriages of the exhibition, we aim to illustrate how the subject matter was conveyed in the design.

1 Science Express: A carriage entirely in white greets the visitor. Leaving the outside world behind, it sets the mood for the exhibition, which will demonstrate how science and research is to affect our lives over the next two decades. The highly minimalist design forms a stark contrast to the hustle and bustle of the station. A timeline on the wall takes the visitor from the research milestones of yesteryear up to the present day. A split-flap display like the ones found at stations and airports comprises the central installation. However, instead of showing destinations and departure times, it constantly poses new questions about our future: How will we live in the future? Will we soon be able to read minds?

How old might we become? Can we stop climate change? In the background, one can hear the endless clatter of the letters as they flip over on the display; every answer raises new questions.

2 Where from + Where to: Visitors are surrounded by a large-scale picture of the universe. They look at their reflection, which gradually fades into the re-emerging image of outer space. In this walk-in installation, visitors are bombarded with fundamental questions about humankind: our place in the cosmos, the past and the future.

In this carriage, not only do we learn something about the roots of humankind, but also the origin of life on Earth. Looking further and further back into the past, it finishes with the origin of the universe – a topic that goes hand-in-hand with the question of the nature of matter. After all, all the building blocks that everything is made from, the elementary particles, originated from the Big Bang or shortly afterwards. Scientists simulate the extreme conditions from the time the universe originated in order to verify their theories on elementary particles.

Orbs and elementary particles inspired the design of the carriage. The design also plays with dimensions here, as giant orbs are scaled down and elementary particles magnified so they can be visualised by the visitor. The dark first section features mainly spherical elements – stylised orbs. The curved elements behind them evoke the curvature of space caused by mass. Whilst a variety of little spheres representing elementary particles structure a bright space in the central

area, the rear section features a bright orange wall panel. The colour refers to high energy physics, which stands for the study of tiny particles. The screen on the wall indicates theoretical physics, which – like string theory – endeavours to explain in models that which cannot be ascertained in experiments.

A mirror ceiling was fitted to make the room look bigger and enable visitors to see themselves in the exhibition setting.

3 Bio + Nano: A delicate structure stretches across the room (Fig. 2) – an amorphous form that tapers and opens out again. On one side, there is a hexagonal grid made of metal rods, which curves out in all directions and joins the organic structure sprouting up from the opposite side on the ceiling.

Some of the countless honeycomb-like alcoves this produces are decorated with colourful images of microstructures. The space behind the structure is reflected, duplicating it and widening the room.

Here, the blend of bio – and nanosciences predicted by science is translated into interior design. The technical structure, which is taken from nanotubes made up of carbon atoms arranged hexagonally, merges into the cell-like organic form. The two threads run in parallel: on the one hand, the exhibition shows what we can expect from nanotechnology in the future and how the world in miniature works; on the other hand, it deals with the rapid advances in biotechnology, which not only describes the molecular inventory of the cells,

Figure 2: The convergence of nanoscience and bioscience in the future is the main theme of the section Bio + Nano in *Science Express*. ©www.archi-me-des.com / Oliver Wia

but also helps to understand all the processes of life.

Both the structures merge at the rear of the room, where the advancing convergence between the nano – and biosciences is illustrated. The boundary between animate and inanimate nature is becoming blurred. For instance, integrated circuits communicate with living cells and programmable micro-organisms are becoming the materials, energy and chemical producers of the future.

4 Info + Cogno: A room entirely in black and white. The minimalist colour scheme accentuates the form of the netlike structures, which completely surround the visitor.

The theme of this carriage is two different kinds of information processing: neurology, which is based on biology, and information technology, which is based on technology. How does our brain work? What procedures can be used to

simulate brain functions? Can our feelings and actions be explained solely through biochemical processes? These topics are embedded graphically in structures on the wall, ceiling and floor which represent nerve cells. The computerised information processing, however, is accompanied by structures based on conductor paths. Considerations for future computer technology are aimed at revolutionising the performance of computers through groundbreaking technologies, such as quantum or biocomputers.

The central area focuses on merging the two fields: here, the nerve cells blend with conductor paths. Will brain computer interfaces be able to connect the brain directly to computers in the future? And will it be possible to perfect artificial intelligence in such a way that they can become increasingly like us?

5 Networked + Global: The use of light and dark creates the illusion of dynamism and speed in this room. The effect is created by walls broken by a series of bright horizontal stripes of varying width that seem to be speeding through the room.

This section of the exhibition deals with the digitisation of our world and the possibilities that global information and communication networks offer. More and more people are involved in the global exchange of information and the global production of knowledge: global scientist networks, the collection of scientific data in accessible databases, the internet of tomorrow and computer-network-based grid-computing all help to increase knowledge exponentially and

better understand the complex relationships.

The principle of networking and signal transmission at the speed of light thanks to fibre optics formed the basis for the design. For instance, the light strips are derived directly from the light conductors of data cables and the light/dark contrast heightens the notion of speed. The graphic design of the carriage walls is a key design element. Typography incorporated into the light strips does not serve primarily as an information carrier here, but rather generates images.

6 Intelligent + Virtual: The visitor is sucked into an irregularly shaped, cavernous room with curving, rib-like arches confined by vertical light strips. These arcades, the passageways of which visually overlap in the centre, give the room a dynamic character and form alcoves containing exhibits that are not immediately visible.

The latest findings from materials research and innovative production processes are showcased. For example, scientists are developing materials with new properties that facilitate applications that have not been possible until now. Conductive synthetic material can be used to make electronic paper for instance.

Innovative production processes also change our product world. For example, computer-controlled machines can produce low-cost complex forms designed with CAD programmes, such as custom-made items.

The design refers directly to these production processes. The complex amorphous overall shape, which results from many differently shaped components, could only be realised

with digital design and production techniques – like the arrangement of the elements, each of which points towards the middle at different angles. The lamination of the components is reminiscent of rapid prototyping – a new way of producing objects by printing them three-dimensionally layer by layer.

7 Effective + Individual: A spotlessly clean, cool atmosphere greets the visitor as modern medicine enters the spotlight. The dominant colours are shades of blue, from turquoise to navy, and the material is transparent and shiny, evocative of a futuristic operating theatre.

The potential of current medical research is presented here: from the deployment of innovative medical technology, which provides spare parts for the body, novel operating techniques and diagnosis methods, to personalised medicine, which in future will be able to offer courses of therapy that are tailored to suit the specific needs of the individual. Findings from genome research will make this possible.

The design reflects how technological advancements increasingly enables us to explore the human body in more detail (Fig. 3). Inspired by tomographic images, the layer grid is found in the sectional models – a key design element. The walls are also structured by horizontal transparent acrylic glass panes, as are the organically shaped exhibit tables that bulge out of the walls.

8 Healthy + Productive: Nature and the lab – our agriculture moves between these two poles. Large-scale background pictures of orchards and cornfields on the one hand and research labs and greenhouses on the other characterise

Figure 3: The potential of current medical research is presented in the carriage *Effective +*
Individual. ©www.archi-me-des.com / Oliver Wia

this carriage, which raises the issue of our future diet.

How will we feed the constantly increasing world
population? What role will genetically modified organisms
play in this? However, in the question of global nutrition, it
is not only the how that is of interest, but also the what. After
all, what we eat affects our health. In future, we might adapt
our diet to our genetic make-up in order to prevent the onset
of particular illnesses.

Next to the large-scale photos, spherical greenhouses
structure the room, the design of which formally follows the
project Biosphere 2. For example, interior spaces are formed,
which focus on what goes on in research laboratories and
greenhouses. The orientation towards interior and exterior
spaces is also reflected in the floor design, which alternates
between soil and field structures and the concrete floor of a

greenhouse.

9 Sustainable + Efficient: Visitors find themselves in a forest of birch tree trunks; a warm orange light radiates from the background (Fig. 4).

Energy and the environment are the themes here. This carriage shows what methods man uses nowadays to examine natural cycles and what technologies help to sustain habitats. One important aspect of this is the future generation of energy: our planet's climate greatly depends on it. Different methods for future energy production are showcased – from the improvement of traditional energy production and intelligent use of regenerative processes to the possibility of producing energy from methane ice or nuclear fusion.

Whilst the forest represents the environmental sector, the energy sector is portrayed in the form of bright red-orange lighting against a dark background, evoking heat and fire. The light strips running along the length of the carriage are reminiscent of the shape of fuel rods and represent electricity, energy and dynamism. Backlit graphics enhance the effect.

10 Flexible + Digital: Technical developments are set to change our everyday lives and mobility: vehicles, buildings and equipment will become more economical in terms of energy and therefore more environmentally friendly. At home, systems will emerge through a network of household appliances that are easier to use and can be adapted to suit our needs. The increase in traffic could also be controlled more effectively through intelligent systems and above all become safer.

The development departments of large companies

primarily work on improving our home environment and mobility. That is why the carriage design is made to look like a research lab. Exhibits from research departments are presented in a white room to keep attention fully focused on the main objects. A few graphic elements that are based on design sketches and accentuate the high-tech studio character are used sparingly on the walls. The only eye-catching design element – a spiral-shaped structure that serves to present car models – adds an element of dynamism.

11 Natural. Artificial: A shimmering room full of colour. A screen of colourful, illuminated tiles that constantly change the lighting surrounds the visitor.

This carriage showcases opinions. Some of the tiles are monitors upon which scientists from numerous disciplines comment on the opportunities, risks and ethical problems surrounding the scientific findings and predictions exhibited on the train. With their personal points of view, the experts highlight possible consequences for the development and identity of humankind. Thus, at the end of the exhibition visitors should feel inspired to think about what they have seen and ask questions of their own.

The design of this carriage reflects the variety of opinions and free thinking. Its variety of colourful panels stacked on top of one another like books on shelves also evokes images of a library in which the world's multi-faceted knowledge is stored.

12 Discover + Marvel: The train ends with a hands-on laboratory where children can experience how creative

Figure 4: *Sustainable and Efficient* is the programmatic name of a carriage which deals with the environment and future energy production. ©www.archl-me-des.com / Oliver Wia

experimentation can lead to innovative products. The arrangement of the seats and tables and is conducive to group work; the design is geared towards the materials, and the furnishings towards high-tech facilities.

Transit Rooms: The room situated between two carriages not only creates a structural connection between the carriages, but also links two thematic areas. Its design is derived from a spiral segment, a screw metaphorically driven into the long chamber of the train, carrying the visitor from room to room. Hence, we refer to them as transit rooms.

These rooms differ from carriage to carriage in terms of their colour scheme, but not in form. This recurring element forms a bracket that holds the twelve different exhibition areas together.

Moreover, with their bright and dominant colour scheme

these quiet rooms offer the visitors an opportunity to reflect on what they have just experienced, take a step back and prepare themselves for a new experience.

The transit rooms form a creative contrast to the constantly changing exhibition design in the carriages. Whilst the latter bears a strong and direct relation to the subject matter presented, the design of the transit rooms is governed by the principle of the metaphor, the abstraction.

In the following, we would like to elaborate on this principle of abstract and associative design expression using the example of two touring exhibitions.

Design abstracting content

The most important requirement of the design of the science exhibitions *Computer.Sport* and *Science Tunnel* was its adaptation to satisfy the requirements of a touring exhibition. As touring exhibitions generally have to be restricted to a limited number of forms, for reasons of manageability, an abstract design that refers strongly to the subject matter is preferable.

Science Tunnel: The touring exhibition, which was commissioned by the Max Planck Society, is already in its tenth year. *Science Tunnel* offers an insight into knowledge of the world and shows the current frontiers of research and how the different knowledge fields are interlinked. The classification principle of its content is the dimensions of our world: from the universe to elementary particles.

The design approach is based on the tunnel of a particle

accelerator; the spatial distortion of the exhibition elements aims to evoke spatial effects created from the perspective of an accelerated elementary particle as it approaches the speed of light. (Fig. 5)

Arranged one after another to form different tunnel passages, the steel construction does not show that it is based on a modular structure. Each exhibition unit is covered with a curved, saddle-shaped membrane, which slants down to eye level on one side and serves as a projection surface. Rear-lit showcases mounted on the support elements make a huge difference to the images of the exhibition. The unusual architecture supports the already highly attractive subject matter of the exhibition and forms the brackets that enclose the themes.

In 2005, the exhibition was given a make-over in terms of both content and design. The tunnel segments were made more open to facilitate closer inspection and accommodate the requirements of a touring exhibition more effectively. The original design presented at the EXPO 2000 in Hanover was not conceived as a touring exhibition, but rather adapted to the structural requirements of a room which also served as an emergency exit and therefore had to remain largely unobstructed.

Computer.Sport: This touring exhibition realised for the Heinz Nixdorf Museum Forum in Paderborn reveals the importance of current computer-based technology for present-day sport. It mainly portrays sport in the media, training equipment, high-tech materials and the pursuit of

virtual sports.

The basic idea of the design was dynamism, a key attribute associated with sport. The overall image of the exhibition is dominated by the spiral as an expression of momentum. It serves as a metaphor for all sports and sports-related subject matter throughout the exhibition and thus represents a reduction to the smallest common denominator.

The construction unites design and functional components. It enables visitors to plunge into the world of sport through spiral-shaped passageways and guides the infrastructure of the exhibition to the different stations. The exhibition elements, which can be arranged freely in the room, require an interconnected power supply and data network that was only possible via cable ducts on the floor. Initially regarded as a problem, this state of affairs ultimately gave rise to the underlying idea of the exhibition: a cable duct system running throughout the exhibition that simultaneously interconnects the individual panel units, platforms, showcases and multimedia stations. 2.5-metre-high hollow spirals serve as bridging elements for the cables, which link connection ducts that are each about three metres apart. At the same time, the spirals form entrance and exit gates to the respective theme areas.

The resulting ensemble separates individual areas of the room from each other and defines them as connected exhibition areas. The design of the cable duct system is also reminiscent of barriers and balustrades in sport stadiums.

Figure 5: The *Science Tunnel* in Tokyo: The touring exhibition offers an insight into the knowledge of the world. © www.archi-me-des.com / Gunnar M. Gräslund

The resulting blend of different elements is what gives the exhibition its individual character and makes it stand out from other exhibitions with similar themes.

Conclusion

A lot of what has been said here about the role of design and exhibits in science exhibitions also holds for other exhibitions. Whenever complex or abstract topics that are difficult for a layperson to understand are to be presented, it makes sense to resort to the means described here to grab visitors' attention, arouse their interest and maintain it for the duration of the visit.

The targeted use of exhibits plays a crucial role in attracting attention and arousing interest. Whilst the aura of the original is intrinsic to exhibits from science, interactive

exhibits developed especially for the exhibition can explain complex issues and grip viewers as they involve them directly in the proceedings.

Exhibition architecture and design can create spaces and an atmosphere where visitors not only feel comfortable but which also involve them in a topic, fascinate and encourage them to want to find out more. An acoustic design for the exhibition environment can also be a useful aid in this: subtle soundscapes create and add to an atmosphere.

The graphic design of an exhibition, however, provides orientation. It structures the subject matter and guides the visitors safely through the labyrinth of information.

Using these means ensures that the presentation of complex scientific topics is anything but dry and tedious. Used and combined in a varied, sensible way, they produce an entertaining and spectacular exhibition experience for a wide range of visitors.

References

Breuer, R. (ed.) Expedition Zukunft. Wie Forschung und Technik unser Leben verändern, *Spektrum der Wissenschaft*. Special Edition. Heidelberg: Spektrum der Wissenschaft Verlagsgesellschaft mbH. April 2009.

Fokus. Expedition Zukunft in *Max Planck Forschung*. Munich: Max Planck Gesellschaft zur Förderung der Wissenschaften e.V. 2009, pp. 10-31.

Max Planck Gesellschaft zur Förderung der Wissenschaften e.V. (ed.) *Expedition Zukunft – Science Express. Wie Wissenschaft und Technik unser Leben verändern – How Science and Technology Change our Life. Exhibition Catalogue.* Munich. 2009.

http://www.expedition-zukunft.org

Engaging The Public

WAYNE LABAR

Liberty Science Center

New Jersey, USA

A codification of the thematic exhibition development process has been created by a variety of forces in the museum field in recent years. Here we are primarily speaking of thematic exhibition efforts, not other processes used by those exhibitions or exhibit development projects more singular in nature or more loosely associated, such as those made famous by the Exploratorium in San Francisco. Since their beginning, thematic exhibition projects have been similar to architectural efforts in that they require the creators to move from a multisystem idea to actual physical operating elements. These projects go through progressive phases of work – from conceptual ideas to more detailed design and finally into exhibition fabrication and installation. Exhibitions of late have shown increasingly sophisticated design and content, which has heightened the importance of phasing exhibition projects in order to manage their complexity.

Directly related to the sophistication of the exhibition process has been the change in who creates these exhibitions. In the early years of museums, exhibitions were primarily led by curators whose work and scholarship took precedence. While additional museum staff members were involved in creating the exhibition, the curator was clearly seen as its "author." A change has occurred in the past twenty-five years of exhibition development and design – one that promotes the team approach concept, where key elements and perspectives required to create an exhibition are brought together to produce the experience. This team approach is documented in such books as Kathleen McLean's *Planning for People in*

Museum Exhibitions[1] and *What is Exhibit Design?*[2] We now have exhibition developers, exhibition designers, curators, project managers, graphic designers, educators and evaluators as part of exhibition teams. But whether one were developing an exhibition fifty years ago or creating one with the multiple role players of today, the creation of an exhibition is primarily a closed, top down approach. *Closed* means that a small group of individuals will comprise the team that produces the exhibition. *Top down* refers to the fact that the product created by this small group of people will be distributed to consumers of the exhibition – museum visitors.

However, in looking at the business world, it is evident that this closed top down approach is becoming outmoded, and one that museum visitors may frown on. In other arenas, people are finding themselves more involved in the actual creation of the products they consume. Whether it is the LEGO Group involving LEGO® Club members[3] in the creation of new kits or CNN seeking and using viewer-created videos that document news events, the public is participating in the actual development process. Additionally, through the World Wide Web and social media, including Facebook, blogs, Twitter, YouTube and others, individuals often create their own content for public consumption. In other words, in today's world everyday people have become empowered and in fact expect to participate in the development of the products, media and entertainment they use. So the question arises – not of whether we as museums will involve the public in creating the "product" we provide – but when and how will

we do it? And a follow up question may be, can we do it using the very same media employed by the business community and the general public, perhaps making the process more accessible through familiar forms of communication?

Linked to this movement of the public's involvement in creating the very services, programs and information with which it interacts is the *long tail* phenomenon, first broadly discussed in *The Long Tail*[4] by Chris Anderson, editor of *Wired* magazine. This concept explains the diversity and segmentation of interests, with more content areas being pursued by smaller but avid audiences – thereby creating narrower and deeper public experts on these topics. One could state that the ability of individuals to delve into and follow a specific line of interest to the exclusivity of everything else in today's long tail of information has resulted in what could be called an explosion of *public curators*. This personal interest in a subject is similar to hobbies of an earlier time, and linked with one's ability and expectation to be involved in content creation, interpretation, discourse and dialogue on the subject, will certainly impact how museums engage with the public – not only at the conclusion of exhibition creation, but in its very development.

Involving people in this exhibition development/design/creative process is not new to the field. From the aforementioned codification, perhaps the most common way the public is engaged in the exhibition development process is through participating in visitor studies. These studies often fall into two major categories – marketing and evaluation –

and are frequently conducted by museum staff or external consultants. Marketing studies focus on what visitors like, while evaluation is focused more on understanding the potential impacts of an exhibition on visitors, and then on the actual impact during the project's formative and summative phases. Examples and descriptions of these types of studies are well documented.[5] While in both cases these studies can actually result in having visitors' input or observations determine and change the actual exhibitions (and they should), they are in effect one-way conversations. Information is received about or from the visitors, and the exhibition team then acts on upon this information in the manner it deems appropriate. In addition, both marketing studies and the somewhat standard suite of evaluation studies – front-end, formative and summative – do not really emphasize or engage the public in creative ideation, critique, brainstorming or other more participatory elements of exhibition development and design.

Noting these changes four years ago, Liberty Science Center began an effort to engage the public in the creation of exhibits and exhibitions. The science center focused on attempting to use and leverage the public's experience with the open source, personal choice, large group participation movement that has increasingly become part of the way people expect to interact via the internet. Our idea was to determine whether we could use this same technology (and associated expectations) as a low-barrier process to have our visitors participate in the creation of exhibitions. Our investigation of engaging the

public in the exhibition development process – called *Exhibit Commons* – began in 2005.

Early efforts under the Exhibit Commons initiative focused on two important aspects of public engagement that had evolved by that time. The first was an attempt to capitalize on the willingness of people to enter their comments, ideas and opinions on websites such as EOpinion, Amazon, TripAdvisor and others. Liberty Science Center was able to enact a major effort in this area because from 2005 to 2007, we were involved in redesigning and installing a renewal of over 70% of our exhibition program. As part of this renewal, experiences were created where visitors not only had the opportunity to input data about themselves; they could also provide opinions and/or create content. The display of visitor-created content was given a primary role in these exhibitions: *Create a Pictogram, How Do You Communicate?, Make Your Point, and Fond Memories.*[6] These experiences proved to be popular with guests, through their participation by creating the material or engagement with what other people created or opined. In fact, this proved to us that staff did not have to be the sole source of information in an exhibition story.

The second approach we tried in Exhibit Commons was to build on the movement known as *hacking*, which refers to an individual's desire to determine how a device works in order to add capabilities that may involve bypassing restrictions placed on them. Recent areas where such activity is popular include creating hacks for the iPhone, Xbox and others. While these activities may be dubious legally, they do reflect innovation,

SCIENCE EXHIBITIONS

ingenuity, curiosity and knowledge of technological principles
– attributes a science center seeks to instill in its visitors.
Therefore, Liberty Science Center chose certain exhibits that
allowed visitors to hack into their operating processes to foster
creativity and let them try to alter how the exhibit works. The
science center focused much of its attention on an exhibit
called *Graffiti Wall*. Digital spray paint cans are used to create
spray paint images on a brick wall shown on a video projector.
For this exhibition the science center offered a web site where
visitors could request to download an emulator and/or
software code that explained how the device was programmed.
It encouraged visitors to change what happened when the
spray cans were activated or when an art work was created.
This experiment was not successful. While one organized
school group actually had students program two ways for the
graffiti exhibit to work differently – documented in a panel
discussion at the 2008 Association of Science-Technology
Centers Annual Conference[7] – no visitors took up the challenge
on their own. The lesson learned here was that the knowledge
and skill barriers were too steep for most to participate in
actually changing a completed exhibition, and thus audience
participation was minimal.

Key lessons learned from these early experiments include:
Visitors are willing to engage in and enjoy providing their
content to each other, and they also like to view other guests'
information (in other words, not everything needs to come
from a position of authority – the museum).

If one expects visitors to contribute in a significant

way and in a creative manner, the learning curve or prior knowledge threshold should be low.

A new approach evolved, offering a different way to develop audience participation in an actual exhibition on the museum floor. Instead of having the public engaged with completed exhibits by either adding to their content or trying to alter their functionality, the concept was to involve them from the very beginning of the exhibition process. In other words, the fundamental question was whether exhibition staff could use the exhibition development/design process that has become the norm in the museum world – a team approach that moves from conceptual design through more detailed design phases to fabrication and installation – and embed the public's involvement and participation in both the team structure and the development process. Underlying this idea was to use a new medium that had gained incredible popularity on the Internet – social media web sites like Facebook – that allowed people from a wide range of geographical locations to share a variety of ideas and content easily and to develop more evolved relationships. It was felt that this approach responded to both of the early lessons directly. Web sites such as Facebook allow users to interact or just observe a wealth of information and creative endeavors from others, and the popularity of such a site meant that the knowledge threshold for how to participate would be low.

Therefore, in 2008 Liberty Science Center started a social media site at the very beginning of its development and design of a new exhibition that would center on the science

and technology behind one of the most universal activities in which humans engage – preparing one's daily meals, or cooking. As of this writing, *Cooking: the Exhibition* is slated to open in the US at Liberty Science Center in July 2011. With an area of approximately 1,400 square meters, it will be one of the most complex experiences ever conceived, since the goal of the exhibition is to have visitors actually cook as part of the experience. After opening at the science center it will travel across North America, and a world tour is under consideration. It was for this project that the science center created *Cooking: The Exhibition Chefs*, to bring the public directly into the exhibition development process.

Located at http://cookingexhibitchefs.ning.com/, this is not only a social media site for visitors, but more importantly, the project site for the museum staff exhibition team. Therefore, all notes, drawings and other material generated for the project are posted here, opening the process directly to the public. All physical staff meetings at Liberty Science Center and many external party meetings are announced on the site, and members arse encouraged to call in, Skype and log on to a shared workspace so that they can participate. The entire process is open to all members (to the extent possible) through a variety of teleconferencing technologies.

While there are many more stages of design and development to undertake in the process, the use of this site and its impact on the exhibition development process and the exhibition itself are striking. Knowing that any experiment such as this will continue to transform the exhibition as

well as the work underway, we have discovered ten areas of observation and realization that shed light on engaging the public more deeply in an activity that has traditionally been behind the curtain.

Observation One: The subject of an exhibition may be important to the scale of engaging the public in an exhibition development process, but probably not to the concept of involving the public.

The popularity of food and cooking, the increase in press and mass media coverage of cooking and the cultural identification people have with cooking suggested to us that the subject would not be hard to engage the public with, and that certainly has been the case. As of this writing, there are 420+ site members from around the world. The fact that we have people involved from areas not geographically close to the science center indicates to us that if they know about it, people interested in the subject will participate. Their involvement is not dictated by the group that is doing the exhibition, but by the subject. All topics probably lend themselves to expert participation, and with the creation of public experts (as mentioned in The Long Tail), perhaps any subject is game.

Observation Two: While starting the process to engage the general public, people who do become involved have special connections to the idea of participating in the development of a cooking exhibition. This is similar but also different from what happens in a physical exhibition development process.

When this process began, it was unclear who would be interested in joining such an endeavor. While the idea of opening up the exhibition process is something the field has discussed and considered, who will participate is a fascinating question. With its 420+ members (growing at a steady rate) and little or no advertising, the makeup of the members reflects the exhibition engagement adage that one's background and previous experiences are key indicators of who and how people become involved in an experience. We have categorized the reasons why people have joined the exhibition development site:

- Exhibition development and design (museum professionals).
- Renting the exhibition (museum professionals).
- Social media (museum and technology professionals).
- Cooking as pastime.
- Cooking as profession.
- Liberty Science Center (members and visitors).
- Project members (family and friends).

This suggests that individuals get involved for personal reasons and is in keeping with studies that show how one's past experiences influence the impact of an exhibition. One clear difference museum professionals should consider is that unlike a visit to a museum – where a visitor can come upon a subject or experience by chance and may perhaps discover an interest – involvement in exhibition development via the web can only occur if a person is interested.

Observation Three: While project details and team dynamics are traditionally shared with team members and related experts, inviting the public changes knowledge borders. Suddenly, friends, family and museum colleagues may be more aware of the work details. Think about how you would respond if your mother criticized your work in front of your professional colleagues and friends!

People join social media sites for different reasons, and opening them to everyone results in certain changes in the relationship between one's work and one's life. This constantly impacts how the exhibition development process evolves and influences future work. Just how the process will change remains to be seen, but as with other aspects of the social media world, this may be a moot point as new generations become more comfortable with a mutable definition of privacy.

Observation Four: As with public involvement on the exhibition floor, there are various levels of involvement in the development process. The more involved, the more a public member becomes integrated into the exhibition team, until the line between public and internal team members becomes meaningless.

While most members engage minimally in the project (by just occasionally viewing what is happening or documents posted on the site), a number of them actively participate. This engagement includes providing links to content, attending meetings physically or virtually, reviewing material and developing content and experiences. In fact, these behaviors have been so meaningful that some members have changed

from being the public into partners with potentially full-scale roles and, perhaps the most defining aspect, have moved into paid positions. For example, one member who joined the site – interested in the subject because of her previous experience as a chef and her educational experience in food – has become the team's lead developer for public programming through the energy and time she spent with the project via meetings announced on the web site. One might say these individuals have transitioned, from virtual to real. On a related note, not only can public members become paid team members, they have also taken on a more physical, real-world presence in unexpected ways. They have already sent us several packages of food they have grown or prepared – avocadoes and star fruit from Florida and maple syrup from Maine!

Observation Six: Social media site elements include a diversity of formats and allow for a variety of engagement levels. This would seem to indicate that the use of such a familiar paradigm makes it easy for everyone to participate. Using a public, commercial network system offered a tool that all staff could master. There are limitations, however, with which one must live; for example, most social media sites are not designed as management software. But more purposeful project management software may set too high a barrier for allowing the public to engage in the process.

All of the Ning social web site capabilities – posting blog notes, music, video and pictures; uploading documents; sending messages to other members and friending each other – have been used by participants. No one has ever

asked how to use the site. This clearly indicates its ease of use. In addition, the site's accessibility can be vouched for, as this writer created it and continues to make structural changes, all without any HTML programming experience or infrastructure requirements. It was literally made and online within one day. Such flexibility has also allowed the team to respond quickly and on-the-fly to the needs of the exhibition development process. The problem we have encountered is that the social site is meant for socializing, not project management, and as a result, we are constantly looking for ways to improve its organization. Where information is stored and coordination with other office management tools are an issue. At times, the internal project team has found that efforts have to be duplicated.

Observation Seven: As we move into the next design phase, our current mode of working with the public may have to change.

Conceptual design of the exhibition is now complete, and we are moving into more refined design phases. This next will be one where, as in a typical exhibition project, members of the team begin to concentrate on the work in which they specialize and then present their ideas together. Prior to this phase, meetings primarily occurred weekly; the number of meetings among different team members will now increase. How to engage the public in these phases without overwhelming team members remains to be resolved. In addition, the more detailed phases will include a larger number of paid consultants and experts who produce

exhibitions. How these organizations relate to the web site and whether there are confidentiality concerns will need to be addressed, as well.

Observation Eight: One must carefully consider expectations and what is meant by the concept of transparency. Others become aware of certain aspects of the project, and this needs to be weighed against the combined assets the process can create.

We all look to learn from one another in the museum field. Our profession has, in general, a long history of standing on the shoulders of those who have gone before. Meanwhile, ongoing subjects that will probably never disappear are questions around the ownership of ideas or design of exhibits and exhibitions. In addition, during exhibition development we often invoke confidentiality when it comes to ideas and proposals for competitive grant applications, designs that are in the conceptual stage and other information. In order to engage all of our team members in *Cooking*, we have posted early drafts of material concerning exhibit ideas, concepts and a preliminary National Science Foundation grant. For some this may feel risky and weaken competitive advantage. While most museums do not directly compete against each other because of the distance between them, an increase in exhibitions that tour and the fact that some museums may just "copy" an exhibit without proper remuneration for the idea or concept make this an issue. As of now, *Cooking* has not come across these situations, but the team is alert to their possibility. So far, the advantages of the process have

outweighed the risks.

As we look to the future of the project, working with the public will constantly need to adapt and change – just as all exhibition team dynamics change according to the phase of work being completed. Questions we will need to answer include whether public team members can play any specialty roles; how to involve them in smaller meetings; how to share concepts and drawings; and what tools can be used in meetings to allow everyone to participate equally. The recipe for our public participation will no doubt become more complex but also richer for the effort. Drop by our site for further tastings, because our rule of thumb for *Cooking* is that too many cooks **never** spoil the soup.

Observation Nine: The creation and maintenance of a social web site to engage the public in the exhibition development process is more work for the museum team. At the same time, it has forced the museum staff into better practices for documenting work and progress.

Compared to previous exhibition projects, there has been more work for several members of the museum team, who review what has been posted on the site, ensure that information is readily accessible to members, add items as necessary regarding upcoming events and at times deal with normal web issues, such as spam. The advantages and knowing that the social site is the principal way through which members learn about completed work where they can add, comment or critique, is that staff has had to be more fastidious in documenting and then posting meeting

minutes, timely agendas and **all** sketches and notes. The result has been an exhibition team with a much improved trail of progress, which has proven useful for tracking down thoughts and ideas that might otherwise have been lost.

Observation Ten and Conclusion: Creating the social media site and seeking the public's involvement has enhanced and expanded the project in many ways. It has clearly been of benefit to this project and should be explored for use in others. This tool needs to be added to the exhibition development process where possible.

Using the social media site to open the exhibition development process has fundamentally changed the Cooking exhibition. While there are many ways to document this, some clear examples include:

- A larger set of resources and content areas.
- The involvement of a considerable number of experts on the subject.
- Experiences of people actually doing exhibitions and more individuals working on the project.
- Better reviews and critiques of ongoing work.
- Exposing the project to expert communities.
- Awareness of potential funding entities.
- Project awareness by potential visitors to the museum.
- Better project documentation.
- Excitement and energy from people new to the exhibition process.

These and other factors have thus far outweighed the

additional work the site has created. While it is hard to judge risk vs. reward, at this point the rewards clearly have the upper hand.

We are not naïve and know that the subject of this exhibition – cooking – does have the advantage of involving a more diverse group of individuals in the project. That being said, the social site engages museum staff in the topic in a way that is different from the typical exhibition development process. By interacting with others, sharing content that relates in ways that may lie outside of the exhibition's direction and opening a process-in-action to the community, we believe we are creating a more robust and impactful exhibition. While the verdict is still out, we do believe that if an exhibition team is committed to maintaining this engagement, including the public offers rewards we are yet able to fully fathom.

Notes

1. McLean, Kathleen. *Planning for People in Museum Exhibitions.* Washington, DC: Association of Science-Technology Centers, 1993. Print.

2. Skolnick, Lee, Jan Lorenc, and Craig Berger. *What is Exhibition Design? (Essential Design Handbooks).* Switzerland: Rotovision, 2007. Print.

3. "LEGO.com LEGO Club: Cool Creations." *LEGO.com LEGO Club: Home.* Web. 15 Jan. 2010. <http://club.lego.com/en-us/gallery/default.aspx>.

4. Anderson, Chris. *The Long Tail.* New York, NY: Hyperion, 2006. Print.

5. "Informal Science | Search Evaluations." *Welcome to Informal Science | HOME.* Web. 15 Jan. 2010. <http://www.informalscience.org/evaluation/search/>.

6. LaBar, Wayne. "Exhibit Commons: Liberty Science Center's Open Source Experiment." *Visitor Voices in Museum Exhibitions.* Washington, DC: Association of Science-Technology Centers, 2007. 140-44. Print.

7. Teller, Alan, Bryan Alexander, Doug Worts, and Wayne LaBar. "Can YouTube® and Wikipedia® be models for creating exhibits?" *2008 American Association of Museums Annual Meeting.* Colorado Convention Center, Denver, CO. 30 Apr. 2008. Panel Discussion.

NanoAdventure:
An Interactive Exhibition in Brazil

SANDRA MURRIELLO

& MARCELO KNOBEL

UNICAMP, Campinas, Brazil

Science and technology centers and museums are valued as dynamic communication and educational spaces which show and demonstrate scientific ideas using varied museographic strategies, based more on the subjects to be communicated than in the objects themselves. In spite of the strong identification of these spaces with the hands-on models starting in the 1960s, when the San Francisco Exploratorium was created in the USA, their origin lies in older periods. For centuries the intention of preserving technological innovation has existed, as is evidenced by the creation of the Musee de Arts et Metiers in France in 1794. Nowadays, proposals only based in manual interaction are being surpassed by communication models that appeal to the intellectual compromise of the visitor. There is also an intention for museums to be places for debating questions related to the everyday life and the interaction among science, technology and society. Thus, museums are nowadays worldwide seen as spaces open to all kind of public, with a strong educational potential.

The public communication of science and technology has developed in Brazil in the last decades, with a growth of science centers and museums since the 1980s. Nevertheless, this expansion has not been homogeneous; up to now the main offer is concentrated in the South-Southeast region, mainly in the cities of Rio de Janeiro, São Paulo and Porto Alegre. The city of Recife, in the Brazilian North-East, also has an important Science and Technology Center. The sector has not only expanded numerically, but also as a research area,

which is made evident by an increasing number of doctoral and masters theses in the area since the 1990´s.

This increase is, however, still insufficient for these spaces to boast a significant impact on the public communication of science and technology. Studies of public perception of Science and Technology carried out in 2006 by the Ministério de Ciência e Tecnologia (Brazil's Ministry of Science and Technology) show that in a country of approximately 190 million inhabitants, only 4% have visited museums and science centers.

A new Brazilian science museum

With the perspective of creating new spaces for communicating science and technology, the University of Campinas (Universidade Estadual de Campinas – UNICAMP), in the city of Campinas, state of São Paulo, Brazil, is developing a new museum (Murriello et al, 2006a). Initiatives for the consolidation of the Museu Exploratório de Ciências started in 2003 and the *NanoAventura* (*NanoAdventure*), its first exhibition, was opened to the public in April, 2005. At that time there was still no definitely assigned physical space for the Museum, reason that explains why the exhibition started as being itinerant. The exhibition was developed in partnership with the Laboratório Nacional Luz Síncrotron (LNLS) and the Instituto Sangari. It received financial support from the Vitae Foundation, the State of São Paulo Foundation for Research Support (FAPESP) and the patronage and support of other partners.

In 2006, a new travelling initiative, the *Challenge Workshop* (Officina Desafio), was launched. It provides technological challenges for teenagers from 12 to 18 years in schools and communities. This initiative received the support of Financiadora de Estudos e Projetos (FINEP) and the Instituto Sangari. At present the Museum has its own space within the campus of the University. Its first permanent exhibition (open air) *Time and the Construction of Space* will open in 2010. The new museum aims to become a space for communication and discussion of scientific and technological culture.

NanoAventura, the exhibition

The aim of *NanoAventura* was to create an interactive exhibit that would attract the interest of children and teenagers (9 to 14 year-olds) in nanoscience and nanotechnology. This non-formal educational experience aims to motivate scientific interest and curiosity on this emerging field as a way to favor long-term learning (Falk & Dierking). Nanoscience is currently regarded as a novelty, but the study of elements on a nanometric scale existed before being recognised as such. The development of instruments to observe and manipulate these elements developed quickly over the last two decades, leading to the emergence of a new technology with its share of promises and uncertainties. Nanotechnology is the engineering of materials from atoms and molecules, making it possible to use the results of nanoscience in order to manipulate and reorganize nanoparticles and thus promote other combinations and create new materials and devices.

This is an emerging field that is among the investment priorities in science and technology, which have multiplied exponentially in the last decade (Stephens) but which is still far from the concerns and interests of the general population. Nanoscience and nanotechnology is usually considered as one single field, called N&N, which is how it will be referred to here.

NanoAventura was conceived as an invitation to explore the nanoscopic world using a playful approach, with images, music and computer simulations (Murriello et al, 2008a; Murriello et al, 2006b). We developed a multimedia experience based on an attractive environment using innovative technologies. The design of the exhibition space aimed to generate an immersive experience. Video games were used to enhance education and enjoyment, and designed with interaction and collaboration in mind. The incorporation of these elements will allow us to deepen research into the use of multimedia resources in science museum exhibitions (Heath).

The exhibition is based on interactive games and visual communication techniques that present basic concepts of nanoscience and potential uses of nanotechnology. *NanoAventura* was designed for a maximum of 48 participants and is an hour-long experience. It presents an introduction to the so-called nanoworld through video and performance, encouraging visitors to manipulate objects through three collaborative computer games and one virtual tour that invites the visitor to explore the LNLS and UNICAMP laboratories and

research spaces. After the games, a facilitator summarises what the participants have seen, and data obtained from the actual performance of the teams is used to stimulate the participants. Finally, to close the session, a 3D video reviews some of the ideas presented, leading to further questioning.

The evaluation process, which accompanied the development of the exhibition from its inception, was used as a tool to refine content.

The results of these evaluations have already been reported, analyzing prior public perception of N&N and the social, affective and cognitive benefits of a visit to the exhibition (Murriello et al, 2008a, Murriello et al, 2008b, Murriello et al, 2006a). We shall therefore emphasize here the strategies used to communicate N&N.

Videos

An introductory video operates as the initial stimulus for the visitor to place himself/herself cognitively in the subject which is being presented, and as an anticipatory element of the games experience. After evaluation of the original video, it was shortened, and its script modified. This material demonstrates two key concepts for the understanding of nanoscience and nanotechnology: the notion of scale and of constitution of matter. The fundamental principles of this new technology are also presented, including its development in Brazil. In the narrative structure of the video, two different phases can be distinguished: the first operates as a zoom in that starts with familiar objects which are of the order of

Phase	Sample	Objective
Front-end evaluation	Children/ teenagers – target audience Questionnaires (n=109) and interviews	Identify previous knowledge on the subject. Content and script definition.
Corrective evaluation	Pupils and teachers (visitors) Questionnaires (n=690) and observations	Analyze the exhibit´s impact, identify problems to improve the experience. Solve environmental and content problems . Lead to changes in videos and games.
Summative evaluation	Questionnaires (n=814), observations and interviews (n=23)	Investigate cognitive gains. Study social interaction and exhibition-audience interaction.

Table 1: evaluation phases

meters and centimeters to reach the nanometric scale. The images advance step-by-step in descending scales by factors of ten, reinforcing graphically its mathematical expression and showing biological elements characteristic of each order of magnitude. Once at the nanometric scale, the video points out atoms as basic constituents of matter, considering this a key concept for understanding the fundamentals of nanoscience and nanotechnology. Carbon is used as an illustration allowing us to show its presence in living and inert matter, as well as the capacity of nanotechnology to generate new structures – fundamental in nanotechnology – such as nanotubes and buckyballs.

The second phase of the video is a dialogue between testimonies from Brazilian researchers and the narration

of the presenter. Images of laboratories and instruments in Brazilian institutions are used as illustrations, to show the potential of the manipulation of matter and the development of this sector in the country. The final part of the video aims to introduce visitors to the experience that follows. Four games are presented with an explanation of their aims and objectives. (The video can be seen at http://www.youtube.com/watch?v=OgGG3VMCVXk)

The final video in 3D format has no text, but consists of a sequence of images and music which summarizes and reinforces the main ideas presented.

Both videos are projected on a large triple screen.

Games

The interactive games were prepared as collective games for teams of up to 12 people each, with a cooperative character. During the experience some competition is encouraged amongst the different groups as a means of incentivating the tasks, while always pointing out that there are no winning teams. As has been demonstrated in other interactive exhibitions, multi-user games are used for a longer time than individual ones, and they also favor social interactions (Kennedy). Their value as tools in the teaching process (Hawkey) was also decisive in choosing this medium.

The games simulate scientific instruments being used, for example, to clean surfaces atom-by-atom with atomic force microscopes, to introduce specific drugs into a cell, to assemble nanocircuits with scanning microscopes, and to lead a virtual

tour through scientific laboratories (Figures 1, 2, 3, 4). The games have all undergone adjustments and changes because of ergonomic, conceptual and functioning problems detected during corrective evaluation (Table 1). A brief description of each game follows.

Nanobiotechnology game

Goal - in group form, cure sick cells with nanoscopically encapsulated medicines. Each visitor has, on the monitor in front of him, three kinds of molecules of medicines and he/she must choose one, encapsulate it, and aim it towards the sick cell, which is the same for the whole group. If the molecule is not encapsulated, it cannot reach the cell. If the chosen drug is the correct one, the health of the cell improves, and the participant notes that the correct drug gives him/her (and the group) more points. The group interaction occurs naturally, because when one of the players discovers which medicine gets more points, he/she informs his group partners, so the task can be finished quickly. Each person has three panels: one that indicates the life of the cells, another one that shows its own points and a third one giving the total points of the group. Each time one cell is cured, another sick one appears and the game starts again. In every change of cell a different medicine is more effective (Fig. 1).

Manipulating atoms

Goal – Remove impurities in a sample using an atomic force microscope (AFM). The group must work together to clean

Figure 1: Nanobiotechnology game

the surface of a sample, removing the impurities that in this case are individual atoms and atom lines, forming nanowires. After a brief introduction, they have some minutes to remove as many impurities as possible. The task of removal of individual atoms can be done by a single player, but eliminating the nanowires must be a collaborative work. Each player has his own AFM microscope and a panel with the individual and the group's total points (Fig. 2).

Virtual tour

Goal - visit the work environment of nanoscience and nanotechnology. During a virtual visit, participants have to comply some basic research tasks, such as finding a sample, taking it to the microscope, etc, with a strong exploratory character. The tasks lead the players to visit three different

Figure 2: Manipulating atoms

scientific environments: the Brazilian National Synchrotron Light Laboratory (LNLS), the UNICAMP nanoscience labs and the so-called *room of knowledge* in which simulations are shown. The players can meet to each other and interact in a virtual environment. At some places the visitors meet robots that give them basic explanations on the place and the instruments they are observing (Fig. 3).

Assembly line

Goal – simulate a nanocircuit assembly line. The players are distributed around equipment that looks like an assembly line. This setup has the purpose of making the player feel like they are using a real microscope that allows one to manipulate nanoscopic elements (fullerenes, nanotubes, gold nanowires) with an AFM microscope to build a pre-designed nanocircuit. The task is briefly shown so the players can see the expected

Figure 3: Virtual tour. Photo: Sylla John Taves.

pattern and after that, work can start (Fig. 4).

Categorization

The game stations were designed to have strong technological appeal. Game instructions are included in the games themselves and are verbally reinforced by guides at each station. To reduce ambient noise, each participant has an earphone to follow the instructions.

During corrective evaluation we developed a categorization to evaluate the games based on the computer games categories developed by Malone & Tepper and on that of Perry's motivating exhibits:

1. Challenge: stimulus to surpass one's own performance.
2. Curiosity: generation of questions and doubts about the topic.

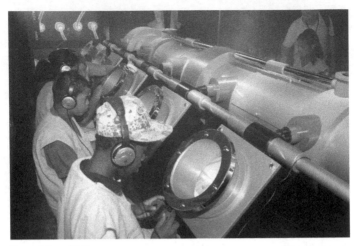

Figure 4: Assembly line

3. Cooperation: collaborative social interactions in pairs and with the monitor.
4. Competition: stimulus to surpass others.
5. Playability: clarity of the proposal and the workings of the game in the context of the exhibit.
6. Meaning: meaningful topic/close to the visitor's experience.
7. Ergonomics: comfort for carrying out the task.

These criteria were evaluated on a good/regular/bad or high/medium/low scale. The results of this evaluation allowed us to see correct aspects and problems of each game and the set of games as a whole (Murriello et al, 2006b). We can affirm that the games attract curiosity and properly challenge the users in a way that holds their attention within the time available.

Website

The extension of the museological experience of *NanoAventura* into the virtual environment presents the possibility of reaching new visitors from different places, not only leading to a diffusion of the exhibition, but also extending the playful-learning experience.

The first site created for the *NanoAventura* project was conceived during the process of creation of the exhibition itself, with a rather broad perspective and without a clear picture of its main use because we did not even know what the impact of the exhibition itself would be. It aimed to create a communication channel, not only to promote the project, but also to make available several extra resources on the complex subject that the exhibition was designed to show and discuss. After nine months of operation, the exhibition website was completely reformulated. With an attractive environment and visual emphasis, the new website can communicate better with its target public and better represents the exhibition. The idea was to build an environment that looks more like a visual experience than an informational Web site with textual content. The information levels were restructured and the arrangement of the information was reorganized (Knobel).

The new site has two separate areas. The first is for the communication of the project itself, *NanoAventura*, where there is a virtual tour with information on the exhibition. The second is designed to communicate nanoscience and nanotechnology to the general public. This area was projected as a blog to allow the exchange of information

between the public and *NanoAventura* staff. The blog can be personalized by every user as a powerful tool for specific searches. Also included were three games designed to extend the *NanoAventura* experience (www.mc.unicamp.br/nanoaventura).

Challenges of the exhibition

When developing *NanoAventura*, during the phases of planning, design and installation we faced multiple challenges which can be roughly divided into the following categories.

To be the first. One of the challenges we faced when developing *NanoAventura* was the fact that it was the first initiative of the Museum. Not possessing a building of our own at the time led us to create a travelling experience. Thus *NanoAventura* was inaugurated in 2005 during the 4th Science Center World Congress in Rio de Janeiro, when the future museum location was still under discussion.

NanoAventura covers 250 square metres with its demountable metallic structure and equipment transportable in large containers. It can also be mounted in covered spaces, such as shopping malls or exhibition galleries. This versatility has permitted its circulation to locations in the Brazilian cities of Campinas, São Paulo, Porto Alegre and Rio de Janeiro. It is worth pointing out that a disadvantage of the system used is the high cost of transport and mounting. At present the exhibition is installed on the site of the Museu Exploratório de Ciências on the campus of the UNICAMP.

Being the first exhibition also meant working

simultaneously to obtain resources, plan the exhibition and consolidate the work team. The short time available for the development of the exhibition based on conditions set by the sponsors was also a challenge, which required coordinated and intensive work. The initial development was carried out by a team of professors from UNICAMP, the LNLS and a company which produces events.

To be interesting and educational. We developed this multimedia experience based on an attractive environment using new technologies as a way to capture the target public (children and teenagers). As the summative evaluation shows, the exhibition provided not only interest but education (Murriello et al, 2008a; Murriello et al 2008b). As Rennie & Johnston (2004) propose, we agree that a learning experience requires engagement. Such engagement may be a mental, physical, or social activity on the part of the learner. The *contextual learning model* (Falk & Dierking) that we have adopted as an interpretative framework for learning in an informal context such as a museum, assumes three main contexts: personal, physical and sociocultural. This model takes into account the intrinsic complexity of the learning process, and the multidimensional character of the museum experience. The *free choice learning*, as defined by Falk & Dierking, could be useful to characterize what happens in interactive science museums.

To communicate N&N. The inherent difficulties of presenting concepts based on unfamiliar notions and on elements that are not seen by the naked eye were the most

important challenge. But another challenge was planning an exhibition on a new subject and one – we presumed – almost unknown to our audience (Murriello et al 2006b).

At the time the planning of this exhibition started, there was no systematic data available about public perception, nor about the level of information available on nanotechnology in Brazil. Furthermore, frequently there is a gap between the knowledge and ideas people actually have and those which researchers assume. In our case, the focus and level of complexity of the exhibition was defined on the basis of a front-end evaluation carried out with a sample of the potential target public. Successive phases of evaluation allowed us to adapt and correct our initial proposals.

The evaluations show that the exhibition acts as a place to discover a new science and a new technology which operates in a scale never seen before. After visiting the exhibition most of the visitors, no matter their age, were able to better define N&N by, for example, pointing out the concept of tiny particles and the prospective uses of nanotechnology (Murriello et al , 2008a; Murriello et al, 2008b).

To be replicated. After some years of successful functioning, *NanoAventura* was invited to participate in a new museum development; in the city of São Paulo we decided to adapt the exhibition based on the results of the evaluations and of what had been learnt during its development. The exhibition design was adapted to a new, somewhat smaller, area and the game stations modernized and improved.

Finally, in 2009 a replica of *NanoAventura* in Catavento

Cultural e Educacional [http://www.youtube.com/watch?v=n8DtA64na8o] was opened.

Perspectives

The development of *NanoAventura* made face up to the challenge of presenting a field still under development, and practically unknown to the public. Our evaluations indicate that the exhibition became a high-impact educational space, where visitors got into the subject, assimilated its basic concepts and were enthusiastic about coming back. Generally speaking, we believe the language chosen and the design of the exhibition have been appropriate in creating an immersive atmosphere, particularly for our target public: teenagers and children. There is a mix of the social, affective and emotional elements which conform to the "museum experience" mentioned by Falk & Dierking. For a better understanding of the subject, we point to the importance of complementing the visit with teaching materials and other experiences which permit the building of long-term learning.

Updating and renewal of the original exhibition continues to be a challenge, since it needs continual upgrades to avoid becoming obsolete in terms of both equipment and software.

From a different perspective, the development of this exhibition has been fundamental in the development of the new Museu Exploratório de Ciências – UNICAMP and has been invaluable in developing teamwork and decision-making. Now the challenge is to consolidate an institution of national and international stature.

References

Falk, J. and Dierking, L. 2000. *Learning from Museums. Visitor experiences and the making of meaning.* Altamira Press.

Hawkey, R. 2004. *Learning with digital Technologies in museums, science centres and galleries.* Futurelab series. Report 9. Available at: www.futurelab.org.uk (Accessed 15 June 2006).

Heath, C., Vom Lehn, D., Osborne, J. 2005. Interaction and interactivities: collaboration and participation with computer-based exhibits. *Public Understanding of Science,* vol. 14, pp. 91-101.

Kennedy, J. 1990. *User friendly: hands-on exhibits that work.* Washington, D.C: Association of Science Technology Centers.

Knobel, M., et al. 2007 Design of an Interactive Web Site for the NanoAventura Exhibition. In J. Trant and D. Bearman (eds.) *Museums and the Web 2007: Proceedings.* Toronto: Archives & Museum Informatics, published March 31, 2007 at http://www.archimuse.com/mw2007/papers/knobel/knobel.html

a. Murriello, S. E, Contier, D., Knobel, M., Taves. S.J. 2006. "O nascimento do Museu de Ciências da Unicamp, um novo espaço para a cultura científica". In. Vogt, C. A (org) *Cultura Científica: desafios.* São Paulo: Fapesp, Edusp, pp. 198-231.

b. Murriello, S.E, Contier, D., Knobel, M. 2006. "Challenges of an exhibition on nanoscience and nanotechnology". *Journal of Science Communication,* vol. 5 (4) Dec. Available at <http://jcom.sissa.it/archive/05/04/Jcom0504%282006%29A01/>

a. Murriello, S.E, Contier, D., Knobel, M. 2008. NanoAventura, an Interactive Exhibition on Nanoscience and Nanotechnology as an Educational Tool. *Journal of Nano Education*, vol.1, pp. 96-105.

b. Murriello, S., Knobel, M. 2008. Encountering nanotechnology in an interactive exhibition. *Journal of Museum Education*, vol. 33 (2), pp. 221-230.

Perry, D. 1994. "Designing exhibits that motivate". In: ASTC. *What research says about learning in science museum?*, vol. 2, Washington, DC: ASTC, pp. 25-29.

Rennie, L. J. and Johnston, D. 2004. "The Nature of Learning and Its Implications for Research on Learning from Museums", *Wiley InterScience* (www.interscience.wiley.com). http://www3.interscience.wiley.com/cgi-bin/abstract/109062554/ABSTRACT. DOI 10.1002/sce.20017 (Accessed July 15, 2007).

Stephens, L. 2005. "News narratives about NanoS&T in major US and Non-U.S. Newspapers". *Science Communication*, vol 27 (2), pp. 175-199.

Notes

1. *In the classification of digital technologies that was realized by Hawkey (2004, p.8) and edited by Futurelab (UK), the first three would be games, while the virtual tour would correspond to a simulation. For the purposes of this article, we call them all electronic or computer games without any distinction.*

CURATION AND DESIGN

Storytelling Memories

Massey University

Wellington, New Zealand

This paper reports on the development of the Storytelling Memories project, which formulated an interactive platform of story immersion and experience within a museum environment. Storytelling Memories was developed as a Master of Design thesis.

The Storytelling Memories project was initially developed to present the memoirs of Bomber command veterans. The project utilised a touch sensitive surface as an interface between the viewer and their life stories. A physical memory box, which acted as the main controller, revealed contained memories within a digital representation of the memory space, when placed near the interface surface. However the platform functionality is transparent and can house the stories and memory of any personal testimony. In could encompass for instance the personal stories and professional histories of noted scientists.

Scientific history has traditionally focused on the development of science rather than the achievement of individuals. The Storytelling Memories platform provides memory retention and presentation surrounding the individual in a way, which mimics the opportunity to have a personal dialogue with the scientist. For example, if the display was regarding Marie Curie, her contribution to science history has come through a rich life journey of family ties and societal changes, which is intensive and pivotal to her development as a scientist. This peripheral information substantiates their professional endeavours and enables a personal connection.

This new mode of exhibit design is substantiated by the recent shift in display techniques within the modern museum. Society is seeking an in-depth inquiry into artefact purpose and historical context. Modern museums now have the difficult task of re-viewing their archives and collecting the rich history behind their contained artefacts. Collected artefacts, are inherently contextually displaced the moment they are removed from their environment. Science history is no different. Placing stories and memories within a digital environment or contextual "Memory House" begins to strengthen the meaning of the story, and enables the viewer to relate to and create associated meaning with the artefacts and memories.

The open-ended navigation structure of the design encourages the user to interact and in an immersive manner, digest the memories at any point in time, and from any narrative path within the system. The intention of this mode of interface is for the public to humanize the scientist and engage with their memory on a personal level, therefore creating an understanding of the person behind the scientist.

Personal testimony and the artefact
There is little connection between a piece of scientific equipment or a gleaming engine and the material world experienced daily. (Kavanagh 1992, 82)

Museums have traditionally been receptacles of artefact and societal preservation. When the contemporary idea of a

museum as a place of historical containment was founded during the 1900's, artefacts were collected and displayed according to their merit as an example of a unique object. Very little information was formally recorded pertaining to the context and emotional connection to the artefact. It was assumed that preserving the artefact alone was enough.

The silences in the historian's record of the nineteenth century were eerie. The absence of first person testimony left the historians devoid of individual perspectives and alternate accounts. The histories of ordinary people had been largely unrecorded and therefore unwritten (Knell 2004, 118)

Artefacts were displayed either grouped together with other similar objects, or in dioramas based on the artefacts purpose and use. With little or no appreciation or record of the artefact's original purpose and existence it is difficult for the public to form a relationship with the artefact. Science Museums are no exception; most feature a vast array of tools and collected artefacts displayed side by side for comparison within glass cases.

On a recent visit to the CosmoCaxia Science Museum in Barcelona (CosmoCaxia Museum of Barcelona) I was entertained and impressed by the varied array of hands-on experiments on display. However, the museum exhibitions were devoid of any strong evidence of a connection between the scientific research and commitment, which had led to such ground, breaking discoveries, and the scientist themselves. Science Centres or Education Centres often exclude an in-depth representation of the scientist. They focus instead on the display of experimental

science with the purpose being to engage the public with science at a fundamental level. A traditional Science Museum, which has a fundamental purpose of preserving evidence of scientific development and implementation, also has the same issue. The viewer seeking a relatable understanding of the pioneering spirit behind the discoveries is left disconnected between the artefacts and the description cards. Testimony and storytelling of noted scientists, who were once viewed as role models and public icons has taken a back-seat in favour of the technology they invented. Further displacing their potential to influence and connect with modern society. John Durant observes that although Science Museums and Science Centres both present a viewpoint on science, representation of the scientist is absent.

For of course it is the social world of real scientists engaging with one another in their work that scientific consensus is generally achieved. To be fair to us all, our museums do introduce scientists into exhibitions fairly frequently, but all too often these people are presented as archetypal lonely geniuses. Only rarely do museum exhibitions manage to set scientists so firmly within their professional and social worlds that visitors can begin to see how new scientific knowledge is actually produced. (Durant 1992, 10)

When testimony is discussed in relation to scientific development the credit is often singular ignoring all other parties involved in the development: *For example Marie Anne Lavoisier is known to have worked alongside her husband, Antoine Laurent Lavoisier, but it is he, not they – who is remembered for*

their contribution to Chemistry. (Kavanagh 1992, 85) This lack of portrayal of the personal testimony of the contributor is not only limited to science museums. War museums have traditionally presented testimony only from the perspective of generals and leaders therefore forming a distorted Great Man view of any given event (Carlyle 1848, 2). Kavanagh discusses transference and avoidance in museum exhibit design as a way of not encouraging interaction or dialogue with sensitive issues particularly contested events and opinions. We use artefacts as a safe non-emotively connected way of representing the past, not acknowledging that it is the human-interaction with the object and its memories therein that is the reason why the object is retained for exhibition in the first instance. The testimony display of the average person is inconsequential, or at best displayed in truncated fragments.

In her book *Dream Spaces* Gaynor Kavanagh describes the object as simply an object, and to only discuss the object in object terms to deny us the personal experience associated with its purpose. (Kavanagh 2000, 101) Roger Miles and Allan Tout also share this view: *Empathetically objects do not speak for themselves – they are mute on their significance in nature or society – and as far as lay visitors are concerned, the non-verbal language of real things is no more than museological conceit.* (Miles and Tout 1992, 27)

The public as a consumer is becoming savvy as to what they want from a museum experience. Museums have noted this evolution in their clients needs and are working towards ways

to make the museum visit more rewarding and informative. As John Durant observes, "museums despite their long history are realising that the art of exhibiting science to the public is still in its infancy... they have been slow to come to terms with the true nature of a museum as a communicative medium." (Durant 1992, 9) Museums catering to Humanities and Social Sciences have already begun to embrace this transition and have provided clear precedents for Science Museums. For example The Churchill Museum in London, UK has centred their exhibition of the World War Two Prime Minister around an 18 metre long touch-table which documents the changing times surrounding Churchill's life. The Florence Nightingale Museum in London has recently commissioned a new display system of her life and experience. The multi-depth exhibition covers personal topics such as her personal thoughts, through to her social and historical context, and her influence on modern day nursing.

A movement towards the presentation of memory testimony will endeavour to provide contextual substance to museological artefacts, but this is a larger undertaking than simply providing a biography of the scientist in question. How does the museum address issues of social misrepresentation or marginalisation of individuals, the holistic representation of historical events, or simply the differing opinions regarding any one situation?

Storytelling navigation

Storytelling Memories is a Master of Design thesis project,

which looks at a simple ways to present the social history of individuals. Interconnected by common events and life experiences the project uses a non-linear narrative structure built on storytelling navigation practice. Originally designed to display the memoirs of Bomber Command Veterans the system can be applied to any genre of memory testimony including that of scientists,

Science museums build a great focus on artefacts, as they are tangible connection to scientific discovery. Forceps, notebooks, vials of chemicals, scales and instruments are all the tools of the scientist – but without representation of their human connection, they remain nothing more than objects. The Storytelling Memories project also begins with the artefact, but uses it as a trigger point for discussion. Positioning them within a visual representation of the environment the objects traditionally inhabit, gives them a relatable context. The environment is populated predominantly with memory testimony of the Veteran in question, but also the similar or differing opinions of other veterans related to the first through location, events, experience etc. It is these differing viewpoints and discussions, which collectively build a stronger picture of memory events surrounding the original veteran and the artefact. Listening to the testimony of the veteran as the museum visitor navigates the memory place invokes an immersive voyeuristic insight into the life of the individual.

Objects have biographies. They move through a world of public and private arenas. An object gains its meaning through the various social, economic, political and cultural

environments through which it passes. (Silverstone 1992, 35)

The use of new media design techniques within interactive installations gives plenty of opportunity to craft a multi-vocal navigation experience. Joel de Rosnay describes three main systems of navigation, the Linear exhibition, which presents information in a sequential manner. The Matrix exhibition, which uses juxtaposed, sectors to convey its message, and the Discovery exhibition, which provides a labyrinth of knowledge. He argues that individually these systems of navigation do not provide for a clear understanding by the user due to a weakness in the descriptions and a lack integrated hierarchy between the different themes. (Rosnay 1992, 23-24) The Storytelling Memories project places the Individual Veteran or Scientist at the top of the interaction hierarchy. The Memory places are environments based on different time periods within the individual's life. No matter how deep into the information hierarchy the museum visitor delves, the spine of the system focuses on one person alone. Storytelling navigation is in essence the same as the action of reading a Biographical book – to get to know the person by becoming familiar with their environment, habits, desires and personality, and the opinions of those surrounding them. The *Memory House* portrays the life of the individual within visual representations of the environment they inhabited at that time – for the Bomber Command Veterans these sections included the childhood home, the squadron base their designation and their life after the war. For a scientist the environments would be similar, childhood,

education, private life, the laboratory, scientific development. Artefacts and collected mementos related to the individual inhabit the environment in a familiar placement providing key triggers for memory testimony dialogue. Threads from other individuals' stories may also inhabit the *Memory House* – an object may have been pivotal to several people during different times in their life. The Storytelling Memories project metaphorically resembles a memory box filled with collected mementos from an individual's life, each one describing a unique thread within the individuals rich life tapestry.

New media databases within interactive exhibits enable the containment of vast quantities of digitised artefacts and dialogue, meaning each *Memory House* can have a myriad array of options to explore. Through an exploration of these snippets, the visitor is able to build their own picture of the life of the Veteran, or Scientist informed by the objects they have chosen to interact with. This interaction fosters a stronger relationship between the user and the story unfolding as the user is given direct control with the environment they are investigating, similar to having a conversation with the individual.

Nathan Shedroff, an expert in experience design theory and practice commented on the ability of new media technology to enhance a storytelling narrative: *Activities like storytelling and conversation are so powerful and necessary for creating knowledge. They allow us to interact with the information in a way that helps us build personal context and integrate the information into our previous understandings.* (Shedroff 2000, 49)

The National Storytelling Network website (The National Storytelling Network) describes storytelling as a valuable form of human expression which has its roots back in the beginning of human civilization. History has in previous generations been passed down through oral and written storytelling, keeping memories alive through personal expression. The storyteller controls the tempo of the presentation, adapting the language to suit the listener's attention and interest. A storytelling narrative offers a non-linear approach to memory interaction, where each time you follow a thread of narrative the outcome is unique.

The museum experience
Passive and poorly interpreted attractions will suffer at the expense of those that develop live demonstration, provide participatory and interactive displays, and give a quality of personal rather than institutional service to their visitor. Informality and friendliness will be valuable attractions. (Science Museum, 1986) (Macdonald 1997, 98)

Although experience fabrication is not new, the advance in technology – in particular digital technology – is allowing designers and innovators to create more ambitious experiences within our designs. Encompassing the more traditional discipline of design such as information design, interaction design, and sensorial design.

Experience design is an important skill set for everyone to have in the next decade and beyond are those that will allow us to create valuable, compelling, and empowering information and experiences

for others. (Shedroff 2000, 267-292) Shedroff continues: *Data is fairly worthless to most of us, it must be organized, transformed, and presented in a way that gives it meaning.* (Shedroff 2000, 267 – 292) He is referring to modern media's preoccupation with collecting and presenting factoid data, or information which serves little purpose other than to add to the viewer's arsenal of knowledge. Factoids are commonly used in science centres and science museums to convey complex information in simple terms to the public. The information serves no emotive purpose, and is oft-times not retained in our memory due to its lack of relation to who we are and what we stand for.

Whether our communication tools are traditional print products, electronic products, broadcast programming, interactive experiences, or live performances makes little difference. Nor does it matter if we are employing physical or electronic devices or our own bodies and voices. The process of creating is roughly the same in any medium. (Shedroff 2000, 267-292)

The first step is to convert the data into information and present it in a meaningful way, which will engage the audience and in the process forming a cognitive model.

This is where aesthetic visual narrative and visual metaphors and are implemented in visually innovative ways based on our intuitive understanding. Consideration is given to the target audience, how they visualise the product, and draw understanding and reference from its components: *Information Design does not replace graphic design and other visual disciplines, but is the structure through which these capabilities are*

expressed. (www.nathan.com) In order for the cognitive model to be successful the information needs to be represented with a sense of order and organisation. Using systems of structure, which users can relate to through our intuitive understanding of patterns within information presentation. Nathan describes the seven common systems of organisation as "alphabet, location, time, continuum, number, categories and randomness." (Shedroff)

The Storytelling Memories project uses location as the overall containment of memory testimony, as it provides a large, easily recognisable context for placement. Time governs the different environments. The same space may be shown over several time periods; each space has the potential to change between museum visits, inviting the museum visitor to explore the environment again for further development of the testimony. Artefacts are categorized in relation to the memories of the individuals. Personal artefacts of the individual are placed close to the museum visitor within the interface so that they can be handled in depth. A visually rich three-dimensional model of the space represents their placement within the environment. The environment is reactive – cupboard doors can be opened to reveal contained documents, books can be opened and buttons can be pressed. If the system was about a scientist, visitors could experiment with chemicals in the lab, play with scientific tools, or look through journals. All objects are embodied with audio testimony, which explains their connection to the individual.

Touch and tangible interface design

The exhibition as an entity must therefore be conceived and used as one single interactive system (and not only as an area of space equipped with interactive systems), within the scope of which the visitor interacts by means of his or her eyes, ears, fingers, and by the fact of his or her body moving through the actual area of the exhibition. (Rosnay, 1992, 24)

Now that computer knowledge is more prevalent in all age groups, museum visitors potentially find tangible operating systems less intimidating and more intuitive. With a more mature sophisticated user group desiring access to interface systems within museums the information displayed needs to also develop beyond gimmick games and quick facts. A good example of the intuitive combination of touch and tangible interaction design is the Reactable. Designed by the music technology group at the Pompeu Fabra University in Barcelona, the Reactable is a music-mixing device. Placing a combination of objects called *Tangibles* onto a multi-touch surface creates music. The tangibles are a variety of different shapes; the cube provides the beat, whereas the puck provides a pulse. When a tangible comes into proximity with another they stimulate and affect each other moderating the beats and sounds. Touching the table surface in the periphery of the tangible adjusts frequency and volume. Each tangible has a unique code tag on its base surface, which is interpreted and played by a computer as a unique sound.

Touch and tangible technology has not remained solely in the entertainment industry.

A Disaster Simulation System developed as a collaborative project at NTT Comware (Kobayashi et al. 2006) also uses the interactive qualities of tangible objects and touch sensitivity. The interface is built on sense-table technology, a system similar to the Reactable. Maps of locations prone to flooding, project onto the touch screen display.

Tangible objects represent safety measures that when placed onto the maps establish parameters. When a simulated disaster is played out across the surface, the tangible objects affect the outcome and present statistical and graphical data onto the surrounding screens. Sensorial triggers are the key to a successful interactive experience.

Audio and visual stimuli are common haptic triggers, and have most commonly been used in museum interface design to enhance the interaction with the exhibit. A memory is created and remembered by various emotional simulations. An old photo can be used to prompt a remembered situation. Voice recordings allow you to resonate and connect with the veteran through an imbued audio presence. Sounds such as aircraft flying overhead, or the low growl of a Lancaster Merlin engine starting up invoke feelings of anticipation, fear or excitement depending on the listeners' connection to the sound.

Touch is also a strong emotional sensation that builds an understanding of the physicality of a memory. Handling an object stimulates memory through our textural awareness of how we relate to different tactile sensations. Storytelling Memories enables artefacts to be rotated and inspected closely, giving the user the opportunity to digitally synthesize the

emotive qualities of handling a physical object.

The graphic interface

The Graphic User Interface (GUI) plays an important role in the presentation of memories for the storytelling memories project. Initial research into Museum Kiosk design revealed little graphic ambition and cohesion, or any depth the information portrayed. Techniques developed within web interface provided inspiration and functionality for the layout and navigation for Storytelling Memories.

Second Story stood out as a leader in graphic interface design in particular relating to storytelling navigation, the containing of large archives of data, and the peoples voice.

The National Archives experience – Digital Vaults website by Second Story references the substantial digital archives of the museum. The interface begins with a load sequence, which initiates the user to the functions and navigation of the system. When an image is selected it moves to the centre, all other images related to it via tags, or keywords span out from the centre in a star diagram. Selecting a new image changes the configuration.

The visual feast of the moving images is beautiful and navigation is intuitive to understand within a few attempts. The site however lacks a great depth of inquiry to the archives, and although the artefacts groupings create a connectedness, they do not give any particular individual voice.

The Theban Mapping project is another web project by Second Story. The Valley of the Kings is documented with an

initial map view. Clicking on highlighted chambers allows the user to explore them at depth through three sections overview, description and maps/plans. The Sections are accessed by a set of tabs always available on main screen toolbar. Each section of tomb is mapped the same way. The tabs offer a tier of information including detailed maps, Three-dimensional fly through views, real-life video, pictures and written accounts. The visual layout of the interface is clear and effective; the map is always to the left, information to the right.

Personal testimony in museums today

Memory testimony is becoming more prevalent within museums. As I discussed earlier there are several successful projects already within museums. More projects are in development, which although are not specific to science museums, act as a strong guideline of good practice.

Imperial War Museum Churchill Museum, London: Developed by Small Design the Churchill Room display contains a 18 metre long interactive table that documents the life of Winston Churchill. It contains thousands of articles about his remarkable life. Specific months in each year are catalogued in digital manila folders which when touch activated open to reveal information and memories associated to the date. The memories are located within a digital representation of their physical container – the filing cabinet, which it itself is a digital manifestation of the memory box. The mode of interaction draws upon the curious

explorative nature of the user, who rifles through the files in the same manner as they would a physical filing cabinet. The memories as well as existing within the context of their relation as a filed object also relate to simulations of pivotal events of the time. Moments in history have an effect on the entire table when opened. For example when the atomic bomb is dropped on Japan it sets off a blast and wipes the table. Or when the Titanic sinks, the whole table is flooded with water. Background simulations tie the dates together and have an effect on all of the open folders. This gives the files a placement within history alongside their localised placement as an object. Overall the table offers a seemingly limitless narration of Churchill's life, and every time you access the table you discover something new. One criticism of the exhibit however is that the entire system would benefit from more images, audio and video files to describe the memories.

MUVI – Community of Lombardia: The Museum of the community of Lombardia Italy have taken steps towards a refocus in what they choose to collect – beginning with a program, MUVI (Giaccardi 2006, 29), which records the personal memories of the local community in an effort of collectively conserve the community past. Beginning with a radio show members of the local villages were encouraged to ring in and talk about their memories of the area. The stories played live on air were uncensored and encouraged debates regarding differing recollections of events. The local accounts have brought back to life old buildings long since torn down, and allowed for differing opinions regarding historical events.

This system of collecting and displaying has been designed so each of the individual members of the community can have a voice both singly and collectively. The local museum has set in place a physical and web-based system to record and add to the memory testimonies they collect. The stories are played back to the community through the local radio station and both online and digital archives.

911 History.org website: Designed by the New York Consultancy Local Projects (Local Projects) the 911 history website was developed to "gather any and every 9/11 story in an effort to understand history form the perspective of those who witnessed it". The website allows visitors to upload stories, video and photos and group them according to time, theme or geography. In the geographical section images are tagged onto Google maps and Google street so visitors can see the events of 9/11 unfold within the context of understandable spaces. Visitors can group photos and stories according to particular events and locations so different voices can be heard regarding similar events.

Florence Nightingale Museum, London: The Florence Nightingale museum provides a in-depth testimony of the pivotal life of the war-time Nurse. The new exhibition designed by Dutch Designers Kossmann De Long will focus on three key periods of Florence's life to illustrate her story. Each section will feature its own three-dimensional display – The gilded cage and family, The Crimea and The health reformer – radiating out from the centre or more earlier testimony of her life to the outer ring which focuses on her influence on

Figure 1: The Cube

modern nursing. Each display will consist of a hierarchy of three tiers of information starting with her own thoughts and ideas, her surroundings and social context and the third provides historical context. This hierarchy of information presentation reflects the hierarchy used in Storytelling Memories, which substantiates personal testimony by providing a social and historical context within which the memories are placed.

Figure 2: Technical and related stories

Storytelling Memories

The Cube: The Storytelling memories project uses a tangible cube controller as a simple hierarchical activator to access the veterans' memories. A separate memory box represents each veteran. The cube is the physical embodiment of the memory box, made of wood, warm and inviting; it simulates the feeling of life. Each of the six faces on the cube corresponds to a different turning point within the veteran's life. When one cube is replaced by the next another set of memories is accessed, specific to each person (Fig 1).

The Touch Table and peripheral screens: The table is a physical window to memory presentation. The interface itself is segmented into two sections relating to a different hierarchy of memory. Memory display within the bottom half of the table contains the memory testimony of the veteran.

Figure 3: The environment of the memories

The memories are placed at the closest proximity to the user so they are easily accessible. The second tier of information is contextual or environmental and relates to the locations that are discussed within the veterans' memories. The third tier located in the peripheral projections is the most distant from the user. It uses collected memories which do not belong to any veteran in particular, but which contain information which substantiates veteran testimony and the context of the memories. This third tier might include technical or related stories. The sections that correspond to the icons illustrated on the side of the cube are *Childhood and Growing up, Squadron life, Inside the Aircraft, On Operations* and *After the War* (Fig 2). Turning the cube activates a new interface. A digital representation of an old drawer contains images and artefacts, reminiscent of mementos packaged away in

an old shoebox under the bed. Each image utilizes a set of tools, a magnifying glass for closer inspection, and an old Bakelite switch that controls sound. Set into the drawer is a digital window into the past; a detailed visual with subtle movements that narrates the environment relating to the memories (Fig 3).

Implementation: Storytelling Memories uses a collection of interactive hardware and software products in an innovative new configuration. The touch table is contained seamlessly within a physical display table. The cube controller is an independent tangible object, and is the head of the navigation tree. The cube sits beside the table in a separate subtle docking system. Each face in the cube also contains a unique Radio Frequency Identification tag (RFID). When the cube is brought into proximity to the table, the RFID tag communicates with the RFID reader located in the tabletop, which tells the computer software to change the interface screen file. When the cube is placed in the dock the top-facing icon indicates which section of the interface is opened within the table. An Arduino physical computing device provides the link between the physical and the digital environment.

The future of the scientist within the science museum

The need for change is eminent for science museums, and they are beginning to implement this transition. New media techniques and interactive design methodology are enabling more expressive and immersive systems of display that have the potential to make the exhibit both educational and

memorable for the visitor.

Science museums are educational facilities. They are preservation houses. But more importantly for the future of scientific research they can provide forums of open debate on scientific development and contribution at the public level. It is important that the public can play witness to the life of the scientist behind the science, so they can empathise and learn from the life and challenges of the scientist through an associated understanding. Public memory has a habit of exaggerating the experiences and opportunities of public figures to a point where the public regards them as something different to themselves – a super being capable of far greater achievements than is possible for most people.

Bringing exhibition design back to the personal testimony of the scientist reveals their human flaws, great sacrifices and the perseverance that has led them to their achievements. The public want to know this personal history, and we also want to know the history of the contributors behind the research figureheads, the everyday man, the technicians, lab assistants and all those who aided the discovery within science. If the Display was regarding Marie Curie, we would want to know about her early life in Warsaw, how she supported her sister through medical school, and her failed relationship with a prominent mathematician. How she struggled to support herself through university, her relationship with Pierre Curie and their scientific collaboration. She was an ordinary person. Whose life started out with the same trials and tribulations all our lives have. Were her scientific endeavours to be successful

solely because of her tireless dedication to science? Or is it also in part due to her finding a life partner to share her experiences with?

Great science is achieved by the diligent work of many hands, not so much a perfect sequence of events but a chain reaction of discovery and tenacity. It is this flowing narrative of highs and lows that we, the public, understand, as it exists in our everyday lives. It is this dedication to providing a holistic description of a life, which provides the human factor within good exhibition design.

References

Arduino physical computing device, programmable circuit-board, Italy, 2009: http://www.arduino.cc/

Carlyle, Thomas. 1848. *Heroes, hero-worship and the heroic in History*. New York. John Wiley

CosmoCaixa Science Museum in Barcelona, 2005: CosmoCaixa Barcelona. http://www.fundacio.lacaixa.es/

De Rosnay, Joel 1992. "Intellectual ergonomics and multimedia exhibitions". *In Museums and the public understanding of science*, ed. John Durant and the Committee on the Public Understanding of Science, 81-87. NMSI Trading Ltd.

Durant, John and the Committee on the Public Understanding of Science. 1992 . *Museums and the public understanding of science*. NMSI Trading Ltd

Giaccardi, E. 2006. "Collective Storytelling and Social Creativity in the Virtual museum: A Case Study. *Results from Design Issues*, Summer 2006, Vol 22, No 3, 29-41 Accessed Feburary 12, 2009).

Kavanagh, Gaynor. 2000. *Dreamspaces*, Continuum International Publishing Group.

Kavanagh, Gaynor. 1992. "Dreams and nightmares: science museum provision in Britain." In *Museums and the public understanding of science*, ed. John Durant and the Committee on the Public Understanding of Science, 81-87. NMSI Trading Ltd.

Kobayashi, K, Tsuchida, S, Narita, A, Omi, T, Hirano, M, Kakizaki, T, Kase, I, Hosokawa, T. 2006. *Collaborative Simulation Interface for Planning Disaster Measures*. ACM

1-59593-298-4/06/0004

Kossman de long Exhibition Design Architects, Amsterdam, Netherlands, 2009: http://www.kossmanndejong.nl/

Knell, Simon J. 2004. *Museums and the Future of collecting*, Surrey, UK: Ashgate Publishing.

Local projects Design Media, Jake Barton Design, 2009: http://www.localprojects.net/lpV2/

Macdonald, S. 1997. *The Politics of Display: Museums, science, culture*, New York, Routledge Publishing Group.

Miles, Roger and Tout, Alan. 1992. "Exhibitions and the public understanding of science". In *Museums and the public understanding of science*, ed. John Durant and the Committee on the Public Understanding of Science, 81-87. NMSI Trading Ltd.

Nathan Shedroff on Experience Design: Nathan's world, 2008: www.nathan.com

The Churchill museums and Cabinet War rooms in the Imperial War Museum, London, 2009: http://cwr.iwm.org.uk/

Theban Mapping Project by Second Story Interactive Studios, 2009: www.thebanmappingproject.com

The Florence Nightingale Museum, London, 2009: http://www.florence-nightingale.co.uk/cms/

The National Archives Experience: Digital Vaults project, 2009: http://www.digitalvaults.org/

The National Storytelling Network: The world enriched through Storytelling, 2008: http://www.storynet.org

The Reactable: Tangible music experience, 2008: http://mtg.

upf.edu/reactable/

Second Story Interactive Studios: Portland Oregon, 2008: http://www.secondstory.com

Shedroff, Nathan. 2000. "Information Design: A Unified theory of Design ". In *Information Design*, ed. Jacobson, R, 267-292. MIT Press.

Silverstone, Roger. 1992. "The Medium is the museum: On objects and logics in times and spaces". In *Museums and the public understanding of science*, ed. John Durant and the Committee on the Public Understanding of Science, 81-87. NMSI Trading Ltd.

Small Design studios, David Small Cambridge, MA, 2008: www.davidsmall.com

Science Adrift in an Enterprise Culture: Finding Facts and Telling Stories in the Maritime Museum

WILLIAM M TAYLOR

University of Western Australia

The building or renovation of maritime museums, particularly in the United Kingdom, United States and Australia in recent years, provides an opportunity to compare these to other institutions that call upon the past and see how they engage common interests in the social setting of history. One thinks of likely parallels with museums of science and technology which also seem caught up in a building boom and where, equally, the natural world is bound to the changeful contours of human enterprise, where nature is coupled with views of humankind's practical and existential needs and shackled to expectations for the progress of culture. As Robert Hicks (2001, 159) observes, maritime museums commonly situate seafaring within both natural and cultural environments. They are likely to "celebrate human industry and ingenuity through the crafts, traditions, and enterprise of the sea."

One can observe, more precisely, how they commonly project the universality and timelessness of seafaring along with its meaningfulness for humanity. This is a generalising tendency that works to distinguish between nature and culture as domains of human enterprise and then, with circularity of thought, conflates the two, subsuming both within an anthropocentric understanding of the world. One could argue that science museums do much the same thing. Further comparisons can be made between both maritime and science museums and the broader category of commemorative architecture, monuments and memorials which presuppose and work on public memory, thus deriving from the past, lessons intended to inform and edify the public

today. These are familiar and praiseworthy aims, but as Didier Maleuvre (1999, 59-60) writes: "That every thing deserves monumentalizing means we view reality as something already forgotten. The real itself becomes a cultural heritage – the reminiscence of something which is no longer quite possible in reality".

These comparisons reveal tensions at work in different kinds of museums and commemorative sites, particularly at a time when public accessibility, social and fiscal accountability are chief concerns for museum curators and designers. Foremost among these is the likely conflict between the need to instruct visitors and the desire to entertain them – between, for example, an emphasis on the classification of objects as key to learning and our 'real experience' of them. This prompts questions regarding the intellectual content and scholarship associated with collections versus the broader purposes served by the museum on the whole. The conflict is clearly evident in many maritime museums where, for example, learned interpretations of artefacts like antique naval timepieces can be found alongside exhibits dramatising the exploits of pirates and the hardships of ship-bound migrants. Then again, questions arise about how to achieve either outcome or both simultaneously, if indeed pedagogic and entertainment values can be, or should be, so readily distinguished. How can expectations for the completeness, authenticity and preservation of collections demanded by specialist, scholarly or scientific communities be reconciled with the open-ended catalogue of sea-faring stories curators and their patrons hope

are more widely understood and enjoyed? These questions lead one to wonder about the distinctiveness of maritime museums, their basis in knowledge of a particular kind or more likely multiple kinds, including forms of historical and scientific understanding. One can wonder what it is about the sea and seafaring that makes for 'lessons' from collections of marine and naval memorabilia, old compasses and sextants, refurbished dockyards and reconstructed ships. What is it, in Maleuvre's terms, that makes for the 'reality' behind these varied artefacts?

As a start for unravelling these issues, this paper looks at several prominent maritime museums and exhibitions, principally with a view to their approach to history and society. It identifies instances where science figures in their approach and works to make sense of the maritime past, some of the lessons science reveals and others the appearance of factuality conceals. The intention is not to treat science as exact and monolithic, even less as the basis for knowledge of a superior kind. Recent writing suggests that museums are more likely to create particular kinds of science, rather than the other way around. Equally, one could argue that maritime museums are likely to extend to the science that is displayed the institution's "own legitimizing imprimatur" (MacDonald 1998, 3). Specifically, the paper aims to identify modes of reasoning, particularly empirical and quantitative means that, along with narratives accounting for experiences of the sea, cast the history of seafaring as *socio-logical* – as subject matter that aspires to reveal social truths and conforms to

expectations for rational knowledge. It is a study whereby the marine environment is meant to provide material for moral edification for what scholars have identified, following Mary Douglas, as an enterprise culture (Heap and Ross 1992). Borrowing terms from the philosophy of science, I propose that maritime museums regularly subject the marine environment to an *empiricist conception of knowledge* and a *rationalist conception of action* whereby nature backgrounds the production of useful knowledge and acts of exploration, communication and technological exploitation. By this means, the museum are not the only places where collections of objects are housed and arranged; they also shore up ontological and epistemological concepts of *the real*. They prefigure and reinforce human responses to what becomes *reality*. The paper aims to demonstrate how the presentation of both facts and stories about the sea and sea-faring not only lead, but more or less oblige maritime museums and their visitors to "celebrate human industry and ingenuity" as Hicks sees the institution's prevailing ethos.

Sea-bound society

Maritime museums have grown from different kinds of collections and varied philosophical, curatorial and practical agenda. They are responses to local, regional and nationalistic needs. In view of these varied circumstances, it is hard to discern a common *raison d'être* behind them. Consider a few examples. The UK's National Maritime Museum in London (NMM at Greenwich) was established in 1934 from holdings

formed over many years, from collections of antiquarians, of scientific instruments and famous chronometers, of model ships and naval art. Its national and international status as a site of maritime heritage is given scientific and architectural prominence for encompassing the prime meridian and the Royal Observatory, the Renaissance-era Queen's House designed by Inigo Jones and the Greenwich Hospital (the Royal Naval College) by Christopher Wren. The ensemble features in a UNESCO designated World Heritage Site. The NMM at Greenwich is strongly active in researching, preserving and commemorating Britain's sea-faring culture though the ways this is done has changed markedly from the celebration of naval might to the encompassing of a broader range of issues, including recent displays chronicling the excesses, inequities and injustice of Britain's empire. Amongst its many exhibits, for instance, the Wolfson Gallery of Trade and Empire was inaugurated in 1999 as part of a major renovation and curatorial overhaul. Along with the Queen and the Duke of Edinburgh who officiated at its opening ceremony, the spirit of Joseph Conrad was called upon whose words on a commemorative plaque explained how: *The conquest of the earth, which mostly means the taking it away from those who have a different complexion or slightly flatter noses than ourselves, is not a pretty thing when you look at it too much.* (cited in Duncan 2003, 17)

By comparison, the celebration of commerce, rather than reappraisal of imperialism, is more in evidence at Mystic Seaport, a collection of buildings and heritage architecture

Figure 1: Mystic Seaport: The Museum of America and the Sea, Mystic River, Connecticut, USA.

set along the lower reaches of the Mystic River in Connecticut and designated The Museum of America and the Sea (Fig 1). The site of former dock and shipyards, relocated and new buildings contains multiple exhibition galleries, tall ships, training and fishing vessels (including the Charles W. Morgan, purportedly the last wooden whaling ship in the world) and a re-created 19th century seafaring village where visitors can observe and learn from docents who perform as nautical instrument makers, smithies and coopers. Whereas Britain's NMH demonstrates a spatial and aesthetic unity owing to its prominent position on the Greenwich peninsula and historic architecture, Mystic Seaport draws on its riverside setting to re-create a hive of activity. Outside one of its larger galleries, explanatory text for the current *Voyages: Stories of America and the Sea* exhibit introduces visitors to the world of industry

Figure 2: The National Maritime Museum of Australia, Sydney.

represented inside: *Join us on voyages across oceans, lakes and rivers. Travel through time with us to share the experiences of immigrants, ocean traders, explorers, fishermen, artists, warriors, and even vacationers. Whether you live in Connecticut or Colorado, New York or New Mexico, your life is being shaped by the sea in ways you might never have imagined before.*

The National Maritime Museum of Australia in Sydney, inaugurated in 1991 (though intended to open for the nation's bicentennial in 1988), differs from these other institutions in being housed in a single, purposefully designed building constructed alongside Darling Harbour as part of that area's commercial redevelopment (Fig 2). Under a cavernous curvilinear roof vaguely reminiscent of warehouses or boat sheds, galleries commemorating phases of Australia's indigenous, colonial and national sea-faring past are arranged.

The goals of urban and economic renewal, coupled with local, regional and nationalistic aims, featured in the building of this and other museums.

Apart from obvious references to the sea and sea-faring, these institutions and a host of others, both large and small, relating aspects of naval history, marine transport, migration and trade, seem to lack the coherence expected of other kinds of museums. One thinks of those based on established natural history or ethnographic collections or others created from works of sculpture, drawing and painting and historiographical methods associated with the fine arts. Of course, the apparent rationality of even these time-honoured institutions can be misleading or altogether false. The perception is an orthodox one, requiring that museums of whatever stripe have distinctive subject matter, determined categories of artefacts and prescribed methods for presenting, studying and learning from them. It presumes that collections are simply ingredient in the pursuit of knowledge, rather than determining what knowledge is and how it is caught up in relations with power, forms of governance and authority as theorists have come to recognise (Foucault, 1980; Luke, 2002). For many people, curators and attendees alike, the perception that museums are basically just collections of things and sources of easy lessons is an outmoded view of what a museum should be. Hence, amongst other recent trends and curatorial practices, there are moves to make 'social history' and 'experiences' from all kinds of collections – ideally, to make exhibits more accountable, accessible and

meaningful to a wider range of people. The success of these moves largely depends upon what one considers 'society' to be and on how it can be known. It depends upon the means undertaken to represent and communicate social realities and to anticipate how museum-goers will respond to the knowledge provided.

Hicks sees the prevailing turn to social history as providing a measure of distinctiveness to maritime museums. The trend serves practical purposes, affording considerable latitude to curators to assemble and contextualise collections of otherwise disparate artefacts relating to the sea, sea-faring, ships and boats. More significantly, Hicks aligns the new maritime museums and exhibits with the civic and morally edifying purposes commonly associated with history and ethnographic collections, recognising the former's "unique perspective on the seascape, the rituals which mediate man's relationship with the sea, and the use of sea metaphors in human cultural memory" (2001, 159). He values their exhibits as democratising the processes of history for incorporating themes of pluralism and diversity, class, race and gender. It is an approach that acknowledges the dominating influence of nationalism and empire on the historical formation of maritime collections, but also highlights freedoms brought about by globalisation and modernity. He writes: *Maritime museums, more so perhaps than other history museums with their narratives of progress towards civilisation, challenge parochialism by depicting seaborne successes of commerce, linkage with other lands and peoples, and technological feats of shipbuilding and*

navigation contrasted with images of disaster, hardship, and conflict. The sea allows triumphs but also arbitrarily consigns seafarers to oblivion, its unpredictability and omnipotence imposing humility. (ibid, 160-161)

The displays making for *On the Water* in the National Museum of American History in Washington, D.C. (NMAH in Washington) appear to transform the marine environment into such a stage (Fig 3). There, 'the social' is made from contrasts between global and provincial values, commercial triumphs and personal hardships, technological achievement and disaster. Equally, it is there that visitors learn how American self-understanding and identity evolved, seemingly from such contradictory phenomena. Formerly, the Hall of American Maritime Enterprise the collection was recently reworked as part of one section of the NMAH dedicated to the history of transportation in the US and flagged *America on the Move*. Located in the General Motors Hall of Transportation, the section is introduced by signage inviting attendees to: *visit communities wrestling with the changes that new transportation networks brought. See cities change, suburbs expand, and farms and factories become part of regional, national, and international economies. Meet people as they travel for work and pleasure, and as they move to new homes.* Through didactic, visual and interactive means and spatial sequencing, the NMAH in Washington demonstrates how Americans have nearly always, all found themselves on the water at some time or another (when not on the road or railways). At the same time, having identified this shared background of transient experience it highlights

Figure 3: Entrance to the *On the Water* exhibit, National Museum of American History, Washington D.C.

particularities of ethnic identity and occupational status, along with the circumstances of multiple pasts formed by forced and voluntary migration, war and military service, commerce and trade.

While not citing Hicks directly, Phyllis Leffler (2004) furthers his overall aim to undertake an ideological analysis of maritime museums by demonstrating how social history rehearses stories making for national identity on both sides of the Atlantic. The expectation that scholarship on maritime museums should include their ideological analysis is understandable (though debatable) if one already takes their focus to be 'the social' – the two critical categories are intertwined with a shared history in western discourse. In maritime museums in the US and UK Leffler observes how issues of social inclusion and diversity are commonly played out, while similar emphasis on the lives and experiences of

those who have gone to sea, either individually or collectively, shows up differences between the countries in terms of their prevailing sentiments, respective senses of place, public behaviour and tastes – all ingredients making for national identity as conveyed by current literature on the subject (including Leffler's). She writes: *In the United States, personal stories predominate as a means to reflect national diversity. The stories of men and women who either came as immigrants, or found work opportunities at sea reflect a collective national consciousness that promotes upward mobility and individual choice. Ultimately, for Americans – the story of the sea becomes the larger story of economic growth, opportunity, individualism, and entrepreneurship. It becomes a positive story. For Britons, the story of the sea is both positive and negative. There is great pride in British naval strength that led to political grandeur and that protected the country from foreign enemies. There is admiration for sacrifices endured by those who went to sea or the skills of those who worked in sea trades. But for Britons, the positive story of the sea is challenged by the four-hundred-year history of British Empire, for which there appears to be a sense of national apology or guilt* (2004, 48).

Curatorial responses to one class of forced and sea-bound migrants, slaves, give weight to these observations. The issue shows up differences between the two countries and their respective maritime museums in terms of sentiment and ideology. But it also highlights a common and underlying conceptual stratum where the meaningfulness of the sea for both Britons and Americans is caught up in movements and exchanges, commodities and valuations of some kind

or another (including the value of enslaved bodies) – all ingredient in enterprise culture. On the whole, the institution of slavery occupies an ambiguous position for museums curators as it does for social theorists (Fisher 1988, 75-83). It is uneasily positioned between – but then also reinforces – familiar extremes making for social analysis· the empowered and the dispossessed, domiciled and the transient, consumers and producers of excess capital, the cultured and the native.

In the UK several prominent museums give the issue of slavery concerted treatment. Typically, they communicate the history and excesses of British imperialism in which slavery is portrayed as the most evil; however, some variation is evident in the manner of representation and emphasis in the lessons to be learned. James Duncan describes the controversial display in the Gallery of Trade and Empire at the NMM in Greenwich (subsequently reworked and reopened in 2007 as the Atlantic Worlds Gallery) where the modelled figure of a tea drinking woman in period costume is contrast to a black arm that reaches upwards from the floor and the recreated hold of a slave ship: *The text to this striking juxtaposition tells the viewer that elegant eighteenth-century society was supported by slavery, and that as sweetened tea and coffee became increasingly popular, so more and more Africans were enslaved. It goes on to add that the global trade of which these commodities were such an important part came to 'create a self-consciously civilised society [that] eventually came to feel that slavery was incompatible with a civilised society.* (Duncan 2003, 22)

A parallel, if slightly different message is given by The

International Slavery Museum which opened in 2007 at the Albert Dock in Liverpool. The facility grew from well attended exhibits in the Transatlantic Slavery Gallery of the Merseyside Maritime Museum. David Fleming OBE, Director of National Museums Liverpool, expressed its vision on the organisation's website in this way: "The transatlantic slave trade was the greatest forced migration in history. And yet the story of the mass enslavement of Africans by Europeans is one of resilience and survival against all the odds, and is a testament to the unquenchable nature of the human spirit." Whereas Duncan's criticism represents a conflict between human rights and class-bound markets desirous of luxury goods, Fleming's comments emphasise the resilience of (some) humanity against all odds. The critic lays emphasis on the collective entity, civilisation, as an agency for social progress; the Director's comments credit individual character traits like resilience and perseverance for upward mobility.

Leffler sees slavery as relatively downplayed in the US though one should add there are other types of museums and commemorative sites that lie beyond the scope of her paper where the stories of African-Americans are likely to be given a fuller account. In terms of representing the enterprise of sea-faring cultures the distance between the US and UK is not as great as one might suppose. One can observe that in both countries the issue and historical circumstances of slavery are likely to be subsumed within a bigger story of social (specifically multicultural) and economic progress. In one of a series of displays making up *On the Water* in

the NMAH in Washington headlined *Living in the Atlantic World* accompanying text establishes the entwined social and commercial contexts for understanding slavery and its evils: *Maritime commerce connected peoples and nations that rimmed the Atlantic in a web of trade, conquest, settlement, and slavery. Europeans carved out vast new colonies in the Americas. From gold to sugar, the resources of the New World transformed European societies. The transatlantic slave trade carried millions of Africans westward to lives of labour and suffering carried millions of Africans westward to lives of labour and suffering. Ships and sailors helped create a complex new world with maritime commerce at its core.*

Representing something of the geographic, material and moral dimensions of this "complex new world" one tableau of visual imagery and artefacts in the NMAH Washington describes circumstances of The Middle Passage involved in the transatlantic slave trade. The display combines a map of Africa, period leg shackles, a cutaway model of a slave ship and a plan of a ship's hold commissioned by a British parliamentary committee responsible for investigating the trade in 1791.

This frequently cited and reproduced plan of a Liverpool slave ship highlights the artefact of sea-faring most commonly positioned to identify and communicate the social reality of the sea: the ship. For Hicks (2001, 162) "The *sine qua non* of each maritime museum is its collection of ships and boats." Leffler (2004, 32) likewise observes how: *People who have spent time at sea or whose lives are bound up with those at sea experience a*

unique sense of place. Living spaces, working spaces, sea and shore spaces, gender spaces, and class spaces operate around points of community and of separation. Ships are floating cities, providing shelter, sustenance, work, leisure, and creative outlets. They are also places of law and order, meting out punishment for offenders. During the time of a voyage, they offer no opportunity for removal from the community, except by death. Those aboard are captive for the duration of the journey. The power of nature or the powers of the enemy are constant threats to safety and security. Those on shore live with the reality of separation from loved ones and the knowledge of danger and risk.

Composing collections of antique models, by means of partial or cutaway and scaled down reproductions of ships and boats or (the real prize for curators) whole, life-size and operable vessels (either period or reconstructed), maritime museums and exhibits provide visitors with analogues for human society. Ships and boats help position sea-faring "within both natural and cultural environments", but this is no easy place to be. Hicks and Leffler reinforce arguments of social theorists (Foucault 1986 (1967), 6; Goffman 1961, xii) who portray naval architecture as akin to laboratories that once defined social relations and forms of disciplinary knowledge. However, one should add an important caveat. They were also sites where social relations were blurred and discipline rendered ineffective. Slave revolts and mutinied crew, incidents of shipwreck, mortality and bankruptcy commonly originating on board may make naval architecture a model for society, but it is an imperfect one (as all societies are).

Oceans of numbers

Just as the maritime museums have grown from varied circumstances, the science that is represented or conducted there is varied. Particular fields of inquiry commonly enlisted include cartography, chronometry and disciplines associated with marine navigation, naval engineering and construction and sciences associated with water-borne commerce and transportation like logistics and risk assessment and management. Some institutions not only call on these fields, but also incorporate active research centres in others, like marine archaeology or oceanography. A facility like Mystic Seaport, for instance, furthers the study of timber sailing vessels along with their preservation and display. Along with historic or reconstructed ships and models in their exhibits, museums commonly implicate sciences relating to developments impacting on life on board, like medicine and sciences of hygiene, psychology and managerial fields related to the organisation of labour. The different fields of application and disparate workings of scientific inquiry in the maritime museum makes it a less overt subject of knowledge and exhibition than in museums of science, technology and industry, though it is no less formative of knowledge about the sea and ships and so equally worth unpacking.

Consider in particular how statistical knowledge supporting different fields and subjects of scientific inquiry enters into the equation in an excerpt from the guidebook to the renovated galleries (1999) of the NMM in Greenwich. The passage acknowledges how the sea may at

first seem remote from the experiences of ordinary citizens: *However, the sea has a major impact on modern lifestyles. Over 95% of all world trade goes by sea, and in 1996 international merchant ships carried 20 trillion ton/miles of goods. World fish stocks diminish with catches of 90 million tonnes a year destroying 20 million tonnes of unwanted fish and other ocean life in the process. We burn carbons and worry about sea-level rise, not surprisingly, since 70% of the world's population lives within eighty kilometres of the coast* (cited in Hicks 2001, 159).

In the guidebook, rhetoric and statistics work to "construct an image of a vast human enterprise which exploits and is shaped by the sea." (ibid) Quantitative information is also an essential element or condition for political criticism. By this means the cited passage first objectifies a domain of social relations in accounting for "modern lifestyles" and citing demographics bound up with commerce and consumption and then hints of ethical issues associated with (in this case) global warming.

Numbers perform similar roles in the exhibition of *On the Water* at the NMAH in Washington. In multiple, highly visual and three-dimensional displays the forms and rationales for transient behaviour (forced and voluntary migration, commerce and transportation) are identified and positioned within broader patterns of production and consumption characterising American life. Unlike its British counterpart, the NMAH pays scant attention to the ethical consequences of such movements (the silence itself entails a political position of a kind). However, the facts making for those are there.

Amongst other details visitors learn how much tobacco could fit in a hogshead in times past (1000 pounds, but "only if you knew what you were doing") or how much seafood Americans consume per year today (16 pounds, though "eighty percent of it is imported"). Tuna is the second most popular seafood consumed in the United States, but mostly comes from Trinidad and Tobago, Vietnam and Mexico. This part of the exhibit displays a large photograph of a local seafood market counter in Arlington, Virginia. It is positioned near to a descriptive plaque describing "consuming in the global marketplace" and images of containerised freight. The packed hold of the slave ship on display in a preceding space is counterpoised here by a display showing "how much stuff" can fit in a shipping container (350 bicycles from Thailand, 200 dishwashers and washing machines from Hong Kong or 640 vacuum cleaners from Malaysia). Moving along, visitors encounter information on "Fuelling our lifestyles" and more facts showing how America relies on overseas fuel imports for approximately two-thirds of its energy consumption. Imports include nearly 13 million barrels of crude oil per day and 3.5 trillion cubic feet of natural gas for the year. This represented 20 to 25 per cent of energy usage worldwide.

The use of quantitative information is common in maritime museums. Along with visual imagery like the drawing of the slave ship and photographs of containerised freight, they reproduce what is known as an *empiricist conception of knowledge* commonly relied upon (but questionably so) by social, economic and political theorists (Hindess 1977a, 133).

This is a concept whereby understanding is thought to result from the presentation of facts that correlate to some kind of reality, independent of an observation language or regime of visuality, ideology or subjective bias on the part of viewers. As I have attempted to show, the reality germane to this paper is a social one, but here, in view of the preceding statistics, it is only potentially ethical and just vaguely political. In displays and quantitative data comprising *On the Water* information making for criticism of America's resource intensive lifestyles or overseas oil dependency, its vulnerability to shocks in global fuel markets or near non-existent energy policies is there, but the exhibition does little to connect the dots in an ocean of facts to make such criticism clear. There is nothing to counter belief that globalisation, the consumptive and transient behaviours the concept justifies and the interests these serve are anything other than natural and inevitable. Rather, visitors are left to draw their own conclusions and this is seen as a lesson in itself. However, it is not necessarily an informed or authoritative one leading to any kind of socially (and environmentally) progressive outcomes.

Consuming stories

Quantitative and statistical means and accounting in the maritime museum serve to represent the sea as a domain of empirical knowledge. Equally, prevailing rhetoric and narratives called upon to tell stories transform the marine environment into a theatre for human experience and aspirations, ingenuity and industry. The ethical imperative

behind telling stories is part of what scholars (Macdonald 1998; Duncan 2003 and others) discuss as the *new museology*. In maritime museums, this is an approach that involves identifying "multiple perspectives" on the sea. It can mean discerning the "voices of the [already] spoken for" and undertaking these tasks "in a way that is disruptive of established representational forms, which is to say it is self-reflective, ambivalent and ironic." (Duncan 2003, 20) However, the approach can also mean choosing the stories that are most familiar or already popular and communicating them in ways that reinforce the status quo.

In British maritime museums the voices revealed and echoed through means of oral histories, excerpts from diary accounts, audio-visual and interactive displays make for a noisome past. They tell the stories of women labouring in the Scottish fishing industry at the Buckie (Scotland) Drifter Maritime Heritage Centre (opened in 1994, subsequently closed) and the revamped Fishing Gallery at the Aberdeen Maritime Museum. Another exhibit at the Aberdeen museum focuses on the North Sea oil industry. It frames testimonies of offshore oil workers so visitors can learn of the harsh conditions on the rigs and ways the workers have tried to reconcile their demanding labour on production platforms with domestic life on shore. The Merseyside Maritime Museum in Liverpool recognises the influence of the merchant navy. Counterpoising the dominance of British naval (military) history in traditional museums, its *Lifelines* galleries aim to narrate civilian connections with the sea. Similarly, the

Museum of the London Docklands uses oral history and other means to tell the stories of dockyard workers and east-enders whose lives are commonly missing from maritime history (Day and Lunn 2004, 90-92).

While intended to bring the sea to life and make maritime heritage more accessible or enjoyable, the practice of telling stories is invariably a political as well as a social one. It accommodates views of what society, its maritime heritage and museums should be and presumes how citizens and museum-goers should behave, feel about and learn from exhibits. In being 'political' there is no one single political idea (as in from the left or right) behind this approach. Rather, stories about experiences are gleaned from the past and packaged to support different agenda. For example, there may be the overarching story of power, social inequality and injustice that we saw before. By comparison, at Mystic Seaport, the visitor map details one gallery titled *Voyages: Stories of America and the Sea* and promises to take visitors on "a remarkable journey through our seafaring lives, past and present". True to Leffler's account of American maritime museums and national identity there are pronounced economic, celebratory and progressivist aspects to this itinerary. Likewise, personal experiences, past and present, are summoned in *On the Water* at the NMAH in Washington where a section of the exhibit introduces visitors to the idea that "Personal Connections" with the sea are not only possible, but unavoidable: *Most of us take for granted the vital activity in the nation's ports, along its inland and coastal waterways, and on the high seas. Explore how*

your life is connected to the goods, resources, and materials that
have spent time at sea. And consider how the way we live has an
impact on the waters, both at home and around the globe.

On the face of it there is little evidence of the negative
aspects of these connections. There is little to illustrate how
experience may include damage caused by environmental
irresponsibility, economic inequality and social injustice.
Instead, the stories are moral tales, calling on the past and
past lives, to identify and inculcate desirable character traits
associated with an enterprise culture. Commenting on the
widespread interest in creating experiences for visitors to
museums and commemorative sites Wendy Brown (2006a,
140) writes "As the historian Joan W. Scott argues, in an
episteme in which experiencing something is considered
to provide authentic and unmediated access to its truth, the
fact of witnessing or undergoing something ideologically
eliminates the need for interpretations or critical analysis."

Conclusion
In this paper I have described some prominent maritime
museums that make for a social history of the sea and sea-
faring. I have sought to show how this approach to the past
affords distinctiveness to these museums as a particular kind
of public institution though useful parallels may possibly
be drawn with museums and exhibitions of science and
technology, particularly where nature can also serve as a
mirror or background to expectations of what communities
can or should be: imperial or democratic, repressive or

egalitarian and above all, curious and enterprising. As for more detailed comparisons and the ways science enters the picture more work needs to be done. Given the need for brevity, I have limited my view of science to describing how practices of quantification and statistical means work to objectify the marine environment and describe a phenomenal realm for experiencing the sea and sea-faring. By way of concluding the paper it is worth turning again to the philosophy of science to expose a corresponding subjective dimension to this undertaking that legitimates the story-telling that goes on.

Just as maritime museums and their exhibits raise philosophical concerns for the status of 'the social' in western discourse, they likewise raise questions about the kinds of human subjects the institution is directed towards and subsequently sustain, their reasoning, sentiments and actions. Telling stories and promoting experiences in maritime museums can work in a practical domain to reproduce and substantiate what is described in philosophical terms as a *rationalist conception of action* (Hindess, 1977b; Hodgson 1985). This is a concept common to sociological, economic and political thought involving a tacit assumption that human behaviour is guided by rational calculation, the assessment of risk and choices based largely and logically on self-interest. Maritime museums perpetuate this assumption even when behaviour communicated in the stories told about some seafarers – slaves, pirates and some migrants, for instance – may not obviously appear 'rational' or acceptable to any reasonable person.

Briefly, consider one final example, an interactive display at the NMAH in Washington which at first seems to challenge the rationalist action model, but then ends up reinforcing it. Modelled after a carnival side-show amusement, visitors approach *A Privateer's Game of Fate* where they are invited to "Join the crew as an ordinary sailor and take your chances" and physically spin-the-wheel to obtain one of several possible predetermined outcomes to the following scenario where: *The money you'll make – and your ultimate fate – depends on the share allotted to you in the Ship's Agreement, the value of the ship you capture (the prize), and what happens along the way.* The "ordinary sailor" intended by the display is no run-of-the-mill scallywag or movie villain. Rather reference is made to a privateer on board an American schooner engaged in war with Britain, a person authorised to profit from any enemy ship they capture. Among the outcomes possible from this particular make-believe conquest is the one where: *you're the eighth man to board an enemy vessel, for which you earn extra share! But the ship has no cargo. You burn it and leave with no prize.*

While ostensibly a story about the vagaries of sea-faring, the show plays out an economic scenario where fate is never entirely the master of one's destiny, but is mediated by the rules of a game. In the end it rehearses a morality play, not about buccaneers who find themselves outside society, but rather the figure known as a "rational decider" (Habermas, cited by Brown, 2006b, 703), a subject very much a part of a social and economic (and implicitly political) order. This is a person who responds to circumstances as they find them

and whose actions are perfectly reasonable given the familiar motivations of patriotism or self-preservation or the desire for profit. As representative of the bigger picture and story of the maritime museum, the sailor portrayed stands in for all us who are told we benefit in some way from a sea-faring culture. By this means we are intended to become enterprising citizens (and pirates) all.

References

Note: unless otherwise indicated text cited from exhibit displays was recorded by the author on visits to the respective museum in 2009.

Brown, Wendy .2006a. *Regulating aversion: tolerance in the age of identity and empire*. Princeton, N.J.: Princeton University Press.

Brown, Wendy. 2006b. American Nightmare: Neoliberalism, Neoconservatism and De-Democratization. *Political Theory* 34.6: 690-714.

Day, Ann and Ken Lunn. 2004. Tales from the Sea: Oral History in British Maritime Museums. *Oral History* 32.2: 87-86.

Duncan, James. 2003. Representing Empire at the National Maritime Museum. In *Rethinking Heritage: Cultures and Politics in Europe*, ed. Robert Peckham, 17-28. London and New York: I. B. Taurus.

Fisher, Philip. 1988. Democratic Social Space: Whitman, Melville, and the Promise of American Transparency. *Representations* 24: 60-101.

Foucault, Michel. 1986. Of Other Spaces. *Diacritics* 16: pp. 22-27. Originally a lecture by Foucault given in 1967.

Foucault, Michel.1980. *Knowledge and Power: selected interviews and other writings*, ed. and trans. Colin Gordon. Brighton, Sussex: Harvester Press.

Goffman, Erving. 1961. *Asylums: essays on the social situation of mental patients and other inmates*. Harmondsworth (Middlesex): Penguin.

Heap, Shaun H., and Angus Ross, eds. 1992. *Understanding the Enterprise Culture: Themes in the work of Mary Douglas.* Edinburgh: Edinburgh University Press.

Hicks, Robert. 2001. What is a Maritime Museum? *Museum Management and Curatorship* 19:2: 159-174.

Hindess, Barry. 1977a. The Concept of Class in Marxist Theory and Marxist Politics. In *Class, Hegemony and Party*, ed. J. Bloomfield. London: Lawrence Wisehart.

Hindess, Barry. 1977b. *Philosophy and Methodology in the Social Sciences.* Brighton: Harvester.

Hodgson, Geoff. 1985. The Rationalist Conception of Action. *Journal of Economic Issues* 19.4: 825-851.

Leffler, Phyllis. 2004. Peopling the Portholes: National Identity and Maritime Museums in the US and UK *The Public Historian* 26.4: 23-48.

Luke, Timothy. 2002. *Museum Politics: power plays at the exhibition.* Minneapolis: University of Minneapolis Press.

MacDonald, Sharon. 1998. *The Politics of Display: museums, science, culture.* London and New York: Routledge.

Maleuvre, Didier. 1999. *Museum Memories: History, Technology, Art.* Stanford, CA: Stanford University Press.

Index

Aberdeen Maritime Museum 465

Academy of Games 223-224

Academy of Sciences 223-224, 254, 307

Adelaide Gallery 103

Advancement of Science 104, 163

AHRC 171

AIDS 67, 235, 347

AMA 27-29, 31-35, 37, 41-42, 44 45, 49-50, 52

American Association of Museums 392

American College of Surgeons 46

American International Exposition 48

American Medical Association 15, 27-28, 38, 48-51, 235

American Museum of Natural History 338

American Planning Association 205

American Prairie Foundation 316

American Registry of Pathology 49

American Society of Neuroradiology 45

Animators 195

Architects 13, 18, 253, 442

Armed Forces Institute of Pathology 49-50

Army Medical Museum 30

Ars Electronica 225

Art 13-14, 17, 30, 60-61, 63, 66, 68-69, 76, 121, 141, 153, 161, 188, 205, 211, 214-215, 217-219, 221-229, 233-234, 239-241, 245, 251, 253, 255-256, 265-266, 270-272, 285, 290, 294, 297-298, 303, 308-309, 326, 328-329, 331, 333, 336, 353, 380, 422, 449, 472

Artist 17, 69-70, 73, 80, 130, 221, 246, 253, 268, 272, 285, 291-292, 296, 306, 330, 336

Assembly of Academies of Sciences 224

Association of American Medical Colleges 42

Association of Science-Technology Centers 380, 392

ASTC 413

Atoms 70, 183, 185-186, 190, 345, 353, 359, 397, 400, 402-404

Audio 428, 430, 433

Bacteria 211-212, 293-296

Bakelite 438

BBC 74-75, 118

Bermondsey Abbey 78

Bible 248

Bioart 214-215, 221, 228

Biodiversity 307, 317, 338, 340

Bioethics 235

Biomedicine 234-235

Biopolitics 213, 231-232

Bioscience 304, 360

Biosonics 252

Biosphere 364

Biotech 212, 215-216, 218-219, 234

Biotechnology 174, 176, 216-218, 232, 359

Brain Research Institute 246

Brazilian National Synchrotron Light Laboratory 404

British Association 104, 163

British Council 290

British Museum 81, 118, 155

Butterfly Conservation Initiative 340

Cabinets of Curiosities 155, 223, 229

California Academy of Sciences 307

Case Study 16-18, 200, 274, 441

Cavendish Laboratory 98

Chemistry 62, 100, 103, 250, 421

Chernobyl 158

Children 118, 122, 124-125, 130, 134, 155, 270, 352-353, 366, 397, 409, 411

Clarendon Laboratory 98

Classroom 173

Climate Change 74, 153, 174, 176, 307-309, 337-338, 358

CNN 376

Collections 12, 21, 30, 38, 117, 120, 134, 142, 155-156, 223, 270, 301, 304,

446-449, 452-453, 460

Colorado Water Resources Research Institute 339

Commercialization 111

Conservation 93, 279, 307, 338-340

Content 18, 43, 77, 100, 106, 120, 147, 153, 155, 160, 195, 197, 346, 356, 368-369, 375-377, 379-381, 385, 390-391, 399, 407, 446

Contextualisation 346-347

Cooking 382-384, 388-391

Craftsmen 247

Culture 13, 15, 19, 21, 28-29, 36, 38, 46, 48, 58, 62-64, 72-74, 81, 105, 109, 114, 117, 150, 172-174, 180-181, 193, 207-208, 211, 233, 241-242, 255-256, 264, 304, 326, 329, 331, 397, 442, 444-445, 448-449, 457, 467, 470, 472

Curator 76, 81, 118, 241, 281, 375

Curiosity 57, 71, 154, 223, 225, 229, 244, 269, 380, 397, 405-406

Dana Centre 166-169, 171

Democracy 165, 206, 233

Dendritic 17, 238-240, 243-245, 248-249, 252, 255, 257, 259-264

Design 11-14, 16-22, 68-70, 81, 93, 117, 119-120, 145, 147, 149, 160, 179, 183-184, 187, 190, 202-203, 226, 241, 243, 251, 254, 263, 303,

319, 344-345, 353-359, 362-364,
366-372, 375-378, 381-382, 384,
387-388, 392, 398, 408, 410-412,
417-418, 421-422, 424-427, 429-
432, 438-443
Designer 119, 123, 129, 217, 251, 253
Deutsches Hygiene Museum 75
Deutsches Technikmuseum 157
Dinosaurs 172, 307
Discovery 55, 63, 96, 127, 156, 212,
248, 423-424, 439-440
Display 11-12, 14-16, 21, 26, 30-31, 36,
38, 48, 77-78, 81-82, 87, 90, 97,
114, 120, 122, 134, 141-143, 147,
150, 154, 160-161, 166, 169, 175,
183-184, 193-194, 199-200, 202,
207, 222, 270, 276, 283, 285,
353-354, 357-358, 379, 417-419,
421-423, 430, 432, 434-436,
438-439, 442, 457, 459, 461, 463,
469, 472
DNA 59, 79-80, 146, 211-212
Documentation 296, 309, 390
Drawings 27, 32-33, 36, 55, 70, 240,
245, 248, 252, 262, 271-272, 276,
281, 285, 289, 293, 295-296, 302,
352, 382, 389
Dreams 75, 441
Economics 314, 338
Economy 102, 172, 213, 313, 315

Ecosystems 307, 317, 334, 338, 340
Education 20, 29, 43-44, 46, 51-52,
64, 93, 114, 125, 155-156, 175-176,
225, 233, 251, 269, 398, 409, 413,
419, 425
Education Centres 419
Elk Island National Park 317
Encyclopedia 206
Encyclopedia of Nanoscience 206
Endangered 17, 306-309, 317-319, 323,
328, 330-332, 334-338
Energy 36, 50, 58, 64, 69, 93, 112, 142,
153, 159, 169, 263, 347-348, 359-
360, 365, 367, 386, 390, 463-464
Enlightenment 154, 258
Enola Gay 146, 150, 175
Environment 14, 19, 46, 72, 124-125,
195, 207, 273, 283, 329, 338, 347,
365-367, 372, 398, 403-404, 407,
409, 417-418, 423-425, 428, 437-
438, 448, 454, 464, 468
Ergonomics 406, 441
European Academy of Design 303
European Commission 174
Evidence 28, 38-39, 82, 266, 273, 275,
278, 283, 296, 300, 419-420,
449, 467
Evolution 99, 157, 172, 174, 211, 219,
233, 348, 421
Exhibit 13, 15-16, 18, 27-28, 31-41,

45-46, 48-50, 52, 90, 92, 153,
169, 179-188, 190, 192-203, 224,
288, 346, 348-353, 363, 375-376,
379-380, 388, 392, 397, 406, 418,
421, 430, 433, 438, 450, 455, 463,
465-466, 471

Exhibition 11-18, 21-22, 26, 31, 35, 44,
55-57, 59, 61, 67, 69-70, 72, 75-77,
79-81, 87-90, 92, 101-102, 104,
110, 117-120, 122-123, 126, 128-130,
133-134, 138-140, 142-147, 149,
152, 154, 159-162, 165-166, 169-
170, 174-175, 195, 211, 217-218,
223-224, 235, 239-241, 243, 245,
248-249, 251-255, 269, 281-285,
299-300, 345-346, 348-349,
351, 353-357, 359, 361, 366-373,
375-385, 387-392, 394, 396-399,
407-413, 421-422, 424, 429, 434,
439-440, 442, 450, 461-462,
464, 472

Experience 12, 14, 18-19, 58, 63, 75, 77,
104, 109, 119, 126, 131, 156-158,
169, 187, 218, 221, 269, 272-274,
276-279, 286-290, 295-298,
300, 344-346, 350-351, 366, 368,
372, 375, 378, 382, 384, 386-387,
397-399, 401, 406-409, 411, 417,
421-426, 430-431, 442, 446, 454,
459, 464, 467

Experimental Art Foundation 214,
234

Experiments 16, 22, 38, 67, 90, 92,
95, 97, 101, 105-108, 112-114, 138,
143-144, 149, 211, 216, 218, 221,
224, 228, 359, 380, 419

Exploratorium 156, 174, 375, 395

Exploratory Science Museum 19

Expo 181, 254, 369

FACT 12, 43, 58-59, 66, 69, 72, 76,
79, 81, 101, 111, 139, 147, 197, 217,
225, 376, 379, 383, 385, 388, 408,
429, 467

Florence Nightingale Museum 422,
434, 442

Food 142, 144, 150, 160, 316, 335, 351,
383, 386

Fractal Geometry 253, 265

French Revolution 93

Futurelab 225, 412, 414

Gallery 61, 70-71, 77-78, 81, 87, 103,
106, 117, 120-122, 124, 129, 133,
142, 145-146, 150, 153, 156,
160-162, 165, 167, 169-170, 177,
208, 211, 222, 271, 281, 283-284,
293, 336-337, 392, 449, 457-458,
465-466

Games 19, 125, 223-224, 398-399, 401-
402, 405-406, 408, 414, 429

General Motors Hall of

Transportation 454

Genome 59, 213, 317, 363

Geologists 257

Governance 29, 158, 165, 174-175, 207, 310, 452

Graphic design 254, 354-355, 362, 372, 427

Great Exhibition 21, 92

Gulbenkian Institute of Science 271, 290

Handling 125, 158, 430-431

Hands-on 18, 72, 87, 90, 108, 110, 156, 200, 222, 346, 350, 366, 395, 412, 419

Haptic interfaces 207

Health 29, 32, 42, 55, 58, 61, 63, 68-70, 74-76, 142, 195, 203, 232, 302, 364, 402, 434

Heart 55-57, 69, 128, 208, 235, 302, 345

Historian 20, 41, 240, 252-253, 419, 467, 472

HIV 66

HTML 235, 265 266, 302 303, 338 339, 387, 412

Humanities 55, 256, 304, 422

Hunterian Museum 275, 279, 281-284, 302

ICOM 149

ICT 192, 203

Ideas 17, 19, 29, 32-33, 59-61, 64-65, 68, 72, 75, 77, 79, 89-90, 117, 119, 122-124, 133, 142, 156, 164-166, 197, 222-223, 225, 228, 235, 259, 375, 379, 381, 387-388, 390, 395, 399, 401, 410, 435

Illustrations 36, 255, 301, 348, 401

Images 36-37, 39-41, 56, 63, 70, 77, 105-106, 202, 206, 240, 242, 252, 256-257, 266, 276, 285, 287-288, 350, 354, 359, 362-363, 366, 369, 380, 398, 400-401, 431, 433-434, 437, 454, 463

Imperial War Museum 432, 442

Industry 155-156, 159, 167, 251, 429, 445, 448, 450, 461, 464-465

Informality 426

Information 13, 17-18, 27, 33, 35, 39-40, 43-44, 66, 78, 119, 127, 132, 139, 153, 159, 168, 176, 195, 197, 212, 229, 254, 265, 269-273, 275-276, 278-283, 285-289, 293, 298-299, 345, 351-352, 354, 360-362, 372, 377 381, 387 389, 407, 410, 417, 419, 424-429, 431-432, 435, 437, 443, 462-464

Innovation 178, 192, 206, 212, 219, 224, 228, 379, 395

Installation 56, 145, 250, 294, 324-325, 329, 334, 352, 357-358, 375,

381, 408

Institute of Cultural Studies 251

Instituto Gulbenkian de Ciência 221

Instruments 64, 87-88, 93, 99, 111,
113, 180, 185-186, 216-217, 272,
397, 401, 404, 423, 449

Interactive 13, 18-19, 106, 118-119, 122,
126, 128, 132, 143, 153-154, 160,
170, 185, 188-192, 203, 345-346,
350-352, 371, 394, 397-398,
401, 409, 412-413, 417, 424-427,
429-430, 432, 438, 442-443, 454,
465, 469

Interactivity 18, 150, 177, 179, 187,
200, 208, 344, 352

Interdisciplinary 13, 15, 22, 56, 60,
63, 67, 72, 222, 240, 248, 264, 303

Interface 103, 253, 302, 417-418, 428-
432, 436-438, 441

International Slavery Museum 458

Internet 167, 361, 378, 381

Interpretation 14, 70, 97, 132, 134,
143, 272-273, 377

Interview 202-204, 221, 235, 339

Journal of Museum Education 413

Journal of Nano Education 413

Journal of Public Understanding of
Science 21

Journal of Royal Society of Medicine
304

Journal of Science Communication
412

Journal of Visual Communication
50

Journeys 234

King George III Museum 11

Knowledge 13, 18, 35-37, 39-41, 64, 68,
90, 101, 109, 112-113, 131, 140-141,
143, 146, 149, 161, 163-164, 166,
173, 175, 179, 200, 205-207, 218,
222, 224, 239, 258-259, 265, 269,
272-273, 278, 281, 285-286, 288-
289, 297, 299, 301, 346, 361, 366,
368, 371, 380-381, 385, 404, 410,
420, 424-425, 427, 429, 447-448,
452-453, 460-461, 463-464, 471

Kunstforum International 254

Kunstkammer 223

Laboratório Nacional Luz
Síncrotron 396

Laboratory 16, 98, 102-103, 108, 112,
174, 212, 221-222, 249, 271, 273,
366, 404, 425

Large Hadron Collider 106

Launch Pad 87, 156

LEGO 376, 392

Liberty Science Center 18, 374, 378-
382, 384, 392

Library of Congress 339

Lightning 260, 266, 322

Literature 19, 76, 163, 233, 456

Long Tail 377, 383, 392

Magazine 114, 338, 377

Mapping 145, 243, 331, 431, 442

Maps 144, 256, 261, 430, 432, 434

Maritime Museum 19, 444, 448, 451, 458-459, 461, 464-465, 470-472

Marketing 61-62, 73, 377-378

Marketplace 21, 113, 463

Marxist 472

Materials 33-34, 66, 68, 71-73, 129-130, 145, 202, 240, 248, 291, 299, 330, 353, 360, 362, 367, 369, 397, 411, 467

Matrix 129, 424

Matter 33, 59, 87, 101-102, 112, 139, 146, 161, 167, 183, 185, 211, 214-216, 218, 228, 262-263, 279, 322, 345-346, 350-351, 354, 356-358, 368-370, 372, 399-401, 410, 424, 427, 447, 452

Max Planck Forschung 373

Max Planck Gesellschaft 373

Max Planck Society 18, 357, 368

Max-Planck-Institut 111, 234

Meaning 13, 16, 64, 109-110, 117, 125, 133, 149, 212, 217, 246, 255, 257, 304, 328-329, 333, 406, 412, 418, 423, 425, 427

Measurement 114, 349

Media 11, 18-19, 27, 33, 36-37, 142-143, 161, 176, 207, 212, 219, 224-225, 228, 252, 256, 259, 349-352, 369, 376-377, 381-386, 390, 424-425, 427, 438, 442

MediaLab Madrid 225

Medical 15, 17, 27-39, 41-51, 57-58, 60, 63-64, 66, 71-72, 74, 78, 198, 235, 250, 268-272, 275, 279, 282, 285-290, 297, 299-302, 304, 363-364, 439

Medical Museion 17, 268

Medicare 29

Medicine 15, 26, 28-30, 40-41, 43-46, 48, 50-52, 54-55, 57-58, 60-65, 67-69, 71, 74, 82, 232, 278, 301-302, 304, 363, 402, 461

Memorial 309

Memory 172, 232, 257, 323, 326-327, 333, 347, 417-418, 422-428, 430, 432, 434, 436, 439, 445, 453

Merseyside Maritime Museum 458, 465

Microcosm 233, 239

Microscopy 30

Microsoft 243

MIT 205-206, 233, 252, 338, 443

Models 12, 27, 30, 34, 36, 46, 67, 206, 211, 218, 224-225, 273-274, 307, 330-331, 347, 359, 363, 366, 392,

395, 420, 460-461

Movement 12, 16, 117, 125, 133, 186,
243, 255, 308, 333, 353, 377-379,
422

Museologist 20

Museu de Ciências 412

Museu Exploratório de Ciências 396,
408, 411

Museum 11, 13-14, 16-17, 19-21, 30, 39,
48, 60-61, 63-64, 72, 75, 77, 81,
86-87, 89-91, 93-97, 104, 116-119,
122, 127, 130, 132-134, 142-143,
146-147, 149-150, 152-157, 159-
162, 165-167, 169-170, 172-176,
195, 202, 205, 207, 210, 212, 222,
224-228, 241, 246, 250-251, 254,
265, 268-271, 275, 279-285, 289,
301-302, 304, 308, 324, 336-338,
356, 369, 375-376, 378, 380-382,
384-385, 388-392, 396-398,
408-413, 417-424, 426, 428-434,
438, 441-444, 446, 448, 450-452,
454-455, 458-459, 461, 464-466,
470-472

Museum of London 77

Museum of Man 63

Museum Studies 149, 157

Museums Association 134

Music 75, 177, 386, 398, 401, 429, 442

Mutant 291-293

Mutations 14, 221, 225, 228-229, 234

Mystic Seaport 449-450, 461, 466

NanoAdventure 18, 394, 396

Nanoscale 174, 183-187, 190, 207

Nanoscience 18, 206, 360, 397-400,
403-404, 407, 412-413

Nanotechnology 16, 18, 159, 173, 175-
176, 178-188, 190, 192-196, 198-
204, 206-207, 216, 352-353, 359,
397-400, 403, 407, 410, 412-413

Narrative 12, 14-15, 107, 156, 162, 245,
266, 399, 418, 423, 425-427, 440

National Archives 431, 442

National Gallery of Practical Science
103

National Library of Medicine 51-52

National Maritime Museum 448,
451, 471

National Maritime Museum of
Australia 451

National Museum of American
History 454-455

National Museum of Science 155, 166

National Museums Liverpool 458

National Science Foundation 388

National Storytelling Network 426,
442

Native 315-317, 321-322, 333, 336, 457

Natural Philosophy 88, 99-101,
111-112

Nature 43, 56, 81, 87-88, 99, 103, 106, 142, 145-147, 154, 169, 180, 182, 195, 211, 216, 219-220, 224, 233, 241, 243, 248, 254, 258, 260-266, 274, 325-326, 338, 346, 352, 358, 360, 363, 375, 413, 421-422, 433, 445, 448, 458, 460, 467

NBC 42-44, 51

Neolithic 63

Neuron 246, 264

Neuroscience 74, 76, 82, 245, 248, 256, 260, 264

New Economic Foundation 197

New York Hall of Science 309

New York Times 303

Nobel Museum 21

North American Bird Conservation Initiative 338

North Pole 91

North Sea 465

Numbers 29, 31, 251, 316, 318, 331, 461-462

Objectivity 41, 51, 187, 203, 205

Objects 11, 15-16, 30, 57, 60, 63-64, 68, 72, 75-76, 87, 89-90, 116, 118, 125-129, 142, 149, 155-156, 165, 185-186, 200, 205, 242, 250, 262, 270-271, 276-277, 279, 287-289, 293, 297, 299-300, 304, 346-349, 355, 363, 366, 395, 398-399, 419, 421, 423, 425, 428-430, 443, 446, 448

Observation 65, 117, 120, 125, 186, 259, 273-274, 291, 295, 297-299, 301, 333, 383, 385-390, 464

Oceans 451, 461

OCIM 205

Opinion 159, 190, 196-197, 205, 285

Oral History 466, 471

Organs 56, 235, 263

Pathologist 272, 301

Pathology 30, 33, 39, 41, 49-50, 272, 284, 299

Patterns 70, 125-126, 130, 158, 174, 243, 331, 428, 462

Penguin 471

Perception 112, 258, 303, 396, 399, 410, 452

Phenomenology 303-304

Philosophy 88, 99-101, 111-113, 174, 213, 219, 229, 231, 304, 448, 468, 472

Photography 48, 252, 262, 271, 287, 297

Physicians 15, 27, 29, 31, 33, 35-38, 40-43, 45-46, 285

Physics 15-16, 74, 86-94, 96, 98-103, 105-108, 110-114, 216, 265, 359

Pictogram 379

Planning 48, 160, 205, 241, 329, 336,

375, 392, 408, 410, 441

Policy 17, 29, 117, 158, 162, 164, 172-
174, 176, 200, 202, 204-205, 235,
333, 340

Politics 16, 21, 114, 138, 140, 150, 172,
174, 197, 207-208, 211-214, 218,
232-234, 442, 471-472

Politics 16, 21, 114, 138, 140, 150, 172,
174, 197, 207-208, 211-214, 218,
232-234, 442, 471-472

Population 155, 232, 313, 316-319, 325-
326, 332, 336, 352, 364, 398, 462

Power 79, 149, 158, 179, 205, 214, 221,
227, 231, 234, 243, 256, 260, 265,
370, 452, 460, 466, 471-472

Practice 38, 40, 58, 69-70, 73, 105,
112-113, 134, 139, 153, 166, 175,
183, 187, 192, 199, 222, 298-299,
301-302, 346, 356, 423, 425, 432,
466

Project 69, 144, 160, 181, 183, 198, 202,
235, 240-241, 248, 253, 263, 271,
275-276, 281, 290, 293, 295-296,
319, 321, 324, 330, 333, 364, 376,
378, 382, 384-391, 407, 417, 422-
425, 428, 430-431, 436, 442, 445

Protestant 56

Psychology 234, 461

Public Understanding of Science 12,
21, 140, 148-150, 162, 172-175, 177,

200, 206-208, 303, 412, 441-443

Publics 16, 138, 158, 165, 173

Quality-of-Life 235

Questionnaires 133

Questions 27, 32-33, 75, 77, 82, 88-89,
98, 109, 133, 147, 153, 167-169,
182, 184, 192, 194-195, 203,
212-214, 216, 219, 241, 277, 282,
353-354, 357-358, 366, 388-389,
395, 405, 446-447, 468

Quotes 203-204

Races 227

Radio 70, 324, 433-434, 438

Radiological Society of North
America 45

Recovery 339

Reflections 81, 109, 172, 211

Registrar 122

Renaissance 56, 259

Representation 16, 40, 43, 148,
160-162, 165, 170, 175, 178-180,
182, 184, 186-188, 190, 192-193,
195, 197-201, 203, 207, 246, 248,
252, 417, 419-420, 422-423, 432,
437, 457

Requiem 309, 338

Research 12-16, 21, 27, 33, 46, 55, 62,
66, 72, 74, 77, 117, 140-143, 145-
150, 155, 158-160, 167, 171-173,
181, 187, 196, 198, 217, 222-223,

225-226, 228, 240-244, 246,
248-249, 253-254, 266, 269, 271,
275-276, 279, 283, 293, 297, 299,
302-304, 309, 326, 328, 338-339,
346, 348-350, 357, 362-364, 366,
368, 395-396, 398-399, 403, 413,
419, 431, 439, 461

Restoration 330, 333, 335

Robots 233, 352, 404

Royal Astronomical Society of
London 11

Royal College of Surgeons of
England 275

Royal Institution of Great Britain
11, 21

Royal Naval College 449

Royal Observatory 449

Royal Society 163, 265, 304

Saturn 257

Scanning 185-186, 193, 242, 261, 401

Schizophrenia 231

Science Center World Congress 408

Science Centres 12, 21, 154, 156, 165,
170, 176, 412, 419 420, 427

Science Museum 16, 19, 21, 86-87, 89,
91, 93-97, 104, 142, 147, 149-150,
153, 155-156, 160, 166-167, 169,
173-176, 224, 270, 308, 336, 396,
398, 413, 419-420, 426, 438, 441

Science-fiction 193

Scientific Instrument Society 113

Scientist 33, 69, 74, 97, 142, 188, 224,
249, 252, 256, 291, 293, 361, 417-
420, 422-425, 428, 438-439

Screening 32, 51

Sea 92, 309, 331, 445, 447-448, 450-
454, 456, 459-462, 464-468, 471

Sea-bound 448, 456

Security 153, 212, 232, 460

Ships 447, 449-450, 453, 459-462

Showmanship 28, 35, 40-41

Skeletons 55, 70, 77-78, 282

Skype 221, 382

Sleeping 69, 75

Smithsonian Institution 157, 175

Sociology 13, 16, 19, 141, 149, 174, 205

Space 11-14, 17, 32, 35, 37, 39, 46, 81,
101-103, 106-107, 112-113, 120, 122,
124-125, 127, 140, 146, 149, 156,
162, 165, 167-169, 184, 186, 202,
211-212, 214, 224-226, 231, 250,
255, 257, 271, 281, 290, 293-295,
322, 329, 345, 347, 358-359, 396-
398, 411, 417, 428 429, 463, 471

Sport 368-370

Stem Cells 233

Storytelling 19, 416-417, 420, 422-
426, 428, 430-431, 435-436, 438,
441-442, 468

Students 108, 186, 195, 201, 222, 247,

254, 277, 289, 297, 301, 380

Studies 20-22, 103, 107, 113, 122, 149,
153, 157, 172, 174-176, 180, 202,
207, 233-234, 251-252, 271, 304,
308, 377-378, 384, 396

Subjectivity 234, 259

Surgeon 49, 57, 92

Surveys 269

Sustainable 332, 365, 367

Swiss Academy of Sciences 254

Taxidermy 206

Taxonomies 207

Techniquest 156

Technology 17, 21, 79, 107, 111, 149,
154-155, 157, 159, 163-164, 170,
172-176, 180, 192, 196, 201-203,
205, 211-213, 216-217, 219, 221,
223-229, 232, 234, 260, 265, 270,
288, 297, 300, 304, 308, 349-350,
357, 360-361, 363, 369, 373, 378,
382, 384, 395-399, 410, 412, 420,
425-426, 429-430, 445, 461,
467, 472

Telepresence 217, 233

Television 37, 41-42, 44, 50-51, 324

Territory 232, 317-318

Testimony 417-423, 425, 428, 432,
434-437, 439

Thackray Museum 16, 116-118, 127,
130

Themes 14, 35, 60, 68, 70, 79, 112-113,
117, 245, 356, 365, 369, 371, 424,
453, 472

Theory 13, 38, 41, 92, 97, 109, 172, 175,
231, 235, 245, 255, 258, 265, 290,
293, 359, 425, 443, 471-472

Thought 64-65, 72, 76, 93, 118, 160,
195, 223-224, 234, 240, 282, 314,
333, 445, 464, 468

Time 28, 32, 34, 36, 56-57, 59, 63-64,
71, 73, 75, 87, 90, 103, 105, 107,
118, 125, 131, 142-143, 154, 168,
186, 203, 213, 217-218, 224, 241,
256, 262, 270, 276-277, 279, 286-
287, 289, 293-299, 307-308, 315,
323, 328, 333, 336, 345, 354, 358,
370, 377, 379, 386, 389, 396-397,
401-402, 406, 408-410, 418, 424,
426, 428, 433-434, 446, 451, 454,
459-460, 467

Titanic 433

Tools 18, 125-126, 128, 154, 203, 299,
387, 389, 401, 419, 423, 427-428,
438

Touch table 436, 438

Translation 11, 149, 205, 215

Travel 62, 205, 322, 382, 451, 454

Tree 239, 243, 246, 248-249, 253, 257-
260, 322, 348, 365, 438

Twitter 376

Typography 362

UNESCO 149, 449

United States Environmental
 Protection Agency 339

University of Wisconsin Arboretum
 336

Venice Biennale 250

Victorian 67, 78, 101-102, 111-113

Videclinic 42-44

Video 56-57, 123, 194, 217, 252, 380,
 386, 398-401, 432-434

Virtual 28, 40, 186, 207, 362, 370, 386,
 398, 401, 403-405, 407, 414, 441

Visitor 12, 14, 16-19, 34, 55, 120-121,
 132-133, 139-140, 144, 146-147,
 179, 183-184, 187, 190, 192, 195-
 196, 199, 254, 270-271, 280, 300,
 329, 344-345, 349-350, 357-358,
 360, 362-363, 366-367, 377, 384,
 392, 395, 398-399, 402, 406, 412,
 423-426, 428-429, 439, 466

Vitae Foundation 396

Voice 28-29, 65, 79, 141, 182, 190,
 430-431, 434

Volume 14, 19-20, 339-340, 429

Voting 167-168

Voyages 450-451, 466

Waldon Association 119-120, 122, 126,
 130-132, 134

Website 118, 168, 302, 407, 426, 431,
 434, 458

Weight 355, 456

Wellcome Trust 62, 67, 176

Whipple Museum 21

Wikipedia 392

Wildlife Service 318-319, 330, 335, 339

Wimshurst 95-96

Wind Cave National Park 316

Wisconsin Historical Society 328,
 330

Wolves 317-318

Wood 250, 288, 317, 436

Wood Buffalo National Park 317

Woodland 250, 326-328, 331, 333

Work 18, 22, 27, 39, 46, 56, 61-62, 66-
 67, 69-71, 74, 80, 87, 92, 97-98,
 100, 102, 105, 108, 117-120, 140,
 157, 160, 176, 179, 216, 222, 227,
 239, 246, 248, 271, 276, 279, 284,
 289, 296, 299, 309, 320-321, 323,
 325-326, 328-331, 333, 336, 339,
 345-346, 348, 360, 366-367, 375,
 380, 383, 385, 387, 389-391, 402-
 403, 405, 409, 411, 420, 440,
 445-446, 454, 456, 460, 462,
 468, 472

World Heritage Site 449

World War II 31

World Wide Web 376

Writers 193

Wroughton 94

Wunderkammer 223

Xbox 379

Xperiment 144-145, 150

X-rays 32, 36-37, 282, 288

Yellowstone National Park 318

YouTube 376, 392, 401, 411

About the Authors

Ken Arnold has worked in a variety of museums on both sides of the Atlantic. He now heads the Wellcome Trust's Public Programmes department, running a range of events and exhibitions in Wellcome Collection (a young venue that explores the links between medicine, life and art). He joined the Wellcome Trust in 1992 after completing his Ph.D. on the history of museums. He regularly writes and lectures on museums and on contemporary interactions between the arts and sciences. He also serves on a number of advisory boards and committees. His most recent book is *Cabinets for the Curious* (Ashgate, 2006).

Dr Sarah R Davies is a researcher with interests in public engagement with science, science in museums, and public responses to emerging technologies. She has a BSc in Biochemistry, an MSc in Science Communication, and a PhD on public dialogue on science, all from Imperial College, London. She has worked at Durham University's Institute of Hazard and Risk Research, been a Fellow of the North East Beacon for Public Engagement, and is currently based at Arizona State University. She has published widely including the journals *Science as Culture*, *Public Understanding of Science*, and *Science Communication*, and co-edited *Science and its Publics* (2008). She has also worked in exhibition development at the Science Museum, London, and taught undergraduate science students about communicating science.

Dr Anastasia Filippoupoliti is a lecturer in museum

education at the School of Education Sciences, Democritus University of Thrace (Greece). She also lectures at the Hellenic Open University. She undertook research in the fields of museology and science communication while she was a postdoctoral fellow at the Austrian Academy of Sciences, and focused on exhibition design and museum planning issues while working as a museologist at the Piraeus Bank Group Cultural Foundation (Greece). She holds PhD and MA degrees in museum studies (University of Leicester, UK) and a BA in history and philosophy of science (University of Athens). She writes regularly on exhibitions, collections and science museums.

Jim Garretts is Senior Curator of the Thackray Museum in Leeds. His previous posts were at the People's History Museum in Manchester, Manchester Jewish Museum, Bury Art Gallery and Museum and Salford Museums and Art Galleries. He holds the Diploma of the Museums Association and is currently an Executive Committee Member of the Yorkshire and Humberside Federation of Museums and Art Galleries. He has been a freelance lecturer at the University of Central Lancashire and has delivered lectures at Manchester Art Gallery, the Scottish Museums Federation, the National Museum of Coal Mining for England and the National Portrait Gallery. He researched and curated a touring exhibition about the Co-operative Wholesale Society in 1995 and has addressed conferences about friendly societies and the co-operative movement.

Gunnar M Gräslund, exhibition designer, is Co-founder and Partner of ArchiMeDes. Apart from creating and designing touring and permanent exhibition systems, he is also responsible for the spatial conception of exhibitions, implementation planning and controlling, as well as the construction of models and prototypes. Gunnar has a degree and master (Meisterschüler) in visual communication/ exhibition design from the Berlin University of Arts, where he worked as an art and research associate.

Dr Antonia Humm is a historian and has been Research Associate at ArchiMeDes since 2001. She is responsible for the development of exhibition and media concepts, content-related research, text production and editing for exhibitions and catalogues, project management, and customer support. She previously worked for various museums and exhibition projects, including the German Museum of Technology and the Berlin Stadtmuseum. Antonia read history, German studies and sociology at the Freie Universität Berlin (FU) and Humbold Universität (HU) in Berlin and completed advanced training in multimedia creation.

Joseph Emmanuel Ingoldsby trained in art and landscape architecture with Ian McHarg, who mentored him on Design with Nature at PENN. The focus and methodology involved a comprehensive analysis of the geology, hydrology, soils, vegetation, and the cultural overlays of both local and regional landscapes. This methodology provided the foundation for

current collaborative work, as he transitioned to exhibitions, installations, digital media and film combining art, science and technology to advocate for vanishing landscapes and endangered species. Through his firm, Landscape Mosaics, Joseph collaborates with community, government, scientists, academic institutions and environmental groups to bring environmental issues to the attention of the public. His research, writings and art may be viewed at JosephIngoldsby. com and LandscapeMosaics.com.

Lisa Jamieson is the Events Manager at Wellcome Collection, a new venue in London exploring the connections between medicine, life and art. She manages a team of three, programming weekly debates, discussions, performances and workshops for independent adults. She is also responsible for developing the education strategy for young adults. Prior to Wellcome Collection she was Programme Manager at the Science Museum's Dana Centre curating the launch programme and leading the UK's arm of *Meeting of Minds*, a European citizens' deliberation. Lisa has an honours degree in Chemistry from the University of Aberdeen and an MSc in Science Communication from Imperial College London.

Dr Denisa Kera, is Assistant Professor at the National University of Singapore where she teaches interactive media design and new media theory in the Communications and New Media Programme. She holds a Ph.D. in Information Science from Charles University in Prague and an MA in Philosophy.

She is an active member of the Science, Technology, Society research cluster at the Asia Research Institute. She has extensive experience as a curator of exhibitions and projects related to art, technology and science. She is an art critic for Czech and Slovak media, among others *Flash Art* and *Umelec*, and presently she is interested in the limits of design and in art related to death, memorials and the possible apocalypse.

Dr Marcelo Knobel is a Professor at the Instituto de Física Gleb Wataghin (Gleb Wataghin Physics Institute), of the Universidade Estadual de Campinas (State University of Campinas, UNICAMP), Brasil. He has a PhD in Physics from UNICAMP, and has undertaken post-doctorate studies at Istituto Elettrotecnico Nazionale Galileo Ferraris, Turin, Italy, and Instituto de Magnetismo Aplicado, Madrid, Spain. Since 1999 he has led the Laboratório de Materiais e Baixas Temperaturas (Materials and Low Temperature Laboratory), from 2002 to 2006 he coordinated de Núcleo de Desenvolvimento da Criatividade (Creativity Development Center, NUDECRI), of UNICAMP and from 2006-2008 was Executive Director of the Campinas Science Museum, also at UNICAMP. He is the coordinator of *NanoAventura*.

Marius Kwint is Senior Lecturer in Visual Culture at the University of Portsmouth. He graduated in Cultural History at the University of Aberdeen in 1988, where he took the Lyon Prize, and wrote his doctorate on the eighteenth-century English circus at Oxford University, where he later served as

Lecturer in History of Art from 1999 to 2008 and as a Fellow by Special Election at St. Catherine's College. He has held research fellowships at the Houghton Library, Harvard University and with the Joint History of Design Postgraduate Programme at the Royal College of Art and the Victoria and Albert Museum, London. He has written for a number of journals including *Past and Present*, *History Today*, *Journal of Victorian Culture*, *Fashion Theory*, *Tate Magazine* and *Asian Art News*, and was contributing editor of the book *Material Memories: Design and Evocation* (Oxford: Berg, 1999). More recently, with Irving Sandler he has written a monograph for Skira, Milan, on the Gujarati-American abstract painter Natvar Bhavsar, and curated an exhibition by the American-Scottish figurative artist Beth Fisher at the University of Portsmouth, on tour from the Royal Scottish Academy.

Brice Laurent is a PhD candidate at the Center for the Sociology of Innovation (CSI) of Mines ParisTech. His work builds on Science and Technology Studies and political science. It focuses on political issues raised by nanotechnology and explores the mutual production of repertoires of political activity (such as representation, administration and mobilization) and nanotechnology as a science policy program. He is a member of the Science and Democracy network. Brice graduated (MSc) in 2005 from the Ecole des Mines and in 2006 from the Ecole des Hautes Etudes en Sciences Sociales (MA). Since 2005, he has been employed as *ingénieur des mines* by the French Ministry of Economics.

Wayne LaBar, as Vice President of Exhibitions and Featured Experiences at Liberty Science Center, oversees thematic content, exhibitions, large-format film and design at Liberty Science Center (LSC). As Principal-in-Charge of LSC Experience Services, which Wayne launched and leads, LSC helps design and develop science centers and museums around the world, as well as producing travelling exhibitions that tour internationally. As part of both positions, Wayne and the team he leads explores how new technology can encourage guests to interact with exhibitions and the exhibition process. With 23 years of museum experience and numerous papers and presentations, his former roles include Director of Exhibits at the Tech Museum, San Jose, CA, Project Manager, at KPA inc, and Project Manager at the Carnegie Science Center, Pittsburgh, PA. He is on the Board of the National Association of Museum Exhibition, and a member of IDSA, CTBUH and ULI. Wayne is a graduate of the Georgia Institute of Technology with a Bachelors of Aerospace Engineering and is a graduate of the Museum Leadership Institute.

Dr Lucy Lyons is an artist and academic. Her PhD, explored how the activity of drawing communicates insight whilst maintaining the dignity of the subject being observed. Lucy was shortlisted for the *Jessica Wilkes Award* and won a British Council *Darwin Now Award* 2009. Solo exhibitions include *Delineating Disease: Drawings by Lucy Lyons* at the Hunterian Museum at the Royal College of Surgeons of England in 2008. She was a tutor in painting and research at City & Guilds

of London Art School from 2001 – 2009 and is currently Postdoctoral Fellow at the Medical Museion at the University of Copenhagen.

Sharon Macdonald is Professor of Social Anthropology at the University of Manchester. She has carried out research on a wide range of types of museums. Her work on science museums includes her in-depth account of the Science Museum, London: *Behind the Scenes at the Science Museum* (2002). Her more recent books include *A Companion to Museum Studies* (2006), *Exhibition Experiments* (2007, edited with Paul Basu) and *Difficult Heritage: Negotiating the Nazi Past in Nuremberg and Beyond* (2009).

Tanya Marriott is a Digital Media lecturer at the Institute of Communication Design at Massey University in Wellington, New Zealand. Her recent Masters thesis focused on developing innovative ways to access museum artefact archives within an interactive and immersive context. Her other research interests also focus on similar topics surrounding the development of personal understanding and empathy through immersive narrative and character identity. Tanya has a background in industrial design and animation, and has worked in the film industry in New Zealand, Canada and UK.

Dr Sandra Murriello is Professor at the Universidad Nacional de Río Negro (UNRN), Argentina, and a collaborative researcher for the LABJOR, UNICAMP (Brazil). Sandra graduated in

Biology in the Facultad de Ciencias Naturales y Museo of the Universidad Nacional de La Plata, Argentina, specialized in Scientific Journalism at the Fundación Campomar in Buenos Aires and has a Doctorate in Geoscience Education from the Universidade Estadual de Campinas (UNICAMP), Brazil.

Miriam Posner, a Ph.D. candidate in Film Studies and American Studies at Yale University, is completing a dissertation on the role of narrative in American medical filmmaking. Miriam has published and presented on Thomas Edison's films about tuberculosis, the visual culture of lobotomy, and the history of American supermarkets. In the summer of 2010, Miriam begins a new position as Mellon Postdoctoral Research Associate for the Digital Scholarship Commons at Emory University in Atlanta, Georgia.

Jörg Schmidtsiefen, exhibition and media designer, is Co-founder and Managing Partner of ArchiMeDes. Berlin-based exhibition agency ArchiMeDes, has been creating and implementing interactive exhibitions and experiences for museums, science centres, research institutions and companies since 1996. One of its specialist areas is science exhibitions, including the recently completed *Science Express* and *Computer.Sport*. Jörg has a degree in visual communication and Masters (Meisterschüler) in Design from the Berlin University of Arts.

William M Taylor is Winthrop Professor in the School of

Architecture, Landscape and Visual Arts at the University of Western Australia where he teaches architectural design and the history and theory of the built environment. He has written on a range of subjects including architectural history and theory, social and political theory, architectural and landscape project reviews. Recent work includes a major monograph *The Vital Landscape, Nature and the Built Environment in Nineteenth-Century Britain* (Ashgate, 2004) and two edited collections *The Geography of Law, Landscape and Regulation* (Hart, Oxford, 2006) and (with Philip Goldswain) *An Everyday Transience: The Urban Imaginary of Goldfields Photographer John Joseph Dwyer* (UWA Publishing, 2010). He is currently completing a multidisciplinary project and book with Michael Levine titled *Prospects for an Ethics of Architecture* (Routledge, forthcoming, 2011).

Jane Wess studied physics at York University and then taught mathematics before becoming a curator at the Science Museum in 1979. Jane took the lead role in the Optics gallery which opened in 1986 and went on to catalogue and display the King George III Collection of Scientific Instruments. With Alan Morton she wrote *Public and Private Science: The King George III Collection* (1993). In 2003 she worked on the Enlightenment gallery in the British Museum. In 2004 she produced *Inside the Atom; Two Sides of a Story* and recently she has produced exhibition catalogues for *The Most Sublime Science* and *From Order to Obsession: A View of Mathematics* which looked at mathematics through its motivations. She

is an active member of the British Society of the History of Mathematics.

Also from MuseumsEtc

Science Exhibitions:
Communication and Evaluation

Edited by Dr Anastasia Filippoupoliti
Lecturer in Museum Education
Democritus University of Thrace, Greece

This important new book is the companion volume to Science Exhibitions: Curation and Design. Drawing on cutting-edge experience throughout the world, and including contributions from Australia, Canada, Greece, Italy, Portugal and Mexico – as well as the UK and USA – the book provides an authoritative, stimulating overview of new, innovative and successful initiatives in the fields of science exhibition communication and evaluation.

The authors are leading museum professionals and researchers in the museum field, from institutions such as English Heritage, Huntington Library, Art Collections and Botanical Gardens, Canada Agriculture Museum, New York Hall of Science, Miami Science Center, and Museum Victoria, Australia.

ISBN: 978-0-9561943-8-1 [paperback]; 978-1-907697-07-4 [hardback].
Order online from www.museumsetc.com

Rethinking Learning: Museums and Young People

Practical, inspirational case studies from senior museum and gallery professionals from Europe and the USA clearly demonstrate the way in which imaginative, responsive services for children and young people can have a transformational effect on the museum and its visitor profile as a whole.

Authors recount how, for example – as a direct result of their focus on young people – attendance has increased by 60% in three years; membership has reached record levels; and repeat visits have grown from 30% to 50%. Many of the environments in which these services operate are particularly challenging: city areas where 160 different languages are spoken; a remote location whose typical visitor has to travel 80 miles; the museum which targets children with challenging physical, mental or behavioural needs.

This is an essential book not only for those working with children and young people, but for those in any way concerned with museum and gallery policy, strategy, marketing and growth.

ISBN: 978-0-9561943-0-5
Order online from www.museumsetc.com

The Power of the Object:
Museums and World War II

In this important new book, based on a conference held by the National Museum of Denmark, international museum professionals deal with the key issues affecting all history museums, using as the basis for their insights the interpretation by museums of World War II.

Among the many issues the contributors address are:

· How best can abstractions like cause, effect and other ideas be interpreted through objects?
· Just how is the role of objects within museums changing?
· How should we respond when increasingly visitors no longer accept the curator's choice of objects and their interpretation?
· How can museums deal effectively with controversial historical issues?

These essays explore how history museums can help explain and interpret the thinking of past generations, as well as their material culture.

ISBN: 978-0-9561943-4-3
Order online from www.museumsetc.com

Narratives of Community: Museums and Ethnicity

Edited by Dr Olivia Guntarik, RMIT University,
Melbourne, Australia

In this groundbreaking book, cultural theorist and historian Olivia Guntarik brings together a collection of essays on the revolutionary roles museums across the world perform to represent communities. She highlights a fundamental shift taking place in 21st century museums: how they confront existing assumptions about people, and the pioneering ways they work with communities to narrate oral histories, tell ancestral stories and keep memories from the past alive.

The philosophical thread woven through each essay expresses a rejection of popular claims that minority people are necessarily silent, neglected and ignorant of the processes of representation. This book showcases new ways of thinking about contemporary museums as spaces of dialogue, collaboration and storytelling. It acknowledges the radical efforts many museums and communities make to actively engage with and overthrow existing misconceptions on the important subject of race and ethnicity.

ISBN: 978-1-907697-05-0 (paperback) | 978-1-907697-06-7 (hardback)
Order online from www.museumsetc.com

New Thinking: Rules for the (R)evolution of Museums

This new collection of essays by leading international museum practitioners focuses on the across-the-board innovations taking place in some of the world's most forward-thinking museums – and charts the new directions museums will need to take in today's increasingly challenging and competitive environment.

Among the twenty world-class organisations sharing their innovative experiences are:

- Canada Agriculture Museum
- Canadian Museum for Human Rights
- Conner Prairie Interactive History Park
- Cooper-Hewitt National Design Museum
- Imperial War Museum
- Liberty Science Center
- Miami Science Museum
- Museum of London
- National Museum of Denmark
- Royal Collection Enterprises
- Smithsonian American Art Museum
- Victoria & Albert Museum
- Wellcome Collection

ISBN: 978-0-9561943-9-8 (paperback) | 978-1-907697-04-3 (hardback)
Order online from www.museumsetc.com

Inspiring Action: Museums and Social Change

Fifteen leading museum and gallery professionals contribute inspiring, practical essays on the ways in which their institutions are responding to the new social challenges of the twenty-first century.

Drawing on pioneering international experience from the UK, USA, Australia and Africa, these experienced professionals explore the theory and the practice of building social inclusion in museum and gallery programmes.

Contributors include: Ronna Tulgan-Ostheimer, Clarke Art Institute; Manon Parry, National Library of Medicine; Gabriela Salgado, Tate Modern; Katy Archer, NCCL Galleries of Justice; Peter Armstrong, Royal Armouries; Keith Cima, Tower of London; Olivia Guntarik, RMIT University; Elizabeth Wood, IUPUI School of Education; Gareth Knapman, Museum Victoria; Jennifer Scott, Weeksville Heritage; Susan Ghosh, Dulwich Picture Gallery; Jo Woolley, MLA; Marcia Zerivitz, Jewish Museum of Florida; Carol Brown, University of KwaZulu-Natal; Eithne Nightingale, V&A Museum.

ISBN: 978-0-9561943-1-2
Order online from www.museumsetc.com

Creating Bonds: Marketing Museums

Marketing professionals working in and with museums and galleries throughout the UK, USA and beyond, share their latest insights and experiences of involving and speaking to a wide range of constituencies. Their practical, insightful essays span the development and management of the museum brand; successful marketing initiatives within both the small museum and the large national museum environment; and the ways in which specific market sectors – both young and old – can be effectively targeted.

Contributors include: Amy Nelson, University of Kentucky Art Museum; Aundrea Hollington, Historic Scotland; Adam Lumb, Museums Sheffield; Bruno Bahunek, Museum of Contemporary Art, Zagreb; Claire Ingham, London Transport Museum; Kate Knowles, Dulwich Picture Gallery; Danielle Chidlow, National Gallery; Margot Wallace, Columbia College; Rachel Collins, Wellcome Collection; Sian Walters, National Museum Wales; Gina Koutsika, Tate; Alex Gates, North Berrien Historical Museum.

ISBN: 978-0-9561943-1-2
Order online from www.museumsetc.com

Colophon

Published by
MuseumsEtc
8 Albany Street
Edinburgh EH1 3QB
www.museumsetc.com

Edition © MuseumsEtc 2010
Texts © the authors
All rights reserved

ISBN: 978-0-9561943-5-0
British Library Cataloguing in Publication information available.

Typeset in Underware Dolly and Adobe Myriad Pro

CPSIA information can be obtained
at www.ICGtesting.com
Printed in the USA
LVHW080234310119
605903LV00007B/46/P

9 780956 194350